YOKO ONO

YOKO ONO

JERRY HOPKINS

Macmillan Publishing Company
New York

Collier Macmillan Publishers
London

*For the photographs appearing between pages 88 and 89,
the following are acknowledged: Page 1, © Jerry Hopkins;
Page 2, 1985 © Fred W. McDarrah; Page 3, © AP/Wide
World; Page 4 top, © Jerry Hopkins; Page 4 bottom,
© AP/Wide World; Page 5 top, © AP/Wide World;
Page 5 bottom, 1985 © Fred W. McDarrah; Page 6 top,
1985 © Fred W. McDarrah; Page 6 bottom, © 1980
David McGough/DMI; Page 7 top, © AP/Wide
World; Page 7 bottom, © 1984 David McGough/DMI;
Page 8, © AP/Wide World.*

Library of Congress Cataloging-in-Publication Data
Hopkins, Jerry.
Yoko Ono.
Includes index.
1. Ono, Yoko. 2. Entertainers—United States—
Biography. I. Title.
PN2287.O56H66 1986 790.2'0924 [B] 86-23604

ISBN: 0-02-553950-7

*Macmillan books are available at special discounts
for bulk purchases for sales promotions, premiums,
fund-raising, or educational use.
For details, contact:*

*Special Sales Director
Macmillan Publishing Company
866 Third Avenue
New York, N.Y. 10022*

10 9 8 7 6 5 4 3 2 1

Designed by Jack Meserole

Printed in the United States of America

This is for the people who must *be artists, or must try to be. They are pushing at the walls the rest of us erect.*

It's also for my wife, Rebecca, and our three children, Erin, Nicky, and Kessel, who together push at my *walls, making me more complete.*

With aloha.

CONTENTS

ACKNOWLEDGMENTS

ELLIOT MINTZ was always friendly when I called. We weren't friends, but we were on the scene together in Los Angeles during the sixties and now he was Yoko Ono's trusted confidant and public spokesperson. When I decided to write this book, I figured he'd be my best connection.

I called Elliot and asked for interviews. Yoko declined. (No surprise, really; she felt she was badly burned by other writers with whom she cooperated.) He didn't. That isn't to say he gave me an interview, because he certainly didn't. But he never said no. In a way, Elliot was more Japanese than Yoko was.

Many did talk, of course, and one of the things I noticed was how difficult it was, in many cases, to keep the interviewee on the subject of Yoko Ono. I had to remind people that I was writing about her, not *him*. John Lennon was an undeniable and unavoidable presence. I knew how Yoko felt all those times when she wished people would look at her.

There were many who talked who will not be named, here or in the text. Several were Beatle insiders who gave me exclusive interviews. Others were entangled in the ganglia of attorneys and recording industry people who spoke anonymously because they feared never working for Yoko again if they told their adventures openly. Several photographers refused to allow their pictures to be published in this book for the same reason. The "keeper of the wishing well," as she calls herself, carries a lot of power along with her enormous wealth.

Others spoke freely. In alphabetical order, they included: Chris Albertson, Patricia Bosworth, Chris Charlesworth, Ray Connolly, Philip Corner, Robert DeHavilland, Terry Doran, John Dunbar, Anthony Fawcett, Henry Flynt, Peter Frank, Ken Friedman, Steve Gebhardt,

David Geffen, Roselee Goldberg, Bill Harry, Jon Hendricks, Dick Higgins, Vivian Janov, Aubrey Jay, Fred Jordan, Allan Kaprow, Alison Knowles, John Kosh, Paul Krassner, Shigeko Kubota, Meyer Kupferman.

Leah Binger Lenney, Nicholas Logsdail, Fred McDarrah, Barry Miles, Howard Moody, Kurt Muncacsi, David Nutter, Michael O'Connor, Nam June Paik, David Peel, D. A. Pennebaker, Richard Rabkin, Yvonne Rainer, Dan Richter, Betty Rollin, Patti Romanowski, Carolee Schneeman, Norman Seaman, Paul Shaffer, Jeff Sheridan, Howard Smith, Cary Sterling, John Stevens, Kathie Streem, Howard Taylor, Sandra and Terry Wake, Bob Watts, Jon Wiener, John Wilcock, Al Wunderlick, and Joji Yuasha.

Interviews with Yoko and with Cynthia and Julian Lennon came from Rona Elliot at NBC in New York.

Steve Gebhardt gave me a look at much of the film. Roger Tomlinson spent hundreds of hours locating and copying stories in the British press, and Yoko Nimura did the same in Tokyo.

Ray Connolly in London and Michael Ochs in Los Angeles made their extensive personal files available.

More thanks to the staff, files, and libraries of *Melody Maker*, *New Musical Express*, Music Sales, *Daily Express*, and *Daily Mirror* in London; *Rolling Stone*, the *New York Times*, the *Los Angeles Times*, *Village Voice*, and *Billboard* in America.

Several previously published books were helpful, especially *The Ballad of John and Yoko* by the editors of *Rolling Stone* (Rolling Stone/ Doubleday/Dolphin, 1982); *Come Together: John Lennon in His Time* by Jon Wiener (Random House, 1984); *The Love You Make: An Insider's Story of the Beatles* by Peter Brown and Steven Gaines (McGraw-Hill, 1983); *The Longest Cocktail Party* by Richard DiLello (Playboy Press, 1972); *Loving John: The Untold Story* by May Pang and Henry Edwards (Warner Books, 1983); *Dakota Days* by John Green (St. Martin's Press, 1983); and *John Lennon: One Day at a Time* by Anthony Fawcett (Grove Press, 1976).

Let's not forget the avid fans, especially Madeline Bocchiaro, Marsha Ewing, and Brian Hendel. The latter two publish somewhat gushy but microscopically informative fan publications. Marsha's is *Instant Karma*, available for $9.50 a year U.S., $13 overseas for six issues, P.O. Box 256, Sault Ste. Marie, MI 49783. Brian's is *Yoko Only*, *A Celebration of the Life and Works of Yoko Ono*, $9 U.S., $12 overseas for this bimonthly, 61 Middle Dr., Toms River, NJ 08753.

For love, shelter, feedback, and other nurturing: Rona Elliot and Roger Brossy, Frank and Linda Lieberman, Esther Newberg, Barry Lippman, and David Wolff.

YOKO ONO

1

Walking

in

New York

JOHN LENNON had been dead for four years when his widow, Yoko Ono, accepted a telephone call from Steve Gebhardt. Gebhardt had worked for John and Yoko in London in the sixties and in New York in the seventies, had represented the Lennons at the Cannes Film Festival, and had a hand in the production of fourteen of their films, including the hour-long *Imagine* and the unreleased in-concert documentary of the John Sinclair benefit. Gebhardt was calling Yoko in the summer of 1984 because he had an idea. He knew, he told Yoko, that he could put together a documentary about John, using only John's voice for a narrative.

Yoko had been approached by many filmmakers since John had been killed, and she had met with several. None had presented the unique angle of having John narrate the story of his own life. It was an interesting concept.

Yoko was cool, nonetheless. Gebhardt had "crossed" her once, and she remembered the incident vividly. In fact, it had resulted in his leaving the Lennon-Ono film company, Joko Films. Joko had produced a Rolling Stones documentary, *Ladies and Gentlemen, the Rolling Stones!*, and Gebhardt had put his name on the film as director. Yoko felt she should have been so identified, even though she was not present during the filming or editing. It was her position that she could "direct" from afar.

So when Gebhardt called with his idea, he was not talking with someone totally open to him. He sensed in Yoko a clear reserve. Nevertheless, he said he'd send the rough cut of a film he had put

together. It was three hours long and needed work, he said, but it showed what he had in mind. Yoko said she couldn't guarantee that she'd look at it. Gebhardt sent it to her office anyway.

When Yoko reviewed the film, she was upset. Oh, there were moments, and as the scenes went rushing past she relived much of her fourteen years with John. And Gebhardt had stayed true to his promise to use only John's voice in the narrative. But it was the final scene that put an end to Gebhardt's hopes. In a section illustrating John's death he had used a bit of John's voice from one of his last public interviews. They were the wrong words to use.

John and Yoko had given the interview two days before he was shot. One of many they had scheduled to publicize their new album, *Double Fantasy*, this one was conducted by England's BBC on December 6, 1980 in the Hit Factory, a New York recording studio.

It was one of the last interviews the couple gave, and the final question, and John's answer, would ring in Yoko's ears forever.

"One final question to you," the interviewer, Andy Peebles, asked. "What about your private life and your own sense of security these days? David Bowie [whom Peebles had interviewed a day before] has recently said that the great thing about New York is that he can walk down the street and people, instead of rushing up and ripping his clothes off, will come up, or rather will just walk past him, and say, 'Hi, David, how are you?' And he'd say, 'I'm very well.' Is it the same for John and Yoko?"

John answered, "Yeah, that's what made me finally stay here. It wasn't a conscious decision. I just found that I was going to movies, going to restaurants, and I had the five years. You think you know. It was just baking bread and the baby. When I left England I still couldn't go on the street. We couldn't walk around the block, couldn't go to a restaurant, unless you wanted to go with the business of the star-going-to-the-restaurant garbage. I've even been walking the streets for the last seven years. When we first moved here, we lived in the Village, in Greenwich Village, which is the sort of artsy-fartsy section of town, for those who don't know, where all the students and the would-be's live, you know? A few old poets and that. You know, people that have lived there for years, still live there. She [Yoko] told me that, 'Yes, you can walk on the street.' You know. She says, 'You will be able to walk here.' But I was walking around tense like, waiting for somebody to say something, or jump on me, and it took me two years to unwind.

"I can go right out this door now and go in a restaurant. You want

to know how great that is? Or go to the movies? I mean, people come and ask for autographs or say, 'Hi,' but they don't bug you, you know. They just, 'Oh, hey, how you doin'? Like your record.' Because we've got a record out now. Before that they'd shout, 'How you doing? How's the baby?' 'Oh, great, thanks.' "

It was a long speech, and it showed that John was genuinely comfortable openly walking the streets of New York. However, Gebhardt hadn't used the whole speech. He had used only the part where John quoted Yoko: "She told me that, 'Yes, you can walk on the street.' You know. She says, 'You will be able to walk here. . . .' "

As if Yoko were to blame!

To be fair to Stephen Gebhardt, perhaps that wasn't his intention at all. Nonetheless, it was a poor choice of words to use for the final narrative. The words already were burned into Yoko's memory. Yes, she had given John permission to walk the streets. She remembered. She could never forget.

2
Coming of Age in Nippon

Y OKO ONO was nineteen and a summer student at Harvard University when she went to a friend for help with an essay she was writing for an English class. Her friend suggested that she recall her earliest memory and use that.

Yoko remembered a trip to New York she and her mother had made from the palatial Ono home in Tokyo to visit her father, who was working in the Manhattan branch of the Yokohama Specie Bank. It was in 1940. Yoko was seven years old at the time, and her mother had left her alone in the hotel room for several hours. She had grown frightened, then terrified, and when her mother finally returned, Yoko ran to her, crying. Yoko said her mother held her at arm's length; she did not comfort her daughter because she didn't want Yoko's tears on her mink coat.

Yoko entered Sarah Lawrence College at the end of that Harvard summer and was soon recalling many of her early memories. In one story, written again for an English class, Yoko told of a nine-year-old girl in Tokyo. The little girl was sick, and her mother called the doctor, who examined the child alone in her bedroom. He told her to close her eyes. The child closed her eyes, and the doctor sat on the edge of the bed and leaned close to her.

"Kiss me," he whispered.

He lowered his face toward hers.

4

"Oh, I love you, you're so beautiful," the doctor said. "So beautiful. So beautiful."

He lowered his mouth to hers.

The child went rigid and opened her eyes. The doctor smiled and said, "Are you scared?"

"No."

"What happened?" he asked.

"Nothing."

"I was just examining you, is that not true?"

The child trembled and said, "Yes, that is all."

The doctor left the room, and the child rushed to her bathroom nearby. She felt as if she had been raped. She roughly and thoroughly scrubbed her mouth, trying to erase the damage she felt.

After a while, the child's mother entered the room to say good night. She was dressed in silk and smelled of perfume. She was on her way to a party. The child was still upset and she whispered to her mother that she felt uncomfortable about the doctor's visit. She hinted that the doctor had done something.

Her mother was aghast and said, "Well, if you feel that way, you must have invited it!" And then the mother went to her party, leaving the child alone.

Years later, Yoko said over and over that her mother was beautiful. "She kept saying, 'You should feel lucky that you have a beautiful mommy.' But it was like having a film star in the house. When you're hungry and want food and someone says, 'Well, I'll show you a film of food,' you are never really fulfilled. It was like that. She was like somebody on a screen, always pleasant, always smiling at you, but she didn't give." In another interview she said, "I often wish my mother had died so that at least I could get some people's sympathy."

Yoko's father was no great help. In fact, during the first years of her life, he wasn't even there; he had left Tokyo two weeks before she was born to work in the bank's San Francisco branch, and it wasn't until she was almost three that she met him. This became a pattern.

"I got no support from my family at all," Yoko said some years later. "In the first place, I think my mother and father had wanted to have a son. You see, my father had been a concert pianist and he had been somewhat successful, but then in the middle of all that, his father asked him to become a banker, so he gave up being a concert pianist. Well, they didn't have a boy, they had me, but I guess they reasoned that even a girl could play the piano.

"Actually, he had a complex feeling about it. He would want me to play, but not so that I would ever be as good as he, so whenever I started to play, he would say, 'No, not that way, let me show you how.' "

Yoko's father also liked to measure the span between his daughter's thumbs and the tips of her fingers. Yoko remembers that he always shook his head in disappointment, because, he said, her hands just weren't big enough for her to be any good.

"I was a sensitive child," Yoko said. "You smell it; you understand that actually the father doesn't want you to be good. And then you think that you're not good because you're not talented."

There was another story that Yoko told, and wrote for one of her classes at Sarah Lawrence. This one was more abstract. In it, dozens of people frolicked in a public park as a small child sat alone on a bench, slowly and methodically pulling a grapefruit apart, removing the pale yellow segments one by one, destroying it.

☐

Yoko came from great power and wealth. One of her great-grandfathers, Atsushi Saisho, was the descendant of a ninth-century emperor and a member of a powerful family active in the overthrow of the ancient Japanese shogun system. He then served as a prefectural governor and a member of the Imperial Household Council under Emperor Meiji, a progressive ruler who moved his court—and thus the country's capital—from Kyoto to Tokyo and was the first to welcome Westerners to Japan.

Saisho had no sons, a mark of shame, so he showered his attention on his eldest daughter, Tsuruko, who studied English and music at a Christian college in the new capital. Converting to Christianity, she met and married Eijiro Ono, who was on the faculty of a leading Christian college in Kyoto. Eijiro, the descendant of a proud but poor family of *samarai* warriors, had abandoned the ways of ancient Japan by first earning a doctoral degree from the University of Michigan in 1890 and then by joining the Bank of Japan in 1896, rising to the presidency of the Japan Industrial Bank before he died in 1927.

The third son of Eijiro and Tsuruko was named Eisuke. This was Yoko's father.

Eisuke inherited his mother's love of Western religious music, and when an older brother returned from Europe with a Russian wife who taught piano, Eisuke became her most avid pupil, learning many classical compositions. In time, the young pianist became a popular

figure at parties in Karuizawa, a village situated in the mountains, a two-hour train ride north of Tokyo. Karuizawa served as a grand retreat for Japan's sociable subculture of foreign diplomats, Japanese business executives, and members of the royal family in much the same way Baden-Baden, Cortina, Gstaad, Ibeza, and Saint-Tropez served similar groups in Europe and Newport, Rhode Island, and the Hamptons on New York's Long Island served the wealthy in America.

Eisuke was a handsome, charming man, at twenty-nine one of the social set's most eligible bachelors, the subject of much whispered talk amongst the unmarried young women who flocked to the resort. One of these was Isoko Yasuda, the quiet, beautiful, twenty-one-year-old whose grandfather, Zenjiro Yasuda, was the founder of the Yasuda Bank and head of one of Japan's richest and most powerful *zaibatsu*, or business cartels. The Yasuda name is not so well known outside Japan these days, but in the 1920s and 1930s it was as prominent as Nissan and Mitsubishi are today.

Zenjiro Yasuda's firstborn (of five) was a girl, Teruko. The "old man," as he was known, worshipped the child, and when she married Iomi Teitairo, a man of moderate means, the young husband was given every advantage. He quickly rose to the bank's presidency, and in a gesture of supreme respect, he adopted the Yasuda name as his own (becoming Zensaburo Yasuda). Then, in 1915, he was inducted into the House of Peers, the upper house of the Japanese *diet*, or parliament.

Zensaburo and Teruko had eight children—four girls, four boys. The youngest of these was Isoko, Yoko's mother.

Isoko was what Westerners call "spoiled." When she was a child, she lived near the emperor's compound, with a view of most of Tokyo. When she came home from school with a good report card, she was rewarded with unmounted diamonds. So it was not surprising when her parents objected to her interest in the charming piano player, no matter how popular he might be at Karuizawa.

Religion was another issue. Eisuke was a Christian and Isoko was a Buddhist—only four percent of the Japanese population was Christian—and the relationship seemed headed for failure.

However, a compromise was struck. The marriage would be permitted if Eisuke gave up his musical career and put his mathematics and economics degree to work for him by joining the banking fraternity. Eisuke agreed, and following the marriage he went to work for the Yokohama Specie Bank and moved into the palatial estate of his wife's grandparents. Isoko was living there at the time, caring for her

grandmother ever since her grandfather's assassination on a Tokyo street (which occurred after he refused to give a financial donation to a left-wing radical).

It was in the Yasuda home, overlooking a third of Tokyo, that Yoko Ono was born on a snow-blown February 18, 1933—a Pisces, born in the Year of the Bird, guided by the Number Nine. Years later, such factors would be important to Yoko, whose name means Ocean Child.

The Great Depression then devastating the United States and much of the Western world had only modest effect in Japan, and in the large Yasuda-Ono home, it had no apparent impact at all. Nearby was the emperor's compound. In pre–World War II Japan, the emperor was popularly regarded not as a ruler, but as an actual god, and such proximity gave the Onos significant social cachet. Even the staff of thirty servants dressed and behaved in the traditional manner, often to the point of entering and exiting rooms on their knees.

Because her father was seldom home and because of her mother's social demands, Yoko was raised by the servants. Even today, she can recite or sing some of the Japanese folktales and songs learned from the hired help. Some of these she performed for her father when she first met him, in 1936 at the age of three, in San Francisco. Yoko said that her mother was appalled and vowed that on returning to Japan she would send Yoko to a private school where her daughter would learn more socially desirable Western behavior.

Yoko returned to Tokyo in 1937 after a brother, Keisuke, was born, and a year later was enrolled at the exclusive Gakushuin, or Peers' School, which accepted students only if they were related to the imperial family or to members of the House of Peers. There, she was given tap-dance lessons and instructed in Mother Goose.

In 1940—with tension increasing between Japan and the U.S., and fearing that America might soon ban visits from Japanese nationals—Yoko's mother took her two children to California by ship, then crossed the country by train to join her husband in New York, where he was now working in the bank's Manhattan branch.

Yoko adapted well to life in the United States. She was shy and remained somewhat apart from her classmates, but she picked up English quickly and embraced American customs and culture as readily as she'd learned Japanese folk stories from her nannies only a few years before.

Then suddenly, in the spring of 1941, when Yoko's mother was pregnant with her sister, Setsuko, the Onos returned to Japan.

For ten years, Japan had waged an undeclared war against China,

seizing all of Manchuria and much of the Chinese coast. In 1940, Japan joined the Axis alliance of Nazi Germany and Fascist Italy. A year later, Germany occupied France and Japan moved into French Indochina. And war between the Japanese Empire and the United States of America was imminent.

Yoko's father was sent to the bank's branch in Japanese-occupied Hanoi, and Yoko was enrolled in Keimei Gakuen, a Christian school in Tokyo begun only a year before for children who had been educated in foreign countries. There, Yoko was encouraged to speak English in the classroom (as other students were encouraged to speak *their* second or third languages) and she was instructed in the Bible.

At home, Yoko went back to the servants, who were now instructed by Mrs. Ono to carry absorbent cotton and alcohol whenever they accompanied her daughter in public. "They disinfected every place I was likely to touch on a train," Yoko wrote some years later in a Japanese magazine. "That was because of my mother's partiality for cleanliness. Thus, I became sensitive to cleanliness, too. Once, I dropped a pencil I borrowed from a classmate sitting next to me because it was still warm from her body temperature."

Even before Japan bombed Pearl Harbor, initiating war with the United States, Hirohito's empire was feeling the effects of its ten-year war with China. Many foods were rare—such as eggs and meat—and the scarcity of gasoline resulted in a switch from automobiles to charcoal-burning buses and taxicabs. With the onset of World War II it got worse, and housewives were urged to harvest edible "weeds" by the roadside and to learn to use the excreta of silkworms as a substitute for soap.

Yoko and her family remained largely isolated from such hardship. While the number of servants was reduced—most were recruited to work in hospitals and factories—and Mrs. Ono was asked to turn in her diamonds for use in the war effort, the basic necessities were never denied, or even questioned.

In 1944, when Yoko was eleven, it all shifted precipitously, as the U.S., allied with England, Australia, and indigenous Asian liberation movements, began to drive the Japanese back.

By 1945, all children twelve and older were required to work in the munitions factories, which were primary targets of the American bombers. Yoko's mother went to the school and asked to have Yoko listed as being younger than she was so she could remain in school.

Much of Tokyo had been destroyed or seriously damaged, and many of those who survived the relentless nighttime bombings had

fled the city when, on March 9, 1945, the dreaded Americans came again. This time, when Yoko and her mother and brother and sister emerged from the bomb shelter and saw shell fragments in the family garden, Mrs. Ono decided it was finally time to flee.

With the last servant, the three children traveled to a small farming village south of Karuizawa. Yoko's mother followed a few days later and there, for the remainder of the war, they lived in humility and poverty.

After Hanoi fell to Allied forces, no word was heard from either Mr. Ono or his employer; Yoko didn't know if her father was alive or dead. Waiting for news and waiting out the war, she and her mother and brother and sister lived in a small house in a cornfield, paying an exorbitant rent, selling Mrs. Ono's kimono and other possessions for food. Once, Yoko later recalled, they traded an ornately carved antique sewing machine, handed down by her grandfather, for a sack of rice. Other times they actually went begging from door to door.

"I was always hungry," she said. "Like *Gone with the Wind*, I was starving."

It was no better at school, where the Onos were teased mercilessly by farm children who openly resented their "rich" way of speaking. Keisuke was so frightened, in the end, that he refused to attend classes. Yoko, on the other hand, fought back, glaring at the farm boys in the classroom, shouting at them in the school yard, strutting proudly to and from school in rough farmer's clothes, her thick black hair braided down her back peasant-style.

When the war finally ended, after the numbing nuclear destruction of Hiroshima and Nagasaki, everything changed again.

Japan had never been defeated in war, and with the loss of World War II came a loss of face. For not only was Japan defeated, but from August 1945 until 1947 it was *occupied*, under the dictatorial control of a vain but imaginative American general, Douglas MacArthur. He was called "the last shogun," and children Yoko's age in Japan came to be called "MacArthur's children" because of the vast influence he had on them.

Initially, for Yoko, the news was good: Her father returned unexpectedly after spending more than a year in a prisoner-of-war camp in China. But then MacArthur included Eisuke's name on a list of 1,500 "Class B" war criminals. The thinking was that if the militaristic leaders of Japan were mostly to blame for the war, then the indus-

trialists and financiers must share that blame. It meant Eisuke was unemployable.

MacArthur, meanwhile, brought in 10 million tons of food to feed the poor and starving and to win the trust of the Japanese people. In addition, in an effort to show respect to the defeated nation, the American general issued orders threatening five-year prison terms to any American soldier who struck a Japanese. At the same time, the existing Japanese political and economic structure was disassembled completely: Women were given the right to vote. The monolithic Mitsui Bank (whose heirs had run Yoko's school during the war years) was closed and its assets were distributed publicly. Ninety percent of the land was reapportioned and given to peasants. Shintoism was disenfranchised, and in a new constitution, adopted in 1947, Japan gave up the right to wage war and the emperor gave up claims to divinity.

That same year, many of the "Class B" criminals convinced American diplomats and businessmen (brought to Japan as consultants) that if Americans really wished to rebuild Japan, the talents of the "criminals" could be of help. Yoko's father joined a new bank, the Bank of Tokyo, first as an adviser and then as an officer.

Yoko was back at Gakushuin and now her classmates included the emperor's sons, Akihito, the crown prince, in the same class as Yoko, and his younger brother, Yoshi. Yoko cultivated Yoshi's friendship, and soon they were sharing the poems they had written. Years later, the Japanese press would say that Yoko was Prince Yoshi's first love. One magazine even went so far as to suggest that, because children in the imperial household didn't live in the same structure with their parents and were instead raised by servants, Yoshi was seeking a mother figure. Yoko was two years older and quite mature for her age—both physically and intellectually—the theory goes, and this was at the root of the prince's attraction.

It may be just a theory, but the fact is they were friends who saw each other during school and worked together afterward, with the prince correcting her poetry.

Yoko by this time had decided that she wanted to be a writer. Back in Tokyo, following a postwar period in the countryside during which she commuted to her school by train, she spent more and more time alone, writing in notebooks that she shared with only a few. After a while, she began submitting them to her teachers. But, she said years later, her teachers didn't understand, telling her that she "didn't fit

into conventional styles. People said my novels were like poems and my essays were like fictions. In Japan in those days, there was no genre called avant-garde. My schoolteachers denounced my work as bad because they judged it from existing standards."

However alienated Yoko says she felt both at home and at school, her life in the postwar years was not uncomfortable. Although her father remained away as he quickly ascended the bank's executive ladder, his income provided amply for his family. So, after experiencing hunger and poverty during the war, Yoko was once more back in the upper, ruling class, again accepting the traditional demeanor of her ancient past.

No matter how much a rebel Yoko claims to have been, she appeared to fit in. It was true that by the time she was sixteen she wore her hair in a curled, Western style, but she also wore her school uniform—a modest, dark jacket and skirt and a loose-fitting white blouse with a big floppy collar. Although she bragged about her experience with cigarettes, alcohol, and sex, only a few really believed her. The truth was her mother forbade her to enter any of the trendy little coffee bars then opening all over the city, much less a nightclub or dance hall. In fact, Yoko spent much of her spare time giving English lessons to her mother's friends.

Tokyo, and all of Japan, continued to make a swift recovery under MacArthur's administration. Yet most Japanese hated their occupiers and held MacArthur in great contempt because he wore an open-collared shirt to the ceremony of Japanese surrender, while Hirohito wore formal attire. The Onos also resented the Americans because they wore shoes inside the home the Onos had rented to soldiers during the occupation.

The Onos cosseted their oldest child, protected her from any unnecessary exposure to the American occupiers, and urged her to dedicate herself to her school. It was around this time that Yoko found herself drawn to the drama club. Here, she dominated.

According to one of her fellow club members: "We decided who would do the leading roles by vote, and Yoko made us vote again when she couldn't get a good part. She never felt happy unless she was treated like a queen."

Yoko's cousin Hideaki Kase remembers that she had a couple of courters besides Prince Yoshi, but says that none of the relationships was serious. In 1952, at age nineteen, Yoko not only hadn't been kissed, she hadn't even held a boyfriend's hand.

Yoko's independent nature showed itself again as her graduation

from Gakushuin neared. Initially, she planned to go to the Tokyo Music School, but then she applied for admission to Gakushuin University, where she let it be known that she wanted to be the first female student to major in philosophy. She cabled her father—by now working in the New York City branch of his bank—for permission. He agreed immediately.

Yoko admits that in some ways her parents supported her. Her father, though absent for most of her life, treated her kindly, in fact doted on her, whenever he was home. And her mother always told her she was intelligent.

"She used to tell me," Yoko later wrote, "that even a woman could become a diplomat or prime minister if she was as bright as I. She also said I should not be so foolish as to get married or that I should not be foolish enough to have children."

After two semesters at the university, Yoko and her family moved to the United States, to Scarsdale, an affluent suburb of New York, to be with Mr. Ono. Prince Yoshi was so moved by her departure that he sent her an autographed picture of himself and a *waka*, a form of poetry that members of the royal family were taught:

> Let us ask the high wave from far away
> If the person I dream of is safe or not.

Yoko kept the poem and the picture, even the paper the gift was wrapped in, and she went off to New York feeling quite alone. Years later, she told *Esquire* magazine that she had learned a great lesson during the war: "nothing was permanent. You don't want to possess anything that is dear to you because you might lose it."

And this applied to relationships as well as to material possessions. "I just didn't care," she said, "and I was very proud that I just didn't care."

3

*Haunting
Sarah
Lawrence*

RICHARD RABKIN was on his way to a career in psychotherapy, preparing himself for a lifetime of troubled people, but in the summer of 1953 he was totally unprepared for the petite yet voluptuous Japanese girl-woman so ready to open the window of her soul. Today, thirty years after first meeting Yoko, Rabkin still marvels at her willingness to share her pain. He remembers that at the time he thought it was so "un-Japanese."

Richard was attending Harvard University's summer session to complete his undergraduate degree. Yoko was there to study voice and to make up credits required for entrance into Sarah Lawrence College, the fashionable girls' school near her parents' home that she had agreed to attend in the fall. Yoko was having trouble with an English course when she went to the budding therapist for advice.

"She was having trouble writing an essay," Rabkin recalls. "She wrote in the Japanese style, and her professor thought it was precious. I told her not to make up a story, but to tell a personal story, something she remembered from her childhood, perhaps her earliest memory. I'm not sure what I expected, but I was not ready for the sadness she revealed. All her memories were painful. *All* of them."

One after another, the stories came pouring out, onto paper or into Rabkin's ears, showing the isolation and rejection she felt growing up with a father who was married to his job and a mother divorced from mothering. How, even though she lived in her parents' home, in order to see her father she had to make an appointment with his secretary at the bank.

14

Richard Rabkin was one of Yoko's very few friends during the summer months in Cambridge. Except for when she was in a classroom, most of her time was spent alone. She even avoided the local Japanese community, she said, because she was embarrassed when everyone deferred to her—"kept bowing and bringing her chairs," Rabkin says—because her accent revealed her aristocratic upbringing.

Betty Rollin, another Harvard student that summer, who would be one of Yoko's classmates at Sarah Lawrence that September, says her lasting memory of Yoko during that time was of her sitting in a tree, reading a book, alone—"not aloof, really, but removed, distant from the rest of us, somehow beyond our reach."

And so it was at Sarah Lawrence, too, where, according to Betty Rollin, there were four distinct types of students. One was comprised of Northern, Christian debutantes, members of the "horsey" set who wore cashmere sweaters, Bermuda shorts, and pearls (with fathers on Madison Avenue). Another group was the youthful artists-in-leotards, the innocent bohemians who were discovering Proust and cigarettes and aimed at a career in The Arts. The third group consisted of rich, urban "Jewish American Princesses." (Sarah Lawrence had long had a secret quota for Jews—a fact revealed years after Yoko left—and by the 1950s, when the majority of qualified applicants were Jewish, the quota had risen to fifty percent.) The final group was completely unclassifiable, although most of them seemed to be eccentric and rich. Yoko "sort of fell into the artsy group and epitomized the unclassifiable," Rollin says.

"She was thought of as quite ethereal. Some people thought of her as a little Oriental stereotype, because she was so quiet, almost geishalike," Rollin says today. "They minced around her. A respectful distance existed. She didn't have many friends. She seemed very shy. Ultimately, I felt sorry for her."

At the time, Sarah Lawrence seemed a perfect choice for Yoko; it offered a physical and academic environment well suited to her quirky, demanding temperament. Although the campus was situated in the midst of suburban Yonkers, New York, only half an hour from midtown Manhattan by train, it was spread over 25 acres of semi-wilderness, forming an oasis of boulder-strewn, undulant lawn amid the encroaching apartment buildings and townhouses of Westchester County. Its students—all girls at the time—were extravagantly pretty, and its handsome president, Harold Taylor, at thirty-four the youngest college president in the country, drove a sports car and frequented the school's tennis courts (located adjacent to the administration build-

ing). Thus, one of the great ironies was that Sarah Lawrence looked precisely like that which it admired least: a glossy, Eastern finishing school.

In fact, Sarah Lawrence was at the cutting edge of college-level education, sort of a Montessori school for young adults that offered its students a chance to learn at the individual's own pace. When Yoko arrived, in September 1953, she and her 400 or so classmates took only three courses a semester and got a generous five credits for each. Classes were small, thanks to the six-to-one student-teacher ratio, and most courses met only once a week for a two-hour session, the rationale being that students needed time to read and discover what interested them *when* it interested them, rather than be shunted from classroom to classroom in the established four-year bachelor's race. There were no required courses. There were no "majors." And there were no grades.

It was not surprising, then, that this permissiveness created an observable "attitude" at the school. This was later described by another student from Yoko's time: "One must realize," Louise Blecher Rose wrote in *Commentary* magazine, "that Sarah Lawrence considers itself to be only accidentally located in America and only accidentally on earth; its real location is another, much better planet. On that planet, bourgeois values are shunned; a student who wants to go to law school in order to get out and make a good living later on is looked upon as an educational failure even if she gets into Harvard."

Yoko apparently loved every bit of it. The loose class scheduling system gave her the freedom of time, and the permissive Sarah Lawrence philosophy gave her the freedom of academic choice, conspiring, in effect, to give her permission to be totally free—and Yoko *was* free. She herself admits that most of her time at Sarah Lawrence was spent browsing in the music library or reading.

Yoko remained at Sarah Lawrence for three years, keeping her distance, making few friends, adopting the more bohemian trappings. One of her classmates, the writer Anne Roiphe, recalls her own first night at Sarah Lawrence as the one when "[I] threw my Bermuda shorts and gold circle pin into the wastebasket and changed into my leotard and jeans." So, too, it was for Yoko, who came to epitomize the budding "beat generation" type on campus that was, in the early 1950s, growing like a dark fungus. The black clothing favored by many of these intense, artistic young women on both coasts of America (especially in Greenwich Village and in the North Beach section of San Francisco) became a uniform for Yoko, and the long, untamed

hair they cultivated, almost a trademark. For the next twenty years, this would be Yoko's "look."

In her classes, Yoko was one of those her teachers and classmates remembered vividly. Leah Binger Lenney today recalls a writing class they shared. Lenney says she fancied herself the Number Two writer in the group at the time—Yoko was Number One. "She wrote two stories that I remember to this day," she says, "and that's 30 years ago! She was head and shoulders ahead of our adolescent maunderings." The stories were among those that she had shared with Richard Rabkin at Harvard summer school.

"She was very sophisticated," Lenney says, "yet out came all this *stuff*! I remember the day that Yoko read one of her stories in class. I met with the teacher later the same day. She was clearly overwhelmed by Yoko and she spent the entire session talking about her, although it was supposed to be *my* tutorial. I remember her saying, 'I think Yoko will be a writer.' "

One of Yoko's music teachers, Meyer Kupferman, says that in his class in theory and sight-singing, where students had to read music and sing from notes on paper, "She was particularly adept, the best in the class. She came to class with a tiny little metal ruler and insisted on making her own graph paper, which wasn't necessary. And then I would play something on the piano and the students would write it down. That's called dictation. She always transcribed it perfectly."

Kupferman also remembers "evidence of a strong intensity." Yoko was, he says, "tightly put together and intent on doing well. The other students were more relaxed. She wasn't relaxed, *ever*. At the same time, she was a kind of shadow figure at the college. When you focused on her, she was fine, but then she sort of disappeared, like a phantom."

In talking years later with Jonathan Cott, a reporter for *Rolling Stone*, Yoko remembered *feeling* like a phantom. Often, she said, she would sit quietly alone in her room either at school or at home and strike matches, watching the flame until she had to extinguish it. Match after match after match after match.

"I thought that maybe there was something in me that was going to go crazy," she said, "like a pyromaniac. See, I was writing poetry and music and painting, and none of that satisfied me. I knew that the medium was wrong. Whenever I wrote a poem, they said it was too long, it was like a short story; and a short story was like a poem. I felt that I was like a misfit in every medium.

"I just stayed in Scarsdale at my parents' home [in the summers]

and I was going crazy because I couldn't communicate with them very well. I was lighting matches, afraid of becoming a pyromaniac. But then I thought that there might be some people who needed something more than painting, poetry, and music, something I called an 'additional act' that you needed in life. And I was doing all that just to prevent myself from going mad, really."

By the time Yoko was a junior, in 1956, she rarely attended classes, becoming a familiar figure at the college music library, where she cultivated a handful of favorite composers, listening over and over again to the recorded works of Arnold Schoenberg and his student Anton Von Webern, two of the twentieth century's most influential modernists.

Both were trained traditionally—as Yoko was—but they rebelled. Schoenberg came to believe that he couldn't express his feelings through the building blocks—the chords, the intervals, the rhythms—used by other composers. So he turned away from traditional harmony and melody, abandoned predictable notions of consonance and dissonance, and composed music that was atonal, lacking a key center. At the same time, he explored the world of fears and dreams that was being studied by another Viennese pioneer, Sigmund Freud. Schoenberg's music became more nightmarish, although always there was a compassion, a warmth.

This avant-garde approach to music composition appealed to Yoko and alienated her from the more traditional tack taken by her teachers at Sarah Lawrence. Schoenberg had recently died (in 1951) in exile in America, and Yoko regarded him as a kindred soul—a rebel, a romantic, an exile.

The situation at home deteriorated rapidly for Yoko, because Sarah Lawrence administrators criticized her poor classroom attendance record and mentioned the possibility of expulsion. By now, Yoko was spending more and more time in Manhattan, where she had met a quiet, young composer from Japan, Toshi Ichiyanagi. Toshi was a student at Juilliard, the prestigious music conservatory, and he, too, was drawn to the avant-garde composers.

It was the day after Yoko brought Toshi home to meet her family that she and her parents fought most vehemently.

At his wife's urging, Yoko's father told Yoko that the penniless pianist was not the most desirable suitor. Her mother echoed the sentiment, then doubled it. She said Toshi was unsuitable under any circumstances, and told Yoko that if she persisted in seeing him, she would be bringing dishonor to the family.

Yoko loudly reminded her parents that their own romance had once been discouraged for the same reason: Eisuke Ono had not been regarded as worthy of her mother's hand. This they countered with the fact that her father gave up his carefree piano-playing ways to enter banking. Yoko was asked: Was Toshi willing to do the same? And did he have the proper education in business, as her father had?

And so it went. Yoko was as stubborn as ever, and the Onos remained equally firm, threatening to disinherit her if she persisted in her youthful foolishness.

Yoko packed and left.

Her parents, of course, caved in, agreeing to sanction—if not the wedding itself—at least a traditional wedding reception. In Japan, such an arrangement was fairly common. The marriage would not be registered in the halls of Japan's statistical records, thus it would be denied "official" recognition. It would be legal, but, somehow, unauthorized.

Hideaki Kase, Yoko's cousin, said it was important to Yoko to have her parents' blessing, that no matter how radical her artistic dreams, or how rebellious her behavior, she still had a conventional view of marriage, and she really didn't just want to live with Toshi. She was therefore quite pleased when her parents rented a large ballroom in a hotel on the West Side of Manhattan, called one of New York's leading caterers, and made arrangements with the Japanese consul general to offer a congratulatory speech.

Yoko did not return to Sarah Lawrence. Instead, she and Toshi moved into a small walk-up apartment not far from the hotel where she was married. She was, she swears, a virgin at the time and used to the suburban soft life.

In the summer of 1956, all that changed radically.

4

Avant-Garde
Life
in
a Loft

AMERICA was in transition.

And in conflict.

On one side stood its most revered World War II hero-turned-president, known familiarly as Ike, whose image was so pleasant and unsurprising that his bald head and big smile became, in caricature, the symbol for a new detergent called Mr. Clean. Popular cultural boundaries were set by such novels as Françoise Sagan's *Bonjour Tristesse* and Grace Metalious's *Peyton Place*, by the marriage of Grace Kelly to Monaco's Prince Ranier, by such best-selling albums as the soundtrack to Broadway's *Oklahoma!* and *My Fair Lady*, by Oscars that went to such middle-of-the-road figures and productions as Yul Brynner (for best actor, *The King and I*), Ingrid Bergman (best actress, *Anastasia*), and *Around the World in Eighty Days* (best picture), and by what *Time* magazine called the "Don't-Give-a-Damn Pill," meprobamate, a tranquilizer better known as Miltown.

On the other side stood Earl Warren, Chief Justice of the U.S. Supreme Court, who ordered sweeping desegregation of the public schools, an act that in the spring of 1956 divided the nation almost as clearly, and violently, as it had been nearly a century before during the American Civil War. More than a hundred U.S. congressmen called for massive resistance to the new "law of the land," and there were uncounted acts of racial brutality, including the severe beating of singer Nat "King" Cole in Alabama.

20

At the same time another singer was seductively bullying his way into the hearts and pants of the restless young: Elvis "The Pelvis" Presley; in April, the top song in the country was "Heartbreak Hotel," and in August, it was a simple lyric about a hound dog.

In San Francisco there was more revolt, led by Jack Kerouac, whose novel, *On the Road*, gave birth to a new and "beat" generation, whose best minds Allen Ginsberg had chronicled in his poem "Howl."

Yoko stood in the middle of her sparsely furnished New York apartment largely unaware of any of this. In such ignorance—mixed with innocence—she launched herself into New York's insulated and isolated, competitive and cocksure, pretentious and petulant, boastful and bitchy avant-garde—a scene, as Yoko later realized, where artists often talked only to each other, or only to themselves.

"Elvis Presley? You probably will find it hard to believe, but there were some of us who really didn't know who he was," says one of Yoko's acquaintances. "It wasn't that we weren't interested, although that was part of it. The truth was, we consciously and determinedly rejected Elvis and rock and roll. It wasn't music. It was disgusting. At least, that's what we believed at the time. We were interested in *Art*."

Within a few months, Yoko and Toshi rolled up their tatami mats and, with the help of friends, moved their meager belongings into a drafty loft in a fifth-floor walk-up at 112 Chambers Street, two blocks from the Hudson River on Manhattan's Lower West Side.

The loft offered nearly 2,000 square feet, a single room with space enough for two basketball courts, windows at either end looking out at nearly identical buildings, and a large skylight overhead. By day, the streets rumbled with the sound of trucks and the nearby Eighth Avenue subway. (Whenever the trains roared into and out of the station, only 50 yards away, the entire building shook noticeably.) The rent was $50.50 a month.

When Yoko and Toshi moved into the loft, the single most influential man in their lives was composer John Cage. To understand the avant-garde art scene the young couple was entering—and to appreciate fully some of the work they themselves were beginning to produce—it's necessary to review a few of Cage's ideas.

Cage believed that all forms of noise could be used by a composer musically *and* that silence was equally important. Eventually, this led to performances where he sat at the piano silently, the beginning and end of the "musical" piece being defined by an assistant's opening and closing of the piano lid. Spontaneous noises in the room—coughs, whispered conversation, the sound of chairs scraping on the floor—

and the individual thoughts of those in the audience became the "content" of the piece.

Cage's work, and his influence on Yoko, was not exclusively musical. Four years before, in 1952, at an experimental school in North Carolina, Cage had assembled a group of dancers, poets, and painters and presented what's generally regarded as the first "happening"—an interdisciplinary performance that mixed music played on a piano and phonograph, poetry recitation, lectures, films, slides, and dance, all executed by the performers independently and simultaneously.

"I have nothing to say," Cage once told an audience, quoting the medieval mystic Meister Eckhart, "and I am saying it."

This whimsical, Zen-inspired approach to music and art delighted Yoko and her husband, so when it was announced in the summer of 1958 that Cage would be teaching a class in experimental music composition at the New School for Social Research on West 12th Street in nearby Greenwich Village, Toshi enrolled and Yoko began attending as a guest.

The classes attracted an impressive assortment of artists and performers, many of whom would succeed in Manhattan's highly competitive art scene—among them painters Al Hansen, Jim Dine, Larry Poon, George Segal, Richard Maxfield, George Brecht, Dick Higgins, and Allan Kaprow; photographer Scott Hyde; and poet Jackson Mac Low. Most of them were meeting each other for the first time in the weekly evening classes, and afterward they drank together in the nearby Village bars, becoming an energetic and enthusiastic band of dreamer-insomniacs. They also found they all lived in the same neighborhood, in small apartments and large lofts south of the Village in what is now called SoHo; back then it was a rundown industrial section, not at all the chic area it would become in the 1970s. They became friends, sharing modest meals and grandiose plans.

What resulted was what one of those on the scene, Yvonne Rainer, called "a dare-devil willingness to try anything." Thus Allan Kaprow and George Segal invited friends to jump through props made from lumber and plastic sheeting and to sit inside chicken coops rattling noisemakers, and George Brecht staged "Motor Vehicle Sundown," wherein participants were instructed to get into their cars at dusk and execute such activities as turning on headlights or radios, honking horns, rolling windows up and down, operating windshield wipers, and so on.

Far less chaotic, but perhaps no more easily understood, were the paintings of another young artist, Frank Stella, who exhibited paint-

ings that were entirely black. In time, as others began painting canvases white and constructing endless geometric forms, this approach to art would be called Minimalism.

The simplicity and off-the-wall sense of humor implicit in such events and works exerted a strong influence on Yoko's own first creations. The carefully raked sand and precisely placed rocks in Japanese gardens, the poetic austerity of *haiku* and the martial arts, combined with an off-the-wall Zen view, showed clearly her own cultural heritage as it was revealed in brief, enigmatic paragraphs that she was now writing in a notebook kept beside her mattress.

The paragraphs were titled and each one comprised—or described—an artistic "piece" to be performed. One piece, entitled "Painting to Be Stepped On," instructed the participants to put an empty canvas on the floor or in the street and wait for people to walk on it. (For this reason, Yoko kept blank canvases on the floor of her loft, waiting for curious, or careless, visitors.) "Kitchen Piece" suggested hanging a blank canvas on a wall and throwing the day's leftover food at it. In "Pea Piece," Yoko asked you to carry a bag of peas, leaving them behind you one by one during the course of a day. Still another, called "Sleeping Piece I," asked participants to make a list of things to do that you then asked others to do for you while you slept.

Some later called this "concept art." Yoko preferred the word *instructional*, a label that was more precise. After all, the point was that the piece was not complete until an outside person (or persons) participated. Even refusal to participate was considered, by Yoko, to constitute participation.

Eventually, Yoko published nearly a hundred such instructional concept pieces in a book, which was called *Grapefruit*. But that would not be for several years. In 1960, Yoko's art was neither producing an audience nor an income.

Survival was difficult. Toshi sometimes worked as an accompanist, but rarely, and Yoko sometimes worked as a waitress. She also taught calligraphy, *sumi* painting, *origami*, and Japanese folk music—the arts she had learned from her nannies long ago in Tokyo—in New York's public schools as part of a student enrichment program. And when things got really tight, she repeated her wartime experience in Japan and sold the last of her jewelry and furs in order to buy rice and vegetables.

"The weird thing about it," says someone who was close to Yoko then, "was her parents were still in New York—still rich, still living in Scarsdale, still descended from *samarai* and Japanese royalty. Yoko

carried the same blood, of course, but here she was living in an un-
heated loft, almost starving to death—and doing it voluntarily. Some
people said she was a dilettante slumming in bohemia, and through
the years, she caught a lot of flack for that. People just didn't believe
she was serious about her art, figuring she could always go home to
Mom and Dad, so where was the commitment?

"I disagree. I think Yoko *was* committed. And I know she was very
proud. Her will was so strong I think she was the one above all the
others who actually *would* starve to death before going home. I think
the criticism hurt. Like all the rest of us, she wanted to be taken
seriously. Every artist does."

If it offered little else, chronic unemployment provided plenty of
time to talk with fellow artists and to plan how their art could find an
audience. One of the most popular gathering places for such talk in
the autumn of 1960 was the Bank Street apartment of LaMonte
Young, an excitable and garrulous poet and composer who had come
to New York from the University of California at Berkeley that Sep-
tember seeking fellow post-Cage enthusiasts.

While still a student, Young had composed pieces that called for
the release of a handful of butterflies and directed a performer to draw
a straight line and follow it. In Yoko he found a kindred soul. His
wildly bushy beard was a match for Yoko's untamed mane of hair, and
he, too, wore black, favoring tailored velvet suits and capes. When he
talked of needing a place in which he and his new friends could
perform, Yoko volunteered her loft.

The series of weekend performances that began in mid-December
and stretched over a period of six months has near-legendary recogni-
tion today. Rare is the history of modern performance art that doesn't
give Yoko and her friends their due. In fact, some art historians today
say that Yoko's loft series not only provided a showcase for a wide
variety of artists, but also served as a watershed for the sort of artistic
activity that led to the tumbling of the last barriers in art.

Allan Kaprow, a friend from Cage's classroom days, commuted
from New Jersey, where he was teaching, to Yoko's loft for every
performance. He notes that because so many of the pieces engaged the
audience, insisted that they participate, the barrier between art and
artist was removed. Some weekends, Kaprow says today, went even
further, removing the need for an audience at all.

"I walked up the stairs and the door was open, and I just walked
in," Kaprow says, "and there were LaMonte Young and the sculptor
Robert Morris doing this piece. I didn't know anything about it, but I

knew they were doing something, because they had been on some kind of list that Yoko and LaMonte distributed when the series started.

"What I saw were two people standing about thirty feet apart, mumbling something to each other. They had a piece of chalk and one was making a mark on the floor and the other was scrutinizing it like sighting a straight line, pitching his head from one side to the other and then mumbling a few words about adjustment to the other, which was then done by the other. Then there were long periods during which they would do absolutely nothing and just look at the line, or LaMonte would walk up the line, which was then about six feet long, and add a little to it. He would then move to the end of the part he had just added, and then Morris would sight it as if he were looking through a surveyor's transit. He would offer suggestions in a mumbled, low voice which was not meant for anyone else to hear. I watched this for several hours, going on at a very leisurely pace, and then, because I didn't think it was going to be concluded in any climax of the usual sort, I just left. Now, that kind of stuff went on there *all the time!*"

On another weekend, Morris framed-in the front door to the loft so that it formed a spiral that didn't end for about six feet. The ceiling and walls converged very rapidly as they spiraled to a point, so that as you entered the door and tried to pass along the hallway, in Kaprow's words, "you were like Alice in Wonderland in a completely impenetrable world that forbade you to go any farther."

Henry Flynt, who read his poetry and played some jazz piano on still another weekend, winces today when he recalls the times when LaMonte performed some of his long musical compositions. "He had a piece with cellos where he played two notes for about three years," Flynt says. "People would hear what was going on as they came up the stairs, turn around, and leave without even entering."

Once Yoko came out with a bag of peas and threw them at the meager audience while at the same time whirling her head so that her long, black mass of hair hissed in the cold loft air. She said the movement of her hair was providing the musical accompaniment to her pea-throwing.

No one dared laugh.

Such performances obviously did little to encourage large audiences from forming. The remote location of Yoko's loft didn't help much either. Nor did the total absence of advertising and adequate publicity. Yoko and Toshi and their friends passed out flyers in the neighborhood and stapled small posters to bookstore and coffee shop

bulletin boards, but that was about it. The rest was word-of-mouth, and that was always mixed.

Nonetheless, during the six-month run of events, a handful of established figures in the avant-garde art world attended—among them Yoko's own personal giant John Cage, painter Max Ernst, and collector-critic Peggy Guggenheim—thus Yoko's artistic "salon" gained a respectable cachet.

Probably the most important figure to attend the events, as far as Yoko was concerned, was the eccentric and energetic George Maciunas, who had heard about the series through LaMonte Young, whom he had met in another experimental composition class at the New School for Social Research. Lithuanian-born Maciunas was trained as an architect but was occupied, in the spring of 1961, with a new gallery that he operated in uptown Manhattan.

"George was an eccentric's eccentric," says art historian Peter Frank. "He wore wire-rim glasses, had a short mop of hair, pronounced eyebrows, and a piercing gaze like a bird, a cross between a falcon and a loon. He was very, very eccentric and proud of it. He cultivated his eccentricities."

George lived nearby, near Canal Street, where dozens of surplus merchants and job lot dealers offered curious machines and plastic objects that he began stuffing into boxes in assemblage, a junk-art style objet trouvé. His apartment was scattered with Rube Goldberg–like contraptions, most of which actually worked, and the refrigerator, painted orange to match the front door, was filled from bottom to top with oranges. Yoko thought he was adorable and was thrilled when he asked her, and several others, to put their works in his A'G Gallery (a name taken from his own first name and that of his partner, Almius Salcius—although some said it really stood for avant-garde).

Before Yoko arranged her first showing at Maciunas's gallery, she and Toshi separated. Friends say the couple never really displayed much warmth toward each other. "My sense was that there was something respectful between them," says Allan Kaprow, "but really nothing else. He had his career and it was well advanced of hers in a way, and they really were quite separate."

Others are franker and say Yoko's marriage to Toshi was a partnership that had allowed her to turn her back on her parents and gain entrance into the avant-garde underground. This world rarely offered much financial reward, providing instead the peculiar comfort that

comes with exclusivity, with being at what at least appears to be the cutting edge of art.

Some say that what Yoko and her friends were doing was not particularly innovative. As early as 1916, in Zurich, Dadaists were randomly cutting up printed material to form "poems," or making poems entirely of nonsense syllables, and reciting them in performance—several of them simultaneously—with the performers dressed in outlandish costumes. In Paris at about the same time, multicolored balloons bearing the names of literary and artistic celebrities were released, and in Berlin, a dead pig was dressed in a Prussian officer's uniform and hung from a ceiling, not in political protest but in artistic defiance.

Then, in the 1930s, came the Surrealists, among them Salvador Dali, who painted melting watches and lectured dressed in a diving suit with a loaf of French bread strapped to the helmet and leading two white Russian wolfhounds. Marcel Duchamp, another Surrealist, covered the ceiling of a gallery with 1,200 coal sacks filled with paper while a phonograph played German military marches and the smell of roasting coffee beans wafted around the room. Later, Duchamp designed a maze of string and a shower of indoor rain that fell onto a billiard table covered with artificial grass.

The difference between the Dadaists and Surrealists and the artists of Yoko's period, Allan Kaprow says, is that the earlier artists "tended to consider the audience as whipping boys. They were intent on shocking people, where we were out to involve people. What we were doing was democratic and, I think, invitational."

Thus later, when Andy Warhol and Claes Oldenburg more or less invented Pop Art, making icons of Campbell's soup cans and giant vinyl pencils and icebags, they were not assaulting the public so much as amusing them, engaging them through laughter. Similarly, when Judith Malina and Julian Beck and their communal Living Theatre broke down the barriers between the audience and the actors, they did so by pulling the spectators onto the stage and involving them in the play's action.

Once Yoko was entrenched in this world—throwing peas at her audience, urging people to walk on her paintings—she really didn't need Toshi any more. Besides, she was having affairs all through the marriage. Everyone who was around them then today describes the marriage in "open" terms. In fact, there had also been a number of abortions, Yoko's primary method of birth control. (Not so common

in the Western world, it *is* commonplace in Japan, where both the birth control pill and IUD are outlawed.) "I was too neurotic to take precautions," Yoko later said. "I was always having trouble, messed up, always having abortions. I would go out and have an affair and come back and, oh, I'm in a mess, and my first husband was very kind."

"Besides," says a friend, "Yoko was the dominant figure in the relationship from the start. It was Toshi who was the stereotypical Japanese—quiet, polite, subservient. Yoko by now had been Americanized. She was very demanding. And very, *very* ambitious."

So, early in 1961, the couple agreed to separate, and Toshi returned to his home in Tokyo, while Yoko, telling him she would join him at a later date, threw herself into an intense relationship with George Maciunas and began preparing for her debut in his gallery.

One of the first paintings she did was called "George, Poem No. 18" and was comprised of a short poem written in Japanese characters on canvas—a canvas she then painted almost entirely black, blotting out the poem.

Others took their direction from the brief instructional paragraphs that she continued to write into her notebook. One, called "Painting to See the Skies," had two holes drilled through the canvas and was hung where viewers could see the light behind it. Another had a single small hole through which the viewer was again told to look; it was entitled "Painting to See the Room." Visitors to the gallery were told to burn still another canvas with cigarettes and to watch the smoke.

The exhibition was completely ignored by the critics, and there were, not surprisingly, zero sales.

Furious but undaunted, Yoko returned to the Chambers Street loft and began preparing for a completely different sort of performance, scheduled for November 24—a Wednesday, the night before Thanksgiving—in the Carnegie Recital Hall, which was adjacent to the world-famous Carnegie Hall but otherwise had little in common with it. Seating only 238 people, the recital hall was known for its presentation of offbeat entertainments, and seemed well suited for what Yoko had in mind.

In the program and in all descriptions of the performance, Yoko referred to the evening's works as "operas," when, in fact, they were operas in much the same way her black painting to George Maciunas was poetry. One of the compositions, "A Piece for Strawberries and Violin," was written for John Cage's protégé, David Tudor, and it featured an "aria" that Yoko sang in a peculiar, high-pitched wail that

would characterize her vocal performances for many years to come. This was by far the most musical of the two works, but in no way did it have the length, structure, sound, or appearance of a traditional opera.

The second work, which took its name but not its content from a story she had written at Sarah Lawrence, "A Grapefruit in the World of Park," was more baffling, and Yoko's subsequent explanation offered only a little understanding:

"I set up everything and then made the stage very dim, so you had to strain your eyes—because life is like that. You always have to strain to read other people's minds. And then it went into complete darkness. I thought that if everything was set up in a lighted room and suddenly the light was turned off, you might start to see things beyond the shapes. Or hear the kind of sounds that you hear in silence. You would start to feel the environment and tension and people's vibrations. Those were the sounds that I wanted to deal with, the sound of fear and of darkness, like a child's fear that someone is behind him, but he can't speak and communicate this. And so I asked one guy to stand behind the audience for the duration of the concert.

"The week before I had given instructions to everyone as to what they should do, so that there would be a feeling of togetherness based on alienation, since no one knew the other person's instructions. So everybody was moving without making any sounds onstage. There was a point where two men were tied up together with lots of empty cans and bottles around them, and they had to move from one end of the stage to the other very quietly and slowly without making any sounds. What I was trying to attain was a sound that almost doesn't come out. I wanted to deal with the sounds of people's fears.

"I wanted the sound of people perspiring to be in it, too, so I had all the dancers wear contact microphones, and the instructions were to bring out very heavy boxes and take them back across the stage, and while they were doing that, they were perspiring a little. There was one guy who was asthmatic, and it was fantastic."

Phil Corner, a pianist and composer who had met Toshi at Juilliard, remembers being approached by one of Yoko's friends a few days before the performance. "There was a toilet backstage and Yoko had it wired for sound. Charlotte Moorman took me aside and said, 'We have a very insensitive toilet flusher, would you be his replacement?' So on the night of the concert, I went back there and flushed it as sensitively as I could. Later, the sound of a flushing toilet became almost a cliché at happenings. For what it's worth, Yoko was the first."

Today, Corner believes the performance—produced by Norman Seaman, a promoter who would remain a lifelong friend—was little more than a "futile and desperate attempt to make her art respectable." Yoko was, he says, tired of being a "downtown artist, starving and unrecognized."

Whatever Yoko's motive for staging the concert, she was rejected. The audience was practically nonexistent, and the reviews in the *New York Times* and the *Village Voice*—the first she received for her work—were unappreciative. The *Times* even misspelled her name, calling her Yoke One.

Suddenly, her parents called.

5

Going
Home,
Going
Mad

THE ONOS were gravely concerned.

Although there had been virtually no contact between them in the five years since Yoko dropped out of Sarah Lawrence, rumors and reports had reached Eisuke and Isoko Ono in sufficient number to cause not just concern, but alarm.

In addition, if Yoko failed to get her own name into the New York newspapers during this period, many others who looked and lived like her did. They, too, favored black clothing and wore their hair long, and if all the newspaper stories were correct, they shared their dirty, unheated lofts and apartments communally. These people called themselves artists. And poets. The newspapers called them beatniks.

Yoko's parents wondered: Could she actually be one of them? It was unthinkable yet possible, thus horrible.

So they called, inviting Yoko home to Scarsdale to dinner.

A vast gulf separated the Onos from their daughter, as well as from the rest of the world. Great social changes that had begun in the 1950s were now sweeping American life and thought as the new president, an Irish Catholic named John Kennedy, sent Peace Corps volunteers into Third World countries, and Freedom Riders traveled by bus through the American South, testing the desegregation of public facilities.

At the same time, the cold war between democracy and communism was heating up as Kennedy launched his abortive invasion of

Cuba, as the Soviets put the first man in space, then started building the Berlin Wall, and as the U.S. sent the first military companies to the country in which Yoko's father had worked during World War II, then called French Indochina, in 1962, Vietnam.

Simultaneously, Rachel Carson's exposé of the widespread damage caused by pesticides, in her best-selling book *Silent Spring*, heralded an increasing concern with ecology. And, in a widely reported speech to the National Association of Broadcasters, Newton Minnow, the chairman of the Federal Communications Committee (FCC), called American television "a vast wasteland."

In popular music, rock and roll's growing popularity reached all the way to the Onos' beloved homeland. In film, many controversial subjects were now being considered openly—such as corporate greed coupled with infidelity (*Room at the Top*, *The Apartment*), interracial relationships (*The Defiant Ones*), and prostitution (*Butterfield 8*, *Never on Sunday*)—while realism and violence more and more became a staple on American television—in "The Untouchables," "Naked City," "The Defenders"—and in dramatic presentations such as *Days of Wine and Roses*.

However cosmopolitan the Onos had become, however fluent in the English language, they remained strangers in a strange land, adhering closely to their traditional Japanese ways and to the family history of wealth and royalty. Yoko, on the other hand, had apparently rejected all this. She may not have understood, or even known about, all the great changes that were rocking the Western world, but it was abundantly clear when she and her parents met for dinner that they lived in different worlds.

The Onos ignored the differences, limiting conversation to shared memories and reports from modern Japan. And they urged Yoko to return, telling her that her brother, Keisuke, was getting married soon in Tokyo. They even offered to pay for her flight and promised the use of one of the small apartments they had kept in a Tokyo high-rise for as long as she wished to use it.

Yoko resisted, but before the night was out she agreed to go. She had no money, and there were no prospects of having any. Although she had decided to resume her loft performances—and had, in fact, scheduled one for the near future—there seemed to be little hope of planning any more after the poor response to the evening at the Carnegie Recital Hall.

Then, too, there was Toshi to be considered. They were still mar-

ried, after all, and Yoko was wondering what, if anything, remained of their relationship. Yoko had heard from Toshi and mutual friends that he was doing well in Tokyo, that he had been embraced by Japan's young avant-garde community.

Tokyo had become quite Americanized in the decade Yoko had been away. In 1962, the Japanese youth—"MacArthur's children"—who had passed through adolescence and into young adulthood during the American occupation now had families of their own and responsible positions in society. Often they occupied Western-styled apartments in the high-rise buildings that had replaced the smaller, lower structures destroyed by American fire bombs. Such residences, in fact, were held in high esteem.

One of these was at 53 Konno machi in the Shibuya-ku district, part of the booming "west city," a neighborhood that in another twenty years or so would epitomize high-gloss Tokyo, with modish shops, chic little cafe bars, and a trendy crowd of happeners sporting what the rest of the country would be wearing the following season. When Yoko moved into her parents' single, tiny room—equivalent to a small studio apartment in New York—it was still a mix of the old and new, with buildings such as hers adjacent to more modest open-air fish markets and vegetable stalls.

That summer, John Cage and Peggy Guggenheim arrived in Japan for a brief tour, and Yoko went along, showing her paintings, reading her poetry, performing her "opera." Largely because Cage was so respected, and in part because Toshi had told all his friends to attend, a virtual "who's who" of the Japanese avant-garde was present. Unanimously, the critics and much of the Tokyo media hated it.

The first event, at Sogetsu Hall, Tokyo's leading showcase for such entertainment and art, attracted many television reporters, and they were the first to jump ship. Yoko wrote later that it was because her event, "inspired by half-closed eyes of Buddha," required that her audience sit in the darkness, waiting for a "sign," a "vibration," some sort of "communication with the fifth dimension." The television cameramen complained that it was impossible to film people sitting in a dark room waiting; it just didn't make for good television.

Yoko wrote later that she was ignored by the majority and crucified by the rest. When critics gave her any attention at all, they showed no mercy, saying she was a novelty at best and a thief at worst. An American reviewer, in fact, said that Yoko stole her ideas from John Cage.

What was especially painful was the fact that most of the critics were Toshi's friends. "We'd be invited to a party together," Yoko wrote in a Japanese magazine some years later. "I'd think that I shouldn't interfere with his association with other artists. Also, it wouldn't be too much fun for me to mingle with people who wouldn't understand me. Therefore, I'd tell him to go to the party by himself. I'd go to see a play or a movie to kill time while he was gone. I was very lonely.

"I'd do various events to stave off loneliness. I'd buy a lot of flowers and give them to passersby or leave them on a sidewalk to see what [would] happen. I called this the 'flower event.'

"At the time, [Toshi] and I were living on the eleventh floor of a high-rise. In the middle of the night, I would wake up almost unconsciously and walk towards the window. I would try to jump off the window. Toshi would pull me back. This kept happening almost every night. He urged me to go see a doctor and I started thinking I should.

"I took overdose of pills. I was feeling that I always wanted to die."

The Japanese find suicide less shocking than most Westerners; in fact, they often regard it as an honorable solution to a bad situation. However, when Yoko swallowed the sleeping pills, she awoke in a hospital for the mentally disturbed. For the next few weeks she was kept there, heavily sedated.

□

A third of the world away, in New York, was a bespectacled, fast-talking New Yorker named Tony Cox. Until recently, Cox had been an art student at the Cooper Union and a sometime saxophone player who played experimental jazz with friends, among whom was Yoko's friend LaMonte Young, in Greenwich Village bars. Young had talked about Yoko and her work. Tony had reacted noncommittally, but seemed interested.

When he left New York, Tony left behind a mixed reputation. According to one of his closest friends at the time, Alfred Wunderlick, a fellow art student at the Cooper Union, Tony was a maverick, known for his love of motorcycles, his habitual disregard for school rules (smoking in class, physically moving other student's easels out of his way so that he could command a prime position, etc.), and the ability to talk anyone into believing anything. Tony spent some time at Yale, where Wunderlick was doing some graduate work.

"Tony was coming up to New Haven a lot and getting into some questionable areas," Wunderlick says. "He told people he was a stu-

dent at Yale and he'd go to the printmaking department and use the equipment. Nobody ever doubted him. Ever. He was a master at bamboozling his way into things."

Wunderlick was visiting his parents in Oregon the summer of 1962 when he next heard from Cox, who said he was going to Tokyo.

In an account Tony later wrote for a church newsletter, the twenty-three-year-old said he had gone to Japan to further his study of calligraphy and to meet the woman he had been told about in New York. It was, he insisted, a "very romantic venture," a description no doubt enhanced by the fact that when he arrived in Tokyo he learned that Yoko was locked away in a hospital room.

According to Wunderlick, Tony went to the hospital pretending to be Yoko's American physician. Cox himself said he merely presented himself as an associate from New York.

"I found her to be heavily drugged," Tony wrote in the newsletter. "She could barely talk. By a strange coincidence, the drug they were giving her was one I had just recently read up on, and I found out that they were giving her an abnormally high dosage. Her husband [Toshi] then asked if I could help get her out. So I met with the director of the hospital and first I told him that I was a colleague of Yoko's from New York and that she was very highly respected in the art scene there and that I also wrote art criticism and that I planned to write about her and that the people in New York City would be very interested in how she was being treated. And then I let him know I knew about the drug they were giving her and the dosage. Basically I told him he would be exposed for keeping her unfairly. Shortly after, he let Yoko out."

Cox said he then left Tokyo for about a month, and when he returned he had dinner with Yoko and Toshi. "She explained that her marriage to Toshi had been over for some time," Tony said, "and they were only together because of family pressure."

By now, the Onos had come to think of Toshi as a stabilizing influence. He was soft-spoken, a gentleman, and if the Onos didn't really understand, or appreciate, the sort of music he composed and performed, at least he adhered to traditional, well-mannered Japanese ways.

Tony, on the other hand, was unforgivably Western, and when Yoko's brother and sister met him, they were not favorably impressed. It was true he had a knack for picking up languages, worked hard at his Japanese, and practiced calligraphy diligently. But he also developed a fondness for *pachinko*, a Japanese board game played in the

neighborhood cafes. There was a slickness and assertive nature about him that put the Ono siblings off.

Yoko was enormously homesick for New York, so she began seeing Cox, with whom she reminisced.

"I'd ask him, 'Do you remember the coffee shop on the corner?' drawing a map. And he'd say, 'Sure, I remember.' We'd get excited. I'd ask him, 'Did you meet an old man living below my loft?' and he'd say, 'I did, I did!' We felt like crying because we missed New York. That's how our relationship became intimate. It's not in my nature to pretend that nothing was happening when something was. This became the primary reason why Toshi and I broke up."

Before the marriage finally ended, all three tried living together. According to friends, it was on New Year's Eve, 1962–63, when the ménage à trois blew up.

"There was big argument over money," says Nam June Paik, a Korean-born artist who arrived in Japan about the same time and later became one of Yoko's close friends.

A reconciliation followed, but the tension remained and soon Toshi was spending less and less time with Yoko. Then, when it became apparent that she was pregnant, they divorced and Yoko quickly married Tony.

Paik reveals another reason for the pregnancy and marriage. He says that Tony's visa had expired and the Japanese government didn't want to renew it. According to Paik, Tony had left Japan once, visiting Singapore and Hong Kong, for the required length of time to allow him to legally reenter for a second six-month period. Now, however, with that second visa running out, Paik swears, "Tony get her pregnant to stay in Japan. When marry, Tony get new visa."

Yoko's family was livid. When she and Tony told the Onos that they had married, the couple was asked to vacate the apartment immediately. They moved into a neighborhood called Foreigner Village in the Shibuya section of the city, a place where students from around the world who came to study in Japanese universities and people who came to study Zen lived. They were, Yoko said later, "like hippies in the early days."

Their life was hard, Yoko said, but money "always came from somewhere, enough to feed us." Several part-time jobs came to the Village unexpectedly, as when a movie company put the word out, "I need a man with thick voice" or "I need three women." Yoko and Tony thus worked as extras, or dubbed English on Japanese films. Some-

times they taught English to Japanese businessmen, just as Yoko had done with her mother's friends after the war.

The first months of the pregnancy were emotional. Yoko herself has said that she didn't want the baby. Tony also said later that many of her friends urged her to have an abortion. Yoko consulted her doctor, who told her it could be far worse to lose the child than to keep it. Her past abortions had weakened her. Tony was also adamant. He wanted the child, and he made that very, very clear.

So in the spring and summer months of 1963, Yoko hid in her apartment, refusing to go out or entertain. "She didn't want anyone see her when pregnant," says Nam June Paik. "She think she ugly. Fat person. I wait nine months to meet world-famous Yoko Ono."

While secluded, Yoko continued to work at her art. A friend, Takahiko Iimura, asked Yoko to compose a soundtrack for a six-minute film he made called *Love*. It showed a couple performing sexual intercourse, but all the shots were extreme close-ups, so the viewer couldn't really tell what was being done; it was more like a moving landscape of undulating textures than anything identifiable. Yoko provided a soundtrack of "minimal" music—a phrase meaning as little and as simple as possible—and merely hung a microphone outside her eleventh-floor window to capture the ambiant sounds.

Yoko also continued to write new "instructionals." Several reflected the minimal activity of her pregnancy, as when she suggested taping the sound of a "room breathing . . . a stone aging . . . snow falling . . . the stars moving . . . the earth turning." Do not listen to the tape, she said; cut it into pieces and give it away, or sell it for a moderate price. In another, she advised staying in a room for a month without speaking or seeing; at the end of the month, she said it would be okay to whisper. In a third, called "Animal Piece," Yoko suggested taking "one mannerism from one kind of animal and make it yours for a week."

Yoko wrote two "Pachinko Pieces," dedicating them to Tony. In the first, she suggested using *pachinko* balls in much the same way she had, in New York, asked people to leave peas behind them as they moved around during the day. In the second, she said, "Whisper all your secret thoughts to *pachinko* ball."

In August, she wrote a Touch Poem.

> Give birth to a child.
> See the world through its eye.
> Let it touch everything possible

and leave its fingermark there
in place of a signature.

It was a poem prompted by and dedicated to her daughter, Kyoko
Chan, born in Tokyo on August 8, 1963.

With the birth of their first grandchild, Yoko's parents relented
and reoffered the high-rise apartment. They left Foreigner Village
immediately, and Yoko began to entertain again, making new friends.
One of these was Dan Richter, a young American who had left the
American Mime Theatre (where he had been the lead performer) to
study foreign types of theater. It was while en route from Bombay to
Japan to study Noh and Kabuki theater that he met a friend of Yoko's,
who introduced them. Richter was in Japan for only six weeks, but he
became close to Yoko and Tony—the latter painting calligraphic flags
for Richter's street performances, which were the mime's only source
of income during his visit—and remembers fondly his visits to their
small apartment, sitting in the hall with the door open only a crack so
the child could sleep undisturbed. Richter left Japan for Greece, and it
would be two years before he entered Yoko's life again.

It was also at this time that Yoko became friends with Nam June
Paik, who had heard about Yoko from George Maciunas, who was, by
now, living in Germany, more or less in flight from a number of angry
American creditors. (Maciunas had staged several events while in Ger-
many and in one of them Paik created a sensation when he got down
on his hands and knees, straddled a long, narrow canvas, dipped his
necktie into blood-red paint, and dragged the tie along the surface of
the canvas as he moved backward on all fours. He called the painting
"Zen for Head.")

Paik was a pixieish man with a ready laugh and a love of gossip. He
and Yoko hit it off instantly, talking long hours about art and music
and then Oriental history and mythology. Yoko liked to tell him—and
anyone else who would listen—how she was fated to succeed because
she was the reincarnation of Hideoshi Toyotami.

"Who?"

"Hideoshi Toyotami," Yoko said impatiently, as if talking to an
idiot.

The Korean artist, who had little knowledge of Japanese history,
gave her his toothy grin. "Who that?" he asked. "Big man?"

Yoko warmed to her subject. Hideoshi was relatively unknown
outside Japan, she said, but to the Japanese he was the greatest man in
the country's long history—a great *samarai* general who became the

master of all Japanese warlords in sixteenth-century feudal Nippon, uniting the country for the first time. "Hideoshi was very clever," she said, "very strong and always victorious."

"Why you think you Hideoshi?" Paik asked.

Yoko held out her hands, palms up. "Look," she said. "Life lines are the same."

She indicated the long line that ran from the juncture of her first and middle fingers straight back to her wrist.

"Long life line," she said. "Same as Hideoshi. Some Japanese people make their line with a knife to look like Hideoshi. My lines are natural! No knife!"

Paik nodded appreciatively, repressing his amusement.

Yoko pushed her fingertips into his face. "Look at this!" she said. "Fingerprints are all round. Very rare. Hideoshi had fingertips that were all round."

Paik peered at her fingertips. Indeed, the patterns were all round, which was unusual, just as Yoko said. Most people's fingerprints were a mix of whorls, loops, and arches.

"Same as Hideoshi," Yoko repeated. "Mean I take over the world some day."

Whether or not Yoko actually believed she was the reincarnation of a *samarai* who had died in 1598 was not important. What *was* important was the sort of individual Hideoshi was, and thus the individual with whom Yoko identified.

He was, first of all, very clever, just as Yoko said. By conducting the first comprehensive survey of land ownership and threatening all resistors with immediate execution, he determined who owned what, and for the first time was able to tax the landowners appropriately, effectively destroying much of the regional gentry. Hideoshi also mounted huge armies in campaigns financed by merchants who wished to expand their markets by including conquered territory. Conducting a Great Sword Hunt, he disarmed the peasants by saying that the metal was being collected to be melted down to construct a great image of Buddha to go into a new temple in Kyoto.

Hideoshi was also ruthless, and possibly mad. His treatment of forced labor, used in his unending building of fortresses and palaces, was cruel, even by medieval standards. And in his campaign to eradicate early Christian missionary influence from Japan, he had more than twenty Franciscans mutilated, then led from city to city for a month, after which they were crucified upside down as criminals. For a time, he gave his power to his nephew, Hidetsugu, but then he took

it back and ordered his nephew to commit *seppuku*, ritual Japanese suicide; Hideoshi then had Hidetsugu's three small children and more than thirty women who had been in his nephew's employ dragged by horses for the full length of the city and stabbed repeatedly in front of a stake upon which Hidetsugu's head was displayed.

In 1596, he installed the three-year-old child of one of his mistresses as regent of all Japan, and two years later he died babbling about the distribution of feudal fiefs.

"Same as Hideoshi," Yoko repeated. "It means that I take over the world."

□

As the cold winter months of 1963 sped past, Yoko seemed far from getting the world's attention, let alone taking control of it. Tony continued to teach, added mah-jongg to his list of newfound passions (along with sashimi and sushi and most other local foods), and waited on Yoko hand and foot.

"Tony was like Yoko's servant," says Shigeko Kubota, an artist who was traveling with Paik. "He help her. He was like convenient guy. Yoko say, 'You do this, this, this, this,' and Tony say, 'Yes, of course.' Tony younger man. Yoko tell me she like younger man. Good fucker! She say younger man better!"

However convenient and desirable Tony may have been to Yoko, by the spring of 1964 the relationship was faltering. That was when Tony's friend from the Cooper Union and Yale arrived. In the year or so since they had last seen each other, Al Wunderlick had traveled in India and Southwest Asia, and the two had begun corresponding. Tony invited Wunderlick to join him and Yoko in a series of performances scheduled for the summer months. Tony's old friend accepted and moved into the single room, thereby forming another ménage à trois.

Wunderlick says Yoko and Tony fought constantly before the tour. "They were definitely Type-A personalities," he says. "There was a certain amount of entertainment value, but it got dangerous at times. They were always trying to kill each other." Years later, Tony himself would recall an evening when Yoko broke a bottle and held him captive in a bathtub for forty-five minutes.

Nonetheless, they decided to go ahead with the performances, and in an attempt to relieve the growing tension, Yoko and Tony and Al each poured their energy into Yoko's art—besides preparing for the shows, they decided to publish her "instructionals" in book form.

The "pieces" had been accumulating for more than ten years, going back to 1953, when she was at Sarah Lawrence striking matches and watching them burn out, which she called "Lighting Piece." To it she added almost a hundred more. Some of the new pieces, written that spring, were among her most poetic. In one, called "Water Piece," she suggested going to where the moon was reflected on a pond, then stealing the moon by emptying the pond with a bucket. In another, she urged the erection of a sculpture on a mountaintop for people to see with a telescope. And in a third, she asked people to construct human body parts that worked more efficiently than the natural ones, body parts that would be waterproof and fireproof; then, she said, sell the parts in a "supporting goods store."

To give the book some structure, she divided the pieces into categories, calling some "musical compositions," others paintings, poems, dances, or objects. (The moon-stealing piece was included in the Music section and the instructional about body parts was in Objects.)

In a new category, devised in June, the month before scheduled publication, Yoko wrote some "Film Scripts." In one of them, she asked the film's audience not to look at Rock Hudson, but only Doris Day; not to look at any round objects, only the square and angled ones; and not to look at blue, only red. In another, she proposed supplying scissors so members of the audience could approach the screen and cut away the part of the projected image they didn't like.

The book was called *Grapefruit*, and when asked, a few years later, she explained that the act of writing the book was "like a cure for myself without knowing it. It was like saying, 'Please accept me, I am mad.' "

Whatever her reasoning, Wunderlick suggested that some of the pieces be cut from the manuscript. He said some were repetitious or too similar, others too personal ("Go to the middle of the Central Park Pond and drop all your jeweleries") or ridiculous ("Stir inside of your brains with a penis . . . take a walk").

Wunderlick's objections were ignored. It was Yoko's money, after all, and so 500 copies of the 5-inch by 5-inch by one-inch-thick book were delivered to the eleventh-floor apartment on July 4, 1964. Yoko's intention was to offer them for sale at the upcoming concert-events.

In the month that followed, the concerts and events she staged in Tokyo and Kyoto offered a dizzying variety. At one, lasting from evening until dawn in Kyoto's Nanzenji Temple garden, Yoko told her audience to touch (that was her Touch Piece in its entirety) and to look at the sky. She then left the participants to amuse themselves in what-

ever way they wished. She reported later that several fell asleep.

At another, a three-day exhibition in Tokyo's Naiqua Gallery, Yoko displayed some of her paintings, including such old favorites as the "Smoke Painting" and "Painting to See the Sky"—the first to be set aflame with cigarettes, the second being another blank canvas with a hole in it. It was also at the Naiqua Gallery that Yoko urged everyone present to fly.

The most interesting performances were those staged at the Sogetsu Art Centre in Tokyo. Still the home of the capital city's avant-garde—in much the same way that the Carnegie Recital Hall in New York was—this was where Yoko introduced several new pieces. In one, "Sweep Piece," a man very slowly swept the entire theater, including the stage, and then the grounds outside—sweeping for the entire duration of the four-hour concert.

In another new work, "Question Piece," Yoko had two friends fluent in French ask each other questions, refusing to answer them, responding to each question with another question, all of this performed in French.

The final show in the series, held on July 20, 1964, was at the Yamaichi Concert Hall in Kyoto. Here she introduced the concept of "instructures." As the two-page program of events explained, these were unfinished or partially disassembled structures. The audience encountered the "instructures" in the lobby, and the idea was that they would "complete" the structures in their minds as they passed by en route to their seats.

By the time Yoko returned to Tokyo, she and Tony were quarreling again, and by the end of the summer, she was spending more time with Al Wunderlick than with her husband.

"They were still living together," Wunderlick says today, "but they were tolerating each other, really. They were into a thing where Tony would try to be away for a portion of each day just to keep the sparks from flying. I was living elsewhere when I started seeing Yoko. It was a messy situation because Yoko had told me that it was all over for them. But Tony was secretly in love with her, and I was Tony's oldest and dearest friend. I felt she was using me as a way of hurting him. So finally I just walked away from it."

In September, Wunderlick left Tokyo for San Francisco, and he says Tony took Kyoko to New York. (Yoko has written since that, in fact, she was the one to go to New York with Kyoko, a version no one else confirms.) Wunderlick says that the idea was for Yoko and Tony to

separate for a couple of months and then reunite in Manhattan to see if there was anything left in the relationship.

Yoko wrote later in a magazine that she felt very "fatalistic" about her return to New York.

"What would have happened if people in Japan welcomed me?" she asked. "I might have lived in Japan ever after as the wife of a Japanese."

6

*Another Try
for Stardom
in Art
in New York*

Yoko was still in Japan when the assassination of President John
Kennedy threw much of the Western world into an emotional
spin. She was still there three months later when the Beatles
arrived for the first time in the United States and met an audience
quite ready to dance again. In the months leading up to her return in
November 1964, the popular arts exploded, becoming for the first
time somewhat sanctified as the media created heroes and demi-gods
on demand from the Sunday supplements. For the first time since the
1920s, there was widespread acceptance of the cultural underground.

This certainly was true in Yoko's old scene in New York, an area
usually ignored by the population at large, as Yoko could surely attest.
Among the new "superstar" celebrities were Roy Lichtenstein with
his paintings of comic strip characters, Andy Warhol with his of soup
cans and his silk screens of Marilyn Monroe and Elvis Presley, and
Claes Oldenburg with his large soft sculptures of food and clothing. A
writer summed it up in a story entitled "The Artist in a Coca-Cola
World."

The film critic for the *Village Voice*, a friend of Yoko's, Jonas
Mekas (another Lithuanian and a friend of George Maciunas), was
also making a name for himself by establishing the first profit-sharing,
national distribution system for young filmmakers who never before
had a chance to show their work outside their own lofts. Among the
first films distributed were Andy Warhol's productions in which he

focused a fixed camera on mundane activities, such as eating and getting a haircut; another, which showed someone sleeping, lasted six hours and created a sensation in the press.

In another corner of Yoko's old world, the Judson Dance Theatre, a less-than-homogeneous group headquartered in the basement of the Village's Judson Church, promoted the notion that anything could be looked upon as dance; thus, dance performances showcased "dancers" with no previous dance training and which started to resemble "happenings," a word used to describe just about any activity that didn't fit somewhere else. (When Allan Kaprow swept the woods with a broom outside Woodstock, New York, and Carolee Schneemann staged orgiastic rituals in which naked human forms were used as objects in "painting-constructions," Kaprow's performance was called a happening and Schneemann's a dance; no one could really say why.)

Yoko was not totally forgotten in her absence. The same month she was staging her performances in Tokyo (June 1964), Maciunas returned from his exile in Europe and included some of her conceptual pieces in what he called a "symphony orchestra concert." (Earlier, he had included her work in similar concerts in Copenhagen, Paris, and Dusseldorf.) Descriptions of her own performances in Japan, meanwhile, had preceded her to New York, conveyed first by Nam June Paik and Shigeko Kubota, and then by Tony.

Nonetheless, Yoko had a lot of catching up to do. While she was gone, Maciunas and his band of renegade artists had acquired the name Fluxus. Even today, there is argument over the meaning and significance of the word. Some say Maciunas was merely taking its most literal meaning from the Latin, "insistent change, or flux." Others grin and talk about the eccentric artist's well-known scatalogical sense of humor and refer to the word's lesser-known meanings, including "the forceful evacuation of the bowels." One of the symbols Maciunas selected to represent Fluxus was a line drawing of a naked man bent over at the waist, breaking wind. (Another was a drawing of a face from an Aztec god, with the tongue rudely sticking out.) Maciunas never explained the word, preferring to say that Fluxus was people, "a fusion of Spike Jones, vaudeville, gag, children's games, and Duchamp."

Art historian Peter Frank says that Fluxus was "less a particular movement than it was, or is, a tendency, an indication of the whole mind-set that emerged in the 1960s. It took the premise that limitations and conventions in art were arbitrary and said it was not necessary to adhere to them. If you wanted to do something and call it Art,

with a capital 'A', it wouldn't explode. Someone would stand up and say, 'That's not art!' You'd say, 'Why?' They'd tell you why and you'd say you rejected those notions. And then do something else and call *that* art."

In the weeks following Yoko's return, Fluxus experienced a period of intense change. By now, many of the artists who were identified with Maciunas openly resented his harshly pro-Soviet politics and his capricious excommunication of various individuals from the group. (The poet Emmett Williams fell from grace, for example, for failing to label a concert "Fluxus" when it included what Maciunas had designated as the requisite percentage of Fluxus artists.)

More friction occurred shortly before Yoko's return, when Maciunas and Henry Flynt picketed a performance of Karlheinz Stockhausen's music outside the Carnegie Recital Hall, handing out pro-Communist propaganda, protesting, they said, the composer's patronizing attitude toward ethnic music. Because the concert was part of Charlotte Moorman's Second Annual New York Avant-Garde Festival and included many Fluxus artists, the rift between "members" of the group grew fierce and deep.

If today the events sound too trivial for serious consideration, it helps to know that such things always keep people in the art world hyperventilating. Yoko, of course, loved every bit of it. Intrigue and gossip were among her favored pastimes, and now that she was back in America, she resumed her romance with the telephone. In Japan, the telephone is rarely used for gossip and small talk. For that reason alone, Yoko was pleased to be "home" again.

Still cut off from her family, she moved into Tony's small apartment and was reunited with Kyoko, who was now eighteen months old and showing tendencies toward becoming very active and extremely demanding. Tony told Yoko he loved her, and he renewed his belief in her art. He also told her that he would make her into an internationally known artist. With the burgeoning interest in art, and artists, he said, at last her time had come. Yoko agreed to stay and vowed to try again.

Yoko now felt that perhaps it had been a mistake to go to Japan in the first place and then to have stayed away so long. If she had stayed in New York, she reasoned, she would be at least as famous as some of her friends. Bob Morris, who had built the rapidly narrowing entrance into her Chambers Street loft in 1961, was now showing his minimalist boxes and large wooden geometric constructions at the fashionable Green Gallery, while Yvonne Rainer was the subject of an effusive

two-part article in the *Village Voice*, Charlotte Moorman was attracting considerable attention as the organizer of the city's annual avant-garde festival, and Carolee Schneemann was drawing sell-out crowds to an orgylike dance program called "Meat Joy."

Yoko figured that *Grapefruit* was the vehicle that would make it possible for her to earn similar attention. She was mistaken. Although a few small bookshops in the Village agreed to carry it on consignment, there were far more rejections than acceptances, and *no one* gave it a proper review. Criticism was awful enough, Yoko knew, but it was far worse to be ignored than disliked.

In the past, Tony had handled most of her promotion and publicity, but now, in the first months of 1965, Yoko took more control of her career as Tony stayed home with the baby. Now she was working as her own "front man."

One of the first people she approached was Ivan Karp, owner of one of New York's most prestigious galleries. Yoko wrote him a long, rambling letter in January, suggesting that he invite a number of established artists—ranging from newcomers Robert Rauschenberg and Jasper Johns to older artists, such as Max Ernst and Marcel Duchamp—to draw circles on a common canvas, thereby creating a work of art by more than one contemporary great. The cost of flying the artists in could be added to the price of the painting, she said, and if that idea didn't appeal to him, could he imagine one of her "nail paintings" hanging in the Museum of Modern Art, with "people coming every day to hammer nails of various sizes, and the painting, thus, changing its face every moment"?

Yoko went on and on, saying that she dreamed of the time when suburban housewives would tell their guests, "Do add a circle to my painting before you have a drink."

Ivan Karp exploded. He had never heard such nonsense. And never, he said, would she ever be shown in his gallery.

At the same time, Yoko went to her friend Norman Seaman, who was, by now, a kindly and protective father figure, unable ever to say no to his "daughter." So when Yoko asked him to book her into the Carnegie Recital Hall so she could perform some of her new pieces, he agreed.

Yoko began badgering everyone she could for publicity. Ironically, it was the folksy, neighborhood Greenwich Village weekly, the *Villager*, rather than the younger, brasher *Village Voice*, that gave her her biggest break and, incidentally, her first serious interview.

In a story that appeared just days before her March 21 concert, the

writer took a kindly, somewhat amused, but clearly respectful stance. She recited Yoko's educational background, asked her about numerous composers (Yoko said she liked Mozart, sort of, but didn't like Bach at all because he was "mechanical," and Schoenberg was lacking in a structural sense, while Cage was a major figure, though more as an influence than anything else), and even went so far as to say that Yoko looked twenty-two rather than thirty-two.

"She is very much a modernist," the writer said in a story that filled up a third of a page, "and although she isn't happy with the label *avant-garde*, she is resigned to its application to her work. She is less happy that her Japanese colleagues find her Western-oriented and her American colleagues find her Japanese-oriented. She feels her works are an amalgam of both cultures.

"Her music philosophy plays a larger role than either melody or rhythm. She feels that all sound possibilities have already been explored and the future of music belongs to imaginary sounds. For example, she said, 'consider the sound you hear in your head as you are seated before a closed piano. Or the sound a snowflake makes when it strikes the ground.' . . .

"Not being a philosopher, I find much of this difficult to comprehend," the interviewer concluded. "For instance, I am not ready to accept as true that all sound possibilities have already been explored, even with conventional instruments, and I think I observe a confusion between music and sound. However, I am willing to learn and look forward to Sunday night's concert enlightenment. It should be fascinating. Also, I am most eager to learn whether the sound a snowflake makes when it strikes the ground on its edge is different from the sound it makes when it falls flat."

Then, much to her joy and surprise, Yoko got what appeared to be the biggest break of all: a feature story in the arts section of the Sunday *New York Times*. In it, Raymond Ericson actually quoted from *Grapefruit* and, after trying to explain the difference between an "event" and a "happening," plugged her concert that night by saying it was her first appearance in New York in four years. Unfortunately, the overall effect of the story was that Yoko was an egocentric. The writer also neglected to mention where Yoko was conducting her long-awaited New York return performance.

☐

That night, after the curtain rose, the slight figure clad all in black came forward slowly onto the stage at the Recital Hall and stopped.

The only sound in the theater was ambient: people in their seats, changing position, whispering, moving their feet, making the small noises of expectation.

The woman was dressed modestly. For her age—and it was difficult to tell her age, but she looked to be in her thirties—the black silk cocktail dress seemed matronly, and the mesh stockings gave her a slightly exotic look. Her broad Oriental face was impassive. Her thick black mane of hair was pulled back severely.

At first, no one noticed she was without shoes. Or that she carried long, sharp scissors. For what seemed a long time she stood motionless centerstage, her small feet together, the scissors held stiffly at her side. When she did move, she went down on her knees, her feet tucked under her buttocks. She knelt, proudly; then, silently, as if performing an ancient ritual, she held the scissors aloft. Light caught the shiny metal. A few in the audience gasped audibly, and there were two or three nervous laughs.

The woman lowered the scissors until they were pointed at the puzzled audience before her. As she placed the scissors on the floor, in front of her knees, it seemed as if the woman were preparing for *seppuku*.

Finally Yoko spoke, in her tiny, yet matter-of-fact singsong voice, and invited members of the audience to come up on stage and take the scissors and cut away bits of her dress.

There was a murmuring in the theater. No one made a move.

Yoko assured her audience that it was safe on the stage; she actually *wanted* them to cut away her clothing.

Still, for several minutes, no one moved.

After what seemed an eternity, someone bravely took the stage and chastely cut off a patch of material near the hem. A half minute later someone else came up, then two or three more. A line formed.

More and more of Yoko's pale flesh was revealed, then her underclothes, as the spectators timidly snipped and cut, hesitantly and always modestly. Never did anyone touch her skin, and she never smiled or frowned or showed any discernible emotion.

When she had been cut down to her brassiere and underpants, the scissors fell silent, and the audience stuck to their seats as if glued to them. Still Yoko remained silent, showing no emotion. Finally, hesitantly, someone came forward and moved the scissors toward her white brassiere. Slowly, one shoulder strap was cut.

It was another long wait before someone else cut the second shoulder strap.

And still another before a third spectator, very slowly and gently, cut away the remaining strap that hooked behind her back. The garment fell away. In modest and instinctive alarm, Yoko quickly covered herself with her hands, gasping.

She called this her "Cut Piece." But only those who attended got to know that. Once again, the press stayed away. There were no reviews. None. Not even from the *Villager* or the *New York Times*. And her friends told her that she should never have covered her breasts with her hands. It didn't show any control, they said.

☐

Through the spring, summer, and autumn months of 1965, Yoko virtually assaulted gallery owners, newspaper columnists, art critics, radio and television personalities, and dozens of artists and performers, urging her ideas and work on them, insisting they look, listen, read *Grapefruit*, come hammer a nail, draw a circle—anything.

Sometimes the silence that greeted her left her with nothing more to say, so she thrust her hands forward, palms up, and said in her still-tinkly Japanese-American voice, "See the life line? Straight line like Hideoshi. See my fingerprints? All same like Hideoshi."

Inevitably, the response was, "Who?"

And Yoko was off and running at the mouth again.

Sometimes the more subtle approach worked best, as when she mimeographed "Ono's Sales List," a one-page tongue-in-cheek mail order catalog of conceptual works which, she said, she was offering for sale. A tape of snow falling at dawn could be purchased for 25 cents per inch and a Crying Machine ("machine drops tears and cries for you when coin is deposited") cost $3,000. For the original of her letter to Ivan Karp, she wanted $300; for the original of her reply from Karp, 2 cents.

Many in the media who received the list were charmed, and columnists from the *Village Voice* to the *Los Angeles Free Press* reprinted all or part of it. But it did not generate any income, and all through 1965, Yoko and Tony moved from apartment to apartment, leaving the Upper West Side and returning to Lower Manhattan to be closer to their colleagues and friends—and the cheaper rents.

"Yoko and Tony were impecunious, at the bottom of bohemia," says Henry Flynt. "They never stayed anywhere for longer than three months. The first month they paid the rent. The second month was covered by the 'security' or 'last month's rent' that was paid in addition to the first month's rent when they moved in. The third month

they were being evicted for nonpayment. That gave them one free month's rent out of every three."

Friends talk about the disarray. Flynt quotes George Maciunas as saying Yoko's apartments were littered with bags of garbage. Nam June Paik recalls that when Yoko and Tony took an apartment with several rooms, they basically "lived in one of them until it got messy. Then they move into next room, until it get messy. Then into third room. When all apartment get messy, she move."

At one point, when Yoko and Tony were quarreling again, they separated and Yoko moved with her daughter into the Student House at the Judson Memorial Church—a series of small, sparsely furnished rooms that were made available to the artists who performed in the church's gallery.

Yoko's performances in 1965 were infrequent, and however imaginative the "pieces" she staged may have been, the response was similar to that which greeted her Carnegie Recital Hall appearance early in the year. At the East End Theatre, she asked members of the audience to come onto the stage and strip to the waist, or at least expose a little stomach. Everyone was then told to lie down on the floor and place their heads on someone's torso to listen to the heartbeat. There were only a dozen or so in the audience, and there were no reviews. It was as if it didn't happen.

At the same time, Andy Warhol and others were asking and getting six-figure prices for their Pop Art, and a new school of painters emerged, presenting what it called Op Art—paintings of optical illusions and bewildering, sometimes dizzying patterns that barraged and confused the eye. They, too, began to command top prices in all the best galleries.

Yoko concluded that what she needed was a gimmick, the concept that would give her something she could actually sell; if not a product exactly, then an environment she could provide that people would pay to experience. It was at the time she was living at the Judson Church that she conceived a performance piece that would be used over and over again for several years. Initially she called it the "Stone Piece;" years later it became "Bagism."

The notion was quite simple. A performer would get into a large, opaque bag, perhaps with another performer, and they would then either take off their clothes and put them back on again, or just sit silently inside the bag. Motionless figures inside a dark bag gave the same silhouette as a large rock, or stone. Therefore: "Stone Piece."

Yoko has insisted through the years that the piece was conceived in

timidity. "I didn't know how to communicate with people," she told *Rolling Stone*. "And I didn't know how to explain to people how shy I was. When people visited, I wanted to be in a big sort of box with little holes where nobody could see me, but I could see through the holes. So, later, that developed into my 'Bag Piece,' where you can be inside and see outside, but they can't see you."

Yoko was working as a waitress in a macrobiotic restaurant called the Paradox—a few of her paintings hung in a small gallery located in the rear room—when she went to the owner and suggested that she be allowed to stage "Stone Piece." It was radical and sexy, she said, and she had the ear of several important writers who would give the little restaurant publicity.

The restaurant's owner agreed, and off and on for several weeks, Yoko and Tony and their friends climbed into and out of large canvas bags. There were the usual notices in columns in the Village weeklies, but nothing more. Yoko concluded that she needed to make the piece more of a production.

Yoko and Tony designed an entire environment, a room 9 feet square and 6 feet high, with opaque white paper walls and ceiling behind which would be positioned high-intensity light bulbs. When the lights were dimmed, one or two of the walls would offer rear projection cinema, and the sound—whatever it might be—was to be broadcast on a two- or four-channel system. Yoko's plan was that the film and tape would be on continuous loops, and while the lights flashed on and off, those attending could climb into the bags, remaining in the bag in the room-within-a-room for as long as they wished.

To create such an environment, Yoko figured she needed at least $2,000, for her an enormous sum. Then along came Paul Krassner, the editor of a small, irreverent—many said blasphemous—magazine called the *Realist*. Paul had been doing some of *Playboy*'s early interviews and, he says today, "I didn't really need the money and probably I was feeling a little guilty about having so much. I think I was looking for creative ways of getting rid of it. I'd been to the Paradox and I'd met Yoko and Tony. There was this tiny, tiny stage in the back room, and they'd get into these big black bags and fuck, or not fuck. It was a very strange phenomenon. I was intrigued. So I gave her two thousand dollars—to fuck, or not fuck, in a bag.

"In return, she gave me an alarm clock with no hands or numbers. Where the hands and numbers usually are, she had painted a sky with clouds. So you never knew when the alarm could go off."

It would be many years before their paths crossed, fatefully, again.

With Krassner's money, production of "Stone Piece" was assured, and the desired environment was created in the Judson Church gallery, where people crawled into and out of bags from one in the afternoon until six-thirty on Thursdays, Fridays, and Saturdays for a two-week period in March.

Finally, Yoko was given some of the critical attention she wanted. In the weeks following the opening, brief but generally flattering reviews appeared in several publications, including *Cue*, the weekly magazine guide to culture and the arts ("hypnotically dreamlike"), the *Village Voice* ("affording a rare opportunity to impersonate a stone"), and one of the most prestigious daily newspapers, the *New York Herald-Tribune* ("a new Zen-type invention").

However, in return for the $2,000 investment, total income was under $300.

All of Tony Cox's friends comment today on his imaginative survival instincts, saying that when the money got the tightest, inevitably he would devise a means of creating more. In the spring of 1966, he read a story in the *East Village Other*, the weekly newspaper being published for the growing number of hippies who were collecting in the cheap apartments east of Greenwich Village (in the neighborhood surrounding the Cooper Union, where Tony had studied a few years before). The story's author told about selling stock in himself as a means of raising needed cash. After some discussion, Yoko and Tony decided to offer 200 shares of Yoko for $250 apiece.

Raising cash through a stock sale was a standard practice for established public corporations registered with the Securities and Exchange Commission, a federal agency. For individuals, it was illegal. Yoko and Tony gave this not a thought.

Both versions of the prospectus that Tony wrote to attract investors were stitched together from cloth composed of dreams. In one, Yoko's "creative genius" was emphasized; Tony said Yoko had published "over two-hundred compositions for works in Music, Painting, Event, Poetry, Object and Film"—an allusion to *Grapefruit*, of course, although it wasn't explained that all 200 had appeared in a single, privately published book.

Tony boasted that Yoko's works had been performed or exhibited in Europe and Japan as well as in the United States and said that she had been reviewed critically since 1960. That much was true. But he also said that the producers of her works at Carnegie Hall and the Sogetsu Art Centre "have always made substantial profits from their productions." There was a world of difference between the Carnegie

Recital Hall and Carnegie Hall and Tony knew it. As for profits, the producers—and Tony—knew better.

The dreams grew even more fanciful in the budget they prepared. Here, Tony projected monthly sales of 1,820 "Stone Books" (a pamphlet to be sold for a dollar) and 600 copies of *Grapefruit*, plus donations totaling almost $11,000 for the same period. When asked to explain where such charity was coming from, Tony either spun a web of big names and bigger promises or changed the subject.

Prospective investors were told they would share the profits from attendance on all productions of the Stone Piece plus revenue from sales of all "Art" items connected with the Stone.

The prospectus then closed with a message about future growth, promising gallery openings in San Francisco and Chicago during the fall of 1966, with portable models to be made available in 1967 "for home and office use."

However flimsy these boasts and promises seemed, Tony's persuasive charm attracted several backers for what Yoko and Tony came to call the Is-Real Gallery. One of the early investors was Robert DeHavilland. He owned a small advertising agency called the DeHavilland Flying Circus, worked part-time for The Stars and Stripes Forever Film Company, and had met Yoko after reading her "Sales List" in the *Village Voice*.

"She gave me a Fluxus card," he recalls today, "and it said, 'Buy a bag full of wooden spring clothes pins. Clip them to anything—a molding, a wire, etc. Pick up later or leave there for the rest of your life.' I liked that. I thought it was hilarious. I told her about my Dime Piece. Of course I was just making it up. I said you go along the street and put dimes on doorway moldings, placed where people won't find them, then two weeks later you collect the dimes. I think she was envious she didn't think of it first."

DeHavilland bought a single share, but brought in some of his friends and they, in turn, bought more. Before long, Tony had sold nearly thirty shares, for a total of almost $6,000. Suddenly the Coxes were rich.

Tony went looking for an empty storefront in the Village, and Yoko began writing a questionnaire that she planned to give to all the gallery's visitors. (True or False: "Roaches are moving forms of flowers . . . coughing is a form of love"; Multiple Choice: "A line is a [] sick circle, [] unfolded word, [] aggressive dot".)

"The gallery was very successful," says Robert DeHavilland, who continued to see Yoko from time to time. "As you entered, you filled

out the questionnaire, and if you wanted to get into the black bag, you paid two dollars. She also had a redesigned stamp machine. You put in a penny and got a piece of cardboard that said 'Sky' instead of a stamp. One time when I was there, she gave me a poem called 'Sky.' 'This,' she said, 'is old Japanese poem I just invented.'

"As wild and wonderful as all this was, it was clear she was very commercial," DeHavilland said. "She told me she was a producer when we first met. I said, 'What do you produce?' And she said, 'What do you want?'

"She was a woman who wanted complete, utter control. That's why she was into numerology and the stars and all of that. It was an I-know-something-you-don't-know type of control. And if you laughed at her, she got very, very angry."

One morning, DeHavilland's answering service tracked him down and said a friend of Yoko's had called in hysterics. It was a teenager who lived in the same building. He claimed that Tony was beating Yoko. DeHavilland rushed over and found Yoko sitting in a corner of the loft. She didn't appear bruised. She told her friend that she was okay.

DeHavilland returned home, where his wife, Helen, insisted De-Havilland return to the loft and bring Yoko home with him. Yoko stayed with the DeHavillands for several weeks. During that period, she never explained what, if anything, had happened.

In time, Yoko and Tony began working on their first film. The idea was to show the naked buttocks of several dozen, perhaps a hundred, strangers and friends from the rear, walking. The underground film scene was exploding in both the East and West Village in 1966, and Yoko and Tony wanted to be a part of it. Andy Warhol and others had never made any money from their strange films, but their existence and the subsequent publicity had helped establish several reputations. Yoko figured that a film called *Bottoms* would help her to become famous, too. The film was not finished. Something else came up instead.

☐

Yoko was now thirty-three. She had been rich twice—first as a child and later as an adolescent and young college student, classmate to Japanese royalty and New York debutantes. She also had been poor twice—as a youngster during World War II and the occupation of Japan and now, as a starving artist.

The current stretch of poverty had lasted for ten years. Yoko's

friends say she was desperately tired of it, and some of them believe that if she had gone back to her family—who by now had returned to Japan—she could have resumed her life among the very rich. But Yoko was too stubborn, too proud to do any such thing. There had to be another way.

She and Tony talked about what more he might do to further her career in New York. In two years, there had been much activity, but little real success. The "Cut Piece" had worked for a while and so had Yoko's "Stone Piece." She had performed in the Carnegie Recital Hall again, had "lectured" at Wesleyan University (asking the audience to move the chairs to make a narrow aisle for the wind), and had received small but attentive notice in some of the city's most prestigious publications. She even had acquired her own gallery, an extreme rarity for artists at any level of acceptance, virtually unprecedented for one at the barely above-entry level that Yoko occupied in the summer of 1966. Yet large success clearly had eluded her. She and Tony decided that it was time to make another major move.

"Tony was a scam artist," says Dan Richter, Yoko's American friend from Tokyo. "He was a con man. I don't mean that in a negative sense. After all, the word *con* is an abbreviation of 'convince' and Tony could convince anyone of anything. All he needed was a good idea, an idea that was promotable."

Yoko and Tony decided that what they needed was a "serious" backer, someone who could do more than buy a $250 share in a gallery, provide more than even Paul Krassner did when he gave Yoko $2,000. What they needed was someone who had so much money that thousands and thousands and thousands would never be missed when spent on Bags and Art.

Someone like a Beatle.

7

Hammering Real and Imaginary Nails

B Y SPRING OF 1966, when Yoko first welcomed visitors to the Is-Real Gallery, the Beatles had been at or near the top of the Western world's best-selling record charts for two years. Such songs as "She Loves You," "I Want to Hold Your Hand," "Can't Buy Me Love," "A Hard Day's Night," "Help!," and "Day Tripper"—all of which went to No. 1 in the U.S. or England or both—had been burned into the soundtrack of a generation. Two films had been released to great profit and critical acclaim. Nearly a hundred different Beatle products were being sold. The Beatles were rich, rich, rich.

More than a year would pass before the Beatles announced the formation of Apple Corps, Ltd., an organization set up to give starving artists a sudden break. Nonetheless, Yoko and Tony certainly were not the first to think of the English band as a source of needed cash. With all those millions of dollars (and pounds and francs and yen, etc.) pouring into the group's London bank accounts each month, many in Yoko's position lined up, setting their sights on the Beatle wealth.

Yoko has never admitted this. Perhaps she was merely mythologizing their first meeting, making it bigger than life. More likely she was rewriting her own history, as she had before and would do again, to create an illusion of innocence. How would it have looked to admit that she had gone after Lennon, that it wasn't a fortuitous accident?

The truth is, Yoko was very well aware of who John Lennon was

when she was still in New York and searching for a path to fame. Allan Kaprow, the happenings artist whom Yoko knew from various Fluxus events, began seeing Yoko and Tony in the summer months. Kaprow and Tony's father lived near each other on Long Island and sometimes Kaprow and Tony sailed together on Long Island Sound in Tony's father's sailboat.

"One day," Kaprow says, "Tony was skippering the boat, and Yoko told me she had a close interest in the Beatles. She said she had seen them in Japan. My memory is very clear. She said, half laughingly, 'I'd like to marry John Lennon.' "*

It seemed, on the surface, ridiculous. Not just because Lennon was a superstar and Yoko was a minor figure in avant-garde art, continents and cultures wide apart, but also because Yoko had said for years that she hated rock and roll. When one of the early investors in her gallery said he had a son in a rock band, Yoko made disparaging remarks about the music. Classical music was all that mattered, she said. Rock music was for barbarians.

And then, with an invitation to appear at a symposium on "Destruction in Art" in London, Yoko and Tony set forth to ensnare a Beatle and to draw from him their needed cash.

□

Yoko was thrilled when she learned that her old friend Dan Richter and his wife, Jill, were living in London, too. Richter was then using his mime training as a choreographer and actor, playing the lead ape in *2001: A Space Odyssey*, then being filmed in a London studio. The Richters occupied a large flat in Hanover Gate Mansions, an upper-class neighborhood across from Regent Park, and when Tony learned that the adjacent apartment was available, he instantly set his sights on it.

When they accepted the invitation to participate in the "Destruction in Art" symposium, Tony had gone around to everyone in New York on his "believer" (some say "sucker") list, asking for money to make the trip. Robert DeHavilland was one of several who turned their pockets inside out. Nonetheless, Yoko and Tony didn't have much money when they arrived, so the first night was spent in a cheap

*This story is confirmed by others who knew Yoko in New York, although it is unlikely that she actually saw the Beatles in Japan, since they didn't appear there during the period of her residence. Possibly she saw them on television or, just as likely, on American television during the summer of 1966.

hotel room; for the next couple of weeks they slept wherever they could find an invitation and an empty *futon* or couch.

According to friends, Tony finally convinced the owner of the Hanover Gate place to let them live in the flat rent free. There were nine rooms, more than they needed. But Yoko was intent upon making an impact on London's art world and wanted the flat to be her first work of art, a demonstration of what Richter calls "the Yoko aesthetic."

With that in mind, Yoko and Tony decided not to furnish the place, so, in the minimalist tradition, they shoved everything they owned into closets and moved their bed to the room farthest from the door, and left all the other rooms totally empty. They installed neutral wall-to-wall carpeting and painted the walls and ceilings white.

"They had a single telephone on a long chord that reached into every room and even into our apartment by the connecting balcony, so that Tony could conduct business when he was visiting us," Richter says. "Yoko and Tony came and went. There were no scheduled meals. There was no apparent order to life."

"She arrived with copies of *Grapefruit* and made a great impact," says Barry Miles, one of the organizers of the "Destruction in Art" symposium. "She was a hustler. She quickly figured out where the best places were, who to see, etc. A lot of Americans were coming over then. The beatnik poets Gregory Corso and Allen Ginsberg had been there. So had the Warhol people. So she'd been given a lot of contacts by people in New York before she left.

"I met Tony first. He seemed a bit cowed by her. He did basically what he was told. He was a bit eccentric. In the middle of a conversation he would hyperventilate—take in enormous breaths and flap his arms about. It wasn't very English to do that and it made an impression."

☐

In a way, it seemed odd that Yoko had been asked to participate in a festival devoted to the concept of violence in art. Even if her "Cut Piece" called for the destruction of a dress and openly indicated the sexual violation of Yoko herself, most of her art was remarkable for its quiet and meditative nature. She didn't wish to assault her audience, only engage it, nor did she want to assault her art, as was made most clear in an article Tony wrote for *Art and Artist*, the London magazine sponsoring the symposium.

"One is able to observe certain relationships between art and life

that are usually overlooked in purely graphic art," Tony wrote in the magazine's August issue. "Instead of saying how the hell did he [the artist] do that, one might say why the hell do I have to do that? The owner and/or maker of the painting must continually come to grips with certain problems that force him to consider what the concept of art is all about."

Tony quoted several of Yoko's *Grapefruit* "pieces," talked about her "Sky Machines" (saying they should eventually replace all Coca-Cola and gum machines), and recounted her views on imagined sounds ("music of the mind"). Appearing in the magazine with the article were several photographs of some of her early works—a "painting to be stepped on," her "painting for the wind," and so on—and of her "Cut Piece," showing gentlemen in suits and ties cutting away her cocktail dress at the Carnegie Recital Hall.

"From what we had heard, we thought Yoko was breaking new ground," says Anthony Fawcett, then a young writer for *Art and Artists* and soon to be one of Yoko's most trusted errand boys. "We liked the idea of her instructions. It was a sort of art that made people think, gave people things to do. There was a small circle of galleries in London you'd go to where you'd expect to be confronted with new ideas. The designers and artists and writers and pop stars formed a sort of trendy group. The arts, fashion, and music overlapped at that time and Yoko fit right in."

London's mainstream press agreed; on the morning following her first appearance (September 28) reviewers fell all over themselves in a jumble of amazed and flattering declaratives.

The *Daily Telegraph and Morning Post* noted that "after activating both the London police and fire brigade with assorted burnings, slashings, choppings and attempts at animal sacrifice," the symposium had come, at last, to an "elevated conclusion" during which Yoko performed her "Line" (draw a line and erase it), "Bag" and "Cut" pieces, followed by her "Wall Piece" (several members of the audience joined her in banging their heads against the wall), and closed by telling her audience to shout the first words that came into their heads for five minutes. The raucous din that ensued apparently pleased Yoko and, bowing, she left the stage to great applause.

The *Financial Times* called Yoko's work "uplifting" and said her pieces were "received by the majority of the audience with a kind of reverence usually given to concert pianists." The reviewer was especially taken by Yoko's "Cut Piece," reacting to it most seriously. "It was impossible to disentangle the compulsion of the audience to cut

and Yoko Ono's compulsion to be cut," he said. "In cutting off pieces of her clothing, members of the audience show unmistakable signs of an artistic striving and she, for her part, is equally unmistakably striving for a kind of nerveless detachment, so that all emotional display and all emotional interplay is precluded. As the piece progressed, one becomes aware of another kind of nudity underneath the clothing of her skin and this inner amorphous nude shape is visible only in her eyes, fixed unwinkingly on the audience."

Yoko was, quickly, a minor star, flung into Swinging London's pop firmament, invited to parties, and asked to do whatever she wished in one of London's newest, brightest art showcases. This was the Indica Gallery, owned in part by Barry Miles, one of the organizers of the "Destruction in Art" symposium. His partners in the bookshop and gallery were John Dunbar, who was then married to pop singer Marianne Faithfull, and Peter Asher, half of the duo Peter and Gordon; the gallery itself was located in Masons Yard, next door to the Scotch and St. James, a club that had given Jimi Hendrix and many other top musicians their start.

"We always had Beatles and Stones at our openings," says Barry Miles. "People felt confident there. They could sit about drinking and talking in the alleyway. John Lennon and Paul McCartney were regular customers. In fact, Paul helped pay for the Indica—put up £5,000 [$12,500] to build shelves for the bookshop, buy book stock, and pay wages. By the time Yoko arrived, we'd moved the bookshop, and the gallery took over its basement space. So Yoko's show was spread over two entire floors."

Yoko spent the five weeks between the symposium and the Indica show preparing the conceptual works for display and designing an elaborate catalog, which in the end reprinted many of her former works (including her whimsical mail order list and most of her Is-Real questionnaire), had nothing to do with the individual works on display, and cost so much that Tony was forced to go outside the gallery for financial backing. According to Dan Richter, this is when Tony was most imaginative. First, he talked another London gallery owner into paying for the catalog, which was, in the bitchy art world, an amazing feat.

☐

Few events in contemporary popular culture have been so completely recounted as the night, on November 9, 1966, when Yoko met John Lennon at a preview showing at the Indica Gallery. In dozens of

books and articles, people who were there and people who were not tell the story of how John wandered into the gallery somewhat casually. The truth is, Yoko had set him up or, at the very least, had arranged a row of dominoes and invited John to push them over.

Even before the show was mounted, Yoko was asking John Dunbar to be sure his songwriter friends Lennon and McCartney attended the opening. Dunbar said he always invited them to his gallery for special events. Yoko insisted again and again, mentioning John's name several times. Finally, Dunbar called, telling John about Yoko's "Bag Piece," in which she climbed into a bag with a friend and either fucked or didn't fuck. John said it sounded interesting.

Tony has said he also called John personally, although that is unconfirmed, and it's highly unlikely he could have gotten through to him directly, except, perhaps, through Dunbar.

John had been stoned and without sleep for two days and nights when he entered the gallery with his friend Terry Doran ("the motorman" in John's song, "She's Leaving Home," because he customized the Minis that most of the Beatles drove). Both floors of the gallery had been painted white and most of the objects for sale were white, including an all-white chess set. (The idea was for players to play for as long as they could remember whose pieces were whose; the next day, Roman Polanski and Sharon Tate played for nearly an hour before giving up.) In the midst of the whiteness stood the artist, a tiny creature clothed entirely in black, supervising the mounting of the last parts of her show.

Lennon and his friend were greeted by Dunbar and then left to wander around the gallery. The Beatle stopped at a pedestal and picked up something labeled "Box of Smile." He opened the lid and saw his face reflected in a mirror. He smiled.

A few minutes later, John stopped beside a white ladder. On the ceiling above was a black canvas with a tiny white dot in the center. Hanging from the painting was a magnifying glass on a chain.

"I climbed the ladder, looked through the spy glass, and in tiny letters it said, 'Yes,' " John later told *Rolling Stone*. "So it was positive. I felt relieved. I was very impressed."

John remembered that Yoko met him at the bottom of the ladder, where she handed him a card. It said "Breathe" on it. John stuck out his tongue and began to pant heavily.

"Like that?" he asked.

Dunbar approached and introduced them. Yoko apparently made no sign that she recognized John's face or name.

John turned to a nearby canvas and saw a jar of nails and a hammer. A sign read, "Hammer a Nail In."

"D'ya mind if I have a go?" he asked. "Hammer a nail?"

Yoko did mind. She wanted the canvas without nails for the opening the following night. She thought quickly.

She answered in her small, lilting voice, "It will cost you two shillings."

John smiled and said, "I'll give you an imaginary two shillings and hammer an imaginary nail."

On his way out of the gallery, John picked up an apple from another pedestal, and after smiling at the £200 [$500] price tag, he took a bite and replaced the apple on the pedestal.

Both John and Yoko said later that they were drawn together immediately, recognizing something of themselves in each other—a common, turned-around sense of humor, a peculiar yet somewhat intellectual sense of the ridiculous side of art.

John Dunbar came up to Yoko as John Lennon left. "You don't know who that is, do you?" he asked.

"You said John something," Yoko said.

"Lennon."

Yoko looked at Dunbar blankly, then Dunbar said, "The *Beatles*?"

Yoko feigned surprise.

That night when she told Tony about the encounter, he said he thought it sounded very promising.

☐

During the next ten months, until well into the following summer, Yoko and Tony did everything possible to establish Yoko's name in London's popular press, and by the end of August 1967, Yoko was a mini-celebrity, a favorite if not of the London art world, at least of the tabloid newspapers that gave the city's Fleet Street much of its saucy reputation.

Starting in February 1967, Yoko was frequently in the headlines for a film that she and Tony produced (financed by another anonymous patron of the arts). This was *Bottoms*, the film that was begun in New York shortly before they left for London.

Once in London, they threw out all the New York footage and started over, filming, in tight close-up, from upper thigh to lower back, the naked buttocks of 365 friends, acquaintances, and strangers who volunteered either out of curiosity or in answer to an advertisement placed in *Stage* magazine.

Years later, Yoko said the film was inspired by her watching a housemaid polish a floor. "I thought that the movements her behind made were very humorous," she said.

"Peoples' behinds have right and left and top and bottom. And each part moves separately. I thought it would be visually interesting to film close-up.

"Conventional movies have a background and part of the picture moves. In other words, there's always a stationary part in it. If you have close-ups of bottoms, the whole picture should move.

"Moreover, you can't control how your bottom moves, unlike your face, regardless of your intelligence. Cabinet ministers and laborers, beautiful women and ugly women are all equal when they take their clothes off. Their bottoms all have innocent looks beyond their control. I put an ad in the paper saying, 'Intelligent-looking bottoms wanted for filming. Possessors of unintelligent-looking ones need not apply.' "

For two days, the men and women came to a loft in Soho and stripped for avant-garde art, gripping a nearby mantelpiece and stepping onto a revolving belt so that the film would show the subject walking.

Everyone was given equal time, twenty seconds of film, which meant that when *Bottoms* was complete, it lasted more than two hours. And the soundtrack consisted of what people said while their bottoms were being filmed, or, in some cases, what they said when they refused. The bottoms were not identified.

The first to be drawn into Yoko's web was Atticus, the "anonymous" columnist for the prestigious *Sunday Times*. The writer, whose real name was Hunter Davies, was just beginning to work with the four Beatles on an authorized biography when he wrote about *Bottoms*. In February, while the film was still in production, Davies was, in the manner of the *Sunday Times*, calmly effusive. And very, very amused.

The British Board of Film Censors took it far more seriously, and critically, refusing to give what Yoko finally had titled *Film No. 4* a certificate for distribution. The board said the film contained material "not suitable for public exhibition."

What did that mean? wondered the London *Times*.

It meant that the British Board of Film Censors had no objection to buttocks per se, but other parts of the various anatomies had been allowed to creep into some of the film's shots. If they were removed, perhaps the board would reevaluate.

When Yoko picketed the board's offices the next day, every news-

paper in town was present. All day, marching the narrow streets of Soho Square, Yoko carried a sign—which showed two sets of naked buttocks and the words, "What's wrong with this picture?"—and handed out daffodils to the police and curious passersby while Tony buttonholed the reporters, complaining not only about the board's verdict but the £57 [$142.50] that the board charged for making its ruling.

The headlines were predictable: "Bottomless Indignation of Miss Yoko Ono" . . . "Oh, No, Ono" . . . "Right from the Start, the End's in Sight."

Unwilling to take no for an answer—and quite willing to use "no" for publicity—Yoko and Tony then applied for a permit to show the film at the Royal Albert Hall, one of London's most prestigious concert halls. Not surprisingly, their application was denied by administrators who feared "disrupting behavior from way-out elements."

And when, finally, Yoko did find some sympathetic response—first from Granada Television, and then from the owner of a small theater in the West End—everyone rushed to their typewriters to say how totally boring it was. The *Times* reviewer called it "hypnotic monotony" and the *Daily Mirror* noted how sad it was when good filmmakers "go wanting in search of a showcase and nonsense like this finds a theatre." Even the most receptive critic couldn't resist taking a shot when, in the *Observer*, Edward Mace said the film "deserves at least as much sympathetic consideration as any other seriously intentioned act of artistic rebellion," but then suggested a sequel on nose-picking.

Yoko decided to defend herself and did so in London's underground weekly, *International Times*, saying that a California filmmaker had asked her for permission to use the concept in San Francisco. Another in New York wrote to say she wanted to make a slow-motion version with her own behind.

"I'm hoping that after seeing this film, people will start to make their own home movies like crazy," Yoko said.

She also said she hoped that in fifty years or so, when people looked back at the 1960s through the films produced during that decade, they would see "not only the age of achievements, but of laughter."

There were other events during the summer months. In June, Yoko and Tony were arrested for dancing naked in Belgium. In July, they reported the theft of the soundtrack of another film, a documentary about the return of St. Isidore's thighbone from Venice to the scene of his martyrdom on the Greek Island of Chios. In August,

Yoko, wrapped in cloth, tied herself to the statuary lions in London's Trafalgar Square. The publicity, in each incident, was significant.

Yoko hadn't forgotten John Lennon during this time. She was, in fact, always in subtle pursuit—hoping, of course, to earn some of his attention by her outrageous activities, but also approaching him directly, if very carefully.

Initially, their contact seemed accidental, like when they both found themselves at a gallery opening for Claes Oldenburg. It was there she first met Paul McCartney, she said, although she claimed not to have recognized him either. Yoko said she and John talked after McCartney broke the ice by reporting that John had liked her show at the Indica.

As the months passed, her approach became more overt. While John and his mates were recording the last of the *Sgt. Pepper* album— scheduled for release that summer of 1967—Yoko had a copy of *Grapefruit* delivered to him in the Abbey Road studios. Another time, when John Cage was in London, Yoko called Lennon to say that Cage was compiling a book of twentieth-century music scores that would begin with Stravinsky and end, hopefully, with the Beatles. She asked him to contribute something.

John invited her to come to the studio that evening, and during a break in the recording they walked across the street and into a house the Beatles had rented for the duration of their recording dates. In the conversation that ensued, John said he liked *Grapefruit* and Yoko said she liked his books, *In His Own Write* and *A Spaniard in the Works*, both of which had been published the previous year. They also discovered that he wasn't much on classical music and she didn't much care for rock and roll. John asked Yoko when he could see more of her work.

Yoko smiled and said she was busy organizing another exhibition for the Lisson Gallery. John wanted to know when.

Yoko said, "When I find a sponsor."

John asked her what the show was about and when she said, "I call it Half-a-Wind. A roomful of everyday objects . . . bed, chairs, table, clock, radio . . . all cut perfectly in half and painted white," he smiled and suggested that she put the other halves in bottles and sell them. John then told Yoko to call his office in the morning for the £5,000 ($12,500) that she said she needed to mount the show.

Actually, it wasn't until after Yoko had John's promise of financial support that she approached Nicholas Logsdail, proprietor of the Lisson Gallery. Even then, it was in the form of a strange letter in

which she invited him to visit her in her flat (not far from the gallery). In the letter, Yoko gave precise instructions on how to find her flat and concluded with the words, "The above instructions are viewing the matter from my side, as it is too complicated to think from your side for me and I don't want it to be too confusing. So you will simply have to reverse the instructions where it says right to left and left to right, but otherwise this should get you to my place. Hoping to see you then. . . ."

Logsdail says he was baffled by the woman, but enchanted, too, and in short order, knowing that John Lennon was paying the bills, he agreed to whatever she wanted to do.

Most of John's friends report that at first he found Yoko somewhat "off-putting." He felt that some of the pieces in *Grapefruit* were infuriatingly absurd ("Use your blood to paint. Keep painting until you faint. Keep painting until you die."), and he was somewhat intimidated by her, because she was a woman operating in a man's world and a Japanese competing in the West, apparently quite successfully.

John called Yoko an "original mind" (in talking with his manager, Brian Epstein) and he felt Yoko possibly offered him an escape from the narrow box in which he felt the Beatles had kept him.

Yoko's friends say she was fascinated, too—coming, now, to regard John not just as a Beatle with a checkbook, but as an artist and intellectual. She genuinely was in awe of his books, found them in the style of James Joyce, and when *Sgt. Pepper* was released to enormous worldwide acclaim in June, she had begun to listen to his lyrics for the first time, finding *them* deeper than she had expected. Yoko also was attracted to him sexually and wanted to have an affair with him.

☐

The large flat opposite Regent's Park had deteriorated. According to musician John Stevens, when he and his wife visited Yoko the first time, he was quite disappointed

"Fran and I sort of dressed up for it," he says, "bit of a night out, ya know? And when we got there . . . well, when you're not offered a beer or a wine, maybe a cuppa tea! The sink was full of dishes. It was very untogether. I said I wanted a cuppa tea. She said she only had seaweed tea. I said okay. She went to the sink and washed out a jam jar!"

Around the flat now were scattered some of the objects she was building for her "Half-a-Wind" show. On one wall was a large photographic self-portrait and around it were framed some of the newspaper

stories and reviews she had received since coming to London.

"She was full of herself," Stevens says. "I felt sympathy for Tony and Kyoko. Tony was functioning as mother *and* father. Funny thing was, Yoko talked about her own mother and how detached she was from her, how she had a sad childhood, and I felt Yoko was doing the same thing. Kyoko was expected to watch TV. Yoko said it was a good education for her when I said she watched too much. Kyoko had to live by Yoko's vegetarian diet. She was given absolutely no meat. Tony sometimes brought Kyoko over to play with Richie, our son, and Kyoko would steam into the kitchen to find a bit of sausage. We'd secretly give her meat."

As the October date for the Lisson Galley opening approached, Yoko and Tony threw themselves into a buzz saw of activity: rounding up art students, as they had for the Indica show, to construct her half-bed, half-chairs, and other objects for the show, while beating the bushes for advance publicity.

One of the first efforts to attract attention to herself was Yoko's "13 Days Do-It-Yourself Dance Festival," producer: Yoko Ono Dance Company, 25 Hanover Gate Mansions, N.2.

"The Festival," Yoko said in her mail order announcement, "will take place in your mind." For £1 ($2.50) a day, subscribers would receive a "card of dance instructions" for the day, along with the prescribed time of performance, so that everyone could be performing at the same time. Individual cards—"Breathe . . . Dance . . . Watch all the lights until dawn"—began arriving in John's mailbox each day.

Yoko's "Half-a-Wind" show opened quietly. The topmost of the three floors presented her "half-a-room"—a bedroom with half a bed on which were half-sheets and half-pillows; half a chair was placed nearby and, next to it, half a sink with half a toothbrush.

The next level down—street level—offered a number of conceptual objects, including old favorites, such as "Hammer a Nail Painting," and newer works, such as the "Switch Piece," which allowed you to "turn on a light 500 miles away when you want to let your wife know you are headed home."

The basement room was for the "Stone," or "Bag," piece.

John did not attend. Brian Epstein had died that past August, throwing the Beatles into disarray. Besides, John was more than slightly upset when Yoko included his name in her catalog. It was enough that he had financed the show, he didn't want name recognition as well.

Yoko and Tony were also fighting again. Nicholas Logsdail said that even before the show opened in his gallery, both were trying to get him to take sides.

It was time to go after John more seriously.

8

Pulling
in
the
Net

YOKO needn't have worried. By the autumn of 1967, John was nearly in her net.

"It was beginning to happen," John said years later. "I would start looking at her book and that, but I wasn't quite aware what was happening to me and then she did a thing called 'Dance Event,' where different cards kept coming through the door every day . . . and they upset me or made me happy depending on how I felt."

Yoko was a mysterious physical presence as well. After sending letters to his home, generally asking for help in getting *Grapefruit* off the ground in Britain or asking, again, for money to pay for future exhibitions, she aggressively began to insert herself into John's life.

First she began calling on the telephone, then she started showing up at the Lennon home unannounced when John and Cynthia were not at home. The housekeeper, Dorothy Jarlett, once allowed Yoko into the house to use the telephone, and the next day she called John at home to say she was on her way over to pick up the ring she had left by the phone.

Another time, Yoko suddenly jumped into John's Rolls-Royce as he and Cynthia were pulling away from the studio. She asked to be dropped off down the road, which she was. That night, Cynthia confronted John. She quotes John as saying, "She's crackers. She's just a weirdo artist. Don't worry about it." Yoko was, he said, "just another nutter wanting money for all that avant-garde bullshit."

Cynthia recalls that when she first met John, his primary fantasy figure was French actress Brigitte Bardot. Running a close second was the French existentialist actress and singer Juliet Greco. Yoko's dark wardrobe and long, full black hair were similar to Greco's. Cynthia finally suggested to John that perhaps he was attracted to Yoko more than he wished to admit. John said no.

However, when Yoko invited John to visit her in her flat, he accepted. They talked, learning they had children the same age—Kyoko was exactly four months younger than Julian. John also discovered, much to his surprise, that Yoko was seven years older than he.

John left Yoko's flat, saying he was going off to India to study transcendental meditation with the Maharishi Mahesh Yogi for three months. Later, John said he had considered inviting Yoko to go with him and his wife and the other Beatles and their wives, but he changed his mind, thinking it might be too complicated.

Yoko said she'd write.

And write she did, sending brief "instructionals"—telling him, for example, to look at the sky and know that the first cloud he saw was the same cloud Yoko had seen earlier—and longer notes, either typed or handwritten on scented notepaper. All were designed to entice and intrigue.

"My career was going well," Yoko said later, describing this point in her life to her old friend Betty Rollin at *Look* magazine, "but my husband and I were fighting about who would answer the phone. He wanted always to answer the phone, so that he would be into everything. I always thought of him as my assistant, you see. But he wanted it to be Judith Malina and her husband [Julian Beck, of the Living Theatre]. He wanted it to be both of us. All I wanted was someone who would be interested in my work. I needed a producer. . . ."

Obviously, John could offer Yoko more than that. Many times in the years to come she told a story about consulting a palmist, who told her she was "like a very, very fast wind that goes speeding around the world." Yoko said she was told that astral projection—out-of-body experiences and psychic travel from place to place—were within her normal reach, but she didn't have a "root."

" 'But' the palmist said, 'you've met a person who's fixed like a mountain [Yoko claimed], and if you get connected with that mountain you might get materialized.' "

Yoko said that John was like a frail wind, too, so he understood. "I'm starting to think that maybe I can live," she said. "Before it seemed impossible. I was just about at the vanishing point, and all my

things were too conceptual. But John came in and said, 'alright, I understand you.' And just by saying that, all those things that were supposed to vanish stayed."

☐

In the months that followed, into January and February of 1968, Yoko's situation at home deteriorated, and by March, she and Tony separated again. Tony stayed in the Hanover Square flat with Kyoko, and Yoko took a small set of rooms in a commercial hotel nearby.

Yoko was now planning another big show, this one at the Royal Albert Hall—the venue that had turned away her *Bottoms* film a year before—and with no less a figure than Ornette Coleman, who was, in 1968, one of the most progressive and respected of American jazz saxophonists. He and Yoko had met in Paris earlier in the year, and when he was unable to get a work permit as a jazz musician in Britain (the way the law read, America would have to provide an equal job for a British jazz musician), a campaign was organized to get every music professor in England to write a letter saying Coleman was a *classical* performer. "It was a matter of calling an apple an orange," Richter says, "and it worked." The concert was set for February 29.

Coleman was a perfect match for Yoko. Long a member of the bopster's avant-garde, he was known for his spare, assaultive style characterized by high-pitched bleeps and screams on the sax and other woodwinds and long suspenseful silences. A perfect counterpoint to Yoko's own banshee wails and cries.

However, Yoko was not happy with the way the rehearsals went. She felt that the sidemen with Coleman—David Izenson, Charles Haden, and Edward Blackwell, all respected in jazz—were unwilling to take her direction. The saxophonist suggested that Yoko write what she wanted and he would try to help them understand. Her instructions to Coleman were pure Yoko—whimsical, baffling, sexual—and, at the musician's suggestion, were included in the concert program.

That's where the first of the troubles began. When the Albert Hall security people saw the program, it was rushed to the administrative offices, where it was declared obscene because Yoko had used the words *penis* and *shit*. The programs were confiscated, and when more were produced and handed out the night of the concert, the guards moved in again, in some cases taking the programs out of the hands of the paying customers.

The hall management then ordered a halt to the sale of tickets. Outside the hall, a cry went up: "Let the people in! Let the people

in!" In the end, it was decided that it was safer to do just that, and when the concert finally began, there were nearly a thousand curious people present (in a large, ornately Victorian room that held eight times that number).

The concert itself was somewhat of an anticlimax, although that word is perhaps the imperfect choice, because many of Yoko's vocal sounds resembled the moans of sexual intercourse. Appropriate bleeps and honks and so on were provided by the accompanying quartet.

☐

There was another Yoko-watcher on the scene by now: Anthony Fawcett, the small, energetic art critic for *Art and Artists* who was offering his services at every turn and praising Yoko's work effusively. He says that in April, after John returned from India, disillusioned by the Maharishi (who apparently let his carnality get in the way of his essence, at least that's the way John put it, explaining that the yogi had fondled one of his female followers and that was that for him!), Yoko went after the Beatle full-bore, writing him an "endless stream of letters."

The split with the Maharishi had left John spiritually adrift. Friends say that although there was no serious strain in his relationship with the other Beatles, he was seeing less and less of Paul and George, who were now pursuing independent lives. With Brian Epstein dead and John's wife, Cynthia, practically a stranger in her own home, John was searching desperately for something new.

His first response was to leave the drug-free life of India behind him and return to his old habits. Into a large pestle and crucible that he kept on the mantel in the living room of his home, John regularly dumped whatever leftover pills and tablets he had, reducing everything to a powder. He would then lick his finger and stick it in the mixture, sucking his finger clean to see what happened next. One night in May, after doing this, and with Cynthia vacationing with friends in Greece, John decided to call Yoko.

His timing was impeccable. At Yoko's suggestion, Tony and Kyoko were vacationing in the South of France. She arrived an hour later in a cab at John's house and was greeted by John and Pete Shotten, an early friend from Liverpool who had worked for the Beatles ever since. Both were stoned. The three went to a rarely used lounge area of the house where they talked for about half an hour before Shotten excused himself to go to bed. He said that up to that point, Yoko had seemed quite shy.

The reticence Yoko felt apparently disappeared when John took her into the small, rather primitive recording studio he had installed at one corner of the attic. There he played some of the tapes he had been making. Suddenly the room was filled with sounds familiar to Yoko. It wasn't rock and roll at all. It was *musique concrète*, "electronic" music created by speeding up and slowing or reversing previously recorded tapes—a type of music more or less invented by some of Yoko's early influences, John Cage and Edgar Varese among the more notable. John told Yoko he was creating the tapes for a song that was going on their next album, "Revolution No. 9." Yoko was thrilled, and in the hours before dawn, she and John continued John's earlier experiments. He began to record some straight feedback from his guitar, and she wailed an eerie yet innocent accompaniment. The tape was then cut up and edited with other tapes—some made directly off the radio, others including some of their idle conversation.

Later, John said it was then that he realized "that someone was as barmy [crazy] as me"—that is, Yoko was more or less "me in drag!"

They decided that they would release the final effort of their all-night editing on an album—which they eventually did, calling it *Unfinished Music No. 1: Two Virgins*—and as the sun came up, bringing light to the London suburbs, Yoko and John made love for the first time.

A few hours later John encountered Pete Shotten in the kitchen and told him he'd fallen in love the way adolescents do—totally, illogically, and blindingly. He told Shotten he was willing to give up everything for Yoko—his marriage to Cynthia, his big house, the Beatles, everything—and the first item on the agenda was for Shotten to find a house for John and Yoko. He also told Shotten he wanted him to take Yoko shopping for clothes.

Before that happened, Cynthia returned with her friends from Greece, and Yoko was seated in the breakfast nook with John. John was still in his robe, Yoko was wearing one of Cynthia's kimonos. They were drinking tea when Cynthia entered the room, followed by her friends.

John looked up and said, "Oh, hi."

Cynthia was stunned. She had known there had been other women in John's life; a year before he had confessed to having one-night liaisons with "hundreds." And even though she had told John that Yoko might be the right one for him, she says today that she really was unprepared to find Yoko in her kitchen, wearing her kimono, and drinking her breakfast tea.

Cynthia tried for a recovery. She said she had had breakfast in Athens and lunch in Rome and wouldn't it be nice if they all had dinner in London, just like jet-setters.

John took a drag on his cigarette and said, "No, thanks."

Yoko looked at Cynthia, smiled, and said nothing. It was, Cynthia says, "a very positive, confident look."

In the months that followed, it seemed that nearly everyone in England, and elsewhere, would do everything they could to wipe that smile off Yoko's face.

9

Enter:
The
Dragon
Lady

A FTER SPENDING a few days with friends in London, Cynthia returned to her home, and Yoko returned to Tony and Kyoko. It was clear to everyone that the relationships had changed. Even Cynthia acknowledged that Yoko was right for John, and when he refused to take Cynthia to New York, where in mid-May he and Paul McCartney announced the formation of an organization called Apple Corps, Ltd., she went back on vacation, this time remaining away for a month.

In the meantime, Yoko and John were inseparable, the picture of newfound love.

"I don't know how it happened," John later told *Rolling Stone*. "I just realized that she knew everything I knew, and more, probably, and that it was coming out of a woman's head. It just sort of bowled me over. It was like finding gold or something, to find somebody that you could go and get pissed with, and have exactly the same relationship as any mate in Liverpool you'd ever had. But you could go to bed with it, and it could stroke your head when you felt tired, or sick or depressed. It could also be mother.

"As she was talking to me, I would get high, and the discussion would get to such a level that I would be going higher and higher. When she'd leave, I'd go back to this sort of suburbia. Then I'd meet her again and me head would go open like I was on an acid trip."

They began appearing together publicly the first week of June—first when they lunched (wearing matching white caftans) at a restaurant during one of their house-hunting forays, later going to the Apple offices, and still later while staging a small but odd event at the National Sculpture Exhibition in Coventry.

Yoko's friend Anthony Fawcett, who had become a close companion since meeting her at the Indica Gallery, was one of the exhibit's organizers. When he told her of the event, she asked to be included. When he asked what she had in mind, she said she and John wanted to plant two acorns in the churchyard, one facing to the East, the other to the West, symbolizing their love and the mingling of their cultures.

"My immediate reaction was mixed," Fawcett later wrote in his book *One Day at a Time*. "I tried to imagine how the acorns would fit into a survey of the best contemporary British sculpture—which at that time were mostly figurative stone and bronze pieces, or abstract 'New Generation' brightly painted steel constructions. But the conceptual idea of acorns as 'living art' was original and . . . I realized that what Yoko was doing for John was changing his attitude about art—and everything else—by showing him that anything was possible, and more importantly that all the ideas he had in his head should be brought out into the open and followed through, not just left as fantasies."

The primary organizer of the event was shocked when he heard the idea. He said he didn't think acorns could be included in the official catalog. As much as he wanted a Beatle represented, the notion was just too odd. Yoko and John said they'd prepare their own catalog and had a picture taken for the cover; inside was the simple message, "This is what happens when two clouds meet."

It was all too strange for church officials, too. "Unfortunately," Canon Verney told them when they arrived (dressed in white again, and in a white Rolls-Royce), "the cathedral authorities have decided they cannot permit you to put your work in the main exhibition area, as it is on consecrated ground."

According to Peter Brown, Apple's director, "Yoko turned into a sputtering little volcano of rage. She launched into a red-faced harangue, insisting that all the leading sculptors in England be telephoned to testify to the validity of her acorn idea. She actually got through to Henry Moore's house, but the great sculptor was out.

"A compromise was finally reached when permission was granted to plant the acorns on a lawn *near* the cathedral. A week later the

acorns were dug up and stolen in the night. John and Yoko sent a second set, and a security guard was hired to stand and watch over them for the duration of the show."

Somehow all this activity escaped the attention of the Fleet Street press, perhaps because it was outside London. Not so what happened three days after the "Acorn Piece," when, on June 18, Yoko accompanied John to the premiere of a theatrical adaptation of his book *In His Own Write*, which was being staged at the Old Vic, England's revered National Theatre. Although they were fifteen minutes late, the reporters were waiting. And on seeing John with Yoko, they cried, "Where's your wife?!"

John said he had no idea and ducked into the theater with Yoko on his arm. Next day, virtually every paper in Britain carried a picture of the couple with the "Where's your wife?" exchange.

Cynthia was still in Italy, but not for long—John had dispatched a friend to tell her that he was filing a divorce petition and intended to take custody of Julian. Cynthia flew back to London and was immediately served with a copy of his complaint, charging her with adultery. She countersued the following day.

Meantime, Tony and Kyoko had returned from France.

Yoko was not so swift to end her marriage to Tony. Instead, they drafted between them another agreement, one that Yoko would never admit publicly.

When Yoko and Tony had plotted to capture a Beatle for his pocketbook, neither had figured on Yoko's also winning his heart. Nor did Yoko and Tony expect that *she* would fall in love with John. When John said he didn't know how it happened, he wasn't alone; *everyone* was somewhat surprised.

However, Tony was not so startled that he didn't propose a plan. One day, when he and Yoko met at the Hanover Gardens flat, he suggested they make a deal: He would give her her freedom if she signed an agreement giving him fifty percent of everything she got from John.

"Tony felt as if he'd been screwed," says Dan Richter, who was present when Tony and Yoko talked. "He encouraged Yoko to see John. He thought it was great. But when he felt he was losing her, that was when he insisted on the agreement. She was close to Tony, and she owed him a lot. He got her out of the mental hospital, he kept her going, raised money for her shows, promoted the airline tickets to London, went after all the publicity, found backers for her films, borrowed money from banks, all of it. She came to realize in a way

that everything she did was him. She felt she owed him. I think she also felt that she could break the agreement later if she wanted to."

According to Richter, the "contract" was only a few paragraphs long—less than a page. Yoko signed it—in Japanese—and Richter signed as the witness.

☐

Yoko and John decided to live together. When Cynthia moved back into the Weybridge house with Julian, and Tony returned to the South of France with Kyoko, Yoko and her Beatle moved to London's fashionable Montague Square. Here, in a one-bedroom basement flat owned by Ringo Starr and previously occupied by Cynthia's mother (and before that, by Jimi Hendrix and William Burroughs), they lived their cluttered and chaotic lives together for four months—a period that would nearly destroy John's reputation and set forever in granite the way many people ultimately felt about Yoko.

Wherever John went in the weeks that followed, Yoko was always there, even to the Abbey Road studios where the Beatles were recording another album. This violated a long-standing agreement they had about never bringing wives or girlfriends to recording sessions. John later complained that he had to ask permission to bring Yoko. The others claimed he merely showed up with her, without notice. Whatever the truth, there is no argument about the reaction to Yoko's presence. The other Beatles didn't like it.

"Yoko didn't help matters either," says someone who was present during the sessions. "She was shy and she didn't say much, so the others thought she was a snob. And the way she whispered in John's ear all the time. It was off-putting, to say the very least."

To everyone around them, Yoko and John appeared smitten, and if there was any doubt, John dispelled it on July 1 when Yoko staged another gallery event, this time at the trendy Robert Fraser Gallery and again with John's financial backing. In the catalog, the show was dedicated "To Yoko from John, with Love" and when the press arrived, he simply and happily announced, "I'm in love with her."

This time no one asked about his wife.

The exhibit itself was surreal. Entering the gallery, press and visitors were greeted by a room full of charity boxes, the elaborate coin collection boxes common on London streets—one for almost every cause imaginable. On one coin box stood a small metal bear with a bandage around his head (as if the bear had a toothache), a contribution from the Royal Society for the Prevention of Cruelty to Animals.

For another worthy cause, a mechanical dog, when fed a sixpence, barked, wagged his tail, and lifted his leg. There were more than a dozen in all, and a sign on the wall urged visitors to contribute freely. Near the sign was a television camera that recorded everyone as they moved through the room.

Once past the collection boxes, patrons of the gallery came, finally, to the single piece of original art: a freshly painted stark white circular canvas six feet in diameter. In the middle in tiny letters was the inscription "You are here."

Where's the rest of the show? the press asked.

The gallery owner merely smiled and said, "That's it."

But of course that wasn't entirely *it*. Before all the celebrity guests and Fleet Street press went home, Yoko and John released 365 helium-filled white balloons. To each was tied a note: "Please write to John Lennon, % the Robert Fraser Gallery, Duke St., London W.1."

The response was staggering, not in the number of letters but in the collective, angry stance. Almost without exception, the letter-writers took John severely to task and criticized Yoko as a home-wrecker. Several even made racist remarks, calling Yoko a "Nip" or a "Jap."

The reaction to Yoko was no better within the Apple offices, as several employees joined their whispered voices to the nagging, critical litany. Her continued presence in the Abbey Road studio during sessions for the "white album" now infuriated the other Beatles, and Paul McCartney began to complain openly, telling Yoko she should "keep in the background a bit more."

"The hostility poured out," wrote Peter Brown in his book *The Love You Make*. "To her face they were sarcastic and cold; behind her back they called her the 'Jap Flavor of the Month' and made jokes about her vagina being slanted like her eyes."

Outwardly, the couple seemed bulletproof. John responded to the criticism by holding a press conference to declare again his love for Yoko, while Yoko delivered long, rambling monologues about the "vibrations" she and John were sending out.

"If these vibrations make just a few people happy," she said, "surely that's enough. It's much better than all that art bit. A smile for everyone. That's us."

One of those smiles was delivered in slow motion, in one of the first films that Yoko made with John. She called it *Film No. 5*, inasmuch as *Bottoms* was No. 4, and the whole thing was John smiling into a high-speed camera. When the film was processed and played back at usual

speed, the smile appeared so slowly that what took a minute to film required thirty minutes to watch.

This, in turn, only resulted in more biting criticism, as Britain's popular magazine of satire, *Private Eye*, published in August the first of many stories about an artist identified as Yoko Hama.

"We've started to make lots of films together," Yoko Hama was quoted as saying. "There's this one of him sitting in a chair picking his nose. Every so often he gives a little gurk. It's called 'The Decline and Fall of Nothing at All.' You can take that how you like, but to my mind it's just a universal message of the way we feel. What's happening between us we want everyone to share. That's why it's so crowded in the bedroom. We've got the Derby County Football Club in and the members of the Let's Get Britain Moving Again League. They're vibrating away like anything. Still, that's life to my mind. A little smile, a little drink, and running off with someone else's husband."

If Yoko and John seemed outwardly nonplussed by all the criticism, inwardly they bubbled and seethed. Yoko was never one to take criticism lightly, and in John she found her match when it came to anger and moodiness. In July, their collective mood was black.

Yoko had continued the varied drug use that began with the first night she spent with John, and in the month of her Fraser Gallery exhibit, they experimented for the first time with heroin. Actually, Yoko had had a "taste" of heroin more than a year before, when she unknowingly snorted some of the white powder at a party she and Tony attended in Paris.

By summer 1968, heroin was becoming fashionable with London's pop elite. Many of the biggest names in Britain's rock scene were addicts, in fact, and so, too, a scattering of individuals in the film and gallery set. Yoko and John spent time with several of these people during July, and it was from one of them that they obtained their first supply.

"John was very curious," Yoko told Peter Brown. "He asked me if I had ever tried it. I told him that while he was in India with the Maharishi, I had a sniff of it in a party situation. I didn't know what it was. They just gave me something and I said, 'What was that?' It was a beautiful feeling. I think because the amount was small I didn't even get sick. It was just a nice feeling. So I told him that. When you take it—'properly' isn't the right word—but when you do a little more, you get sick right away if you're not used to it. So I think maybe because I said it wasn't a bad experience, that had something to do with John taking it."

Peter Brown says that for most of the month that followed, Yoko and John "lay in the basement of Montague Square . . . submerged in a self-inflicted stupor." Others close to the couple say Brown exaggerates. They say Yoko and John used heroin sparingly. Whatever the truth, the drug was perfect for their needs at the time. A heavy "downer," heroin offered a mellow escape.

☐

While there was still a lot of heat from the press and the other Beatles, the worst was to come.

In September, as the meetings between John's and Cynthia's solicitors intensified, Yoko learned that she was pregnant. (News that led John, wisely, to drop his adultery charges against Cynthia.) When John told a few close friends at Apple, he was told to keep his mouth shut. He was also told to tell Yoko to keep her mouth shut. Yoko and John agreed, but at the same time they decided to release the tape they made the night they first made love, and to use on the front and back covers of the album sleeve photographs of themselves, showing total frontal and rear nudity.

"It just seemed natural for us," John explained later. "We're all naked, really."

The photographs—taken by Yoko and John themselves, using a remote control shutter release—conveyed an innocence. There were no fancy lights. The background showed the litter of the small apartment—discarded newspapers, piles of dirty laundry. They didn't even bother to brush their hair. The effect was not the least sensual or sexy.

Nonetheless, when John took the photographs into Apple and insisted upon their use, all hell broke loose. The other Beatles and most of the Apple staff were appalled, wondering aloud if John had finally lost his mind. And although the pictures were John's idea, some swore it was all Yoko's fault.

"Originally, I was going to record Yoko," John later told *Rolling Stone*, "and I thought that the best picture of her for an album would be her naked. I was just going to record her as an artist, we were only on those kind of terms then. So after that, when we got together, it just seemed natural for us, if we made an album together, for both of us to be naked.

"I know it won't be very comfortable walking around with all the lorry drivers whistling and that, but it'll all die. Next year it'll be nothing, like mini-skirts or bare tits, it isn't anything. We're all naked really. When people attack Yoko and me, we know they're paranoiac,

we don't worry too much. It's the ones that don't know and you know they don't know—they're just going around in a blue fuzz. The thing is, the album also says: look, lay off, will you? It's two people—what have we done?"

However harmless John's intentions, the printers usually employed by Apple wouldn't go near the photographs, and once a printer *was* found, EMI, the company that held the distribution rights to all Beatles material, absolutely refused to market it. And advertisements for the album, entitled *Unfinished Music No. 1: Two Virgins*, ironically, were turned away by all the leading pop music publications.

Finally, a small London company owned in part by the Who, Track Records, and an even smaller company in America, Tetragrammaton Records, owned in part by Bill Cosby, agreed to distribute the album—but in a plain brown wrapper.

As this was going on, John and Yoko were giving interviews freely, not just to promote *Two Virgins*, then set for release in November, but also the Beatles' "white album," set for distribution the same month. On the morning of October 18, Apple publicists were arranging a press conference with representatives of four of Britain's largest daily newspapers.

Several days earlier, one of the newspaper writers being asked to the press conference had called John to warn him of a raid on his house by narcotics detectives. It would be a cop named Pilcher, John was told. John knew the name: Detective Sergeant Norman Pilcher. He had been making a name for himself lately by arresting pop stars on drug charges. In recent weeks, Mick Jagger, Keith Richards, and Marianne Faithfull had been arrested.

Shortly after dawn, the telephone rang in the Montague Square flat. It was someone who identified himself as a member of the drug squad. He told John that the raid was set for ten that morning.

This sent Yoko and John into a flurry of housecleaning. When Pete Shotten arrived for an innocent visit, John was vacuuming the floor.

"You know what those cunts are like," John said. "They'll bust you if the fucking dog smells something in the rug. They'll Hoover up all the miniscule bits and put them under a microscope and bust you for it even if the stuff's been there for three years. Since fucking *Jimi Hendrix* used to live here, Christ knows what the *fuck* is in these carpets!"

Shotten left soon afterward, carrying the vacuum cleaner bag, and John returned to Yoko in their bed to await the fateful knock.

It was nearly noon when someone finally knocked on the door.

John opened it, and there stood Pilcher, six other uniformed policemen, a policewoman for Yoko, and two dogs on leashes.

In the hour that followed, the flat was torn apart as both humans and canines looked and sniffed for drugs. Finally, a small amount of cannabis resin was produced from a binoculars case.

Later, Yoko and John would insist that it had been "planted."

From the jail where they were taken, John called Derek Taylor at Apple Records. Moments later, Taylor hung up the phone and calmly informed his secretary that she was to cancel the press conference because the Lennons were unable to attend.

The Fleet Street press was hardly surprised. Many papers had been informed of the raid in advance. Consequently, the evening papers had been present at the flat, and that night ran pictures of Yoko leaving with John and being hurried into and out of the police station, where they were charged with possession of hashish and with obstructing police in the execution of a search warrant.

They were granted bail of £100 [$250] each, with a surety of another £100.

Only hours after being released, Yoko doubled over in pain and was rushed to Queen Charlotte Maternity Hospital, where she nearly miscarried and was given a series of blood transfusions. Doctors declared her in "fragile condition" and insisted she remain in bed in the hospital indefinitely.

The trauma brought Yoko and John closer, causing them to intensify their talk of marriage. John had married Cynthia when he had gotten her pregnant (with Julian), and his conventional views hadn't changed, no matter how much his life had.

But before they could marry, they each had to get divorced.

As it happened, the Lennon dissolution was imminent, and on November 8, Cynthia was granted a decree nisi, which was to become final six months later. Beatle watchers were startled by the settlement, only £100,000. In 1968, that represented nearly a quarter of a million dollars, a sum John was earning monthly.

The same week, Tony Cox gave an interview to the *Daily Sketch*, saying he would start his own divorce proceedings soon. In the meantime, he said, he was writing a book about extrasensory perception and planning an album of songs sung by Yoko, to be taken from personal tapes. When Yoko and John read that, they were furious, because John was Yoko's producer now. In fact, they were planning another album project and expected to begin recording before the

month was out even though Yoko was still in the hospital.

For several weeks before the arrest and Yoko's hospitalization, Tony had been negotiating with John, at first through Peter Brown and then with Beatle solicitors. Yoko had attended some of the meetings. Now, with Tony talking to the newspapers as if nothing had been talked about or agreed upon, Yoko and John insisted upon a quick settlement.

Of primary issue was the agreement between Yoko and Tony that gave Tony half of whatever she got from John. With Yoko and John talking about marriage, that could be interpreted as Yoko having access to millions and millions of pounds.

Although John's attorneys advised him that the paper Yoko had signed was worthless, telling him it never would survive a challenge in court, the wisest course seemed to be for John to "buy" the agreement back to avoid any unwanted publicity. Tony was deeply in debt, and a number of creditors were pressing him for payment.

Thus, about £40,000 [$100,000] in debts were paid, most of it back rent on the Hanover Gardens flat, unpaid film processing bills, and repayment of bank and personal loans.

John also moved Tony to the Virgin Islands, his next choice of residency, where it was further agreed that Yoko and Tony would obtain their divorce—with custody of their child to be shared.

As the days passed in the hospital, John remained at Yoko's side around-the-clock, at first sleeping in an adjacent bed, then on pillows on the floor when the bed was wheeled away for use by another patient. On November 21, Yoko and John were told that things had taken a turn for the worse, and she'd probably lose the baby.

John called Apple and had someone rush over with a Nagra tape recorder. With a stethoscope microphone, John recorded the last of the feeble heartbeats.

"Since the child was old enough to warrant a death certificate, they were asked to name it," Peter Brown wrote. "John called it John Ono Lennon II. He ordered a tiny coffin for him and had it buried in an undisclosed location without telling anyone but Yoko. That night at the hospital he cried himself to sleep on the floor at her bedside."

The next day's papers carried the news. Said the *Times*: "Yoko Ono, the Japanese artist and friend of John Lennon and the Beatles, has had a miscarriage in Queen Charlotte's Maternity Hospital. Mr. Lennon has said he was the father."

However genuinely shaken they were, they insisted upon carrying

on, and when an old classmate of Yoko's from Sarah Lawrence, Betty Rollin, arrived two days later, they presented a picture of determined high energy. Rollin was a senior editor of *Look* magazine and was invited to do some interviews.

"Totally absorbed," Rollin wrote, "Yoko sits up in bed, her fingers like little hammers tapping the typewriter keys. Newspaper clippings about her and John are spread across the bed. She is composing songs from them.

"John, meanwhile, is tearing about the room, slightly wild-eyed, looking for something, as usual. 'Where is it? Where is it?' he yelps, scrambling under the bed. In the background, a tape is spinning of Yoko singing some of her newspaper compositions. 'Where his girlfriend Yoooooko Ono was beeeeing kept under observation' croons the taped Yoko in a shrill monotone."

Soon they were back in Weybridge, where they discovered that Cynthia and her mother had cleared out nearly all of the furnishings as well as much of the wall-to-wall carpeting. Still, Yoko and John seemed oblivious to their surroundings, apparently not at all concerned about having to use the garden furniture in the living room, chatting openly with Betty Rollin, who was continuing her interview.

Rollin had had time to talk to some London artists about Yoko since she had seen her in the hospital, and she came away impressed. By now, however, Rollin was less than impressed by Yoko—in fact, Rollin distinctly disliked her.

"Maybe it's not art," Rollin wrote. "But whatever it is, it's creative; she has integrity about it; and, generally, I think far-out art or non-art stretches our awareness and, if nothing else, gives us a better perspective on what's far-in. Besides, it's great just to be silly sometimes, don't you think so? But the thing about Yoko is that when she's being silly, she doesn't think it's silly. Her boyfriend has infinitely more humor about what he does. Also, he's not pushing so hard, and that's not only because he's there. I doubt if he ever pushed. Actually, Yoko is pushy—ambitious is a nicer word—the way 20-year-old actresses are. But she is 34. John, by the way, is 28.

"Yoko is bossy too. She is bossy with the people in the Beatles' Apple office, and they resent it. And she is bossy with us. 'Say it *this* way,' she shrieked once, trying to dictate the story to her specifications."

On their final day together, Rollin caught Yoko alone preparing a meal. Yoko began the conversation by chastising Rollin for spilling

sugar on the tablecloth the day before. She hadn't cleaned it up, Yoko said.

An awkward silence followed. Finally, Yoko said, "We are really very difficult people."

Another awkward silence followed, and then Yoko told her former classmate about how her mother had ignored her as a child and had disowned her when she married a pianist from the middle class.

Rollin asked Yoko about her daughter. How did she feel about Kyoko living with Tony so far away?

"She says it must be," Rollin recalled in her article. "I ask her if she is not afraid of doing to her child what her parents have done to her. She reminds me that psychologists say that people usually treat their children the way they were treated [themselves].

"Then she tears a head of lettuce apart, washes it and dries it thoroughly."

Exactly one week after Rollin packed up her tape recorder and returned to New York, *Two Virgins* was distributed internationally. By now, the nude photographs on the album's cover had been in general circulation throughout London, appearing on the cover of *Private Eye* and not only on the cover of *Rolling Stone* but also inside that magazine with both front and back views reproduced on a fold-out poster. Within days, Yoko's deadpan smile and buxom figure were hanging on walls all over England and America.

At last, Yoko had taken her clothes off and the act had drawn an audience.

Press reaction was predictable. In a story headlined "That Picture—the Great Debate," *The People*, one of London's most sensationalistic newspapers, said that "scores of letters have poured into *The People* office indicating that however beautiful John and his girlfriend, Yoko Ono, may appear in their own eyes, the sight of their nude bodies on the sleeve of a record album was regarded as far from picturesque by the great majority of folk."

Another typical reaction came from the *Sunday Express*, whose columnists described the photographs as "hilariously awful" and "excessively uncharming." While the *News of the World* headlined, "Oh, oh, Yoko!"

Derek Taylor and his assistants in the Apple press office did their best to defend, but it was hopeless.

"Personally I see nothing wrong with the record sleeve or the disc," Derek said. "Nobody ever criticized Adam and Eve."

At the same time, new advertisements were designed. "It isn't a

trend or a trick—" the copy read, "it's just two of God's children singing and looking much as they were when they were born, only a little older."

All to no avail. "Whether he intended to or not," said *The People*, "John Lennon certainly proved something last week. That there is a limit, even for a Beatle."

"It seemed," said Anthony Fawcett, still a constant companion to Yoko, "that John was trying very hard to lose whatever following he still had left and that he would be the first rock and roll superstar to be destroyed by public ridicule."

So, too, the superstar's girlfriend, who was swept up in the onrushing tide of vitriol and given, perhaps forever, the role of villainess (even when they went to court on November 27 and John pleaded guilty to possession of the hashish that was found in their flat and Yoko's charges were dropped—thanks to John's guilty plea). By the end of the year, when Yoko and John dressed up as Mr. and Mrs. Santa Claus for the Apple Christmas party, it seemed that virtually everyone in the Christian world hated her, and that she was well on her way to becoming the most vilified woman on earth.

10

"Hey, Chink! Get Back!"

I N THE ICY WINTER MONTHS of December 1968 and January 1969, the winds of attack turned cruel. Beatle fans were now calling out at her as she alighted at the Apple offices with John.

"Nip!" cried one.

"Get back to your own country!"

Another called, "Hey, Chink!"

Still another gave Yoko some roses, stems first so that she would scratch her hands as she took the gift.

Inside the Apple offices, executives and assistants alike were exchanging Yoko stories on a daily basis.

Pete Shotten, who had been sleeping under the same roof when Yoko and John first made love, and who went shopping for a house for them, was by now telling lots of stories.

One was about the house hunt. He found one John adored, he said, but when Yoko said she hated it, John buckled. Shotten also talked about a trip to the island off the coast of Ireland that John owned. In an odd set of circumstances, Shotten and Yoko and John found themselves temporarily stranded on the windblown island, huddled together in the psychedelically painted caravan that John had flown in by helicopter some months before. Shotten thought it funny for a Beatle to be so situated and he started to laugh. John got the giggles, too, but they were both silenced when Yoko said, "Well, *I* don't think it's funny!"

When Shotten assisted John in vacuuming the Montague Square flat the morning of the arrest, he said, Yoko remained behind closed doors in the bedroom and every time John went to her, she began screaming that she didn't want Shotten there.

"We can handle this ourselves, John!" she told him. "We don't *need* him around. I don't *want* him around!"

Peter Brown told stories, too. One concerned the Apple boutique the night before it closed. Yoko was not the only one to help herself to the stock, but the way Brown told the tale, she appeared the greediest when she spread a large swatch of fabric on the floor and piled merchandise onto it waist-high. Then, Brown said, she knotted together the corners of the fabric and dragged the huge bundle out of the store on her back "like an Oriental Santa Claus" and into John's Rolls-Royce.

And, yes, says another Apple executive, it's true, Yoko did treat everyone as if they were servants. "She said, 'There's only rich men and rich men's chauffeurs in this life. John is a rich man and anyone who works for him is his chauffeur. That's how it is.' I found that very difficult. I never felt like a chauffeur. I found that to be a most disagreeable point of view."

Feelings were also harsh among the other Beatles, all of whom were, in January 1969, trying to record still another album. This was tentatively called *Get Back*, later renamed *Let It Be*. The assorted pressures and tensions already felt by the four musicians were now complicated by the decision to have the recording sessions filmed as a documentary.

This meant they had to move into a vast, drafty sound stage at Twickenham Film Studios. Environment has a lot to do with recording ease and creativity and this was a distant cry from the warm familiarity of Abbey Road. The 8:00 A.M. calls to accommodate the cameramen added more pressure—but not as much as Yoko did. If the other Beatles bristled at her presence during the "white album" sessions, this time they barked and growled.

John said it all: "You sit through sixty sessions with the most big-headed, uptight people on earth and see what it's fuckin' like, and be insulted by [these people] just because you love someone. And George, shit, insulted her right to her face in the Apple office at the beginning. Just being 'straight-forward', you know—that game of 'Well, I'm going to be upfront because this is what we've heard. And Dylan and a few people said she'd got a lousy name in New York, and you give off bad vibes.'

"That's what George said to her and we both sat through it, and I didn't hit him, I don't know why, but I was always hoping that they would come around. I couldn't believe it, you know. And they all sat there with their wives, like a fucking jury. And judged us. Ringo was alright. So was [Ringo's wife] Maureen, but the others really gave it to us."

Probably the unkindest cut was delivered by Paul, who put his feelings about Yoko into a song. Paul always said that "Get Back" was about his desire for the Beatles to "get back" to their musical roots in rock and roll. He had, in fact, urged the others to go back on the road once the new album was in release. (They said no, and that's when the documentary was planned.) Nonetheless, there was more than a looking back in this song. When Paul sang the exuberant chorus in the studio—"Get back! Get back! Get back to where you once belonged!"—he looked right into Yoko's eyes.

Sometimes the boys tried to make the best of it for the cameras, joking to keep it light. John even danced with Yoko at one point, waltzing around and around the stage like hairy, white-wardrobed versions of Ginger Rogers and Fred Astaire.

The truth was, the Beatles as a group were history. John, George, and Paul all felt as if they were members of a backup band whenever it was the other's song. They snapped and quarreled—sometimes while the cameras were rolling—and before the ten days of filming and recording were over, both George and Ringo had angrily quit and rejoined the group.

Finally, the Beatles took refuge from the movie studio and were followed by the camera crew onto the Apple roof, overlooking London's Savile Row. There they played what turned out to be their last concert together. Yoko stood stolidly, on-camera, nearby.

☐

Yoko carried on, as the British say. She had survived the bitchy avant-garde art world in New York, after all, and this was no worse than that. The way Yoko saw it, she was *never* appreciated. So what else was new? The only difference now was that the people who didn't appreciate her were international celebrities. Beatles. And that, in a wonderfully perverse way, made Yoko Ono an international celebrity, too.

"There was already a lot going against Yoko Ono when she walked into the goldfish bowl," said Richard DiLello (Derek Taylor's assistant). "She was overeducated, spoke several languages, was highly

proficient in the culinary arts, and a writer of verse and creator of sculpture. She was well versed in history and a survivor of the New York avant-garde scrap race. She was also an older woman and Japanese. Somehow she managed to carry it all with ease, as she did her hair, as part of the terrain."

As far back as her miscarriage, she and John were showing a willingness to laugh in the face of adversity or, if not laugh, at least turn "defeat" into concept art. One of their visitors at the time Yoko was hospitalized was John Kosh, who was called from his job at the Royal Opera House where he worked as a graphic artist. Kosh was asked to design a book that would include some of the more extreme hate mail that was still pouring into the Apple offices.

"The mail was so ludicrous, so spiteful, you couldn't take it seriously," Kosh recalls today. "She was being blamed for World War Two and the death of British soldiers."

Kosh was also asked to design and supervise the assembly of an "Aspen Arts Box" for the Aspen Arts Society in America. This was a cardboard box of works by several artists that could be reproduced and distributed to the society's membership. Yoko and John's contribution was a recording of the baby's final heartbeats.

Yoko made the same tape available elsewhere, too—first offering it to a young magazine publisher to include stapled into his monthly as a floppy disc, and later on the second John Lennon and Yoko Ono album, called *Unfinished Music No. 2: Life with the Lions* (the title being a parody of a popular British television series, "Life with the Lyons").

Through the winter of 1968–69, Yoko's projects piled up like cordwood. In December, she and John appeared at the Royal Albert Hall, huddled together on stage in a bag, part of the London underground's "Alchemical Wedding." They also sang "Yer Blues" together on a Rolling Stones television special and, most important, plunged deeper into their filmmaking.

John's friends were much surprised by the depth of his commitment in this area. Whereas once he said avant-garde was "French for bullshit," he now seemed not just willing but eager to take an active role in producing avant-garde films.

Yoko was calling her scripts "scores" by now, and in 1968, she assembled more than a dozen. One proposed making a film about "Mr. So . . . from cradle to grave," to be filmed over a period of sixty years. Another suggested distributing copies of a film to many directors, having each reedit his or her print without leaving anything out;

the idea was then to show all the versions together omnibus style.

Another, written during a time when Yoko and Tony were estranged, was designed to last ninety minutes and do no more than show a man and a woman lying in bed together with their four-year-old child (Kyoko). "All they do is just sleep," Yoko wrote, "and the 366 sexual positions are all in the mind of the audience." Her instructions for the soundtrack showed some of the torment she felt. It consisted, she said, of conversations between "a couple who are about to split, whimpering of a child, whispers, sighs and love groans."

Another idea rooted in personal experience was called *Woman* and was to document the last six months of a pregnancy. This was to be realistic, not romantic, Yoko explained, because she didn't want women thinking there was anything glamorous about having a baby. Too many women became disillusioned and ended up hating the child, she said, and she wanted to "eliminate such tragedy in the world."

Still another was to have presented a "peculiar mixture" of a Japanese tea ceremony and an English tea party, with the only person in the film "a Japanese woman with very good breasts."

There were many more, and in January, she and John commissioned a young film crew in Austria to make one of them, provocatively entitled *Rape*. This showed a cameraman following an innocent young girl picked up randomly from the Vienna streets, pursuing her relentlessly and without explanation for three days. Some felt that this was a metaphor for the way the media treated Yoko and John.

If Yoko and John did feel "raped" by the hungry media, they did little to discourage the assault. Much of the controversy they brought on themselves as they continued to screen their early films—*Bottoms* went into a small theater in London in December; about the same time "*Film No. 5*," or *Smile*, was premiered at a film festival in Chicago—and engaged the media in open and acrimonious debate over the nude album cover and the "value" of the music within.

A few reviewers were courteous, even flattering—among them Jonathan Cott, one of *Rolling Stone* magazine's more intelligent writers. He used such phrases as "self-realized" and "a contemporary music classic" to describe it, compared the work to that of Cage, Bartok, and Ravel, and talked about "the clear unravelling of multiple threads of beautiful sounds always joining, never tangled."

But not everyone agreed with him. Most thought the album was pretentious and boring. London's *Evening News* was typical, calling it an "electronic dirge . . . shapeless, tuneless, toneless," headlining the

terse review, "That Record Is Just a Rotten Apple." Many publications didn't even review the music at all, preferring, instead, to dwell upon the controversy. Even the *International Times*, London's usually sympathetic underground, headlined an interview with John, "Total Freedom Project 'B': Being a Conversation with John Lennon's Prick on the State of Meat."

Other publications echoed the same myopic view. An article called "Shock It to Me" that appeared in America's *Teen* magazine said, "Nudity is not new. Nudity is not crudity. Nudity is not interesting."

Billboard, the bible of the music industry, went even further, closing an editorial with the edict: "Moral standards may change, but standards of good taste should be inflexible."

Headlined the *National Observer*: "Plain Wrapper or Not, Record Too Hot to Handle."

And so it was throughout much of the Western world as virtually everyone in the media covered the controversy. In New Jersey, nearly 30,000 covers were seized at Newark International Airport and denied entry into the United States. Elsewhere, it was being sold from under the counter, or not at all, because of the frequency of obscenity arrests in several communities. In a survey conducted by the *Observer*, in fact, it was apparent that "few major record stores outside New York City are willing to handle the album."

Yoko later explained how she handled the constant attack, describing her defense, or philosophy, as "the secret of energy and the secret of life."

"It's like the three pots with seeds in them," she said, referring to a well-known parable. "One was watered with love, one was watered with hatred, and one was watered without love and without hatred, without any energy. Which one do you think survived the most? The ones with love and hatred survived the same. No matter what kind of energy you give, it thrives. The one with no energy died, but love and hatred survived the same.

"You see, when all that hate energy was focused on me, it was transformed into a fantastic energy. It was supporting me. If you are centered and you can transform all this energy that comes in, it will help you. If you believe it is going to kill you, it will kill you."

☐

The Beatles continued their dangerous drift, and while they battled in the studio over *Let It Be*, they were also divided over a choice of a new manager.

Ever since Brian Epstein died in 1967, the four musicians had run their own business, and by January 1969, the venture was proving to be an enormous headache as well as a significant failure. The Apple boutique had collapsed. An expensive basement studio was unusable, and commissioned inventions became expensive dreams. Many of the new artists signed by Apple Records failed to get any hits, and from Apple's point of view, *Two Virgins* was little more than an embarrassment. Not even the experienced friends the Beatles had installed in the Apple executive offices could stem the outward flow of cash.

"If Apple goes on losing money at this rate," John told several magazines, "we'll be broke in six months."

Finally, it was decided to seek outside help. The trouble was, the Beatles couldn't agree on who should provide the desperately needed guidance.

After several false starts and declined offers, Paul McCartney concluded that the solution lay directly under his nose. A few months earlier, he had begun dating an American photographer, Linda Eastman, whose father was a lawyer with a substantial reputation in New York. Lee Eastman even had experience in the music business, including work with bandleader Tommy Dorsey. But the other Beatles rejected Eastman when he declined to attend a first meeting and sent his son, Linda's brother, John, instead. Unlike Linda, who was down-to-earth and a bit of a "raver," John Eastman reeked of conservatism and old money, which alienated the other three.

They went, instead, for another New Yorker, a tough bulldog of an accountant named Allen Klein. When he saw John's fears about being broke in six months spread all over the pages of an American rock paper in January, he flew instantly to London, checked into the Dorchester Hotel, and called John, inviting him and Yoko to talk.

Klein was a master of the hard sell and a genuine Beatle fan. He also had managed rock singers going back to the great Sam Cooke, and for the past two years had been taking care of the books for the Rolling Stones. He knew the Beatle song catalog intimately and was able to recite lyrics at will—and in his intense pitch, he recited several to prove it. He promised he would negotiate a new royalty contract with EMI with a huge cash advance that would solve their money problems and told Yoko that he would get her a million-dollar advance from United Artists for the films she was making. And what did he want in return? Only a percentage of whatever money they earned as a direct result of his efforts.

Yoko and John were "snowed," and at the end of the meeting, John

dictated a note to Sir Joseph Lockwood, chairman of EMI. Yoko dutifully typed out his words: "Dear Joe, from now on, Allen Klein handles all my stuff. . . ."

Yoko was present again a few days later when Klein made his pitch to George and Ringo, quickly winning their commitment and loyalty as well.

Paul refused to accept Klein under any circumstances. Paul already had the legal representation he wanted in his future brother- and father-in-law. To Paul, they represented the cultured side of New York—well-spoken, well-dressed, and well-off.

Allen Klein, on the other hand, represented the coarse underside of New York, where *chutzpah* (Yiddish for bravado verging on arrogance) and a lot of yelling prevailed. For Paul to have picked Klein over the Eastmans would have been comparable to seeing John Kennedy pick as attorney general not his brother Bobby but some lawyer who made his living chasing ambulances.

Initially, Linda told Yoko that she supported her being next to John all the time, in recording sessions and business meetings, wherever *she* felt she belonged. But soon she adopted Paul's point of view, and Paul didn't like Yoko.

In a way, it was probably inevitable that Yoko and Linda would have a falling-out. John and Paul had been "married" for many years to their music. Now Linda was taking Paul away from John, and Yoko was taking John away from Paul. It was unlikely under such circumstances that Yoko and Linda could ever have remained friends for long. Perhaps when it finally came time for John and Paul to end their collaboration, Allen Klein was a convenient excuse.

"She was all right and we were on very good terms," Yoko said later, "until Allen Klein came to visit. She said, 'Why the hell do you have to bring Allen into it?' She said very nasty things about Allen. I protected Allen each time she said something about him and since then she never speaks to me."

Yoko was never one to cultivate "girlfriends" anyway, preferring the company of men and, in particular, the company of John alone. So the big events in her life remained those she shared with him, especially the ones where he drifted even further from the Beatles and entered her world of avant-garde music and art.

In March, Yoko was invited to participate in a concert at Lady Mitchell Hall in Cambridge. As Anthony Fawcett remembered it, the Sunday afternoon opened with a dozen jazz musicians from all over Europe making a "three-hour assault on the audience, in a gigantic

improvisational session. Then John and Yoko, who had been waiting in the wings, strolled out to meet the audience."

Not even the promoters of the concert had expected John. When Yoko was invited, she was asked if she would bring a band.

"They didn't realize that we were together," she explained later. "They were saying, 'Well, are you going to bring a band?' So John said, 'I'm the band, but don't tell them.' So I said, 'Yes, I'll bring a band with me.'"

Yoko called her old friend John Stevens, the American drummer she'd sung with during her performance at the Royal Albert Hall with the noted American jazz saxophonist Ornette Coleman, and he brought Danish saxophonist John Tchcai, a former Coltrane sideman.

The reviews were harsher than the sounds Yoko made. Even the local Cambridge newspaper was cruel, saying: "Miss Ono began with a fearsome siren note, as Japanese as a Noh Play Chant, and sustained it to the point of self-torture. Lennon was squatting at her feet, back to the audience, holding, shaking, swinging electric guitars right up against a large speaker, or hitting the instrument against the speaker, to create ear-splitting feedbacks. . . ."

John later tried to explain. "What she'd done for the guitar playing was to free it the way she'd freed her voice from all the restrictions," he said. "I was always thinking, 'Well, I can't quite play like Eric [Clapton] or George [Harrison] or B. B. King.' But then I gave up trying to play like that and just played whatever I could, whatever way I could, to match it to her voice."

Ten days later there was astonishing Beatle news: on March 12, almost simultaneously, George Harrison and his wife, Patti, were arrested for marijuana possession and Paul McCartney and Linda Eastman were married in a private ceremony to which none of the other Beatles were invited.

The marriage created headlines internationally, of course, and according to Yoko and John's friends, this doubled their own resolve to marry as soon as possible. But they weren't planning a quiet civil ceremony. They wanted to get the Archbishop of Canterbury to marry them, and then, they told friends, they were going to stage history's most public honeymoon.

11

Yoko Lennon's Peace Piece

THE ARCHBISHOP declined to officiate at what could have been one of the most unusual pairings in his long career. Some say he objected to the fact that both Yoko and John were divorced. Others insisted that although he merely said his schedule was too crowded, the truth was that he didn't want any part of what surely would be a circus.

Initially, it promised to be a one-ring circus, as Yoko and John searched for an alternative to the archbishop that would be simple yet offbeat.

Their next choice was to marry on the car ferry between England and France, but they were not allowed, and they were no more successful with cruise ships. They tried various embassies, but three weeks' residence was required in Germany and France.

They settled on Gibraltar, a British protectorate, when Peter Brown learned that they could be married there without legal delay. Brown chartered a plane and arranged to greet them when they arrived. With him was a photographer named David Nutter. Yoko and John arrived at 8:30 A.M. and half an hour later were at the British consul's office.

The ceremony itself was the epitome of casual simplicity. Yoko and John were dressed in white—he in a sweater, jacket, and rumpled slacks; she in a mini-dress, a wide-brimmed hat, and knee socks. All

through the three-minute ceremony she wore sunglasses and he held a burning cigarette. Both were wearing tennis shoes.

The newlyweds posed for pictures on the steps of the consulate, and soon afterward they were flying to Paris, then to Amsterdam where, they told Nutter and Brown, they were going to spend their honeymoon in bed for peace.

"For peace?"

"For peace," said John. "Will you see that the press is invited."

"The press?"

"The press. Tell 'em we'll be in bed waiting for them."

Now the one-ring circus was elevated to spectacle, or, according to those who disapproved, lowered to garish carnival.

John's fans were marching back and forth in front of the Apple offices carrying black-bordered signs proclaiming, "John—No! No!," a reaction to his sudden marriage, when the newlyweds began lettering their own signs, which they stuck to walls around their bed in a room at the Amsterdam Hilton Hotel.

"Hair Peace," said one, "Bed Peace," another. The world's press came flocking, and John explained, "What we want is for people to stay in bed or grow their hair instead of getting involved in violence. Hair is nice. Hair is peaceful."

Yoko smiled benignly and added, "Remove your pants before resorting to violence."

Many of those who came to Yoko's bedside expected some sort of naked love-in, or at the very least a bit of nudity. But no, Yoko and John were covered up, wearing white pajamas over underwear, pulling the bedclothes to their waists.

From an outsider's point of view, it was a zoo. Here, in a large £100-a-day ($250) room, they sat in bed, holding court, the king and queen of pop, flashbulbs exploding, writers competing for something a little juicy, cameras filming virtually everything.

The coverage was massive and frivolous. A headline read, "John and Yoko Are Forced Out of Bed by Maria the Maid." What that meant it didn't matter. The tone was set.

"Do you really think this is a significant form of protest?" one of the reporters asked.

"It attracted all of you here, didn't it?" John replied.

Another asked Yoko, "Aren't you afraid of being viewed by the world as ridiculous?"

"The worst thing that can happen is giving everybody a laugh,"

she said. "And it's good to laugh, too. Because the ones to make war don't know what laughter is."

"But what about the fascists?" another reporter asked. "How can you have peace when you've got a Hitler?"

Yoko said, "I would've gone to bed with him. In ten days I'd've changed his mind."

The establishment press was amused but also outraged by the "bed-in," particularly the London press, which published a torrent of abuse. "This must rank as the most self-indulgent demonstration of all time," one columnist wrote. While the *Sunday Express*—by now Yoko and John's least favorite rag—said, "Beatle Lennon and his charmer Yoko have now established themselves as the outstanding nut cases of the world."

For seven days, Yoko and John remained in the double bed, eating brown rice and undercooked vegetables, smoking cigarettes, and talking ten hours a day nonstop.

The bed-in ended on March 30, and a day later Yoko and John were in Vienna for another puzzling, public event. Here, they slipped into a black bag together and held a press conference in Sacher's Hotel, formerly the Hapsburg Palace. This was followed by a premiere on Austrian television of their film *Rape*. And *that* was followed by a memorable telephone call to London. Upon their return on June 1, they said, they wanted one hundred acorns.

Derek Taylor was aghast. "One hundred acorns?"

"Shouldn't be very much trouble," John said. "They won't take up much room in the office."

"What . . . what do you want them for, John?"

"We'll be sending them to world leaders to plant for peace."

"Yes, of course, John. Is there anything else?"

"Just one thing. We'll also need home addresses for the hundred world leaders."

John said he and Yoko wanted the acorns to be in hand the following day, and for Taylor and his staff to arrange a press conference at London's Heathrow Airport. They wanted to show the press the acorns when they announced the "Acorns for Peace" campaign.

"Good Lord, man!" Derek said to his office staff when he hung up the phone. "This is March. Don't John and Yoko know that acorns come in the fall?"

Taylor had several large oak trees in his garden, and the next morning he and his children managed to find a handful, and then on

the way in to work, he stopped along the A-30 where there were many other large, old oaks. Still, he was far short of the number needed and decided, on his own, to show up with only two, the number John said would be sent to each world leader. (The second acorn in case the first one failed to germinate.) Meanwhile, everyone at Apple not committed to "life-and-death duty," was reassigned to round up home addresses for Halie Selassie, Richard Nixon, Chou En-lai, and all the rest on the growing leader list.

Yoko and John entered the Heathrow press room to an explosion of lights and questions. They were asked about their diet and the clothes they wore and where they planned to live. Finally, the talk turned to peace and what they thought they'd accomplished in Amsterdam.

Wasn't it, said one, just a big put-on?

Yoko jabbed John in the ribs, signaling him, angrily, to let the rude reporter have it. John kept his agile tongue in check and said, "We're not laughing at you any more than you're laughing at us. The way we look at it is this: In Paris, the Vietnam peace talks have got about as far as sorting out the shape of the table they're going to sit around. Those talks have been going on for months. In one week in bed we achieved a lot more. What? A little old lady from Wigan or Hull wrote to the *Daily Mirror* asking if they could put Yoko and myself on the front page more often. She said she hadn't laughed so much for ages."

At the press conference, Derek Taylor handed John a glassine envelope containing the acorns and John explained what he and Yoko were going to do with them. For a long moment there was absolute silence as the press tried to determine whether or not *this* was a put-on. Finally one of them set the mood for all that was to follow and asked, "Will they go fourpenny or fivepenny post?"

"Air mail," John shouted back. "Peace can't wait."

Later, John said, "Yoko and I are quite willing to be the world's clowns if by so doing it will do some good. I know I'm one of these 'famous personalities.' For reasons only known to themselves, people do print what I say. And I'm saying peace. We're not pointing a finger at anybody. There are no good guys and bad guys. The struggle is in the mind. We must bury our own monsters and stop condemning people. We are all Christ and we are all Hitler. *We* want Christ to win. We're trying to make Christ's message contemporary. What would He have done if He had advertisements, records, films, TV and newspapers? Christ made miracles to tell his message. Well, the miracle today is communications, so let's use it."

It was inevitable and irrevocable that John find himself at the center of the peace campaign. This didn't mean Yoko wasn't at the heart of it, too. In fact, John later said, the bed-in was entirely her idea and so, too, was the humorous approach in nearly everything that followed.

Even so, John was the more political of the two animals, as demonstrated by his participation in the antiwar film *How I Won the War*, in his public anti-Vietnam statements, and in his exchange of impassioned letters about "revolution," which were published in the *Black Dwarf*, a Socialist newspaper published in Britain. In fact, Yoko generally ignored politics before meeting John. Once she was introduced to the subject, however, she knew precisely what to do with it. One easily could've imagined finding the events she staged with John in *Grapefruit*, headlined "Bed Piece" and "Acorn Piece."

The Apple offices were in a constant state of bedlam. As Derek Taylor put it, "Apple is the most famous place in town, because if you've just stepped off a plane from New York or L.A. or San Francisco, curiosity demands that you come here even if you invariably get the runaround." Taylor overlooked the Tower of London, Piccadilly Circus, and Buckingham Palace in his sweeping generalization, but he wasn't far off. The crowds still formed to watch the changing of the guards at the palace, but so, too, did they form at 72 Savile Row.

For those inside the Apple offices, the chaos was intensified by the ongoing power struggles. While Yoko and John were in Amsterdam, it was announced that the Beatles' old friend, Dick James, who controlled thirty-seven percent of the group's music publishing, was selling out to Sir Lew Grade without so much as a warning. Grade, known primarily for his commercial television channel ATV, already owned thirty-five percent. John and Paul were horrified at the thought of Grade becoming the majority owner and countered Grade's offer to buy their 159 songs with money of their own.

Allen Klein was in the middle, of course, as he began to take up the Beatle reins, although he still didn't represent Paul. The first two weeks of April, Yoko and John and Klein visited Ansbacher's, the banking firm, to discuss financing arrangements for the counterbid. Even if John was still making statements about how broke he and Apple were, the Beatles seemed a good risk; *New Musical Express* reported in April that Apple world sales reached £1.4 million ($3 million) the first four months of the year. Nonetheless, Klein couldn't find a bank to top Grade's offer. The Beatles then made an offer to buy only a portion of the available shares—just enough to bump their

present ownership to a majority. This would cost them less, only £2 million, a sum they *knew* they could borrow.

The meetings went on for over a month, into the middle of May, and Yoko was present at most of them. Her friends say that this is when she began to develop her business acumen.

"She is a great watcher," says one friend. "She sits quietly, doing her Japanese geisha act, hands folded on her lap, just listening. And she remembers *everything*. All those early months with John, she listened and she learned. She watched Klein, the street fighter from New York, and she watched the smooth gray heads who wore bowlers and three-piece suits. She became an expert negotiator and businesswoman by watching some of the world's most high-powered high-rollers show her how it was done. Nobody, not even the Harvard Business School, could provide that kind of education."

As negotiations with various banks and entertainment organizations and individual stockholders continued, as Derek Taylor and his staff scrambled for acorns, and as the millions of dollars and pounds came pouring in with generally ecstatic reviews of the "white album," Yoko and John continued to proclaim their love, releasing three recordings within a month.

The first was *Unfinished Music No. 2: Life with the Lions*, which included Yoko singing "No Bed for Beatle John," Yoko's quasi-musical recitations of newspaper stories, the dying infant's heartbeats, and an entire side of Yoko's "voice modulation" ("some people call it screaming," John said) and John's guitar feedback recorded at the avant-garde concert in Cambridge shortly before they married.

The cover photographs, showing a forlorn John lying on the floor next to Yoko in her hospital room on one side, Yoko huddled under John's arm the day of their court appearance on the other, did little to make the package attractive, and, once again, the press reaction was unflattering.

"A sad endurance test," said *Disc and Music Echo*. Added the *New Musical Express*: "If you adore the sound of a baby who won't stop crying, this is for you. It sounds as if some dreadful torture is being performed on Yoko and John is recording her vocal protests."

The second recording was the *Wedding Album*, a two-record set whose highlights included a "song" called "John and Yoko," in which the newlyweds repeated each other's names over and over and over again, and some randomly recorded conversations and monologues from the marathon bed-in in Amsterdam.

The packaging for this album was elaborate, as once again Yoko

and John called in John Kosh. Kosh, who was now Apple's art director, remembers they wanted the records included in a box of wedding memorabilia.

"They wanted to include a piece of the cake," he says today, "but we had to settle for a photograph, plus some photos from the wedding itself, a strip of those pictures you take in an arcade machine, a copy of the marriage certificate, and a doily. I suggested they include a jigsaw puzzle of the *Two Virgins* picture, where the piece with John's cock fit where Yoko's vagina was and the piece with her vagina fit where John's cock should be. EMI refused to approve it."

By far the most accessible record was a song that John quickly wrote after their return from Amsterdam. This was "The Ballad of John and Yoko," a chronicle of their recent events, sung to a rock and roll beat and ending with the phrase, "Christ, you know it ain't easy." John wanted it to be the next Beatles single, but was in such a hurry to record, he could find only Paul McCartney. John played piano and Yoko sat peacefully under it.

The same day the song was recorded, April 22, John changed his name from John Winston Lennon to John Ono Lennon in a brief but official ceremony on the Apple roof.

"Yoko changed hers for me," John said after taking the oath and having his picture taken with Yoko (both were dressed all in black). "I've changed mine for her. One for both, both for each other. She has a ring. I have a ring. It gives us nine O's between us, which is good luck. Ten would not be good luck. Three names is enough for anyone. Four would be greedy."

Yoko stood nearby, left hand on her hip, a satisfied, almost regal look on her face.

With the coming of May, there were dozens of new projects planned. Every day, it seemed, Yoko and John had another couple of dozen to announce, most involving the promotion of world peace. For this activity, they decided, they needed an office and appropriated the big ground floor space normally occupied by Ron Kass, the Apple music publishing executive from America who was then on vacation. (When Kass returned he was one of several fired by Allen Klein in a house-cleaning operation that reduced the payroll by nearly a fourth. Klein was securely in place by now, even though it seemed that the Beatles eventually would lose Apple to Lew Grade.)

Pictures and posters went up on the walls. Desks and chairs and big tables were moved in to hold the gathering literature and to provide work space for the first of several planned big mailings. Finally,

Derek Taylor's staff had accumulated a sufficient number of acorns—resorting to buying the last of them "from a very expensive dealer." Now they had to go into special boxes that Yoko designed.

At the same time, Yoko and John grew increasingly unhappy with the space at Weybridge house. This was, after all, John and Cynthia's home. Yoko wanted something of her own and she wanted something nicer. Finally, in mid-May, they bought their first home, Tittenhurst Park, a stately Georgian mansion near Ascot costing £150,000 ($370,000). It was situated on 74 acres containing fifty varieties of trees, the legacy of the original owner whose wife was a horticulturist.

There were seven main bedrooms, three reception rooms, three bathrooms, large kitchen regions, and extensive staff quarters, as well as several small guest cottages. Although there were no walls or fences around the property, the house was distant enough from the road to promise quiet and privacy.

Yoko loved the place, but thought it needed a lake. John said they'd put one in.

But first they had another major event to stage, another bed-in for peace—this one in America. John applied for a visa and, with Yoko, made plans to sail on the *Queen Elizabeth II*, on which Ringo was making a film with Peter Sellers, *The Magic Christian*. Yoko and John were to be in some of the scenes filmed en route. Ringo was taking his wife, Maureen, and George and Patti Harrison were also planning to make the trip. It was squarely aimed at being fun.

John's application for a visa was denied without explanation, and the others sailed without him and Yoko. Derek Taylor and his wife, Joan, were among those on the trip. They told Yoko and John they'd get more information in New York and then return with alternate bed-in plans.

The Taylors returned in under a week with news that John's visa request had been denied because of his drug conviction. There was no appeal process possible, they told the Lennons. However, they could, if they wished, go to the Bahamas—part of the British Commonwealth, thus John couldn't be denied entry—and beam their message to America by radio and conveniently fly in the American press for interviews.

Once Yoko and John and their entourage arrived in the islands, however, this plan also collapsed. New York, the center of American media, was still more than a thousand miles away. Worse, the beds in the only available hotel rooms were single beds cemented to the floor more than 18 inches apart. Yoko and John were appalled. So once

again they loaded twenty-six pieces of luggage into a plane; this time they flew to Canada.

John and Yoko were detained at the airport in Toronto as customs officials searched their bags—spilling press releases and acorns everywhere at one point—and fussed over whether or not John could be admitted because of the hashish conviction. Finally, he was given a ten-day visa, almost an insult—most visitors to Canada from the U.K. were given at least ninety days matter-of-factly—and after spending a single night in Toronto while Allen Klein made a futile last-ditch effort to get them admitted to the U.S., they flew on to Montreal.

"In Montreal we took on the world," remembers one of those in the entourage. "Berkeley was an armed camp. Students were getting shot in the streets in a confrontation over a People's Park, and one of the first things John and Yoko wanted to do was call Berkeley. We found a big room in the Queen Elizabeth Hotel, and what happened next made Amsterdam seem like a small rehearsal."

For ten days the Lennons entertained hundreds of reporters and photographers and called radio stations all over North America, giving interviews to anyone who asked and to many who didn't (sometimes surprising disc jockeys by calling them on the air). At the same time, the American political left checked in with them. Calls came from Norman Mailer, activist Allard Lowenstein, and Senator Ted Kennedy.

They also had several prominent visitors to their hotel room, and on June 1 had gathered around them a full and impressive panel of prominent New Age liberals.

In one corner was Tommy Smothers, the funny, left-leaning folksinger whose popular American television show had broken so much new ground politically, satirically, and musically.

In another beamed Allen Ginsberg, the hairy poet laureate of the Beat Generation who more or less emceed San Francisco's Love-In four years earlier, thus also becoming a spokesman for the hippie generation.

Sitting at the end of the bed was Timothy Leary, the former Harvard professor whose psychedelic crusade had propelled him onto as many front pages as John and Yoko.

Dancing around the bed were a handful of Hare Krishna devotees.

It had the appearance of a "hip Appalachia," except where in the original Appalachia meeting Mafia dons had gathered to plan and plot, now a cross section of the New Left had assembled to sing.

12
Cold
Turkey

"ALL WE ARE SAYING," the hotel room full of "freaks" and friends sang over and over again, "is give peace a chance!"

The song was recorded on June 1, and the tapes were flown to London the following day; the day after that, Yoko and John flew to Toronto to get their visa extended. Permission to be in Canada, granted on entry, ran out that day, and the Canadian Customs Service was quick to deny a renewal. It was time, the customs man said, for the circus to leave town.

When the couple returned to their London office another room full of derisive press cuttings and hate mail awaited them. Regarding their Canadian bed-in, everyone battered away, including *Private Eye*, whose writers were now calling Yoko "Okay Yoni," the surname a not-very-subtle use of the Indian word from the *Kama Sutra* for vagina: "While photographers snapped the happy couple, Mr. Topes [John] snapped, 'We are just two people in bed. If President Nixon and Mao Tse Tung did the same, they would be guilty of an offence under international law.'

"Mrs. Topes [Yoko] then danced about with nothing on, symbolizing the liberty of the individual."

If that weren't enough, Betty Rollin's *Look* magazine story had been serialized in one of London's large-circulation daily newspapers. The Lennons had only been vaguely aware of the story when it was published in the U.S., although some copies of *Look* regularly reached English readers, and tearsheets had been made available.

Now, for several days, the story was pasted all over an English newspaper with a circulation of more than 4 million. The miscarriage

and its aftermath, Rollin calling Yoko "bossy," all of it was rerun like an old television show. And Yoko was incensed.

□

After reading the mail and press, Yoko and John left their business in Anthony Fawcett's hands and escaped on a driving vacation through Scotland with their children. Even though John was not an experienced driver—he had left that for chauffeurs and friends for many years now and had never driven much anyway—he insisted upon driving the entire way from London, the four of them and their luggage packed into a small Austin Mini.

A larger car, an Austin Maxi, was delivered to the Lennons on the third day of the vacation, and the next day John apparently was chattering away, not paying any attention to the road, when a curve came up and he drove straight into a deep ditch.

The car was destroyed, although it remained upright. Ambulances arrived and all four were taken to a hospital in Glasgow. John was the most severely gashed and received seventeen stitches. Yoko received fourteen; Kyoko, four.

Yoko also severely wrenched her back and when a television crew arrived to film a prearranged interview, she and John turned them away. Leaving the hospital, they then moved in with some of John's family in nearby Liverpool for a couple of days, finally returning to London by chartered plane on August 6.

The car, meanwhile, had been crushed into a cube and was returned to London by rail, where it was ceremoniously placed in the Lennon garden as a piece of sculpture. This was Yoko's idea and John loved it.

The accident had caused Yoko and John to miss a press conference scheduled for July 3 to introduce the single "Give Peace a Chance." That same day, Rolling Stone Brian Jones was found dead at the bottom of his swimming pool. A pall hung over the press party, which Apple had decided to hold anyway, and after the song had been played over and over and over again, by eight o'clock in the evening, the last guest had wandered away.

The gloomy mood of the party reflected what was happening to the Beatles empire. It was collapsing despite all evidence to the contrary. The records were selling and the royalties were rolling in relatively undiminished, but the Apple concept had failed, and not being able to stop Lew Grade, they had lost all financial control over their early

music. They also had lost control of the *Get Back* movie and songs; unable to agree on what to do with them, miles of tape and film went into storage.

Soon after the accident, Yoko and John were using heroin again. Peter Brown said Yoko blamed the pain of their injuries for returning to the drug. John said it was more than just the physical pain; it was also psychological.

"We got such a hard time from everyone," he later told *Rolling Stone*, "and I've had so much thrown at me, and at Yoko, especially at Yoko. Like Peter Brown in our office—and you can put this in—after we come into the office after six months, he comes down and shakes my hand and doesn't even say hello to her. That's going on all the time. And we get into so much pain that we have to do something about it. And that's what happened to us. We took 'H' because of what the Beatles and others were doing to us."

During this period, Yoko and John established a routine they were to follow for many years: They kept to themselves. There were sixteen rooms in the mansion, but only three or four were used regularly: the kitchen, where Val, the faithful Lennon cook, prepared brown rice and vegetables; a small adjacent room where John usually remained glued to the television set; a makeshift recording studio that eventually would take on the proportions of a major facility; and, of course, the bedroom.

Of these, the bedroom was the most used. When their heroin use was heaviest, it would be here they'd remain for days, eating infrequent meals from trays. Now there were no visitors, and the only messages in and out were conveyed by the cook; by Yoko's old friend from her days with Tony Cox, Dan Richter, who soon moved into one of the guest bedrooms; or by Anthony Fawcett, who lived in another guest room.

Paul McCartney finally managed to break through the defenses of Tittenhurst and convinced John to join him and George and Ringo for one more album. Yoko was there, sitting at John's feet. With the *Get Back* tapes, and film, still unedited and stuck away on a shelf, McCartney felt it necessary to start over again, naming the new effort after the studio address, *Abbey Road*.

The subsequent recording sessions limped along for several months, and in the meantime, through August and early September 1969, Yoko and John began to go back into the world a bit. One such venture took them to the Isle of Wight, where Bob Dylan was headlin-

ing a massive outdoor pop festival; following the performance, the Lennons and George Harrison returned with Dylan to Tittenhurst in a chartered helicopter.

More exciting for Yoko were a number of projected screenings of her films. The first of these was September 3, when three of their early films—*Two Virgins*, *Mr. & Mrs. Lennon's Honeymoon* (a documentary of the Amsterdam bed-in), and John's slow-motion *Smile*—were all included in the Edinburgh Film Festival. The second followed a week later when the ICA, which had shown Yoko's *Bottoms* film two years before, scheduled an evening of the films she had made with John. The first of the two films the couple made available was *Rape*, largely because it had never been shown publicly in Britain. The other was a new one, called *Self-Portrait*. This was a self-consciously controversial effort that showed, for fifteen agonizing minutes, John's penis moving slowly toward dubious erection.

Initially, they planned to attend the evening in their honor, but in the end they had Anthony Fawcett round up a couple of friends of Yoko and John's approximate sizes, who then were placed inside a dark bag and taken to the Institute of Contemporary Art in a limousine. The bag was carried onstage, where the hidden twosome chanted to the accompaniment of an enormous clatter made by the audience, beating wooden spoons on biscuit tins.

Back at Tittenhurst, Yoko and John were beating their own wooden spoons. Discovering that Yoko was pregnant, they knew they had to quit their heroin habits immediately. This time, though, they decided to do it alone, to remain in their bedroom and "cold turkey."

John's habit was stronger than Yoko's, apparently, and according to those in the household, who couldn't help hearing the muffled cries behind closed doors, on several occasions he begged Yoko to call a friend for just one more bag. She was resolute.

For days they were nauseous and vomiting, eating little, sleeping fitfully, snapping at each other when willing or able to talk at all.

Their bodies screamed for relief, and the mind, battered and drained of energy by the muscular spasms and lack of nutrition, tried not to respond.

Slowly, it got better.

After a week, it was clear to Yoko that they needed purposeful activity. Press reaction to the film evening at the ICA had been typically amused, and the ICA invited the Lennons to stage a second evening of films a month later. Right away, they began to make another film, *Apotheosis*, by affixing a camera to the bottom of a hot air balloon

and releasing the balloon to capture the sight of the earth receding.

At the same time, Yoko and John were asked to attend an outdoor rock concert that was hastily thrown together in Toronto in the wake of the much-acclaimed Woodstock Music & Art Fair held the previous month in upstate New York.

The Rock 'n' Roll Revival Concert featured other contemporary acts, including Chicago, Alice Cooper, and the Doors, but the focus was on the early greats: Chuck Berry, Bo Diddley, Jerry Lee Lewis, Gene Vincent, and Little Richard. The promoter, calling London only a day before the show began, hoped only to have the Lennons as guests, but John said he'd appear only if he could perform.

The promoter was shocked, but naturally he happily agreed, saying he'd put John and whomever he brought with him on last, the idea being that he was the perfect choice to close the show because all the early greats on the bill had been among his strongest early influences.

With only twenty-four hours before departure time, John began calling his friends to form an ad hoc backup group, the Plastic Ono Band. Obviously, there was no time to rehearse. They'd be lucky, in fact, if all the visas were approved in time. However, the group assembled was an impressive one, including one of the great modern blues guitarists, Eric Clapton (who was also much influenced by Chuck Berry); session bassist and Beatle friend Klaus Voorman; and Andy White, a drummer who had been doing some Apple sessions and later would join a band called Yes.

The next morning, Anthony Fawcett called Tittenhurst to see if the Lennons were ready to be taken to the airport. Val, the cook, said they were still sleeping. Fawcett insisted she wake them. John finally came to the phone and told Fawcett that they weren't going.

"Cancel it," he said. "Yoko doesn't feel well. Send them a telegram and a big bunch of white flowers. Tell them we send them love and peace."

Fawcett ignored the order and rushed to Tittenhurst, arriving just as Eric Clapton called to say he was raring and ready to go. A new flight was booked and with as much enthusiasm as could be expected under the circumstances, Yoko and the band of musicians headed for Toronto.

The subsequent performance was a total disaster.

The lack of rehearsal didn't help. The four musicians had never played together and now they were left to *talk* about which songs they might do in what would be John Lennon's first post-Beatles performance. The pressure was felt; everyone in the party was nervous.

Then there was an argument backstage when Little Richard told John that *he* wanted to go on last.

John was feeling sick to his stomach from nerves and the continuing effects of the heroin withdrawal. He didn't know what to do. The promoters wanted him to close the show. Yoko was at his side telling him the same thing, calling the man who virtually invented rock singing a has-been. The promoters and Yoko prevailed, and after John vomited uncontrollably for almost half an hour backstage, the Plastic Ono Band made it's world debut.

Although they performed three rock classics—"Money," "Dizzy Miss Lizzy," and "Blue Suede Shoes," the latter a song John used to sing in Liverpool in the Beatles' early days—most of the emphasis seemed to fall on two new songs, which were performed toward the end of the set. One of them was "Give Peace a Chance"—a No. 2 hit in both England and the U.S. in July—the other, performed for the first time publicly, was one that John had written out of his own tortured experience with Yoko only the week before.

Much like "The Ballad of John and Yoko," the new song, "Cold Turkey," reflected immediate, personal events.

It wasn't known outside of a small circle of friends that John had even used heroin, let alone had been addicted, so the audience was stunned. And it was clear from the lyrics and John's strangled and choking delivery that he had experienced the hardest means possible of kicking the addiction.

The applause came slowly, then filled the Toronto night. As it finally faded, Yoko came forward. She had spent most of the concert huddled in a white blanket at one side of the stage. Now she came forward to sing an original composition. This, too, was autobiographical and written—and wailed—in great pain. She called it "Don't Worry, Kyoko (Mummy's Only Looking for Her Hand in the Snow)."

Soon after the auto accident in Scotland, Yoko had put her daughter on a plane for New York, where she was to join her father. She hadn't heard a word since. Kyoko was now six years old. Yoko had had her daughter with her less than half of that time.

Now Yoko stood behind the microphone, still wrapped in the white blanket, as the musicians began what became a monotonous repetition of a single chord, and Yoko began her cry to Kyoko, telling her over and over again not to worry.

For the next ten minutes, Yoko's voice rose and fell, alternately taking on the grating sound of a screech and that of a yodel, as if she

was expelling an endless stream of air while changing the shape of her throat and mouth.

The audience was totally mystified and following a final unwanted encore in which she merely called out John's name for a while, she silently left the stage. John and Eric Clapton then leaned their guitars against the speakers, causing horrendous, ear-piercing feedback, and left the stage as well.

One of those in the audience was D. A. Pennebaker, hired by the concert promoters to produce a documentary of the show to be shown later in theaters in much the same way his critically praised film about Bob Dylan, *Don't Look Back*, had been released. Pennebaker was stunned. Neither John's nor Yoko's performance fit the rest of the show. Besides, the music was questionable at best.

It was decided later—by Pennebaker—that in order to save the film, the Plastic Ono Band had to be cut entirely.

Allen Klein had joined the party in Toronto and accompanied it back to London, talking nonstop all the way to convince John *not* to announce the formation of a new band until the new recording contracts he had negotiated with EMI and Capitol took effect. Nonetheless, as soon as they'd returned, Yoko followed John into a meeting with Paul McCartney.

"When everything's said and done," McCartney said, "we're still the Beatles, aren't we?"

"Aw, fuck," said John, "I ain't no Beatle."

McCartney refused to hear of it and insisted that the Beatles would live forever.

John bolted from the room shouting, "It's over! Over! I want a divorce, just like the divorce I got from Cynthia! It's finished!"

On October 9, John's twenty-ninth birthday, Yoko was rushed to King's College Hospital, where again John slept on the floor by Yoko's bed as doctors tried to save the child. It was no use, and less than twenty-four hours later she miscarried her second child with John. She had been several months pregnant and attending physicians told her that because of her history of abortions and miscarriages, she would not be able to have a child. Ever.

Yoko was told to consider having a hysterectomy or at the very least to start using a contraceptive. John said he'd use a condom. Yoko wept. John held her and said they'd charter a yacht and visit the Greek islands.

It was a strange time. On the heels of the cry of joyous freedom let loose at Woodstock, it seemed, in October, November, and December

1969, that the "counterculture" was sinking into a morass of repression, self-destruction, and bad publicity.

In October, in San Francisco an actor and actress appearing nude in the revue *Oh Calcutta!* (produced by British critic Kenneth Tynan and featuring a sketch about masturbation by John Lennon) were arrested for "suspected genital contact," and Dianne Linkletter, daughter of American television personality Art Linkletter, apparently leapt to her death from her West Hollywood apartment; Linkletter insisted his daughter was under the influence of LSD. Said Linkletter, "This wasn't suicide, it was murder!" October was also the month when the father of an entire generation, author Jack Kerouac, collapsed and died from a massive abdominal hemorrhage caused by alcoholism.

In November, Timothy Leary began a crusade for the California governorship, only to be arrested midcampaign for marijuana possession; Janis Joplin was charged with "vulgar and obscene language" in Florida; and Jim Morrison was jailed in New Mexico for public drunkenness and "interference with the flight of an intercontinental airplane," the latter the result of his throwing his drinking glass at a stewardess while en route to a Rolling Stones concert.

And the Beatles album *Abbey Road* dominated the album charts. But it was the final concert in the Rolling Stones' American tour that put the symbolic cap on the movement, when, at a motor speedway in Altamont, California, Mick Jagger and his pals looked on as the Hells Angels—hired as bodyguards—beat and stabbed a fat, naked member of the audience to death.

Yoko and John watched all these events on television. Rarely by now were either ever in a room where a TV wasn't turned on. In the 1960s—at least since 1963, when President John Kennedy was assassinated—television had become an essential ingredient of *everyone's* environment. The Watts riots in Los Angeles in 1964; the black riots in Newark, New Jersey, two years later; Martin Luther King, Jr.'s assassination in 1968; the bloody escalation of U.S. involvement in Vietnam throughout the late sixties—these events and many more were brought into the living room as never before.

Consequently, Yoko and John became more and more involved. How couldn't they? John asked. And thus, some of their films were screened to raise funds for starving Biafrans, while they themselves climbed into a bag in London's Hyde Park (noted for its freewheeling, free-thinking orators) to protest the hanging of James Hanratty, a black man they believed had been wrongly executed.

A few of Yoko's many homes, past and present:

Top left, the fourth-floor loft where Yoko staged her first events

Center, the Bank Street apartment where John and Yoko were watched by the U.S. government

Bottom left, the Dakota

Above: Yoko performing "Stone Piece" at Judson Memorial Church in 1966. *(Fred W. McDarrah)*

Below: Yoko wraps composer LaMonte Young at a 1965 Fluxus event. *(Fred W. McDarrah)*

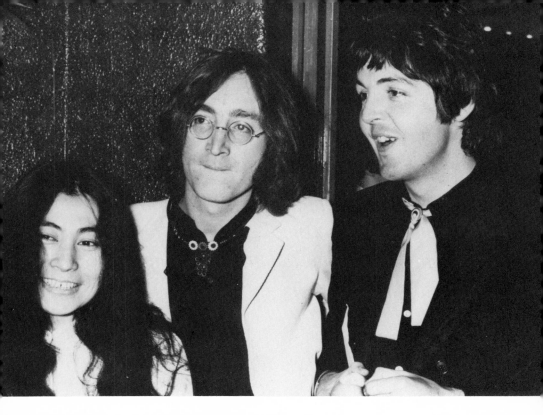

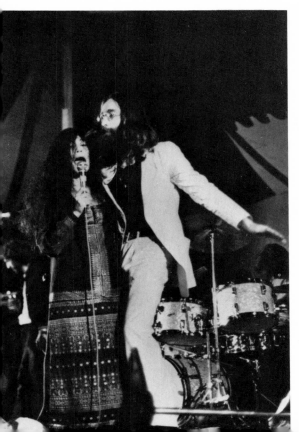

Above: At the 1968 opening of *Yellow Submarine* with John and Paul McCartney, exhibiting none of the animosity that would later develop among the three. (*AP/Wide World Photos*)

Below: The first public performance of the Plastic Ono Band at the 1969 Toronto rock'n'roll revival. This picture captures perfectly Yoko's frenetic vocalizations, while John hovers behind, as if to protect her from the public criticism that constantly surrounded her singing. (*AP/Wide World Photos*)

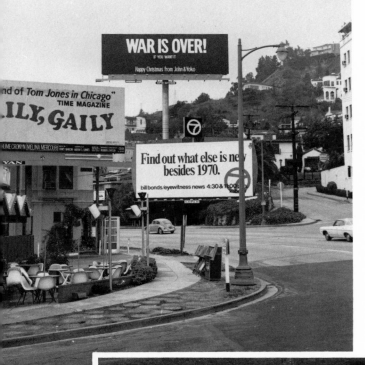

Left: One of the many billboards John and Yoko posted in 12 cities worldwide during their peace campaign. This one appeared on Sunset Boulevard in December 1969. (*Jerry Hopkins*)

Below: John and Yoko in a rare moment with Yoko's daughter, Kyoko, in 1969. The custody battle that would develop between Yoko and former husband Anthony Cox remains unresolved to this day. (*AP/Wide World Photos*)

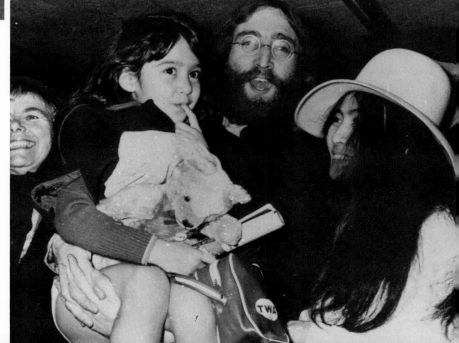

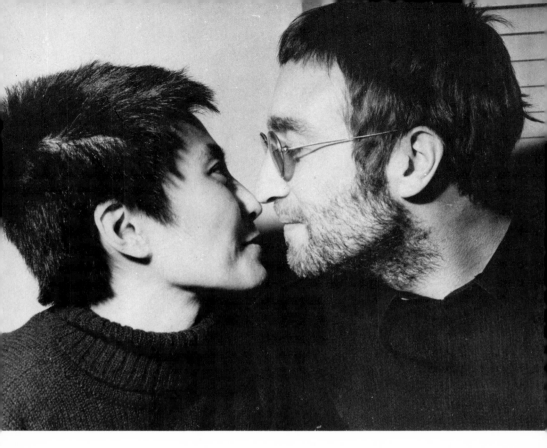

Above: Yoko and John share an Eskimo kiss during a 1970 interview. Both had their hair cropped short in Denmark, then sold the hair at a London auction, donating all proceeds to a British organization called Black Power. (AP/Wide World Photos)

Below: Yoko onstage during her 1973 stint at Kenny's Castaways. (Fred W. McDarrah)

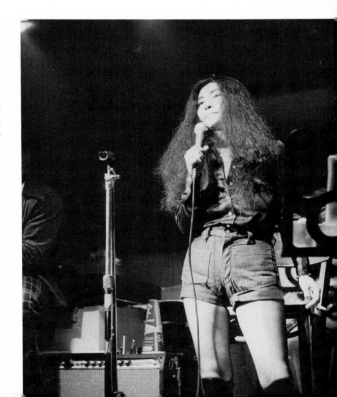

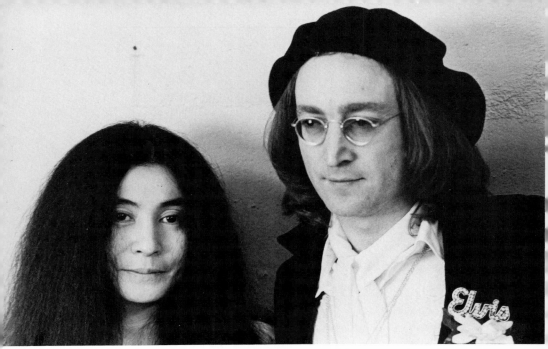

Yoko and John pose during the 1975 Grammy Awards. (*Fred W. McDarrah*)

Below: A worn-out Yoko poses with John outside a New York studio during the recording of *Double Fantasy*. This August 1980 picture was taken just a few short months before Lennon's murder. (*David McGough/DMI*)

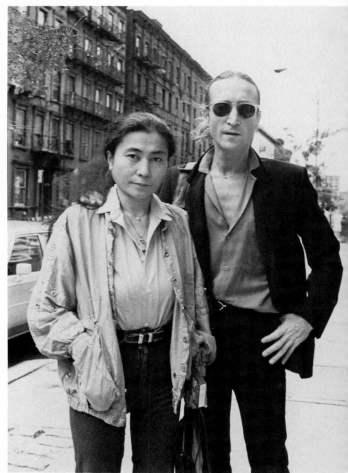

LENONO
STUDIO ONE
1 WEST 72ND STREET
NEW YORK, NEW YORK 10023

```
BLESS YOU FOR YOUR TEARS AND PRAYERS.
I SAW JOHN SMILING IN THE SKY.
I SAW SORROW CHANGING INTO CLARITY.
I SAW ALL OF US BECOMING ONE MIND.
THANK YOU.

            LOVE,

            Yoko
            December 14' 80
            N Y. C.
```

Above: The note in which Yoko sent her blessings to the hundreds of thousands worldwide who kept a vigil of affection and respect for John Lennon. *(AP/Wide World Photos)*

Below: Yoko's eyes fill with tears during the 1984 groundbreaking for Strawberry Fields, the $1 million, 2.5-acre garden memorial to John in Central Park. On her left, stepson Julian and son Sean. *(David McGough/DMI)*

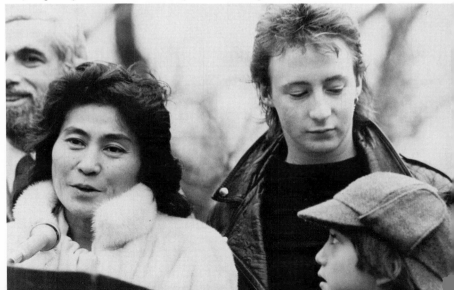

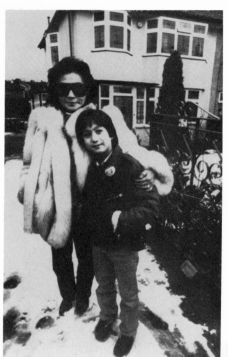

Left: Yoko and Sean visit John's childhood home in Liverpool in 1984. *(AP/Wide World Photos)*

Below: A rejuvenated Yoko sings at the last performance of her "Starpeace" tour. Although the tour was reported to be a multimillion-dollar failure, Yoko received almost unanimous critical notices for the first time in her career. *(AP/Wide World Photos)*

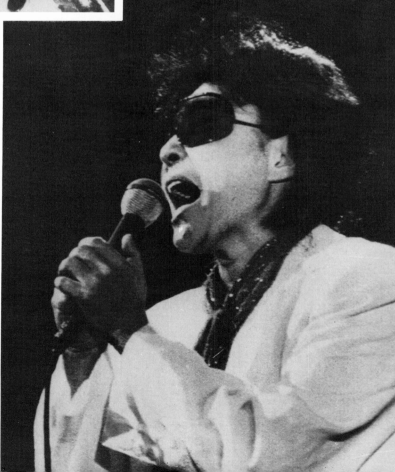

There were other "events" that attracted more attention. The first came on November 26, when John told his chauffeur to drive to his Aunt Mimi's house in Liverpool to fetch his M.B.E., the Member of the British Empire medal that had been awarded to each of the Beatles by the queen in 1965. With Yoko at his side, he then personally delivered it to the servants' entrance of Buckingham Palace with a note that read, "Your Majesty, I am returning this M.B.E. in protest against Britain's involvement in the Nigeria-Biafra thing, against our support of America in Vietnam, and—" he unfortunately added, "against 'Cold Turkey' slipping down the charts. With Love, John Lennon of Bag."

John added the reference to "Cold Turkey" to take the edge off what otherwise might seem a formal announcement, but also because he really did believe in the song's message: Drugs either kill you or make you wish you were dead. The media missed the point and charged John with a crude attempt to promote record sales.

That night, after a press conference at Apple, Yoko stretched out on the office couch and slept as John talked with reporters long into the night.

The next day a message arrived at Apple from Bertrand Russell, who said he was very pleased to see John putting his Beatle reputation on the line. "Whatever abuse you have suffered in the press as a result of this," he wrote, "I am confident that your remarks will have caused a very large number of people to think about these wars."

The Pentagon in America had a War Room. Three thousand miles away in London, in Apple's Savile Row offices, Yoko and John had, in December 1969, an Anti-War Room in the closet nearest the door in their first-floor office. By now, more and more posters were going up on the wall, with the earlier "Bag Peace" placards being replaced by graphics for what Yoko and John now planned as a worldwide billboard campaign.

The idea was to create an "environment" for peace, so that peace could flourish. To announce this notion, Yoko and John had written a special Christmas message: "War Is Over—If You Want It—Happy Christmas, John and Yoko." This message, in huge white block letters against a black background, went up in prime billboard positions on December 15 in London, Paris, Rome, Berlin, Athens, Tokyo, New York, Los Angeles, Toronto, Montreal, and Port-of-Spain.

The Lennons' peace campaign was back in high gear, and that meant it was time to call in the media, to start handing out interviews (as one reporter put it) "like cigars at a christening."

"The fact is," John told one of the pop music writers while holding court with Yoko in their Apple office, "I've got a new group now and it's called Peace. When we were just the Beatles, we didn't need the press after we'd made it, except when we had a new record out, because they only wrote a lot of drivel about us anyway. But now I'm promoting peace. . . ."

By now, Yoko was talking nearly as much as John, and for several days the interviewers and photographers came and went, much as they had in Amsterdam and Montreal, and the lilting accents of Yoko and John formed an endlessly bubbling river of peaceful prose.

On December 15, they appeared at a "Peace for Christmas" charity concert at the Lyceum Theatre, a benefit for the United Nations Children's Fund, performing "Cold Turkey," "Give Peace a Chance," and a seventeen-minute-long version of "Don't Worry, Kyoko." Besides the original Plastic Ono Band, the musicians this time included George Harrison, the complete Delaney and Bonnie band, Billy Preston, and Keith Moon. *Rolling Stone*'s reporter said John "showed the crowd that his fervor for peace and Yoko hadn't dimmed his talent or displaced his sense of humor." However, it was noted, when Yoko sang, she was greeted with "malicious snickers and twisted grins . . . embarrassed looks and hip scorn. Without John's strong backing," the writer said, "she'd be crucified."

Perhaps. Perhaps not. "We're not used to seeing an Asian that ain't bent over, smiling, apologetic," Dick Gregory said later. "She never was that. When was the last time people in the press interviewed *any* Asian, much less an Asian woman that looked you right in the eye and answered your question and could be as belligerent with her answer as you are with your question?

"I've never seen a relationship that was as equal," Gregory said. "They came together, they moved together. It would have been very easy for him to be just John Lennon. The press didn't want this Asian to be part of it. But he said, 'It's me and her. We are one.' He demanded that you not overlook her."

The day after the Lyceum concert, Yoko and John and a small entourage that included Anthony Fawcett flew to Toronto to plan a "bigger than Woodstock" peace festival. The visit to Canada was arranged by John Brower, who had promoted the Rock 'n' Roll Revival, and a freelance writer named Ritchie Yorke, who had plastered the city with thousands of "War Is Over" posters and thirty roadside billboards. He also arranged for the Lennons to stay at the French provincial country home of guitarist Ronnie Hawkins.

Fawcett recalls the days that followed as being quite intense, as three extra phones were installed so that Yoko and John could begin marathon telephone interviews with American radio stations. The household grew as the Lennons flew in the cook from the Paradox in New York where Yoko had worked as a waitress and had crawled into her first black bag; comedian Dick Gregory also came to stay and so did British journalist Ray Connolly and, later, Ralph Ginsberg, editor of *Avant-Garde* magazine, who was invited to talk about some erotic pen-and-ink drawings John had done, showing him and Yoko making love.

In the days that followed, Yoko continued to accompany her husband everywhere, staging press conferences, giving interviews, and meeting with two of Canada's best-known citizens, the prime minister, Pierre Trudeau, and the man who had invented two of the catchphrases of the decade—"global village" and "the medium is the message"—Marshall McLuhan, as well as with members of the Le Dain Drug Commission, which was studying the possible legalization of marijuana in Canada.

The Lennons defended the use of soft drugs and attacked the addictive opiates. There was, however, an element of some hypocrisy or, at the very least, dangerous ignorance. It was true that Yoko and John had put heroin in their past, but they had replaced it with methadone, which they had done previously, and in December 1969 it was still very much a part of their life-style.

"Macrobiotics and methadone," is the way one of those present described the Canadian visit. "The Big Two M's of Lennon life."

At the time, methadone was generally regarded as "safe." It would later be found that it was as addictive as heroin, and harder and more dangerous to kick.

Yoko and John were back in London for Christmas and on December 29 were off again, this time to Denmark for a reunion with Kyoko and a meeting with Tony Cox, who was living with Kyoko and his new wife, Melinda, in a remote farmhouse about an hour's drive from Aalborg, where the Coxes occasionally lectured at a small university.

By now Tony had been through nearly as many changes as Yoko. Not only had he remarried—Melinda was independently wealthy, a Texan he had met in New York—but he also had begun a deep investigation of Christianity and the occult sciences. Because he had stopped all use of tobacco, alcohol, and drugs, Tony strenuously objected to having Kyoko exposed to the Lennons, who were known to

use and possibly abuse all three. According to those present, Tony still hadn't completely forgiven John for driving his daughter into the ditch in Scotland the last time she vacationed with her mother.

"John and Yoko seemed to really be looking for the truth when they came out to the farm," Tony wrote later, "and they did a lot of symbolic things. They burned their cigarettes in the snow outside the farmhouse and they cut their hair off. They were also determined that we should heal our relationship. They had literally shown up in tears and said they regretted the trouble they caused us. They offered me a film project to help make up for some of my losses. They also offered me Allen Klein's job; their first contract with him was just ending then. But I said I couldn't do that. I'd committed myself to finding God. There was still a certain amount of tension between us, and John invited Dick Gregory to join us. When Dick got there he said that the answer to our problems was to fast and pray together and so we went on a fourteen-day fast."

Other visitors came and went as well, including the Peace Festival promoters, John Brower and Ritchie Yorke, who arrived complaining about Allen Klein. Klein himself soon joined the party, and so did two members of a California-based cult called the Harbingers, who said they would capture the "Earth Force" surrounding the Beatles and use it with some superhuman beings from another world to bring peace to the planet. They also offered to fly John and Yoko to the peace festival site in a psychic-powered air car that would only cost $500 and never use any fuel. The overall length of the plane was to be 22 feet, an important factor in Egyptian numerology. While in Denmark, the Harbingers also tried to cure John of his smoking by hypnotizing him into remembering his past lives.

For nearly all her life Yoko had been open to many such things—in fact, she was at the time planning to create some erotic lithographs of her own based on the *I Ching*, a favorite reference in recent years. She and John also had had their astrological forecasts read the previous month in order to better prepare themselves for the 1970s. However, even for Yoko, the Harbingers were a bit too much.

The Lennons and their entourage returned to London on January 23—carrying their hair in a white plastic box.

13

*Plastic
Ono
Primal
Scream*

ANOTHER CONTROVERSY was already under way when Yoko and
John got back.

Anthony Fawcett remembers that John's lithographs were
his project, the result of his urging John to do something with all the
sketches he made. It started almost a year before, he says, soon after
the wedding in Gibraltar, when John produced twenty or thirty pen-
and-ink images—some self-portraits, some drawings of their wedding
and Amsterdam bed-in, but mostly nudes of Yoko and very explicit
sketches of their sexual acts, with an emphasis on masturbation, fel-
latio, and cunnilingus.

According to Ray Connolly, the British journalist closest to the
Lennons, the lithographs "reflected the mutual obsession which John
and Yoko had at this time." It was during this period, after all, that
John said sex was his only exercise, and although the remark was
worded this way for the laughter it produced, there was, in fact, some
truth to the statement.

Well, said another journalist at the time, if John was so crazy about
sex, how did he feel about infidelity?

"We're not immune to sex, you know," John said, glancing at his
wife at his side. "We're always sussing each other out. But you have to
weigh up whether or not it's worth it. There's a difference between
fancying other people and having sexual fantasies about them. We

wouldn't mind going to see a bit of a sex show, you know, being voyeurs, but we wouldn't want to join in."

Yoko added her own answer: "We know the odds too much. Before we met we were both too free. I always felt I was the creative one in the family and so I had to have my freedom. Now John and I have made a match. We don't really have close friends because when you do get close to another couple you start thinking in terms of a communal scene, not necessarily of sex, but of sharing everybody. So we try to keep a slight distance from everybody, even with our own children. We know that if we start to love our children too much, then it will draw us slightly apart. It's terrible, but even with them we keep a little distance. Sometimes I think that because Julian is with Cynthia and Kyoko is with her father that we have the best two baby-sitters in the world looking after our children."

It's easy to agree with Ray Connolly that such belief and behavior is obsessive—or at the very least self-serving. Clearly the lithographs were a part of it. And certainly they were exhibitionistic. No one could argue with that. According to the Lennons, however, there was nothing wrong with showing off when what you were showing off was love.

John produced dozens of sketches quickly and "we picked ten or twelve," Fawcett says today. "The original idea was to have them proofed by Picasso's lithographers in Paris. They did one or two, but then got busy with Picasso, so we found a press in London and John went down and began to draw directly on the zinc plates. There were fourteen drawings in all, and Yoko was really proud of John's accomplishment. We printed 300 sets with a dozen or so artist's proofs. After that, the plates were to be destroyed."

In the months that followed, show commitments were made to galleries—to the Denise Rene in Paris (for September 1969) and to the London Arts Gallery and the Lee Nordness in New York (both for January 1970).

The London show was like a comedy when, on January 15, police plainclothesmen mingled with a crowd of 300 champagne sippers and made mental notes. The next day, they returned to the gallery and, after asking everyone present to leave, spent three hours examining the drawings, finally confiscating eight.

What happened came out in court when a detective said that one middle-aged man was "clearly annoyed" by what he saw.

"Was he stamping his foot?" the magistrate asked.

"No," the detective said. "He was not moving around. But anger was registered on his face."

On the surface this all sounded too farcical to be taken seriously, but at the time of the gallery raid, the Lennon "love lithos"—as Fleet Street quaintly described them—attracted derision and ire. And in the weeks that followed Yoko and John's return to Tittenhurst on January 25 with their short haircuts, one bad joke after another seemed to settle around them with the inevitability of Beatle hits.

By now, the Beatles' last album, *Abbey Road*, had gone to No. 1 in both the U.S. and England, while "Cold Turkey" had peaked at No. 14 in Britain and No. 30 in America—the latter nothing to write home to Liverpool or Tokyo about, but respectable nonetheless. The Plastic Ono Band's *Live Peace in Toronto*, the documentary recording of the Lennons' appearance at the Rock 'n' Roll Revival, also had gone Top 10. However, this merely provided a backdrop for irritating failure.

First there was the matter of the artificial lake at Tittenhurst (the excavation of which involved the removal of three acres of dirt and the discovery of three unexploded bombs from World War II). Because the topography would not allow a lake—the soil was such that all the water would drain away—a thick rubber sheet was installed as a false bottom, standard in the creation of reservoirs. Then the water was pumped in and 10,000 pounds of fish were introduced. Unfortunately, however, Yoko and John neglected to create any life-support system—algae, plants, etc.—and within a few days every single fish was dead, floating and stinking in the late winter London sun.

Another somewhat comical disaster occurred when George Harrison talked John into entertaining the Swami Bhakdavedanta and then inviting members of the Radna Krishna group to occupy his four guest houses. John suggested that the white-garbed chanters could assist in remodeling the house, and for the next couple of weeks Yoko watched what resembled a 1960s version of a Laurel and Hardy movie.

"No one had the courage to tell them to leave," says John Kosh. "They chanted all day long and argued over whose turn it was to take the garbage out and then knocked out the wrong walls."

There was also the matter of an official biography that the Lennons had commissioned several months earlier. It was in November 1969 when Yoko and John called Tony Palmer to their bedside and asked him to write a book about their lives.

"I was a little skeptical at first," said Palmer, a respected journalist and filmmaker, "but eventually agreed to do it. The catch did not

come until I was about to leave. John just popped in the one snag: The proof had to be with the publishers by the following Monday. It was then Tuesday."

Palmer somehow managed it, producing 75,000 words in a week, and the manuscript was rushed to the Lennons, who were then in Toronto planning the peace festival. Initially the couple approved the manuscript, but by the time they returned to London, Yoko had changed her mind because, she said, the stars in the heavens were no longer propitiously aligned.

More serious problems came in early spring when Yoko and John announced their support of still another cause and *no one* reported it, when the Toronto Peace Festival collapsed, and when Paul McCartney announced to the press that he was leaving the Beatles.

Of the three, the aborted, or ignored, publicity campaign seemed the least significant. Yet at the time it was a shock, and it showed clearly how bored even the Fleet Street press had become by the Lennons. As usual, they called a press conference at Apple, and the press rather reluctantly attended. The Lennons said they were donating their newly shorn hair to Black House, an interracial community center in North London, to be auctioned off to raise funds for the center's works.

Appropriately dressed all in black with the start of a beard, John held two hanks of long hair aloft like a triumphant American Indian fresh from a scalping attack. Then he and Michael Malik, the leader of Black House who called himself Michael X, both held up the hair along with a large pair of boxing trunks supposed to have belonged to the American boxer Muhammad Ali. Yoko, also clad all in black, stood in the middle and looked boyish in an unruly crew cut brushed forward to a point. Photographers snapped away.

The next morning, for the first time in Lennon history, not one photograph of the bizarre event appeared in any of the London newspapers. But this was not the first time the press had begun to turn its back on the Lennons. According to a member of the Apple publicity staff: "Yoko believed her art was important and she thought anyone who disagreed was a jerk—though sometimes I wondered who was kidding who. Well, there was a time when Thames TV wanted something of hers, and I got a paper napkin with a small drawing of a matchstick man in one corner saying, 'Hello.' Fucking lazy, I'd say at this distance [today]. But I submitted it and they sent it back, saying they thought she'd like to be better represented. I went back to her and she said, 'That's it! That's it! I'm a busy woman.' "

Nonetheless, the Michael X incident came as a definite shock. "Finally," says one of those present at the time, "John and Yoko had overexposed themselves. I should have caught on, but I was as caught up as they were. When no one finally paid any attention, we were all of us numbed by it."

An equal stunner came in March when the peace festival collapsed. When the promoters announced that admission was to be charged at the festival gate and the Harbingers chimed in with promises that flying saucers would land at the festival site, Yoko and John sent a telegram: "You have done exactly what we told you not to do. We told you we wanted it to be free. We want nothing to do with you or your festival. Please do not use our name or our ideas or symbols. Yours in disgust, John and Yoko."

Says Anthony Fawcett today: "It was the end of the peace trip. Things had gone too far, there was no turning back. Seeing them with their hair cut off, and listening to them, one knew it was different. The ballad of John and Yoko was over."

The biggest shock of all came on April 10 when Paul McCartney released his first solo album and with it an interview with himself in which he said he was leaving the Beatles "because of personal, business and musical differences."

Q: Did you miss the other Beatles and George Martin [while recording the album]? Was there a moment, e.g., when you thought, "Wish Ringo was here for this break"?

A: No.

Q: Are you planning a new album with the Beatles?

A: No.

Q: Do you foresee a time when Lennon-McCartney becomes an active songwriting partnership again?

A: No.

John was furious and he complained loudly and bitterly to Yoko for days. Hadn't *he* recorded *four* albums with Yoko and, at McCartney's urging, kept his own wishes to leave unspoken? Hadn't he even allowed McCartney to talk him back into the studio to record *Abbey Road*?

John was also appalled at some of the barbs that McCartney aimed at Yoko:

Q: What do you feel about John's peace effort? The Plastic Ono Band? Giving back the M.B.E.? Yoko's influence? Yoko?

A: I love John and respect what he does—it doesn't give *me* any pleasure.

Q: Will Paul and Linda become a John and Yoko?
A: No, they will become Paul and Linda.

For days the Apple offices were under siege as journalists prowled the hallways cornering anyone they could get to make a comment. Finally, McCartney himself granted a long interview to Ray Connolly. In it he insisted there was "no one who's to blame" individually for the breakup. However, he also pointed an accusatory finger at Yoko.

"John's in love with Yoko," he said at one point, "and he's no longer in love with the other three of us."

Then, talking about writing songs with John, McCartney said, "It simply became very difficult for me to write with Yoko sitting there. If I had to think of a line, I started getting very nervous. I might want to say something like, 'I love you, girl,' but with Yoko watching I always felt that I had to come out with something clever and avant-garde. She would probably have loved the simple stuff, but I was scared.

"I'm not blaming her, I'm blaming me. You can't blame John for falling in love with Yoko any more than you can blame me for falling in love with Linda. We tried writing together a few more times, but I think we both decided it would be easier to work separately.

"I told him on the phone the other day that at the beginning of last year I was annoyed with him. I was jealous because of Yoko, and afraid about the breakup of a great musical partnership. And it's taken me a year to realize that they were in love. Just like Linda and me."

However much McCartney tried to temper his remarks, the point was clearly made, and from that point forward, Yoko was blamed for destroying the most popular musical group in history. Even the band's official biographer, Hunter Davies, agreed. Writing in the *Sunday Times*, he said that after John and Yoko got together, "the rest of the Beatles didn't matter any more."

That story itself made headlines over much of the Western world when the news services quoted Davies extensively, making his the final word. For weeks, the massive piles of newspaper clippings that poured into the Apple offices bore headlines like "Beatles Expert Says Yoko Is Worm in Apple."

A month earlier, amid reports that she was pregnant again or suffering from complications following her last miscarriage, Yoko and John entered the London Clinic, an expensive private hospital. The truth was, they were addicted to heroin again, and they'd checked themselves into the clinic to detox.

The Lennons were not alone the entire four days they remained in

the hospital. Telling everyone they were there because of the pregnancy, they entertained a number of friends, including journalist Ray Connolly, and the black radical Michael X, who brought with him as a gift a plastic bag full of marijuana.

It was after that happened that John sent Anthony Fawcett out for papers, meaning cigarette rolling papers. When Fawcett returned with the evening newspapers, Yoko chewed him out mercilessly.

Yoko and John were weaned from the heroin and for a third time were put on methadone.

Home again, they went back into seclusion, quietly celebrating their first wedding anniversary (March 20), and entertaining only a few visitors.

One of these was their old friend Dick Gregory, who said John asked him to "come and help. I came in to rebuild his body. My main concern was cleansing out the body and not doing it too fast. I was able to put him on the type of vitamin regimen that would replenish what the drugs had wiped out, and also fast him on a small scale. I explained to John: You have to take out the physical source of the pain. Then you can work on the mental source."

If Gregory's plan was Step One, Step Two seemed to arrive soon afterward, when a book called *The Primal Scream* came in the mail. John said later the title intrigued him. "I mean, Yoko's been screaming a long time," he told *Playboy*. "Just the words, the title, made my heart flutter."

The author, Arthur Janov, a Los Angeles–based psychotherapist, had come to regard the scream as the product of central and universal pains that reside in all neurotics. He called them Primal Pains because they were the "original, early hurts upon which all later neurosis is built."

In other words, obsessions and phobias and all the rest in the neurotic's bag of problems had but a single source, what Janov called major and minor Primal Scenes, all traceable to the patient's early relationship with his or her parents. Say, for example, the patient was pushed beyond his limits as a child. Janov said that each time the parents exerted pressure—to crawl sooner, walk sooner, be brighter, etc.—or showed rejection when expectations weren't met, a minor Primal Scene was created. After several years of this, usually between the ages of five and seven, Janov says an "understanding" accompanied one of the minor scenes, and the child realized that his parents didn't like him the way he was. Suddenly, painfully, realization turned into a *major* scene.

Thus was born neurosis, and from that moment forward the child, and then the man, built a set of defenses that created an "unreality." Janov said that if he could get the patient to relive the major Primal Scene lucidly enough, the only recourse was to let go with the Primal Scream. This would begin to "cure" the neurotic, allowing him to lower his defensive walls and step forward as a real, "feeling" self again.

"That's me, that's me!" John cried. His father had abandoned him and his mother soon after he was born, and when John was five, his mother turned him over to her sister. Now, twenty-four years later, as John sat reading next to Yoko in their bed, he saw a way to overcome the pain he felt from that early rejection. Before calling Janov in California, however, he wanted Yoko to read the book.

Yoko was not so enthusiastic, although she did like the way Janov said he "discovered" the Primal Scream. It came, he said, when one of his patients told of a theatrical performance in which someone dressed in diapers shouted, "Mommy! Daddy! Mommy! Daddy!" throughout the act, then vomited, distributing plastic bags to the spectators, asking them to vomit, too. It reminded her of some of her own early concerts as an avant-garde performance artist in New York. When she expressed some doubts about Janov and his theory, however, John suggested she call him and see what he sounded like on the phone.

In California, Janov and his wife and co-therapist, Vivian, were thrilled. When his publisher had asked him to whom he'd like review copies sent, he said, "John Lennon and Peter Fonda." But he hadn't expected them to call.

Janov told Yoko that he accepted patients on the basis of long, handwritten autobiographies. According to what his wife says today, however, their minds were made up before the Lennons put pen to paper.

"John was the most important figure in the world," she says, "and we thought it would be inspirational to other people if he and Yoko were enrolled, so we went out of our way. They said they couldn't come to America, because of John's visa problems, so we went to England to them."

Prior to the Janovs' arrival, Yoko and John were directed to go into separate rooms and remain isolated for twenty-four hours, with nothing to read, no visitors, no radio or TV or telephones, and no tobacco, drugs, or alcohol. Dutifully, John went into his makeshift studio and Yoko to another room in the house.

Initially, both Yoko and John were much impressed by the Janovs.

With a preference for flared slacks and leather jackets, Janov looked more like a movie star than a therapist; "a silver-haired Jeff Chandler," John called him. And Vivian was a vivacious brunette with hair chopped close to her head and a good, sincere smile. They told the Lennons that their fourteen-year-old son played the bass and attended a "free school," while their daughter, who was then seventeen, had at eleven been hooked in with Henry Mancini and Walt Disney as a singer and actress, and at fourteen had been signed to both Capitol Records and Bob Dylan's manager. Both had gone through their father's Primal Therapy.

The intensive, all-day sessions began the next day. Janov worked on John, his wife on Yoko. At first the sessions were held at Tittenhurst, but when the ongoing construction and other activities were deemed too distracting, Yoko and Vivian moved into the Londonderry hotel in London's Hyde Park section, John and Janov across the street at the Inn on the Park.

For Yoko and John this was a painful period. As explained by the Janovs, it hurts to relive the past, and the techniques employed by the therapists in getting these experiences told also hurts. Often they punched the patients in the stomach to halt "neurotic breathing" or pinched the muscles of the shoulders and neck to get the tension out.

"I hurt people," Janov said. "I need access to the pain centers in the brain to get at the Primal Pains. The pain channels need to be opened. So I dig in."

After three weeks, Janov said he thought he could get John's visa restriction waived because the U.S. Immigration and Naturalization Service often made exceptions for people who needed medical treatment. John said that if Janov was successful, he and Yoko would close up their house in Ascot, shut down their Apple offices, and follow the Janovs home to Los Angeles.

□

For the next four months, the Lennons put their shared careers on a shelf. Of course, this did not mean they were slipping from view. Following the sales success of the *Live Peace in Toronto* album and that of a new single produced by Phil Spector, "Instant Karma"—No. 3 in the U.S., No. 5 in England—came, finally, the album and film, *Let It Be*. This was the Beatles' last album and although all four generally hated what had been done in the final mix, it went to the top of the charts and produced two hit singles, the title song and "Come Together."

At the same time, an updated version of Yoko's book of performance pieces, *Grapefruit*, was published in America by Simon & Schuster. In format and content, it was little changed from the edition Yoko published in Japan in 1964. The only differences were it now included perhaps a dozen new pieces, the text of a lecture she delivered at Wesleyan University in 1966, letters to gallery owners Ivan Karp and Nicholas Logsdail, and an introduction by her new husband.

"Hi!" John wrote in his introduction. "My name is John Lennon. I'd like you to meet Yoko Ono."

The book received only a few reviews, but much publicity, most of which took the by-now predictable tack that Yoko was silly or daft, certainly not to be taken seriously. And given the degree of her fame—and notoriety—sales were disappointing. The first six months, 50,000 copies were sold in the U.S.—far fewer than the publisher expected—while in Britain, the "highbrow" firm of Peter Owen moved a meager 2,000 copies. The publisher blamed the poor sales showing on the Lennons' refusal to participate in publicity. Others said the Lennons were wise to decline, that Britain was still quite bored by them.

Inspired by the renewed interest in her early work, nonetheless, in April and May, Yoko authorized the use of her name, along with John's, in a "Fluxgroup Project" in Lower Manhattan not far from her old loft. This was a series of events staged in a small store run by artist Joe Jones, and if most of the performance pieces described in the press release were never executed, certainly Yoko could be applauded for her humor and creativity. The program began with a "banquet" that included grapefruit wine, grapefruit hors d'oeuvre, marinated grapefruit, and grapefruit soup on April 11, and on subsequent evenings, tickets were sold to "desolate places, miserable shows, distant places via difficult passage" and measurements were taken of each visitor by white-coated attendants: "measurements of head volume, mouth, palm, between fingers or pocket capacity, shoe & foot difference, extended tongue length, inflated cheek width, hair strength . . . number of hairs in nostril, weight of pocket fuzz. . . ."

As all this was—or wasn't—going on, the Lennons were in a rented home in Bel-Air, California. With Janov's help, and for "medical reasons," the U.S. government had finally relented and given them their visas.

Initially, Yoko seemed to enjoy the therapy. They were now participating in group sessions on a daily basis, and if she felt the process was painful, at least she seemed to believe in it.

"They are trying to open me up," she told a writer from *Esquire* magazine, "so I am completely defenseless. I have to reach deep into my pain, the early pain, and bring it out so I can get over it. Because otherwise, it's always going to be there, and paining me and all that, and start to be like a cancer. Starting to destroy my body."

John told the writer that Janov's therapy was strengthening his friendship with Yoko. They had been in danger of becoming self-destructive, like Scott and Zelda Fitzgerald—two balmy people in danger of blowing up.

"I've thought about those mad couples from the past," John said. "There were quite a lot of them, and that's what we didn't want to be. So we kept telling each other, 'We're not.' And we'd be together twenty-four hours a day. That was our love, to protect our love. We were really beginning to choke each other. . . ."

"Though we were in love desperately," Yoko said, "we were destructive. We were possessive and jealous and all that."

To find themselves, the Lennons said, they were exploring their childhoods, and Yoko said she was remembering things she thought she'd forgotten forever.

For several hours, Yoko talked—about her mother's vanity, about her father's measuring her hands and declaring her inadequate on the piano, about the hardships of World War II, about her abortions and early marriages, about her struggles as an artist, about her attempted suicide. Never before had Yoko revealed so much to a stranger. Afterward, John told her that he had been proud of her.

In time, however, Yoko—and John—grew somewhat disenchanted with Janov and his therapy. This came out in the group sessions, held in the Primal Institute's West Hollywood headquarters (a one-story building that had previously been a private club and still had rich magenta wall-to-wall carpeting, dark wood paneling, and vermillion flocked wallpaper). There, the Lennons joined a group of screamers every day. At first, they accepted the therapy without challenge, but one day Janov appeared with a camera and said he wanted to film the session.

"No way!" John cried. "I'm not going to be filmed rolling around the floor screaming. No fuckin' way."

Janov said, "Well, some people are so big they won't be filmed." His voice was sarcastic. "Did it occur to you that I might just happen to be filming the session and you have nothing to do with it?"

John shot back, "Who are you kidding, Mr. Janov? You just happen to be filming the session with John and Yoko in it, right?"

"That's right."

Yoko and John had nothing more to say. They walked out.

It wasn't the same after that. More and more, Yoko began to argue with Janov and find fault with some of his claims—for example, that his therapy cured asthma, epilepsy, colitis, headaches, and most allergies.

"Look," she told John finally, "I *never* did believe in this man. I think he's a flake."

"Maybe," John said. "Maybe not. I dunno."

"I think he's just another father figure for you. Like the Maharishi."

John looked contemplative and said maybe she was right.

The decision whether or not to continue the therapy was made not by any of the parties concerned, but by the U.S. government when John was denied a renewal of his visa. He was told that he and Yoko—who was, after all, still an alien, even if there were no drug convictions on her record—had to be out of the country by August 1.

14
Up
My
Legs
Forever

JANOV said the therapy was incomplete. John and Yoko needed thirteen to fifteen months, he said, and counting the time in London they'd had between four and five.

Janov needn't have worried. Between group therapy sessions and frequent ice-cream binges—Janov had told them to indulge themselves in any whim—they both wrote new songs that reflected their primal experience. So when they returned to Tittenhurst in July, both began recording again, planning albums that eventually were released under the titles *Yoko Ono: Plastic Ono Band* and *John Lennon: Plastic Ono Band*. Both albums featured a lot of screaming.

Yoko's album was by far the more "primal" in a way; John's was true to the Janov message and more commercially accessible. John confronted his relationship with his parents in his songs and dissolved into heartbreaking cries and yells, but he never abandoned melody and lyrics. Yoko, on the other hand, merely wailed, producing her best screaming to date against an insistent and sometimes haunting instrumental backdrop, provided by Klaus Voorman, John, and Ringo Starr on drums.

In a way, Yoko actually "topped" John in her effort to show her soul. John was never more personally revealing. One song dealt openly with the rejection he felt from his parents. In another he denied loyalty to magic, the *I Ching*, the Bible, the tarot, Hitler, Jesus, Kennedy, Buddha, mantra, (Bhagavad) Gita, yoga, kings, Elvis, Zimmer-

131

man (Dylan), and the Beatles, in that order; all he had left was himself.

Yoko's songs were far simpler, more direct. They carried titles that were by now fairly predictable, either enigmatic ("Why," "Why Not") or self-pitying ("Greenfield Morning: I Pushed an Empty Baby Carriage All Over the City"), but offered no melody or lyrics, only haunting and swooping bleats and yowls—cries of pain that John was only *beginning* to express.

More than two months passed and seldom during that time did Yoko or John leave Tittenhurst. They had, by now, everything they needed there: a state-of-the-art recording studio, editing rooms for their films, darkrooms for photographic projects, and every sort of office appliance, including paper shredders and Telex machines.

Tittenhurst seemed, in a way, to be the home of a rich hippie gone slightly mad. By now, most of the remodeling was complete, with half of the house decorated completely in white (including a £100,000 [$40,000] rug imported from China), the other half in black, a demonstration of Yoko's fascination with the concept of yin and yang.

Many of the rooms remained empty—partially the result of Yoko's minimalist attitude, partially John's not caring—and others contained only piles of personal history: bags of stuff from the long-closed Apple boutique; Yoko's art pieces from several exhibitions, scattered in broken disarray; posters and framed photographs and antiques that were purchased whimsically. Books and records and musical instruments were abandoned everywhere.

An expensive intercom system connected all the rooms, although no one was ever in most of them.

There were more than two dozen telephones and upward of five different telephone numbers; sometimes Yoko and John couldn't say what their telephone number was when asked, because there were so many and the numbers had been changed so often.

Yoko was growing bored. She told John she wanted to live in New York again. John said he had no visa to go to New York. Yoko told him to get one, or she would go without him. At the same time, she dispatched Derek Taylor to New York to talk to several of the hip movers and shakers. She wanted a reading, she said. She wanted to know if people in the world of art and culture had forgotten her.

So Taylor went to Manhattan to talk with poet Virgil Thompson; with *New York Post* columnist Al Aronowitz (who had interviewed the Beatles in the early days and claimed to be Bob Dylan's friend); with *Village Voice* columnist John Wilcock, who knew Yoko from her days in the loft; with her dear friend, filmmaker Jonas Mekas, who had

invited her to start producing a series of films to be shown in the theater where he worked. Taylor thought it rather strange that Yoko didn't want to talk to her friends herself, but he went and asked, and everyone said she'd be most welcome if she returned.

As Derek Taylor conducted his survey of Yoko's friends, Allen Klein and others were working at getting John and Yoko new visas, and in November, after completing the two Plastic Ono Band albums, the Immigration and Naturalization Service finally relented and the visa applications were approved, so long as John agreed not to seek employment (therefore depriving an American of a job).

Yoko was "home" again in New York on November 26, and within days was again entertaining the press from her hotel bed and planning two new films. For the films, she and John sought outside help, going to Yoko's old friend Jonas Mekas.

Mekas was still holed up in the south Village, running the Anthology Film Archives, a sort of museum of art and avant-garde films that were sometimes rented by small theaters and universities. One of his employees was a tall Ohioan named Steve Gebhardt, who, while running the Cincinnati Film Society a few years before, had shown Yoko's *Bottoms* film, awarding her her first prize money, $50.

The Lennons arrived at the archives unannounced and swept through the outer office with their entourage and into Mekas's office. Mekas brought in Gebhardt and the Lennons hired him on sight. He then called a friend in Cincinnati, Bob Fries, who joined him, and within three days they were filming. Yoko told them they had only a month to prepare the two films; she wanted a showing in December.

Conceptually, both films were simple. One, to be called *Up Your Legs Forever*, was, like *Bottoms*, to show 300 or so individuals nude. The only difference was that this time the camera wasn't stationary; instead, it was to pan up from the feet to just below the genitals, so that when the film was complete there was a long series of leg shots. The second one, *Fly*, was to show a fly crawling over the anatomy of a sleeping nude female. The first film was chaotic in its production, the second strange and hilarious.

For two days all the secretaries at Allen Klein's New York office were diverted from their normal duties to call hundreds of people to ask them to contribute the use of their legs in a film John and Yoko were making "to promote peace."

"They rented one of the ABC television studios in Manhattan," Gebhardt said, "and sent out for a hundred hamburgers, a hundred cheeseburgers, and a hundred black-and-white malted milks. One by

one, people stood on a podium. The camera was on an electric dolly. Fries was running a tape machine, getting the random comments, while John and Yoko sat nearby. John was taking pictures with his Nikon, forming a collection of naked celebrities. There were a lot of underground filmmakers, people like Shirley Clarke and Jonas (who wouldn't take off his underpants), plus *Rolling Stone*'s publisher Jann Wenner and a lot of people from Andy Warhol's group. It was a real sideshow, and it was endless. We filmed for two days and two nights without stopping, while John and Yoko sat there in director's chairs, chain-smoking."

May Pang, a young secretary then working for Allen Klein, was drafted to come to the studio, where she continued the phone-calling process even as filming began, working now with Yoko's personal telephone book. In this way, the legs in the film came to include painters Robert Rauschenberg and Jasper Johns as well as old friend John Cage.

The subjects were first asked to sign a release, and then they were sent to a small dressing room where they changed into a robe. When the subject was in place on the podium, Dan Richter gave the person the choice of lifting the robe or dropping it, at which point the filming began.

May Pang later wrote that "as one woman raised her bathrobe Yoko leaned forward to study her legs. 'Move your toes closer together,' she said. The woman obeyed. 'Hold the robe higher.' The woman raised her bathrobe. 'Do you think you could lift it a little higher?'

"The woman followed instructions. 'Your thighs are beautiful,' announced Yoko, glancing at John, who was clicking away with his camera.

"John smiled at the woman. 'You've got lovely thighs, my dear,' he said, 'but we need a little more leg on this.' "

When the film was finally edited, it included 333 sets of legs and ran an hour and fifteen minutes in length.

For the filming of *Fly*, Yoko and her crew moved into Danny Seymour's loft on the Bowery. Seymour was another filmmaker who, in exchange for the use of his space, was given the right to make a film of "the making of *Fly*," which eventually he called *Ono*.

Gebhardt and Richter were given the job of creating the proper environment. So they painted one corner of the loft white, brought in an expensive Oriental rug and an attractive bed, and then, with Yoko, they began to audition "actresses." Dozens came in and took off their clothes and lay face down on the bed as Yoko and the others looked on,

waiting and watching to see if the individual could remain absolutely still for a long time. Finally, Yoko selected a woman who had long fingernails and appeared to be in a state of total paralysis.

"The idea of the film came to me," Yoko told *Rolling Stone*, "when I thought about that joke where someone says to a man, 'Did you notice that woman's hat?' and he's looking at her bosom instead. I wondered how many people would look at the fly or the body."

Flies had been rounded up by friends and were kept in a jar. Both cameras were equipped with a close-up lens, essentially a portrait lens, which allowed a filmmaker to fill an entire frame (or theater movie screen) with something the size of a dime. Gebhardt was behind the camera; Yoko and John stayed in a corner some distance away, talking. Right away there were serious problems. The flies wouldn't take direction.

At Yoko's order, a fly was placed on the woman's nipple. It flew away. Yoko frowned and asked that another fly be put in place. The same thing happened again and again, until nearly all the flies were gone.

Flies in winter are almost as scarce as acorns, so while several of Allen Klein's gofers and secretaries scoured the neighborhood restaurant kitchens for a new supply, Yoko and the others sat down to discuss the problem. Someone suggested painting the woman with honey. Then the fly would stick around.

They tried that, but the movement through the honey left unattractive marks.

Next they tried a sugar-water solution. The flies appeared totally disinterested and still flew away. At the end of the day they began calling around and finally found a place on Long Island that raised flies for scientific experiments. A limousine was dispatched to pick up a thousand of them.

Meanwhile, the discussions continued. Yoko was determined to make this film and there had to be a solution. Finally, Dan Richter remembered something he'd learned while acting in *2001: A Space Odyssey*: Flies could be slowed to a crawl when sprayed with liquid carbon dioxide (CO_2).

Yoko wanted to know if the fly would then do what she wanted. Richter said the fly would do what the fly wanted to do, but at least it would remain in focus long enough to get a shot.

"Flies have no discipline," Steve Gebhardt complains today, remembering the frustration he felt at the time. "A fly would go up a leg and suddenly head inland and go out of focus. Yoko would be yelling

instructions from across the room. We were trying to accommodate her. But, I tell you, flies just don't give a shit.

"Yoko said put the fly on her pussy. I said the woman was having her period, there was a Tampax string there. She said, 'Take it out.' I told her to do it herself, and she did. And then we resumed filming."

Yoko insisted that the film end at dawn, with the fly finally leaving the body, then leaving the loft through a nearby window. For more than an hour they tried to make it happen, and finally Gebhardt gave up and had the cameraman move the camera up and away from the fly to the window, giving the *impression* that the fly had left.

In ten days Gebhardt and Richter and their friends produced and edited more than two hours of film, delivering prints to the Elgin Theater only hours before the screening of Yoko's films was to begin. The program included *Rape: Parts 1 & 2*, *Apotheosis*, *Fly*, and *Legs*—in all, more than four hours of film. At the last minute, Yoko and John decided not to attend.

Some said it was because of drugs again. May Pang said in her book, *Loving John*, that John was using heroin openly during the filming of *Fly*. Others confirm Pang's story and say Yoko was abstaining, but the problem was accelerating nonetheless.

Meanwhile, an interview John had given a few weeks before appeared in the December and January issues of *Rolling Stone*.

In it, John was more candid than he'd ever been, stripping away much Beatle mythology. The Beatles era was *Satyricon*, a party, he said. "I was an emperor. I had millions of chicks, drinks, drugs, power, and everybody saying how great I was. How could I get out of it? It was like being in a fuckin' train."

Finally, John said he didn't want to talk about the orgies and all that any more for fear of hurting Yoko, who was seated nearby.

Before the long interview was over John was asked why he couldn't be alone without Yoko.

"I can be, but I don't wish to be," John said. "There is no reason on earth why I should be without her. There is nothing more important than our relationship, nothing. And we dig being together all the time. And both of us could survive apart, but what for? I'm not going to sacrifice love, real love, for any fuckin' whore, or any friend, or any business because, in the end, you're alone at night."

Rolling Stone's publisher, Jann Wenner, asked John what he thought of Yoko's art. John was defensive. He said critics didn't like her because she was a woman, Japanese, and they blamed her for the

breakup of the Beatles, when in fact, "her work is far out, Yoko's bottom thing is as important as *Sgt. Pepper.*"

The interview ended with Wenner asking what picture John had of himself when he was sixty-four (a reference to the Lennon-McCartney song "When I'm Sixty-Four").

"I hope," John said, "we're a nice old couple living off the coast of Ireland or something—looking at our scrapbook of madness."

To every interviewer who came to the hotel bedroom John was equally gracious. Talking with Albert Goldman, a Columbia University English professor who covered the pop scene for *Life*, he said Yoko's vocal style "influenced my guitar playing a lot." (Asked for an example, John pointed to "Why" on Yoko's new album and defied Goldman to say which of the sounds were Yoko's voice and which were his guitar.) Then, talking with another interviewer from *Rolling Stone*, Jonathan Cott, John said Yoko had "a sixteen-track voice" and claimed he was "overawed" by her talent.

"I think, fuck, I better watch out, she's taking over," John said. "And I say, 'Are you taking over?' And then I say all right, all right, and I relax again. I mean, she's going to haul 375 legs and make a bloody film about a fly crawling over some woman's body—what is that? But it's all right, I know her."

Yoko was present at all interviews, of course, and although she seldom was asked direct questions, she contributed because John always allowed her the space for it.

"An artist couple is the most difficult thing," she told Jonathan Cott. "On the David Frost program recently some guy was saying, 'I like to write music and my fiancée likes to write poetry.' The fact is that we both paint, compose, and write poetry and on that basis I think we're doing pretty well."

However supportive John was, and however confident Yoko seemed to most outsiders, it was clear that she still felt enormously overshadowed, as anyone married to a Beatle would. Never was anything she created—a film or *Grapefruit*, for example—reviewed without her being identified as John Lennon's wife. Sometimes the insecurity she felt was candidly revealed, as when May Pang confronted her during the filming of *Fly*.

"Yoko was standing near me," May wrote, "staring into my face. I smiled at her, but even though she knew I was looking at her, she ignored me. She said nothing. Finally she murmured, almost to herself, 'You know, I was famous before I met John.' Then she walked

away. It seemed as if Yoko had wanted me to eavesdrop on her own thoughts by creating the illusion that I wasn't there to hear. It was a very strange moment."

There were stranger moments back in London, where Paul McCartney filed a lawsuit to end his relationship with the other three Beatles. The court hearing began on January 19, 1971, and bumped along for more than two months. For much of that time, Paul, the only Beatle to testify in person, and his attorneys argued that Allen Klein was not to be trusted. As evidence, recent tax fraud convictions in the U.S. were marched out. Therefore, Paul protested, his own earnings and career were in jeopardy.

John, George, and Ringo submitted affidavits presenting an opposite view. Before Klein came along, John said, friends of the Beatles "robbed and lived on them," taking up to £20,000 a week, and nobody did anything about it until Klein became his manager. Evidence was further introduced showing that Klein had taken only £60,000 [$150,000] from the band although the Beatles' earnings had jumped by £9 million in the year and a half since they had signed an agreement with him.

The charges flew back and forth, and as a result, the relationships between John, George, and Ringo deteriorated along with those between Paul and the rest. Most impactful of all, from John and Yoko's point of view, was testimony given the end of February when Paul quoted both George Harrison and Allen Klein as blaming Yoko for the Beatles' split.

In a statement read in court on February 26, Paul said one of the reasons George left the group was "he could not get on with Yoko."

Worse, Paul claimed Allen Klein had told him on the telephone that "the real trouble is Yoko Ono. She is the one with ambition." To this, Paul added the thought: "I often wonder what John would have said if he had heard that remark."

In the end, virtually everything went Paul's way. The judge ruled "however successful Mr. Klein may have been in generating income, I am satisfied, on the evidence of the accountants and the accounts to which I am referred, that the financial situation is confused, uncertain, and confusing." Thus, he said, a "receiver" was to be appointed by the court to "produce order" and "manage the business fairly between the partners." What this meant was that all the Beatles assets were put into untouchable accounts and thereby "frozen" while a court appointee tried to dissolve the partnership amicably.

As is customary in England, the court also ruled that the "losers"

in the case—John, George, and Ringo—were to pay the "winner's" court costs, about £40,000 [$100,000].

By now, Yoko and John were at the opposite side of the planet, visiting Yoko's family in Tokyo.

This began six months of travel that would be among the most dramatic in Yoko's dramatic life.

15

*Don't
Worry,
Kyoko*

B Y MOST ACCOUNTS, Yoko's reunion with her parents was polite but awkward. In large part, the awkwardness was Yoko's fault. Not only did she fail to tell her parents she was coming to Japan—surprising them with a telephone call from the Tokyo Hilton—but when invited to tea, she and John arrived dressed inappropriately.

Yoko's father, now sixty-seven, was retired from the Bank of Tokyo and was living with his wife in a spacious home in Fujisawa, 35 miles southwest of the city. When they entertained guests, they used their silver service and dressed formally. For the arrival of their first daughter and her new husband, they decided to dress "down," and so appeared in somewhat informal wear as the chauffeured limousine arrived at the house's gated entrance. Eisuke was wearing a sport shirt open at the neck and a suede coat with a leather collar. His wife, Isoko, wore a nice dress.

Yoko and John were playing the hippie role to the very hilt. John was wearing rumpled U.S. Army fatigues and Yoko was wearing a man's shirt and jeans, also rumpled.

Yoko and John and her parents exchanged formal pleasantries. When John walked in the garden with Yoko's mother, he was most charming; he said the Yasudas were a beautiful family, and when Isoko suggested that John convince Yoko to pull her hair away from her face and wear it in a bun in traditional Japanese style, John merely smiled and said, "How does one *convince* Yoko?"

And when Yoko sat with her father to talk about John, and Eisuke

seemed upset by John's long hair and beard, Yoko said, "What do you think of the *person*?"

Her father asked a question back: "What do *you* think of him?"

Yoko said she loved him, and Eisuke responded, "Then I think well of him."

The next day, Yoko's mother talked briefly by phone to the press. She said she and her husband were much impressed by Lennon-*san*. She said he refused to sit in chairs and sat cross-legged on tatami mats and drank *o-cha* (tea) and talked.

"Most of the time it was about Yoko's brother and sister," Mrs. Ono said, "but we also talked about her home in England. It sounds beautiful. We would love to go there, but I'm afraid we are too old."

For the remainder of their six-week stay in Japan, the Lennons remained in the hotel—where they were registered as "Mr. and Mrs. Gurkin"—and took day trips by limousine and train to see the sights. Yoko derived great pleasure introducing John to the neighborhoods of her past, and they left Japan, in March, feeling good.

The good feeling was reduced somewhat the same month when, on March 12, Apple released John's new single, "Power to the People." As usual, the second song was one of Yoko's, her fourth Plastic Ono Band "B" side, "Open Your Box."

When the people at EMI, the company that distributed Beatles records, heard the song, they refused to release it. She told people to open their windows, closets, bottles, and flies. Finally she told John to open his legs.

EMI managing director Philip Brodie said the lyrics weren't obscene, but certainly distasteful.

Yoko acquiesced and agreed to go into a studio to record a substitute line. And in America, when "Power to the People" was released, the back side was "Touch Me," a cut from her *Plastic Ono Band* album, selected largely because it was short enough to fit.

□

But there was something nagging Yoko. However satisfying her reunion with her parents, the very act of re-creating a family situation had increased Yoko's longing for Kyoko. More than a year had passed since Yoko had seen her daughter—in Denmark—and since then Tony and his wife and Kyoko had totally disappeared.

John hired private detectives and finally some word came back. On April 23, Yoko and John flew to Majorca, where, they told Allen Klein and Dan Richter, Cox and his wife were enrolled in a meditation

course being taught by—of all people—the Maharishi Mahesh Yogi.

Klein told Yoko that "possession" was nine-tenths of the law and so long as Cox had the child physically, he had the upper hand. To which John responded, "Then maybe it should be us with the possession."

Yoko was aghast. "You mean *take* her?"

John nodded.

"Let Tony do the chasing for a while," Klein said.

Richter drove the rented car to the school where Kyoko was being watched while Tony was in class. Kyoko was in the playground when they arrived and on seeing her mother, ran up to her. John and Yoko quickly shepherded her into the car.

"Where's my daddy?" Kyoko asked.

The child was whisked to the major village on the island, Palma, where Yoko and John took her to their hotel room while planning their flight home to London. Yoko noticed that Kyoko seemed feverish and John called the hotel doctor. By now the child's disappearance was reported to the police and Cox filed a kidnapping complaint. Less than two hours after they took the girl, police arrived at the Lennons' hotel room and invited everyone to come with them to police headquarters.

There they confronted Cox, who accused them of abducting his daughter. Yoko and John countered by saying that was ridiculous, how could a mother kidnap her child? Tony shouted that Kyoko was in his custody. Yoko responded that Tony didn't *have* custody of Kyoko—no one did; when they divorced in the Virgin Islands, neither parent was given custody.

The police broke up the shouting match and separated everyone to take formal statements. Several hours later, Kyoko was temporarily turned over to her father, and Yoko and John returned to their hotel to plot a legal strategy. A local attorney was hired and another was flown in from London, accompanied by someone from Apple.

On April 25, all parties returned to the Palma court, where Yoko and John were told that they would have to report to a magistrate on the first and fifteenth of each month while the kidnapping allegation was being investigated. Promising to return whenever they were wanted, they then flew with their entourage to Paris and then to London.

The Coxes remained in Majorca with Kyoko, and the Lennons flew to the Virgin Islands to collect documentation showing the "open" custody. On May 5, everyone was back in Palma and, following a brief hearing in court, the judge dropped all charges against

Yoko and John, after which the four adults were coaxed into a some-what tense but generally friendly meeting by Allen Klein.

Klein suggested "joint custody," an agreement then gaining mo-mentum in the U.S., whereby the separated parents of a child would take turns being with the child on a prearranged schedule.

"The Coxes were told," Klein told the press, "that if Mr. Cox does not agree, the Lennons would have to take the matter to the Virgin Islands, where Yoko's divorce took place and where, in all probability, Yoko would get complete custody."

According to Dan Richter, that "tore it" for Tony Cox. Yoko talked with her daughter on the telephone while in Majorca this time, he said, but that was all. "Tony didn't want Kyoko to see her mother without him present. I think Yoko was more bothered about not being *able* to see her than not seeing her. And Tony used Kyoko as leverage. Whatever good feelings were left after the accident in Scotland and after that strange meeting in Denmark fell completely apart in Majorca. As far as John and Yoko were concerned, there would be no more money for Tony, and as far as Tony was concerned, no more visitation for Yoko."

On May 8, Yoko and John returned to London, and Tony and his wife and Kyoko disappeared again.

As the Lennons' pack of private detectives went back on the case, it was time for Yoko and John to resume their mutual careers.

By now, Yoko had built up a substantial body of recorded material. Counting her *Plastic Ono Band* album and the last single—the one that backed John's "Power to the People"—Yoko had been featured on or dominated five albums and four singles. This was more than most performers recorded in a lifetime, and Yoko had done it in under three years.

No matter what anyone thought of it, and no matter that the body of work existed largely because of John, it was *there*, it filled up bins in record stores, and it went home with people who were curious. Conse-quently, she could not be ignored.

These were not pop songs in the strictest sense, and, generally, the critics either dismissed them or, worse, ignored them. The backing instruments, and instrumentalists, may have been familiar to pop mu-sic critics, but the improvised cries and yowls were totally alien and therefore disregarded. Only Jonathan Cott seemed to recognize, and acknowledge in *Rolling Stone*, what Yoko was trying to do.

In her interview with Cott, Yoko talked about her "Who Has Seen the Wind." There was something "of a lost little girl about it," she

said, a sense of "quiet desperation." Cott appreciated what Yoko was saying and himself added that "religion, a philosopher once said, is what you do with your aloneness . . . or, one might add, with your pain and desperation. Yoko's music pushes pain into a kind of invigorating and liberated energy, just as a stutterer finally gives birth to a difficult word, since it existed originally at the fine edge between inaudibility and the sound of waves of dreams."

About her music for *Fly*, Cott said, "It's almost like going into a dream, getting something that doesn't exist in the physical world, unutterable sounds—a kind of metaphysical rhythm."

Such appraisal gave Yoko little comfort. Cott was alone in the avant-garde wilderness, and the lack of acknowledgment from others made his voice seem all the lonelier.

At the same time, the record company—Apple—gave only slight support, accepting her songs on the singles because John insisted. To date, she had never had a two-sided single of her own. And although she was allowed to release albums—again to placate John—they sold poorly and the distributor invariably did its best to discourage any further efforts. For example, *Yoko Ono: Plastic Ono Band* peaked at No. 182 on America's *Billboard* chart and didn't appear anywhere else, not even on any of Britain's best-selling lists. Thus it was well-known that whenever Yoko's name was mentioned in the sales and promotion departments at EMI, it was greeted with self-pitying groans.

In a few months' time, opinion would shift somewhat, and Yoko would get some of the reward she sought, but first the spotlight was focused on John again as he recorded *Imagine*, his most popular album since leaving the Beatles—of course, Yoko was involved every step of the way.

"The title song was originally inspired by Yoko's book *Grapefruit*," John said. "In it are a lot of pieces saying 'Imagine this, imagine that.' Yoko actually helped a lot with the lyrics, but I wasn't man enough to let her have credit for it. I was still selfish enough and unaware enough to sort of take her contribution without acknowledging it. I was still full of wanting my own space after being in a room with the guys all the time, having to share everything. So when Yoko would even wear the same color as me, I used to get madly upset: 'We are *not* the Beatles! We are *not* fucking Sonny and Cher!' "

The recording began in the studio at Tittenhurst Park, where Yoko reportedly kept telling the musicians that they could not deviate from John's written score and then turned around and told John that he

should let Nicky Hopkins play piano on "Imagine" because he was the better pianist.

Suddenly, on June 2, recording was interrupted and the Lennons flew to New York, drawn by a report that Tony and Kyoko were spotted visiting his parents on Long Island. Talking with the press, they said they already had spent between $100,000 and $125,000 on the search and were willing to spend whatever more it cost. By the time the Lennons arrived in Allen Klein's office, he had hired a team of private detectives and had an attorney on retainer. But Tony and the child had disappeared again.

With visas good for another nine months, Yoko and John decided to remain in New York, moving into a large suite in the Park Lane hotel, which they used as headquarters for the search while resuming recording of the album at the Record Plant.

It was here, while recording backing vocals for some of the songs, that Yoko got to know two young women who would be a part of her life for several years. One was Arlene Reckson, the Record Plant's receptionist, who was drafted by John to help Yoko shop. The other was May Pang, one of the young secretaries in Klein's office whom she had met during the filming of *Up Your Legs Forever* and *Fly*.

In her book May Pang said that Yoko had no interest in clothing and wore the same clothes day after day. John wanted her to dress more fashionably, and so Yoko was taken to an assortment of the better shops, including Bonwit Teller, Bergdorf Goodman, and Bloomingdale's.

Friends say that Yoko at first shopped reluctantly, genuinely not caring how she looked. In time, however, she began shopping with John. Their chauffeur took them to the boutiques on East 60th Street and then downtown to an herb shop where Yoko found her favorite perfume, essence of apple, with which she drenched all of her clothes.

Their shopping technique consisted of Yoko trying on things to see if they pleased John. When she found something that he liked, she bought it in every color. If they did not have a color in her size, she'd buy the item in a size smaller or a size larger.

With the *Imagine* album sessions complete, the Lennons decided to return to Tittenhurst, where they planned to film a leisurely sequence of silent scenes, to be accompanied by the songs from *Imagine* and *Fly*, to comprise a ninety-minute "video."

The Lennons hadn't abandoned filmmaking in the first half of 1971. They had merely put it on a shelf, and insiders say that they were

anxious to get back to it in part because of the rude reaction they had received when they took *Apotheosis* and *Fly* to Cannes in May where they were presented to their first world audience at the Filmmakers' Fortnight Festival, which ran concurrently with the main Cannes Film Festival.

This "underground" festival was composed largely of film buffs who, as the *New York Times* put it, "express uninhibitedly their reactions to films being screened."

Certainly this was true in the Lennons' case. When the balloon stayed largely in the clouds without any sound for eighteen minutes in the first showing, the audience roared its discontent so loudly that when the lights came back on, John was seen beating a fast retreat. Yoko came stumbling along behind.

Fearing a repeat reaction, Yoko hastily cut thirty minutes from *Fly*, so that when it was screened later in the day, it was only twenty minutes long. This time the audience greeted her work with laughter and whistles every time an identifiable piece of anatomy came into focus.

Yoko was incensed at the reaction her films had received. So was John. "Fucking university bums!" was his response.

Yoko said she wanted to leave Cannes immediately, and she knew her decision was the right one when, as they were checking out of the hotel, some young men who identified themselves as underground filmmakers asked them to finance their next project.

"I'm not a walking charity, you know!" John said. Yoko said nothing and led the way to the limousine.

Many of the sequences in *Imagine* showed real effort, largely thanks to Steve Gebhardt, who at the time was being paid only $100 a week by Allen Klein. At Yoko and John's request, Gebhardt followed them to England with all of the film exposed during the making of *Fly* and a large suitcase full of John's snapshots. (As for Yoko and John, they had arrived in New York with two suitcases and returned to Tittenhurst with three suitcases and five large steamer trunks, four of them filled with clothes, one of them containing only shoes.) His first assignment: catalog everything. His second assignment: create a film that made John look like Errol Flynn and Yoko like Rita Hayworth.

In the late 1960s and early 1970s, many rock performers indulged themselves by making quasi-autobiographical films, partly out of a genuine desire to expand their creative base, but mostly because they had egos to stroke and money to burn. *Magical Mystery Tour* was a

perfect example. So, too, the Rolling Stones' *Rock and Roll Circus* and the Doors' self-indulgent *Feast of Friends*. None of these earned wide distribution—in fact, all resembled home movies of interest only to the most avid fans.

Imagine seemed to be another example of the same genre. In one sequence, Yoko and John changed costumes several times, were driven away from the house in a hearse, rowed a boat to the man-made island in the middle of their man-made lake, and began a game of chess as the camera, which was mounted on a helicopter, ascended into the sky.

In another scene that accompanied the title track, John sat at the piano and played the song while Yoko opened the shutters in the room one by one, slowly turning a dim space into an environment glowing with morning light.

And then they returned to New York, where many of their friends were invited to join them in finishing the film. Thus, Jonas Mekas directed one scene, and Miles Davis was seen shooting baskets in another. And in still another, after discovering that Fred Astaire was staying at the same hotel, they enticed him to enter a room for them.

According to those present, none of it was easy. May Pang remembers most vividly the interminable waits in England while Yoko made up her mind which costume to wear. And Steve Gebhardt recalls a sequence filmed on Staten Island in New York where "Yoko reduced me to tears."

"This was the sequence over which we planned to run the credits of the film," Gebhardt says. "John wrote 'I love Yoko' in the sand and Yoko wrote 'I love John' and the tide came in and washed the words away. And she got on my case. I think it had to do with our relative size. I'm six-feet-six and she's just over five feet and she got really bossy. We had to shoot over and over again and she kept telling me what to do and finally she had me in tears. John came over and took me for a walk on the beach and gave me a pill.

" 'What's this?' I said.

" 'It's okay,' John said. 'Just take it.'

"Later he told me it was methadone. He gave it to me to calm me and after that I had no problem with Yoko.

"But of course that wasn't the end of it. We worked on *Imagine* for months and months cutting it. We completely burned out the editor, my friend Bob Fries. Yoko would hang over his shoulder, directing every cut. It's very difficult to be directed frame by frame. All I remember is Yoko barking out instructions: 'Cut film here!' When it

was all over, Bob didn't sit at an editing machine again for ten years."

In July, long before *Imagine* was finished, the battle over Kyoko heated up again as Tony Cox, surfacing in Houston, Texas, filed a lawsuit to "confirm" his custody of the child and to halt "harassment" by Yoko and John, a reference to their persistent detective work.

In his suit, Cox claimed he had been given custody of Kyoko when the divorce was granted in the Virgin Islands in 1969 and again in Majorca just three months before. He also claimed that "no child could responsibly or sensibly be brought up" in the Lennon life-style.

This sent the Lennon lawyers scrambling in three directions at once—to Houston, to Majorca, and to the Virgin Islands, where on July 13 Yoko filed a new petition for permanent custody, saying that the issue of custody had never been settled.

Meanwhile, she and John had until July 22 to appear in a Houston courtroom to answer Cox's claims. Delays were granted to prepare their case, and the Lennon detectives began scouring the Texas city in a futile attempt to find Cox (who never appeared in court and whose only address was that of his attorney, who refused to divulge his whereabouts).

As all this was going on, George Harrison organized a much-publicized benefit concert for the flood-ravaged Bangladesh. Early in the planning stages, John was invited to participate. Bob Dylan, Eric Clapton, Leon Russell, and Ringo Starr already had agreed to perform. John wanted to know if Paul McCartney had been asked.

"He was asked," said Allen Klein, "but he declined."

"I don't want anyone to think the Beatles are getting back together," John said.

Klein assured him that he would appear with his own backing group.

"With Yoko, too, of course," John said.

"Of course," Klein said, "of course."

But George Harrison refused to hear of it. He didn't like Yoko when she first appeared with John three years before and he didn't like her now. And he *abhorred* her music. So he told John definitely not, explaining that the concert was to raise money for a good cause; it was not, he said, a showcase for Yoko's avant-garde singing any more than it could be a showcase for the Lennons' peace propaganda.

John said yes, he understood, and he told Yoko that she would have to remain in the wings the night of the concert while he put in a "friendly Beatle" appearance.

Now it was Yoko's turn to shout. Friends say she bellowed a vigorous no that made Harrison's earlier rejection of her seem affable. Before it was all over, John became so angry he crushed his eyeglasses in his fist and stormed out of the hotel room, taking a taxi to John F. Kennedy International Airport where he caught the first plane home to London.

Yoko followed a few hours later, joining John at Tittenhurst, where they quickly made up in bed. They'd intended to come "home" all along, hadn't they? John asked.

Of course they had, Yoko said, and now that they were in London, wasn't it a great coincidence that *Grapefruit* was being published in paperback.

Oh, said John, that's why we're here.

It was something they'd planned all along, and for the next week they entertained the press in the Apple offices on Saville Row.

If the critics and journalists failed to take her as seriously as she wished, Yoko still found comfort in the amount of attention she and *Grapefruit* got. Even the book's cover—showing naked legs and buttocks stuck into what appeared to be a toilet bowl—was reproduced in several of the papers.

When the Lennons appeared at book-signing events in stores, crowds formed. At Selfridge's, one of London's leading department stores, a 6-inch thick wooden "crush barrier" was bent and then broken under the pressure. One man bought a dozen copies, which didn't reach Yoko for her signature. The books were last seen scattered on the floor, being trampled by other customers.

Some writers actually said nice things about the book—"genuinely worth pondering" said the *Record Mirror*—although most were noncommittal, dealing with the book and Yoko as a couple of eccentrics. England encouraged eccentricity and in the Lennons' case rewarded it.

Yoko loved the attention, and in the two weeks they were in London, she and John plotted a massive public relations campaign to change her image in America when they returned in August.

In part, this plan was prompted by an article in an American magazine, *McCall's*, which appeared in July, headlined "The Two Women Who Broke Up the Beatles." The other woman was Linda McCartney, of course, but if Yoko derived any pleasure from Linda's sharing the so-called blame, it faded quickly when she read what *McCall's* had to say about her art.

"Since childhood there had been Yoko's art, a nihilistic art rooted in Dada, but with a lovely imaginative intelligence," the writer said. "It's themes were voids hiding (Concert piece: 'When the curtain rises, go and hide and wait till everybody leaves you. Come out and play'). Masks, dismemberment, sleep and escape. Her art was arrogant. Like a character out of R. D. Laing's *Knots*, Yoko was perverse—once hurt, she lashed out to shock and be hurt and rejected again."

However perceptive the comment, Yoko hated it. She also hated the rest of the article, where her recent efforts with John to promote peace were dismissed as "the Public Pajama Year" and when the writer, in describing what happened when John first took Yoko to meet the other Beatles, wrote, "Moral scorn bounced from the white walls. Paul and George looked at Yoko as though she were the Dragon Lady with a dagger in her garter."

John was even angrier than Yoko. "The Dragon Lady!" he shouted. "Jesus fuckin' Christ, man! It's time this fuckin' stopped!"

Back in New York, the Lennons occupied three suites in the St. Regis hotel where, for two weeks, they entertained the rapacious press.

Their plan was simple, but effective. When a reporter arrived, he or she was greeted by May Pang, who chatted for a while, discerning any prejudices. She then left the room and reported her findings to Yoko as John went in to talk about how misunderstood his wife was, defending her against all the ugly rumors that she had broken up the Beatles, etc.

Finally, Yoko came out and joined the interviewer and John. And soon after that, John left the room, leaving Yoko in charge.

"Yoko had watched John, whom reporters always found funny and likeable," said May Pang, "and during her own interviews, she played the role of a charming, likeable, subdued woman. All the journalists who met her told me afterward how, despite their preconceptions about her, they found her to be a lovely human being."

Imagine and *Fly* were being released in a few weeks, in September, and the interviews were, of course, designed to promote record sales, but also to announce Yoko's first major exhibition in several years, since she and John had co-produced the "Half-a-Wind" show in 1968. Yoko told everyone that this new show, at the Everson Museum in Syracuse in upstate New York, would be her biggest and most important, an exhibition of all her best ideas, executed by her friends.

Again her plans were interrupted by the custody fight when, on September 28, Tony Cox entered a Houston courtroom and testified that he had lived in fear of his wife throughout their marriage. She had stabbed him in the heel with a pair of scissors, he said, and on another occasion had held him for forty-five minutes in a bathtub with a broken bottle at his neck.

As for John Lennon, Cox said that he "seduced my wife and got her on drugs" and then took a bath with little Kyoko and had the bath filmed. A home movie showing John in a tub in Tittenhurst with Kyoko, then aged five, was entered in evidence.

"I think it's immoral for a daughter to see her father in the nude at any age," Cox said.

By now, the court in the Virgin Islands had approved Yoko's petition for custody and that fact was one of the first entered into evidence by the Lennons' attorneys, along with the judge's written opinion that they were fit parents.

The judge said of the Lennons, "They are in obvious good physical and mental health, and it is certain they manifest none of the symptoms of persons addicted to hard drugs. And I cannot conceive that it would necessarily follow that a person who models in the nude for a livelihood ipso facto becomes an unfit parent."

Furthermore, the judge in the Virgin Islands said, a letter written by Kyoko to her mother—in which she said, "Why do you give us so much trouble? It makes me afraid when I live with you"—had obviously been prompted by Cox.

Yoko's attorney in New York also argued that communal bathing was a Japanese custom, so ordinary in Japan among family members that it didn't even deserve mentioning. He even got Cox to admit that he participated in a nude event at a film festival in Belgium, for which he and Yoko were arrested. Cox also acknowledged that he had worked on *Bottoms*. Cox insisted, however, that he had subsequently changed his mind about nudity.

The next day, September 29, 1971, Judge Peter S. Solito ruled that the decision of his court would take precedence over that of the Virgin Islands court. He then awarded Cox and his wife temporary custody of the eight-year-old child and extensive visiting rights to Yoko. Among other provisions, the court order gave Yoko the right to take her daughter with her for ten days at Christmastime, with the stipulation that the Lennons post a $20,000 bond to ensure Kyoko's return and that they come to Houston for a weekend beforehand "in order to reestablish a relationship with the child."

The parties sat across from each other in the courtroom. Cox's lips were turned up in a small, satisfied smile. Yoko sat impassively, silent and motionless, her hands folded on her lap, staring straight ahead.

Kyoko was nowhere to be seen.

16

To
the
Barricades!

THE LENNONS returned to New York from Houston to throw themselves into frantic final preparations for the show at the Everson Museum in Syracuse.

However glum Yoko remained about the loss of her daughter, she admitted she was excited by the activity. It was as if the work distracted her.

Twice in the past year she had been asked to mount an exhibit of her works, but neither time were the terms acceptable. One of the galleries had even asked *her* to pay the cost. She had not been reluctant to do that in the past—using John's money or, in the years before, using Paul Krassner's money or any money she could find—but now her ego demanded more.

"I don't want to be a Gloria Vanderbilt," she told friends, referring to the millionairess who often paid for her showings.

So when the Everson Museum invited Yoko to mount a retrospective on October 9—John's thirty-first birthday—and agreed to pay all costs involved, Yoko accepted immediately. However, with only a month to prepare what normally should take six months to a year, Yoko decided that a one-person show was unthinkable, so she would have to ask her more artistic friends to join her. To assure attendance by the media, invitations to the opening went out at the same time.

May Pang remembers the Allen Klein staff working late into the night to address a thousand invitations, each of which was submerged in a small plastic bag filled with water because the show was what Yoko was now calling a "water event."

"Five hundred artists and celebrities had been asked to contribute a water piece to the show," May wrote in her book, "and Yoko told me to nag them until their contributions were delivered to Syracuse. I had to call John Cage, Dick Cavett, Ornette Coleman, Willem de Kooning, Bob Dylan, Henry Geldzahler, Dennis Hopper, Jasper Johns, Paul Krassner, Spike Milligan, Jack Nicholson, Isamu Noguchi, Andy Warhol, and Frank Zappa to ask them where their water pieces were.

"After much persuasion, compasses, steam engines, poems about water, test tubes filled with colored water, India ink bottles, microphones immersed in tanks of water, Mason jars, ice cubes, fish tanks, a refrigerator, and stacks of blotting paper began to pour in. . . ."

Bob Watts, an old friend from her Fluxus days, contributed a Volkswagen convertible full of water—top down and full of fish. (All of them died the first day.)

Ringo's contribution was a green plastic bag about the size of two pillows and filled with water; under it was a message identifying the bag as a sponge from Greece. John's object was a strange pink mass inside a plastic bag and labeled "Napoleon's Bladder."

Yoko's contributions included a "drip painting," which was no more than water dripping from a balcony into the bell of a saxophone equipped with a microphone; the amplified sound of the drip provided some of the "music" for the show, as did a toilet that played one of John's songs, "Working Class Hero," when flushed. There was also an ice sculpture in the shape of a giant "T"—called, of course, "Iced Tea."

The exhibit filled three entire rooms and was not limited to "water objects," but also included many items Yoko had brought to America from Tittenhurst. In addition, there were many new items, constructed by Yoko's old friend George Maciunas. These included glass hammers and an elaborate water bed that was installed under a skylight; it was called "Cloud Piece," and the instructions were: "Lie down and watch until a cloud passes from left to right."

Opening day was pandemonium. Yoko and John and many assistants had been up all night, knocking off at 9:00 A.M. for a few hours of sleep. By two that afternoon they were back in the museum, facing a solid wall of photographers and journalists who had been flown in aboard a chartered jet.

In all there were about 200 in the museum's auditorium when Yoko stepped forward—wearing black boots, black hot pants, a black sweater, black beret, and a brown plaid jacket—to deliver her opening remarks.

"In this show here, I'd like to prove the fact that you don't need talent to be an artist," she began. " 'Artist' is just a frame of mind. Anybody can be an artist, anybody can communicate if they are desperate enough. There is no such thing as imagination of artist. Imagination, if you are desperate enough, will come out of necessity. Out of necessity, you will start to get all kind of imagination. Even the best artist, if they don't have the necessity, they will be dried up and they won't have any imagination. So there is no talent, no professionalism, there's no nothing, only that people, billions of people in this world, every person in the world who's desperate for communication, the one kind who still don't know that they're desperate for communication, but they'll soon learn, and the minute they learn how desperate they are to communicate, they're gonna start communicating . . ."

On and on Yoko rambled. She was tired and making only a little sense, so when the floor was opened to questions and Yoko again started rambling, John gently cut her short by inserting a gracious "Thank you, next question" whenever she paused to take a breath.

When the doors were finally thrown open to the public, Yoko and John retired to a back room to be with friends who had come up from New York. Within a few hours, much of the exhibit was trashed. Objects were stolen. The glass hammers were broken, along with an expensive Venetian glass bowl contributed by Peggy Guggenheim. Water was spilled everywhere. And one of Yoko's paint-it-yourself black canvases exhibited a large heart with an arrow through it and the inscription "Paul and Linda."

Considering the chaos, the attention given Yoko during and after the exhibition was most generous. Although John was at her side for the press conference, it was Yoko who drew all but one of the questions. More important, most of the critical reviews that followed offered abundant praise.

The show was described as a "retrospective" and although it was, in fact, only partially that, *Newsweek*, the *Nation*, and several others all took that tack, reviewing not just the Everson Museum show but also her films and earliest conceptual works.

"The big world knows Yoko only as Mrs. Lennon," Douglas Davis wrote in *Newsweek*. "The much smaller art world knows better, but still not enough. Yoko has been a presence in the American avantgarde for more than a decade. An early friend of John Cage, a crucial member of the 'Fluxus' movement, which cooled off the first free-for-all happenings and turned them into quiet, personalized events, she has been a continuing influence on other artists through her concerts,

performances, films, 'paintings,' and writings. In every case, that influence has been reductive and meditative.

"Yoko's special talent is direction, not invitation. At her best, she focuses the eye gently upon tiny corners of the world, away from the center of the street. She slows down minds that are going too fast, making them listen, watch, feel. This is clearest of all in her film *Fly*, which relentlessly follows one insect hopping gleefully about a nude body. Of course, the academy will not call it art, but that is a positive benefit. When a colleague charged her with using celebrity to spread her work, she agreed: 'If I can't get anyplace in your special little world, I will try something bigger.' Now she is a media nomad, like her husband, John, and she is better off that way."

More and more critics *were* taking her seriously. Once back in New York, after celebrating John's birthday late into the night in Syracuse, she and John resumed their busy schedule of interviews, spending two hours in a television studio with Dick Cavett and hundreds of hours in their hotel room with writers from just about everywhere.

One of them was their old friend Ray Connolly, who headlined his long report home to the London *Evening Standard*, "The Way Yoko Is Coming Out from Behind John's Shadow."

Yoko *was* stepping out of her husband's shadow, and in October, November, and December, she began staging a bewildering variety of appearances and events that stretched from a tiny theater off-Broadway (where "A Grapefruit in the World of Park" was resurrected) to a studio at New York's Channel 13 (where she and Jonas Mekas loomed about for ninety minutes in a compelling and baffling attempt to explain conceptual art) to the prestigious Museum of Modern Art (where she staged an *imaginary* show).

For the latter event, staged in December, she placed an advertisement in the *Village Voice* with a picture of herself walking in front of the museum carrying a shopping bag with a big "F" on it. Inasmuch as she was posed beneath the word *art* in the museum's sign, presumably she meant to play a not-so-subtle joke about flatulence. In any case, the "show" itself consisted of a sandwich man who walked back and forth in front of the museum off and on for two weeks, wearing a sign that said a number of flies had been placed in a glass container as big as Yoko herself. Yoko's favorite perfume was then added to the container and the flies were released, then tracked all over the city by a photographer flown in from England. The pictures he took were then published in a book 12 inches by 12 inches, along with several instructions: "Go through the photos in this book and choose a spot you like.

Declare ownership of the spot. Send letters to your friends declaring your ownership.

"Visit the spot whenever you feel like and invite your friends. Keep the spot clean and tidy, or as you see fit. Every year, send a card to your friends reminding them of your ownership. . . ."

□

Now that Yoko was back in New York, she was feeling secure—or at least more secure than recently. This was, after all, *her* city, whereas London was more or less John's, and she enjoyed taking her husband on long walking tours—around the Village to show him where she had worked at the Paradox and where she had had her first gallery, then south to Chambers Street to show him the building where she had had her loft.

Yoko told John she didn't want to live in hotels any more. Someone told them about a vacancy at the Dakota, an old but fashionable apartment building overlooking Central Park that required interviews of prospective residents. John put on a suit. When Yoko appeared in her usual hot pants, a shirt unbuttoned down the front, John got vicious.

"You look a fuckin' whore!" he said in front of friends. "A tart!"

Without a word, Yoko left the room, returning moments later more formally dressed. John was in the midst of telling a joke.

In the end they didn't take the Dakota place, but moved instead into a tiny place in the West Village owned by Joe Butler, a member of the rock band called the Lovin' Spoonful. To Yoko's delight, it was adjacent to the building, on Bank Street, where John Cage lived and where, some years before, she and LaMonte Young had planned her loft concerts. The apartment—one of four in a four-story brick building—had only two rooms plus a kitchenette, but it suited the Lennons perfectly. They had lived comfortably in small flats before, and even when in large estates, they found they spent nearly all their time in a few rooms.

There was also a quiet, an isolation seldom found in Manhattan. The building was located on a cobblestoned street that ran into a small park at one end, so there was little traffic. And yet, it was only a five-minute walk to the heart of Greenwich Village.

John's new album, *Imagine,* was released in September and by the end of October was No. 1 on both the U.S. and British charts—his most successful album since leaving the Beatles.

Yoko's recordings were not doing so well. Her first two-sided sin-

gle, coupling two songs from *Fly*, "Mrs. Lennon" and "Midsummer New York," released in October, and the album *Fly*, which was distributed in December, both sold poorly and never registered on any chart anywhere. Her music just wasn't accessible. Even if she used John and a number of well-known friends and respected studio musicians—Eric Clapton, Jim Keltner, Klaus Voorman, Jim Gordon, and Bobby Keyes among them—the bulk of the four-sided album was difficult. One entire side was the soundtrack to the film *Fly*, music that was not helped by the removal of nude photography. Another three songs featured the Joe Jones Tone Deaf Music Company, which consisted of eight instruments that played themselves with a minimum of human assistance, constructed by Yoko's Fluxus friend Joe Jones. Other tracks presented the sound of a toilet flushing—another "oldie" from her Fluxus catalog—and the rings of a telephone, followed by Yoko's voice saying, "Hello . . ."

The reviewer in *Rolling Stone* was kind. "I don't believe Yoko's music is the music of the future, as some of her fans say, but it isn't noise, either, as some of her critics say," Tim Ferris wrote. "It is serious work, often rewarding of close attention, better listened to alone than in groups, and capable at its best of expanding one's idea of certain kinds of musical horizons. It has considerable potential, which is why I wish Yoko would start discriminating between what she can do and cannot do well. The results might well be more surprising than what she has done so far."

☐

Soon after they came to New York, while they were still in the St. Regis hotel, they were visited by two of Manhattan's most visible and outspoken political radicals, Jerry Rubin and Abby Hoffman. Rubin and Hoffman were two of the Chicago Seven, charged with disrupting the 1968 Democratic presidential nominating convention in Chicago.

They met the Lennons in Washington Square—John had been wearing American flag sneakers and clothing that appeared to be from a thrift shop, and Yoko was dressed in black. Afterward, Rubin said he was struck by John's sense of humor and Yoko's sincerity.

The Lennons certainly were no strangers to radicalism. By autumn 1971, after having witnessed their billboard and acorn campaigns draw little more than amused laughter, and after seeing plans for a peace festival sink into a sea of inflated egos and unkept promises, they decided it was time to take a more militant stance.

Back in March, in an interview in the *Red Mole*, England's most radical magazine, both had taken a strong antiestablishment position on almost every question they were asked—Yoko was especially firm on the subject of feminism—and for the pictures taken to accompany the interview, both wore *Red Mole* T-shirts (showing a cartoon drawing of a mole with one fist held aloft) and military-styled helmets bearing Japanese characters meaning "Peace."

About the same time the editors of another publication, a satirical underground monthly called *Oz*, were arrested on charges of obscenity. At issue was a copy of the magazine that appeared the year before with a lesbian drawing on the cover, with other drawings inside showing sexual acts and rats disappearing up vaginas—all contributed by teenagers. The trial that followed lasted longer than any other in British history, and when the editors were found guilty, the judge sentenced them to fifteen months in prison. In response to the verdict, John immediately wrote two songs, "God Save Us" and "Do the Oz," and in August, he and Yoko joined 1,500 protesters in a demonstration on London's busy Oxford Street—wearing their *Red Mole* T-shirts, carrying placards reading "For the IRA, Against British Imperialism" and shouting through a bullhorn, "Power to the people, power to the people right now!"

Back in America, while in upstate New York for Yoko's retrospective at the Everson Museum, they joined local Onondaga Indians protesting the takeover of part of their lands by the government for the construction of a freeway.

In New York City, for the first two weeks in their new apartment, they lived with their "landlord" Joe Butler, who remembers that they spent most of the day walking around the place nude, while John taught himself to type—typing "the most obscene things, like 'I'm sucking Yoko's pussy.' "

An early visitor to the flat was feminist Kate Millett, who said, "It was pretty frantic because there were these secretaries running around and the telephones were always ringing. But it was nice to get through the front room into the bedroom and just sit. The TV would be going—thank God they didn't have the sound on—and everybody would smoke dope and talk. Yoko would love it if you'd be there to see her. It must have been a little bit overwhelming to have so much attention focused on John Lennon. She held her ground. She was tough. So I would spend as much time with her as I could. We'd talk about what we ought to do, and what needs to be done—delightful pie-in-the-sky stuff. But a lot of it was serious, too."

In November, Yoko and John performed at a benefit concert in the Apollo Theater in Harlem to raise funds for the relatives of black prisoners who were shot a few months earlier in riots at Attica, the prison in upstate New York.

It was not a popular cause. Although it was later established that the ten guards who also died had been killed by other guards, first reports said it was the prisoners who had "slashed the throats of utterly helpless, unarmed guards," and that is what the public believed. It didn't matter that the guards had used dum-dum bullets that had been outlawed by the Geneva Convention.

When Yoko and John appeared on the stage of the Harlem theater with Aretha Franklin and performed to a sea of blacks, when John sang a song he had composed for the occasion called "Attica State," and when Yoko sang her feminist composition "Sisters, O Sisters," the Lennons were followed and photographed, and detailed reports went into the files of several local, state, and federal law enforcement agencies.

The surveillance had begun.

Rubin and Hoffman and other radicals were spending more and more time at the Bank Street address, where they plotted a massive rock and roll tour aimed at driving President Richard Nixon from the White House. They were planning to end the tour in August 1972 in San Diego, at the time of the Republican national convention, where it was certain that Nixon would be renominated.

Yoko and John agreed to "break in" their new act—with a street singer named David Peel on guitar, Jerry Rubin on thumb piano, and Yoko on a small "talking drum" that she beat with her fingers—in Ann Arbor, Michigan, at a benefit in December for John Sinclair.

Sinclair was a young activist, one of many during the sixties who used rock music to bridge the gap between the antiwar movement and the counterculture. He had managed a band from Ann Arbor, Michigan, called the MC5, and when Yoko and John agreed to come to his defense, it was because he was sitting in a Michigan jail, two years into a ten-year sentence, for selling two marijuana cigarettes to an undercover cop.

For a dope-smoking peacenik such as Lennon, Sinclair was the perfect cause. However, it didn't help his own cause when the others agreeing to appear included a veritable Who's Who in radical America; in addition to Jerry Rubin, there were three more of the notorious Chicago Seven—Rennie Davis and Dave Dellinger, two of the New Left's most experienced organizers and figureheads, and Bobby Seale,

chairman of the Black Panther party—plus poets Ed Sanders and Allen Ginsberg, singers Phil Ochs and Stevie Wonder, and a ragtag assortment of other political and sexual activists.

There were more than 15,000 in the audience in Ann Arbor's Chrysler Arena when the Lennons finally took the stage, following much rhetoric, at 3:30 A.M. They were wearing matching black leather jackets over lavender T-shirts that were decorated with cannabis flowers and the message "Free John Now." They performed four songs: "Attica State," "Sisters, O Sisters," a song about the Irish civil war, and finally, a new one called "John Sinclair."

Three days later, Sinclair was released from prison. Although it had nothing to do with the protest—it came as the result of a previously scheduled court hearing—Yoko was much encouraged.

"We hope you're the first," she told Sinclair on the phone (from the Record Plant in New York, where she and John were now recording). "We aren't going to stop until all brothers and sisters are freed from the prisons, inside and outside the walls."

Yoko had worked long and hard. She had done all the clerical work in organizing the benefit—the typing and most of the phone calling. And when David Peel, the poor street singer, came begging to be paid for appearing at the concert, she handled his middle-of-the-night, door-banging complaint. She and John had performed for only fifteen minutes and the music was, charitably, rough. Nonetheless, Yoko was proud.

The critic for the *Village Voice* was unimpressed and her criticism of the concert disturbed Yoko to the point of submitting for publication a passionate yet meticulous reply.

"Both in the West and the East," she wrote, "music was once separated into two forms. One was court music, to entertain the aristocrats. The other was folk songs, sung by the people to express their emotions and their political opinions.

"But lately, folk songs of this age, pop song, is becoming intellectualized and is starting to lose the original meaning and function. Aristocrats of our age, critics, reviewed the Ann Arbor Rally and criticized the musical quality for not coming up to their expectations. That was because they lost the ears to understand the type of music that was played there.

"That was not artsy-craftsy music. It was music alongside the idea of, message is the music. We went back to the original concept of folk song. Like a newspaper, the function was to present the message accurately and quickly.

"And in that sense, it was funky music, just as newspaper layout could be called funky. Also it is supposed to stimulate people among the audience and to make them think, 'Oh, it's so simple, even I could do it.' It should not alienate the audience with its professionalism but communicate to the audience the fact that they, the audience, can be just as creative as the performers on the stage, and encourage them to make their own music with the performers rather than to just sit back and applaud. . . ."

Once again, Yoko was denying the avant-garde precept of artists talking to each other or to themselves—engaging the audience instead, inviting its members to participate.

Suddenly, a week before Christmas, Yoko found all this irrelevant. On December 18, she and John found themselves back in a Houston court, fighting for Kyoko again.

The Lennons had been ordered by the court to appear a week before Christmas to "reestablish a relationship" with Yoko's daughter, and when they arrived in Houston, they believed the agreement would be honored. So they were shocked when Yoko called her ex-husband and Tony put Kyoko on the phone.

"Mummy," Kyoko said mechanically, "I don't want to see you."

Only a week before Kyoko had called Yoko to tell her that she missed her, wanted her to come to Texas. Now this? Yoko and John called a press conference and made it clear that Cox was violating a court order to let the girl see her mother for the weekend. Yoko said Kyoko sounded like "a human machine" when she called. She said she believed that the girl had been coerced into making the call.

"I could hear Tony in the background," Yoko said, "telling her what to say."

"I'm living with a woman who is screaming for her child every night," John said. "We've got so desperate we've been putting messages on records. We've got a Christmas song out that begins 'Happy Christmas, Kyoko.' " (A reference to a song they recorded for holiday release.)

Unable to locate Kyoko, or Cox, Yoko and John returned to New York on Sunday night, and the next day their attorneys went back to the Houston court and filed a contempt of court injunction against the missing Cox. The judge went along and said he was convinced that "every time they [the Lennons] come down here, he's going to find some reason not to let them see the baby."

Cox appeared for the contempt hearing. By now he had become a member of the Evangelical Church, a fundamentalist Protestant sect,

and all through the hearing he thumbed through a prayer book and a Bible. When the judge sentenced him to five days in jail, he cried out as he was led from the courtroom, "If any Christians are hearing my voice, I hope you pray for me!"

He was released under $5,000 bail the next day, and the Lennons returned to Houston on December 29 for another try at seeing Kyoko. Cox had been ordered to bring the girl to the courthouse. He didn't show up, so again the Lennons' lawyers went to court, this time filing a motion asking that temporary custody of Kyoko be transferred to her mother. This motion was granted, but it didn't matter. Cox and his wife and the girl had disappeared, not to be seen again.

As the new year approached, Yoko and John found themselves in an emotional pit. Kyoko was gone. The battles with Paul McCartney hadn't ended, and as a result, the personal Lennon money supply temporarily dried up. And both Yoko and John were using heroin and methadone again—heavily.

One day, soon after the start of the new year, 1972, John noticed someone working on a motorcycle in front of the apartment. A week later he noticed that the man was still there, still repairing his motorcycle, taking apart and reassembling the same parts over and over and over again.

"Yoko," John said, "come here."

Yoko came to the window.

"I think we're being watched."

17

Deportation Blues

WHO was it?
Was it the Federal Bureau of Investigation, an agency known for its intense hatred of the radical left?

Maybe it was the Immigration and Naturalization Service. After all, John's visa was due to expire in March. Perhaps the INS didn't want to renew it.

It could've been practically anyone; in the end, John figured it was the FBI and the INS together. He was right. And there were others out to get him, too.

In January 1972, at the direction of Senator Strom Thurmond, a known right-winger from South Carolina, the Senate Internal Security Subcommittee of the Judiciary Committee produced a classified memo on the Lennons. It was only six paragraphs long, but it said plenty. The New Left was using the Lennons to "obtain access to college campuses; to stimulate eighteen-year-old registration; to press legislation to legalize marijuana; to finance their activities; and to recruit persons to come to San Diego during the Republican National Convention in August 1972."

It was suggested that it would be a "strategy countermeasure" if John's visa were terminated immediately.

Thurmond sent the memo to the U.S. attorney general, John Mitchell, along with a note urging Mitchell to take appropriate action. He also sent a copy of the memo to Bill Timmons, a member of President Nixon's White House staff. It's not known what, if any, action the White House took; many documents still remain classified.

However, on February 14, one of Mitchell's deputies, Richard Kleindienst, sent a memo to the Immigration and Naturalization Ser-

164

vice commissioner, Raymond Farrell. Kleindienst was confused; he didn't even know that the Lennons were in the country.

"When is he coming?" the deputy attorney general asked. "Do we, if we so elect, have any basis to deny his admittance?"

Yoko and John were unaware of this, of course, and if they seemed aware that they were being watched, it didn't seem to inhibit them. In fact, they continued their political activism with a fervor that was nourished by the challenge—a typical believer's response.

In the winter months and on into the early spring, the Lennons continued to entertain a host of leftist friends. Jerry Rubin was still a regular. Black leaders including Bobby Seale and Huey Newton visited and so did Bob Dylan, who lived nearby on Bleecker Street and had recently recorded a song, "George Jackson," about a black militant killed in a California prison shootout. With David Peel and some other ragtag Village friends, they formed the Rock Liberation Front, a loosely organized band of freaks and crazies devoted to exposing hip capitalist counterculture ripoffs.

As the parade of activists came and went, the agents outside took pictures and careful notes.

Yoko was now dedicating her life to the cause of feminism. She'd already recorded "Sisters, O Sisters," the anthem she'd sung at the Attica and Sinclair benefits. For an upcoming album she was then recording with John, she added another, "Woman Is the Nigger of the World." In public she was often seen wearing a bandolier of thirty-caliber bullets around her waist for a belt.

This was Yoko's most feminist period. The previous December, she and John had received in the mail a copy of a new underground magazine, called *SunDance*, and they agreed to write a monthly column. The first, for the issue that appeared in January, was clearly Yoko's thing: "Contemporary men are too steeped in the game of competition and following social rituals," they (she) said. The women's movement needed to respond to the needs of ordinary women or the fight was lost; if the women's liberation movement didn't develop a broader demographic appeal, it could "end up with men making another token gesture such as allow a few comely Smith graduates on TV news."

A woman's New Left didn't gather around Yoko in the Bank Street place as a male counterpart did for John. Yoko was more or less on her own. But according to John, she had a terrific impact, at least on him.

This was not new. Hadn't he changed his middle name from Winston to Ono? Hadn't he called his first post-Beatles group the

Plastic Ono Band? Hadn't he insisted that Apple release her albums and put one of her songs on every one of his singles? Hadn't he insisted that she share his stage with him and also his interview bed?

During the same period, Yoko wrote a long, rambling article called "The Feminization of Society," which was published in February 1972 on the Op Ed page of the *New York Times*, a major breakthrough for her (especially since the article had already been rejected by the *Village Voice*).

"The ultimate goal of female liberation is not just an escape from male oppression," she wrote. "How about liberating ourselves from our various mind trips such as ignorance, greed, masochism, fear of God and social conventions?"

Yoko had become by now the Queen Bee of the New Left, an insistent sort of mother figure who had replaced her quiet shyness with a relentless and rambling verbal mix of opinion, command, and plot. To assist her in the execution of all her plans, she hired an assistant, Kathy Streem.

"She told me I reminded her of her daughter," Streem recalls. "I was on my way to being twenty then and I was living with Jerry [Rubin]. Yoko didn't like Jerry much and she gave me money to get my own place. Paul Krassner [who, since giving Yoko $2,000 when she wanted to stage her black bag event, had been editing the iconoclastic and satirical leftist magazine, the *Realist*] was visiting the Bank Street apartment regularly and Jerry was jealous. I remember on New Year's Eve when Paul arrived, Yoko said, 'Here, Paul, come sit next to me.' There were no other chairs and Jerry left in a huff."

Yoko told her new assistant to write all the underground newspapers and ask for free subscriptions. (An approach that upset several in the Lennon camp, who figured the least Yoko could do with her newfound millions was *pay* for a subscription.) She was starting something called the Youth Energy Syndicate (YES), she told Streem, and she wanted to start sending the papers articles that she and John would write.

"There was a Youth Energy Account," Streem says today, "and Yoko'd give me a note to the accountant. She'd say, 'Put this on the YES account.' And they'd hate it. The Apple people didn't want to give me money and they didn't like Yoko spending John's money. There was a lot of fighting over money then, and what I think is maybe she was spending his money before someone *else* spent it. *He* certainly didn't mind. Anything she wanted, she got." Within a few months,

however, the Youth Energy Syndicate went the way of acorns and billboards.

John wrote a story that was widely published in the underground press about Ireland and the IRA. Other, shorter stories followed, and then Yoko gave her assistant an eight-page, single-spaced story about a Japanese soldier stranded on a Pacific island who still thought World War II was being fought. In recent years, several "hold-outs" had been discovered on remote islands, and while their stories were interesting to the general public, they were *not* to the underground press. Yoko checked every one of the newspapers that poured into the Bank Street apartment for the next few months and no one, not one, published it. She began to lose interest.

☐

The Lennons always took their message to the media whenever and however often they could, and on February 14, 1972, they began an entire week as co-hosts of the popular "Mike Douglas Show." At the time, Douglas had one of the most highly rated daytime talk shows in America, and the Lennons took full advantage, offering a rich and unusual mix of Yoko's instructive art and the couple's hard-core radical politics.

The first moments of the first show set the tone, when Douglas mildly asked the Lennons what they wanted to talk about during their week.

"Love, peace, communication, women's lib—" John said.

"Racism!" Yoko interrupted.

John nodded his approval and added, "racism, war, prisons . . ."

Not long after that, Yoko introduced two of her "pieces." One was a "Mending Piece," she told Douglas. They would begin with a broken teacup and each day glue some pieces back together, so that by Friday the cup would be repaired. The second was, for Douglas, more puzzling.

"Call a stranger every day and say, 'I love you—pass this message along,' " Yoko instructed. "By the end of the year, everybody in the world will have gotten your love. There are so many lonely people in this world, and we have to tell them we're connected."

With Douglas's bemused agreement, Yoko was given a telephone and she dialed a seven-digit number at random. A woman answered.

"This is Yoko. I love you. Pass this message along."

There was a long silence and finally the woman replied. "Yes, all right," she said, her voice indicating that she really couldn't think of anything else to say.

Yoko hung up, and Douglas introduced a commercial break.

It was more of the same all week, as the Lennons presented an array of guests never before seen on daytime television—including Jerry Rubin (whom Douglas said he didn't like), Chuck Berry, Bobby Seale, and a macrobiotic chef (who taught Douglas how to make pizza)—and Douglas tried to keep it light, singing Sinatra-ish ballads and telling little jokes.

The Lennons' visas were due to expire soon, so they hired an attorney, Leon Wildes, a former president of the Association of Immigration and Naturalization Lawyers who had never lost a case. Wildes knew that a first six-month extension of a tourist visa was usually granted as a matter of course and he expected no trouble. However, when he called Sol Marks, director of the New York district of the Immigration Service, Marks said an extension was out of the question.

"But why?" Wildes said.

"Are you aware," Marks replied, "that Mr. Lennon was convicted of possessing cannabis resin in England in 1968?"

Wildes was flabbergasted. Yes, he said, he knew about the conviction and he said that John had pleaded guilty to the charge so that Yoko, who was then pregnant, wouldn't have to stand trial. Besides, Wildes argued, in Britain possession of hashish was a misdemeanor.

Marks was unmoved, and on March 1, the Immigration Service gave the Lennons fifteen days to get out of the country.

At almost precisely the same time, on March 3, the Domestic Relations Court in Houston gave Yoko temporary custody of Kyoko and ordered the missing Tony Cox to surrender the child. Unaware of what was happening in New York, or unwilling to let that affect his decision, Judge Solito said he was now satisfied that Yoko was willing and able to provide the child with a "suitable environment" and that John would "cooperate in every way possible, necessary and advisable" in her "proper upbringing and education." There was, however, one catch: Yoko's custody of her daughter would have to be exercised "within the territorial limits of the United States of America."

"Talk about a rock and a hard place," says someone who had been in the Lennon camp. "A court in Houston was saying she could have her kid back but she had to be in the U.S., and the immigration people were telling her she had to leave. Yoko was tearing her hair

out. She was crying. She was screaming. She was impossible to be with."

Leon Wildes went into high gear and on the same day, March 3, petitioned to change Yoko and John's administrative category from that of "non-immigrant visitors" to that of "third-preference immigrant" visa applicants. This was a category for individuals whose "exceptional ability in the sciences or arts will substantially benefit . . . the national economy, cultural interests or welfare of the United States." Although this wouldn't get around the pot bust charge, Wildes believed it would buy them some additional time.

Marks was still unmoved, and on March 6, three officers of the Immigration Service appeared at the Lennons' apartment door with a letter saying that because it appeared they didn't intend to leave the country voluntarily, they were to appear at a hearing on March 16 to show cause why they shouldn't be deported.

By now, of course, it was abundantly clear—at least to Wildes and the Lennons—that the pot bust in London had little or nothing to do with the deportation hearing. Although it would be many years before Yoko and John's charges of political harassment could be proved— with documents obtained under the Freedom of Information Act— even then a few immigration people (who liked John's music) were talking off-the-record, confirming the Lennons' worst fears.

Wildes told the Lennons that it could help their case if they stopped seeing their radical friends, if they avoided the high-profile, antiwar causes.

John said that was exactly what Nixon and *his* friends wanted them to do.

Yoko said, "We won't!"

Wildes shook his head and argued intently. He told his clients that it wasn't a *right* that they were asking for, it was a *favor* the U.S. government had the discretion to bestow—or not bestow. And continuing their present behavior was only going to "piss Richard Nixon off."

The Lennons held a press conference on the eve of the scheduled deportation hearing and ignored their lawyer's careful instructions, telling the gathered press that they were forming a new country called Nutopia, where there were no boundaries, no passports, and only cosmic laws.

"All people of Nutopia are ambassadors of the country," John said. "As two ambassadors of Nutopia, we ask for diplomatic immunity and

recognition in the United Nations of our country and its people."

Wildes was aghast. "Yoko apologized later," Wildes said. "She said, 'Leon, you have to understand. We are artists. We have a message.' "

Wildes did his best to delay the hearing and gained another month, and by April 29, the Lennons had begun to line up an impressive cast of character witnesses, leading off with the youthful and dashing mayor of New York, John Lindsey. In a strongly worded letter to the INS, he said, "The only question which is raised against these people is that they speak out with strong, critical voices on major issues of the day. If this is the motive underlying the unusual and harsh action taken, then it is an attempt to silence the constitutionally protected First Amendment rights of free speech and association, and a denial of the civil liberties of these two people."

At the same time, as revealed much later in government documents, the FBI's J. Edgar Hoover was spreading the rumor that Jerry Rubin was a CIA plant and urging his men to check out reports that the Lennons were "heavy users of narcotics."

The horrible thing was that the FBI was finally right. Yoko and John *were* still using drugs—regularly and heavily. Mostly it was methadone and mostly it was John, although friends on the scene say that Yoko was, as usual, "more or less tagging along," joining John in his use of drugs, but never matching his determined abuse.

By mid-May, soon after Nixon announced he was mining North Vietnamese ports and ordering massive new bombing raids (prompting a number of congressional Democrats to file a resolution to impeach the president for "high crimes and misdemeanors" in waging illegal war in Southeast Asia), the Lennons appeared at an antiwar rally in midtown Manhattan.

"We're here to bring the boys home," John said. And Yoko said, "It's time for North Vietnam to invade America."

The hearing opened with surprising news. Yoko, long assuming that she was, like John, an illegal alien, was told that she had been given a "green card," granting permanent residency in the U.S., when she was married to Tony Cox. This blew away completely the government's case against her. Still the case remained against her husband.

There followed a veritable parade of star witnesses. Dick Cavett testified that the Lennons represented an "important artistic presence in this country" and an inspiration "to young people in danger of falling into apathy."

Old friends came forward next, including Norman Seaman, who had produced Yoko's concerts at the Carnegie Recital Hall. He captured the drama immediately, saying that "Some said she belonged in an insane asylum, others praised her depth of imagination. I found her a person of unusually deep humanity. If her present troubles were written down, it would be a real tearjerker, sort of a Stella Dallas story—a woman looking for her child, being cross-examined in a courtroom as to her right to stay with her husband."

Finally, some presented a sheaf of petitions opposing the deportation—the result of efforts exerted by a group of Yoko's artistic New York friends. The artists signing the petitions included Joseph Cornell, Larry Rivers, Willem de Kooning, Jim Dine, Jasper Johns, Roy Lichtenstein, Claes Oldenburg, and Robert Rauschenberg. The writers included Saul Bellow, John Cheever, Joseph Heller, Norman Mailer, Henry Miller, Joyce Carol Oates, John Updike, Kurt Vonnegut, Jr., and the late Edmund Wilson. The poets: Robert Creeley, Lawrence Ferlinghetti, Allen Ginsberg, Stanley Kurnitz, and Karl Shapiro. The musicians: David Amram, Leonard Bernstein, Ornette Coleman, Bob Dylan, Nina Simone, and Virgil Thomson. The actors: Fred Astaire, Claire Bloom, Diahann Carroll, Tony Curtis, Ben Gazzara, and Jack Lemmon.

And that wasn't all. Wrapping the whole thing in red plush was a statement by Allen Ginsberg for the American Center of P.E.N., the world association of poets, playwrights, essayists, editors, and novelists:

"It is with great pleasure that we wish to add P.E.N. American Center's great Roc's voice to the vast chorus of poetic larks and Ambassadorial Editorial Owls who've already raised cries throbbing to Heav'n that American shores, woods and lakes not be banned to the great Swan of Liverpool, John Lennon poet musician (in the line of descent of Campion, Waller and Dowland, fellow language-ayre minstrels celebrated in the great tree of Britain's poesy) and his paramour-wif conceptual Authoress Yoko Ono, birds of a feather.

"Such mighty creatures as these who've winged oer Atlantic's deeps to Manhattan Isle are threatened to be cast hence for once consuming hemp leafs in their home nesting ground. So tiny a natural peccadillo, and so great a cage, as large as the world, to keep them out of America!

"May all the chorus of singing creatures on Turtle Island (North America) bid them welcome to stay immegrant here including even the lonely near-extinct Federal Bald Eagle."

Yoko was ecstatic. Never before had such effusive praise rained down upon her.

"What makes Yoko Ono and John Lennon so crucial to our contemporary culture," wrote Kate Millett, "is their refusal to live only in the world of art. Instead, they have reintegrated art with the social and political facets of life and offered us something like moral leadership through their committed pacificism. Using all the resources of their prestige and popularity, they have unceasingly protested the crimes of humanity upon itself."

Yoko and John finally took the stand in their own defense. Both declared themselves non-Communists, and Yoko, when asked, said that it was John's support that enabled her to carry on in her ongoing search for Kyoko.

"I think my ex-husband took my daughter away because she was developing a close relationship with my husband, John Lennon," she said. "We have followed all the leads. We have hired private detectives. But as soon as we arrived someplace, because we are famous, everybody would know we were there and my ex-husband would . . ."

Yoko's voice cracked and she began to cry. The government showed no sympathy and asked whether she would still wish to live in the United States if John's application was denied.

"You're asking me to choose between my husband and my child!" she cried. "I don't think you can ask any human being to do such a thing."

The matter was left unresolved as the Lennons' attorney began preparing a 14,000-word brief that was to be submitted to the court on July 1. Exhausted, Yoko and John decided to escape New York.

Their reasons for leaving New York were abundantly clear. True, they were finally taking their attorney's advice and leaving their radical friends behind, but that wasn't all.

In June 1972—the same month that five men were arrested for breaking into the office of the Democratic National Committee in the Watergate complex in Washington—John's album of radical songs, *Some Time in New York City*, finally went into the record stores, and John and Yoko crossed America in a chauffeur-driven car. The idea was to finally shake their ungodly addiction to methadone while cramped into the rear seat of a Rambler station wagon. By the time they reached California, they figured they'd be clean.

Of course, they took a small stash of pills along in case the withdrawal pains were too awful.

And, of course, the pains were too awful.

18

The Calm Before the Storm

WHILE still in New York fighting deportation, Yoko and John were in touch with an organization that monitored police abuse in the United States. Yoko told someone in the organization that she and John wanted to get away for a quiet vacation, and she was told to call a woman in Ojai, California, near Santa Barbara, two hours north of Los Angeles. The woman had a mansion in an agricultural preserve and it was not being used.

When Yoko was told about Ojai, her enthusiasm convinced John that this was the perfect place. Ojai was known for its classical music festival, its quiet conservatism, its genteel and wealthy citizenry, its orange groves and private schools. It was also well known as a center of spiritualism. The famous guru Krishnamurti lived in the east end of town, not far from the mansion Yoko and John rented, back in the 1920s, and, in fact, had his key mystical experience while walking in the Ojai hills. Before that, the mysterious, visionary Chumash Indian tribe lived in the area. After Krishnamurti came the Theosophists, who founded their own colony of mystics. More recently, Ojai was home to Aldous Huxley, the author and early psychedelic explorer.

They loved the house. The owner was an Anglophile, so the beautifully landscaped grounds had the look of an English garden. Inside, the two-story structure was furnished with antiques and well stocked with food and books; in a closet John found a guitar and took it onto the porch to play.

The Lennons remained in the house for four weeks, driving into town occasionally to prowl through the occult bookstores, once ap-

pearing in a restaurant in nearby Ventura, a beachside community, where John sat in with a local band and sang.

It was also while in Ojai that Yoko and John finally met Elliot Mintz, the intellectual radio talk-show host with whom Yoko had been carrying on a telephone relationship. He was a big fan of theirs and played their albums on his late-night show in Los Angeles.

Mintz was already one of Yoko's confidants, and he recalled that on the day they met they talked politics for half a day nonstop, remaining outside by the pool. The Lennons then played their new album, *Some Time in New York City*, and took Mintz into the bathroom.

Yoko and John sat on the edge of the tub as Mintz stood nearby, showing a slight uneasiness. Yoko turned on both spigots in the tub, creating the loud noise of gushing water. Then they whispered to Mintz, "We think the house may be bugged."

However paranoid they might have been, the stay in Ojai was a bucolic respite from New York. Only their landlady objected in the end. There were too many visitors, she said, and she didn't like it when the students at a nearby private school learned that the Lennons were there and began flocking to the house. And when she inspected the premises, she found the ashtrays overflowing, dirty clothing scattered everywhere, and chopsticks in the garbage disposal. She was furious when she found her son's guitar abandoned on the porch. And the telephone bill—mostly Yoko's doing—was astronomical. So she asked the Lennons to leave.

The Lennons responded by offering to buy the property. She declined, and after a day spent complaining and packing, Yoko and John got back into the rear seat of the Rambler and headed north toward San Francisco.

By now, *Some Time in New York City* had been released (mid-June). Besides the spate of hastily assembled agit-prop protest songs ("Attica" and "John Sinclair" among others from John, "Sisters, O Sisters" and "Woman Is Nigger of the World" from Yoko), another version of "Cold Turkey" was put in, and Yoko had on one side of the two discs still another long (seventeen-minute) rendition of "Don't Worry, Kyoko." Filling out the set were some live jams from their impromptu show with Frank Zappa.

Response to the release was pitiful. With rare exception, the critics hated it. Most remarked on Yoko's "off-key" voice. The politics were called "witless" (*Rolling Stone*) and "condescending" (*Village Voice*). And the sales were embarrassing. Where *Imagine* had sold more than 1.5 million copies, and went to No. 1, this album barely crept past the

164,000 figure, and it never appeared on a chart anywhere.

In San Francisco, the Lennons still found themselves dependent on methadone, and Yoko sought out an acupuncturist. At the time, acupuncture had a growing "underground" following in the U.S., although it was still illegal then to practice it. Yoko believed that if they could find a Chinese practitioner, the well-placed needles would restore the natural flow of their drug-wracked and ruined energy.

They found a Dr. Hong through a new friend at *SunDance* magazine. One of the editors, Craig Pyes, said later that John urged him to publish a story about methadone. "We got off heroin cold turkey in three days," John said, "but we've been trying to shake methadone for five months."

Yoko also believed that once their bodies were cleansed of the drug, the acupuncture treatments could assist them in conceiving a child. Initially, the Lennons stayed in San Francisco's Miyako hotel, but in time they moved into Dr. Hong's tiny pink stucco house in nearby San Mateo, where they slept together on the living room couch.

In a week's time, they were finally clean.

Before returning to New York, they visited their old friend Paul Krassner, who had left New York to live on the edge of a cliff overlooking the Pacific in Watsonville, "the artichoke capital of the world." Krassner was a nonsmoker and he refused to let the Lennons smoke in his house, believing that if he made an exception to his rule, he would be dehumanizing the Lennons. At the same time, he asked the famous couple for help.

The Watergate break-in was only six weeks old then and largely ignored by the national press; the Nixon coverup was functioning perfectly. However, Krassner immediately recognized the importance of Watergate and he planned to devote the next issue of his magazine, the *Realist*, to an article linking Watergate with several other conspiracies, going back to 1963 and the assassination of John F. Kennedy.

Krassner recalls today that the printer was unsupportive of the theory and wanted to be paid in advance. "I didn't have the $5,000," Krassner says, "and the day I got back from the printer, Yoko called. We got together and I gave them the galleys to the story. The next day we went to the Bank of Tokyo in San Francisco and they withdrew $5,000 in cash, and in that way I beat Woodward and Bernstein into print with the Watergate story by two months."

The Lennons stayed in California for a total of six weeks, and after

sending their driver back to New York in the car alone, they flew home, cleaner of body and soul. They had left hard drugs behind again, and once more Yoko had put them on a diet of rice and vegetables. They still smoked their endless cigarettes, but except for that, they were in better physical shape than they had been in years.

But their troubles were not over. The deportation order still hung over them, and the offensive publicity was accelerating as their former limousine driver of seven years, Leslie Anthony, sold his "memoirs" to the sensationalist Fleet Street press.

Worse was the trauma of the ongoing search for Kyoko. Everywhere Yoko and John went, they looked. One day, when they were on the West Coast, in Sausalito, Yoko thought she saw her daughter, and she had her driver crisscross the small town for several hours, frantically scanning the streets.

Back in New York, Yoko and John encountered a terrible mess, especially in their film offices. They had leased space in a building at 496 Broome Street, a few blocks from the Bank Street apartment, leaving Steve Gebhardt in charge. There, as custodian of what was called Joko Films, and sometimes Apple Films, Inc., Gebhardt kept the backlog of avant-garde work moving from campus to campus and, occasionally, into a legitimate theater; drafted licensing agreements; and tried to keep track of the money spent.

Oddly, the amount allocated for films was never that much. Allen Klein always complained about John's money being "wasted" on Yoko's whims, but by the end of May 1972, Yoko and John had begun no less than twenty-seven different film projects and completed nearly a third of them, spending under $375,000. By the end of August, another ten projects had been added to the list, running the total spent to just short of $520,000, an insignificant sum considering how much product was made.

It was while they were in Mill Valley, staying in a large rented home amid the redwoods while finishing their acupuncture treatment, that Gebhardt flew out to discuss their first really major film project, a documentary of the Rolling Stones, which eventually was released as *Ladies and Gentlemen, the Rolling Stones!*

"I went to California on July 4th," Gebhardt says, "and I said I wanted to do the Stones film through Joko. She said do it. Later she denied knowing anything about it.

"I'm not complaining really. She was very generous. She paid my way to Cannes that year and after saying I'd have to pay my wife's

expenses, she changed her mind and paid my wife's way, too. And then she put us both up in a hotel for a week in London. We were told not to tell Allen Klein anything."

Gebhardt says that Yoko edited the John Sinclair film herself, knowing that there was no market for it. "She kicked all of the men out of the editing room," Gebhardt says. "She called them pigs. She also hired a salesman who was legally blind. Can you dig it? Someone selling film who is blind? Yoko said they felt sorry for him."

At the same time, Gebhardt was trying to get a final decision regarding the John Sinclair documentary, *Ten for Two*, which took its name from the ten-year sentence he got for possessing two marijuana cigarettes. Gebhardt felt that delaying the distribution any longer would kill whatever market remained for it. Yoko vacillated and then, just before a meeting with Sinclair, she called Gebhardt aside.

"It was a meeting at 7:30 in the morning," Gebhardt says. "The film was finished. There was a finished poster. Sinclair and his wife and his manager were coming to the meeting and they thought the money earned from the film would go to the causes espoused in the film: the legalization of pot and all that. Yoko said no, she wanted the money to go to women's causes.

"The truth was, the film wasn't good for John's deportation case, but Yoko never admitted that. Instead she gave us this diatribe, this lecture about women. I tried to negotiate a middle ground, but it was hopeless. I never understood why she didn't just explain about immigration and apologize. No, she pulled the rug out instead. That was the end of the John Sinclair movie."

☐

Soon after they arrived home in New York, the Lennons were visited by Geraldo Rivera, the ABC television journalist. He said he wanted them to perform at a benefit concert the end of August for his One to One Foundation.

Yoko said she didn't know what that was. They had missed Rivera's televised exposé of the ghoulish conditions under which the retarded lived at a New York home. Rivera explained and said he wanted the retarded to "come out of the closet" to be seen and helped by others. To do this, he said, he needed money and he wanted John and Yoko to headline a show at Madison Square Garden.

John was reluctant, fearing a public appearance after so many months of idleness. But he appreciated Rivera's asking for Yoko, too.

Yoko told John it was for a good cause and nonpolitical. Finally, John agreed and they began rehearsals, using the band they'd played with on *Some Time in New York City*, Elephant's Memory.

For nearly a month they worked, but John grew insecure. Yoko suggested they call Paul and ask him to appear. Paul refused. At the same time, Rivera had convinced ABC to run the concert as a special. However, programming executives didn't want Yoko involved; they said she had an awful voice. Rivera argued Yoko's case, saying if she hadn't urged John to do the benefit, there would be no show. Finally, ABC relented.

The concert included Stevie Wonder, Roberta Flack, and Sha Na Na, and it was, under the tense circumstances, a great success. The Garden was completely sold out, including $50,000 worth of tickets that the Lennons bought for retarded children to ensure that all seats were paid and yet allow the retarded to attend.

He and Yoko sang "Come Together," "Instant Karma," "Imagine," "Cold Turkey," and "Hound Dog," and then, with the entire cast and audience, a reggae version of "Give Peace a Chance."

They raised $1.5 million for the retarded, and it was the last fully rehearsed public concert that John gave between the 1966 Beatles tour of America and his death in 1980.

When ABC broadcast the concert later, Yoko had been edited out, along with Geraldo Rivera. Not a single frame of either of them remained in the show.

"Yoko was livid," says a friend who was there at the time. "She actually threw a fit. I can't say I blame her. And John was just as pissed. He felt he'd been used again, and he and Yoko swore never to say yes to anyone ever, ever again."

When the final sales figures came in for *Some Time in New York City*, showing that the record-buying public liked John and Yoko's politics only slightly more than the U.S. government, the Lennons also decided not to record again, a pledge they soon broke.

The Lennons went into retirement.

Yoko began puttering with her art. In September, an arts society in London had showcased five of her films at the Alexandria Palace, including *Up Your Legs Forever*, and Yoko began talking about making films again.

In October, her old friend from her days on Chambers Street, Charlotte Moorman, asked her to participate in an event staged on a ferry boat that taxied between Manhattan and Brooklyn; Yoko contributed several hundred pairs of blue jeans, hanging on racks, with

instructions that said, "Try them on. If they fit, wear them home."

☐

Six months had passed since the deportation hearings in April and May. A decision was expected in February 1973, when it was more or less likely that Yoko's application for permanent residence would be approved.

"Even Mr. Marks, the New York district director of the Immigration Service, is now not so sure it was a good idea to try to deport her," Hendrik Hertzberg wrote in the *New Yorker* magazine. In a long article published December 9, 1972, Hertzberg quoted Marks as saying, "We admit we maybe acted a bit hastily on that one, but they wanted to ride together."

Hertzberg's view of John's chances were not so positive, and it seemed at the time quite reasonable.

"If John loses—and he probably will, though his chances are better than they were at the start—Mr. Wildes will take his case to the Board of Immigration Appeals, in Washington, and, if necessary, to the federal courts. The appeals process could take years, and as long as it continues, John will be obliged to remain in the United States if he wants to preserve his chances of eventual success. It could easily happen that the government's attempt to deport John Lennon will have the paradoxical effect of forcing him to remain in this country longer and more continuously than he otherwise might have."

It was interesting, and somewhat prophetic, when a writer for the *Sunday Mirror* in London, Jack Bentley, previewed the film *Imagine*, which was to begin a run in England the week following Christmas.

"As my vote for one of the saddest, loneliest couples in the world," he said, "and I give you John and Yoko.

"Sure, they have an abundance of fame, money, talent and a magnificent obsession for each other. But one has only to glimpse a few scenes from their new full-length documentary film, *Imagine*, to see the picture of two people who have everything that adds up to nothing.

"*Imagine*, which gets its first showing next week at Nottingham, Liverpool and Leicester . . . followed by a London release on December 30, is a study in frustration and hyper-boredom.

"Not that it's a boring film. In spite of the home-movie approach, here is an unprecedented, intimate look into the Lennons' life at home and abroad.

"Perhaps it should have been subtitled: What in hell can we do

next to take our minds off what's really bugging us?"

Surely, the couple had much annoying them. Since June they'd been battling with Allen Klein. At first, the arguments were verbal and then legal. The rift started when it became clear that Yoko was not among Klein's favorite people; when word of his dislike reached her, she began working on John, and soon they, and in time Ringo and George, filed lawsuits charging mismanagement and other assorted transgressions, none of them easily proved.

Then, in November, on election night, at Jerry Rubin's apartment, when it became clear to those gathered around the television set that Richard Nixon was in for another term as president, John started fondling another woman's breasts in front of Yoko, then took her into Rubin's bedroom. Yoko remained in the living room, silent, transfixed. (Later, Rubin said that he thought it was all over for the Lennons at that moment. "He was totally out of it on drugs," Rubin said. "Their relationship ended right there. . . .")

Christmas was especially difficult. There was no word from Kyoko. No call. Not a card. Nor anything about her from the platoon of detectives still on the case.

At the same time, Rubin and his friends finally were told to stay away—an attempt to show the courts that the Lennons were no longer associating with radicals, an effort that came too late and only served to deny them the company of real friends during the holidays.

"Happy Xmas (War Is Over)" appeared on the British record charts, along with a peculiar No. 1 hit called "Long-Haired Lover from Liverpool," sung by Little Jimmy Osmund, and news of this activity made John homesick.

The Bank Street place was closing in. It seemed ungodly cramped all of a sudden, and they began to ache for space, enough space, as one friend put it, to place a room between them. Perhaps it wasn't the apartment that was closing in, but the relationship. For four years they had been inseparable. Between ill-tempered arguments about everything from friends to meals, they talked about getting a larger flat— possibly in the Dakota, the building on Central Park they'd considered a year before.

John spent much of nearly every day sitting cross-legged on the black satin sheets of the double bed, watching television, refusing to see anyone.

Yoko was only slightly more social, giving interviews somewhat reluctantly to promote her new two-record album, *Approximately In-*

finite Universe, released in the U.S. in January 1973, in England a month later.

Some were puzzled by the title. Could anything be both approximate and infinite? they asked.

Yoko grumbled a reply: Isn't everything?

Yoko's lyrics, on the other hand, were her most specific, most radical, and most pained. Almost every song spelled out her struggle. The album was dedicated to "my best friend John of the second sex," and many of the twenty songs included in the two-record set detailed the hurts of their relationship.

In other songs, she defended John, telling her sisters in one of her feminist anthems not to blame her man too much. He was doing his best, she said. He was afraid and lonely, too.

Back and forth it went. In one song, she hated John, in another, she embraced him and forgave him. In a sense, this was Yoko's "primal" album, the one in which she bared her soul in a way she had never done before. And the reviews, for a change, were generally promising.

Nick Tosches of *Rolling Stone* hated the album, saying Yoko's lyrics were "laughable . . . idiocy." But others strongly disagreed, giving Yoko some of the best notices of her career. Britain's *New Musical Express* said Yoko was "the real thing" and the *New York Times* said she was "a lyricist who can express her pain with as much cogency as Lennon."

"It's easy to poke fun at Yoko Ono," said Andrew Bailey in London's *Evening Standard,* one of England's more literate tabloids. "Or at least it was for me until I'd heard this album and let its effect soak in. Yoko has more than a dilettante interest in the women's Lib movement but her strange ways of communicating have sometimes disguised her sincerity. But here, backed by some powerful Lennon rocking, her lyrics cut through with stark simplicity. Yoko says the obvious, without frills or cuteness."

The public couldn't have cared less. The album appeared on the U.S. Top 200 chart for only one week—at No. 193—and nowhere else. And the single, a rather arrogant song about the "revolution" called "Yingyan," backed with a depressing "Death of Samantha," sank like stone.

Finally, the Lennons deserted the cramped flat in the West Village and moved into the Dakota. The building was nearly a hundred years old and in many ways it looked and felt older; gargoyles decorated the

exterior, the elevators ran on water power, and it was no coincidence that the block-sized Gothic structure was the setting for the film *Rosemary's Baby*. Yet it was popular with celebrities. At the time the Lennons moved in, other apartments were occupied by Rex Reed, Lauren Bacall, and Leonard Bernstein.

In spring 1973 there were two significant events.

First, Yoko finally won permanent custody of her daughter, Kyoko. The only trouble was she still had no idea where Kyoko was. In the last six months private detectives had failed to find a trace.

Yoko issued a statement to the press: "I want to hear from anyone who can help me find her."

No one came forward.

In June, Yoko and John flew to Washington to attend some of the Watergate hearings. After suffering for so long as victims of the Nixon administration themselves, and with the deportation threat still a part of every day, they told friends that they thought it was time they watched Nixon squirm for a change.

Although they sat quietly in the balcony, their appearance drew attention rather than discouraged it. John had shaved his head, giving him the look of a hawk-nosed, bespectacled monk, and Yoko was dressed in her "uniform" of that period—hot pants, a low-cut blouse, and a black beret. Consequently, they were besieged for autographs.

While in the capital, the Lennons, wearing coolie hats, joined a picket line outside the South Vietnamese embassy and protested the imprisonment of a Vietnamese woman who opposed the Saigon government. They told fellow marchers that it felt good to be back on the barricades, especially now that Nixon and his gang of thugs seemed on the brink of their own exile.

Newly confident, determined to re-create the closeness they felt in activism, they flew back to New York and then to Cambridge, Massachusetts, where Yoko performed for 350 delegates attending an international conference sponsored by the National Organization for Women (NOW).

The Lennons were trying very hard to make it work and it wasn't. The move to the Dakota, they truly believed, would help. All they needed was some space. They thought that if Yoko could concentrate on her art, her recordings, perhaps that would help.

May Pang, the young Chinese girl who had worked for Allen Klein, for several months just a part of the "scenery," a "piece of furniture," slowly began to insinuate herself more intimately into the Lennons' lives. She was innocent and sweet, Yoko told John, and in

time, Yoko began asking May to assist her in the flat and in shopping. By summer, May was working for the Lennons full time.

John was recording a new album, to be called *Mind Games*, when he told May that he wanted to sleep with her. In the book she wrote years later, *Loving John*, May said she thought the notion was Yoko's rather than John's. She said Yoko actually encouraged her to go off with John.

"John was in the middle of a strange situation," May wrote. "His wife and mistress were coexisting, for the most part, under the same roof. The way he chose to deal with the strangeness was to ignore it. Yoko, on the other hand, seemed to enjoy watching and attempting to supervise the situation."

Pang said she knew it was a tradition in Japan for upper-class wives to allow their husbands to have lovers. She said she knew that it was quite common, in fact, for the wives and mistresses to be friends. However, she was Chinese, not Japanese, and the arrangement made her uncomfortable, embarrassed.

According to May, Yoko told her she was going to Chicago for a week to attend a feminist convention; it was a good time for the young secretary and John to spend some time together.

19
Living Apart, Coming Apart

MAY PANG was twenty-three, ten years younger than John and seventeen years younger than Yoko—literally, young enough to be Yoko's daughter. Friends say the age difference both threatened Yoko and worked for her. It bothered her, they say, because she hated seeing her man with a younger woman. At the same time, because May was so young, so innocent, Yoko knew she could exert control.

May Pang's parents were born in mainland China and came to the United States in the 1930s. She told John that when she was born, in 1950, her father refused to come to the hospital to see her because she wasn't a boy. She said she never got over that rejection, just as John hadn't fully accepted his own father's leaving when he was young.

The first night Yoko was in Chicago, John and his lover stayed together in the Dakota apartment, but after that they spent every night together at May's small apartment on the opposite side of Central Park. Every night John left her apartment before four in the morning so he could arrive home without anyone in his household thinking he'd spent the night somewhere else.

It was ridiculous. During the week she was away, Yoko called John once or twice a day, and he told her he was seeing May. Nor was it a secret to anyone else. All the household help knew of John's, and May's, comings and goings. (May continued to appear each day to work as John's, and Yoko's, secretary.) The building security staff and

doormen and elevator operators and maids all knew. Even the neighbors knew. And many shared what they'd seen and heard when Yoko returned.

Chicago had been a revelation for her. "Yoko really strutted her stuff," says a friend who was there. "She was wearing her uniform—the beret, the hot pants, the boots. And she had the women's rap down. In a way it was kind of cute. She came on strong, she said men were pigs, and she was wearing hot pants and talking in her little tinkly voice. A lot of the other women didn't know quite what to make of her."

Before Yoko returned to New York, John told May he wanted to take her to Los Angeles. According to May, John said Yoko approved.

Yoko's friends confirm that. They say Yoko was quite ready to be free of John. Some years later, in an interview with *Playboy* magazine, Yoko explained her feelings:

"I'm what I call a 'moving on' girl," she said. "Rather than deal with problems in relationships, I've always moved on. That's why I'm one of the very few sort of survivors as a woman, you know. Women tend to be more into men, usually, but I wasn't.

"When I met John, women to him were basically people around who were serving him. He had to open himself up and face me—and I had to see what he was going through. But I thought I had to move on again because I was suffering being with John. I thought I wanted to be free from being Mrs. Lennon.

"Society doesn't understand that women can be castrated," she said. "I felt castrated. Before that I was doing all right, thank you. My work might not have been selling much, I might have been poorer, whatever. But I had my human pride intact and I was doing all right. The most humiliating thing was to be looked at as a parasite. . . ."

The money was a big problem by now. When John and May flew to California, he took $10,000 in cash and told May that it had to last. He also said they'd be staying in his lawyer's apartment in Hollywood, and not in a hotel or in a big house as they might have preferred.

The money problems weighed heavily. Because of all the lawsuits between the Beatles, Apple royalties were still frozen in an escrow account. With millions gathering interest but remaining out of reach, John and Yoko were "paper millionaires," forced to live on the checks that came from post-Apple recordings.

For most people, this high six-figure sum would give more than ample comfort. For the Lennons, it was close to "poverty." It was, by now, costing them nearly $100,000 a month to cover the rent and

necessities—expenses at the Dakota alone absorbed close to $50,000 every month (and Yoko was saying they needed a second set of rooms to use as offices). From the various recording studios they received bills for another $20,000 to $30,000. Although they had closed down their Joko film operation, bills from that company continued to arrive. Limousines and Yoko's ongoing clothes-buying binges and John's alcohol, drugs, and books ate up all the rest.

When she returned to the empty flat—John and May were in Los Angeles—Yoko began to monitor the expenses closely. She was writing many of the checks now, paying the incidental bills. (Major bills were handled by the accountants.)

Tentatively at first, then more aggressively, Yoko began to show an interest in John's business affairs. She had always tagged along to meetings with the lawyers and so on, but now she went alone, and where John was content to sit complacently by and listen to whatever was said, she wanted to know everything. She asked questions. She made demands.

According to May Pang, Yoko was also monitoring her husband closely, getting daily reports of his behavior in California either from friends there (Elliot Mintz was a primary source) or directly from John himself. May said that Yoko still called once a day at least, sometimes a half a dozen times.

May says that Yoko was upset about reports she had received that John was holding May's hand in public, or even kissing her. Yoko insisted that they not show affection in front of their mutual Los Angeles friends.

At the same time, Yoko demanded that if anyone asked, the separation was Yoko's idea, not John's. And John agreed to go along. It wasn't a lie, after all, although he wondered why she was so insistent.

In addition to meetings with attorneys and telephone calls, with John gone, Yoko filled her days with plans to resume her solo career, abandoned more or less when she met John. She was an artist, after all.

Back in May, she had performed alone, headlining a benefit concert for WBAI, a listener-sponsored radio station in New York. The concert was held at Town Hall, where Yoko sat in a director's chair covered with a white bag, reciting her songs as Elephant's Memory provided a hard rock backing. Later, in keeping with Yoko's whimsical past, the bag was auctioned for $20. Yoko's shirt, which she took off onstage, fetched the highest price of the evening, $30.

It wasn't much, but it worked. Yoko enjoyed being alone in the

spotlight again. The applause was not as enthusiastic as she might have hoped (a friend said at the time), but it was sufficient to be encouraging.

"The thing to notice is that John wasn't there," the friend recalls. "John . . . wasn't . . . there. He wasn't prancing around as her assistant, like when he went on one of the television channels with Jonas Mekas. He wasn't performing in her backup band, like he was in Toronto and in Detroit and just about everywhere else. She was *alone* on the stage. And loving it."

Yoko believed that one of the best ways to assert her rediscovered independence was to go into a club alone, to perform not just in a benefit, where people come to support a cause, but to perform where people actually paid to get in because they wanted to see the performer.

She put the word out: She wanted a small club, preferably in the Village, where she could try out her "act." At the same time, she called the members of Elephant's Memory together to tell them that John was on the West Coast for a while and until he returned, she wanted them to work with her.

They had heard the same rumors everyone else had heard—that Yoko and John had separated, that John had gone to Los Angeles with May Pang. They argued among themselves for several days. Some wanted nothing to do with Yoko—said, in fact, that they couldn't stand her music, her voice, or her personality. Others, including the guitarist, David Spinoza, insisted it wouldn't hurt to be associated with Yoko. No one else was offering them much work, he said, and besides, Yoko still carried the Lennon cachet, which, inevitably, could never hurt their careers.

The boys told Yoko they'd be glad to work with her and went into rehearsals immediately. By now, Yoko had wrung a commitment for a week in Kenny's Castaways, a small bar on Bleecker Street in the heart of Greenwich Village.

Yoko opened on Tuesday night, October 23, and played for six days, through Sunday, the twenty-eighth.

"I did my thing," Yoko recalled later. "I mixed the experience I had with rock, but in between the songs I would do all sorts of little events, like pass an empty bucket and then tell a story about the bucket, or whatever."

The shows were an odd mix and the reviews were mixed as well. There came out of it, however, a single, indelible image that would stick to Yoko for many years to come.

It happened on opening night. Photographer Bob Gruen was there. He was, by now, a trusted friend. He had taken the photographs for *Approximately Infinite Universe*, and the previous spring his wife, Nadya, had worked for a while as the Lennons' personal assistant.

Yoko was a small yet voluptuous figure with a mane of coarse black hair hanging below her shoulders, her eyes slitted in a kind of contemplative arrogance. She exuded a kind of ripeness. The clinging top and hot pants, the knee-high boots, gave her a sexuality rarely displayed so openly.

Between songs, she came forward and suddenly held a pair of women's underpants aloft.

"Try them on!" she cried.

The room fell silent. For years this image would linger in the public mind.

Yoko continued to hold the panties aloft. "Come see if they fit!"

Before she had gone on that night, she had received a call backstage from John. He was drunk and Yoko had told May that she was supposed to watch that. "You know what happens when he drinks," Yoko said.

John seemed determined to start an argument—not with Yoko, with May. He was convinced that she was after his money.

Yoko told John he was drunk. She said she'd call him after the show and hung up.

"I didn't know what to do," May wrote in her book. "I knew how complex and paranoid John was; I knew how complex and unpredictable Yoko could be. I was no match for either of them. Yoko told John things as a way of maintaining her authority over him. Perhaps I should have suspected that she would tell John things about me— things that weren't true but that John would still believe in order to keep his idealized image of Yoko intact."

When she called John after her show, Yoko seemed more interested in telling him how the audience had received her than she was in hearing about May. John was still drunk and Yoko finally hung up on him.

Yoko was surprised when John arrived at her doorstep the next morning. He had brought May back to New York with him, he said, but had sent her off with friends. Yoko and John talked. He had made a complete ass of himself a few weeks earlier when he'd gotten drunk in a Los Angeles nightclub with Harry Nilsson and had worn a sanitary napkin on his head. He had been thrown out of the club and the

story had made all the newspapers. Yoko told John that she was very unhappy about that.

John looked remorseful. Yoko told him he had to take control of his life. He had to stop drinking. He had to return to Los Angeles—with May—and resume the work on an album he'd started with Phil Spector.

John then went to sleep, and Yoko prepared for her second night at Kenny's Castaways. Hours later, John and May returned to California, this time to a house they had found in Bel-Air.

In the weeks that followed, through November and into December 1973, Yoko stayed in constant touch, calling John every day and usually their mutual friend Elliot Mintz. When she heard that John was still drinking wildly and that Spector fired a gun into the recording studio ceiling, she decided it was time for a visit.

Yoko checked into a bungalow at the Beverly Hills Hotel the next day and invited John and May for lunch. That was when she learned that they had moved another woman into the house, Arlene Reckson, a friend of May's who had worked for Yoko and had helped her shop when she was a receptionist at the Record Plant, where Yoko and John had finished recording the *Imagine* album.

Yoko told May that Arlene was preventing them from growing as lovers. She suggested that Arlene be told to leave. She saw John once after that, alone, for another of her stern dressings-down, and then, after a couple of days of talk with Mintz and shopping, she returned to New York.

In mid-December John told May the affair was over, and May and Arlene returned to New York. The first person May called when she got home was Yoko, who told her to come right over to the Dakota so she could take care of things.

When May arrived at the apartment, Yoko suggested that May date one of the musicians in her backup band.

May said she wasn't interested.

Yoko told May to move into the Dakota, take one of the rooms and one of the telephones as her own.

May said she'd think about it and stayed with Yoko until Yoko drifted off to sleep.

The next day, Yoko told May that Julian was going to visit John for the Christmas holidays, and that John planned to take the boy to Disneyland. It would get complicated for John, Yoko said—all that moving around in public—and she suggested that May return to Los

Angeles to help him, because, frankly, she and Julian didn't get along (Julian was then 10). May said she'd go.

The press knew of the separation. The end of November and all through December the British tabloids had run headlines like "Miss May Pang—a New Friend in Lennon's Life" and "Lennon and Yoko Part."

Yoko was talking openly now. In one interview, she said she and John were on a "vacation" from each other. She admitted she was "strong-minded," but so was John, and maybe it was just too much after so many years of never being out of each other's sight.

"I have no idea whether John will come back to me," she said.

The papers lapped it up. For months now, the Lennons had received only the smallest of notices. Even when they both appeared publicly in nightclubs—she with Elephant's Memory, he with the sanitary napkin on his head—the press had come and gone quickly. Not since the deportation hearings had there been a story of such ongoing interest: a regular soap opera.

In January 1974, John took May to New York for meetings with his attorneys. Now even the money earned from the Beatles' solo albums was being frozen in the Apple accounts. Paul McCartney was convinced that he could earn great sums from his own albums and he didn't want to share that, ever, in any way, with anyone else. He was pressing for a quick end to the delay in finally dissolving the Beatles once and for all.

There was also pressure put on John and Yoko to give back to Apple all the money they'd spent on Yoko's films and recordings.

During one of the meetings, one of the attorneys told John that Yoko had asked another lawyer to handle her divorce. John went rushing over to the Dakota; Yoko admitted that she was considering divorce and mentioned June as a possible date.

In the months that followed, Yoko was depressed. John and May were still in New York in February, and on her birthday, February 18, they visited Yoko at the Dakota. She refused to get out of bed.

By now, Yoko planned to take Elephant's Memory on a tour of Japan, but in March her guitarist, David Spinoza, began talking to the press about how difficult it was to record with her. He later told Yoko he had been misquoted when the press said he worked with her only because the money was good. Otherwise, he apparently said, he'd be away in a minute.

He and Yoko fought vehemently, and soon after that he announced

to the press that he would not be going to Japan with Yoko because of other commitments.

When John heard about the split, he told Yoko to hire any guitarist she wanted and to go ahead with her plans. According to May Pang, John really didn't want Yoko to go—fearing the criticism she might receive—but he was never quite able to say no.

Yoko was now being seen with a columnist for *New York* magazine, Rick Hortzder, but her spirits continued to sink. When asked to write something for a popular Japanese weekly magazine, *Bungei Shunju*, in advance of her arrival, the story she told was most revealing.

Yoko wrote nearly 9,000 words, which appeared in the magazine under the title "My Love, My Battle." In it, she reviewed much of her life, sharing her memories of her childhood during the war and details of her first two marriages, including a brief confession about her attempted suicide and confinement in a Tokyo hospital.

She recounted her years as a struggling artist and told stories about her early adventures with John—*Two Virgins*, the bed-ins, and all the rest.

Finally, she wrote of her separation from John, saying that when he was in New York recently, they cried and laughed and took each other's hands.

However, she said, "I've had a strange image regarding my way of life.

"I am a fish on a cutting board. I feel tormented because I'm out of water. I'm breathing hard because I'm out of oxygen. I want to be killed because living is painful. I want to be cut up with a knife. That's the vision I have of myself."

The image was very Japanese and perhaps it was appropriate for a daughter of Japan to return with such visions. Nonetheless, her return was far from traditional.

She arrived in Tokyo in August 1974, before her long, autobiographical article was published. Others wrote about her, and it was clear that no matter who her parents were—they were still alive and well and living in a Tokyo suburb in retirement—and no matter how impressive her school-day connection to Japanese royalty, she was greeted as a foreigner.

There is in Japan something called *katakana*, a kind of lettering reserved for the rendering of foreign names in newspaper and magazine headlines—it is somewhat "looser," or hurried, than the more formal Japanese characters—and several Japanese publications used it

for Yoko's name. Two of her three husbands were foreigners, it was noted in the Tokyo press, and Yoko's avant-garde ideas were alien, as well.

Yoko's parents were ashamed. Yoko was incensed. Still, she forged ahead, presenting her songs with strength and force. She performed several feminist anthems as well as her pleading cry to her missing daughter, "Don't Worry, Kyoko."

She was dressed all in white, with a neck scarf. Between songs, she took her cigarette lighter and wrapped it in the scarf and flung it into the audience.

Another time she came to the lip of the stage, planted her hands on her hips, and said, "I'm not gonna dance for you. You better start feeling the truth. I'm gonna be around for quite a while."

At one of her concerts, when she lighted a cigarette, she was greeted by shouts of "No smoking!" in English from Japanese hecklers. She shouted back, "You boys would look cuter if you shut up!"

The audiences were small, with a good many empty seats at every show. Later she said that was because she detected the spirits of the children killed during World War II, more than thirty years before. These spirit children filled the empty seats, she claimed, and they cheered her, reminding her of her mission to bring peace to the world.

Midway through the tour her story appeared in *Bungei Shunju*. The press that followed was devastating, and it was no one's fault but her own.

"To the average Japanese housewife, the declaration of the vegetarian artist that she apologizes to the plants she eats comes as something entertaining, not believable," said a writer in the *Mainichi Daily News* (the popular English-language daily published throughout Japan). "Considering the price of vegetables in Tokyo, most housewives would prefer it the other way around.

"Reading a section of her autobiography in which Ms. Ono reveals that she came upon the idea for the film on buttocks by watching her maid scrub the floor when 'I was down and out in Tokyo,' a young Japanese wife could only say, 'Well, if that's her idea of being down and out . . .'

"In New York, Ms. Ono's simplistic, anti-Establishment pronouncements find sympathy with a generation that is rebelling against staid middle-class tastes. In Japan, people are still satisfied with the fruits of material culture; if anything, they would be glad if only they could afford more.

"They have time to read about Yoko Ono's exploits with John Lennon, but her urging people to 'get up when you want to, to eat breakfast when you want to, to just be yourselves,' no doubt sounds to them like so much 'Let them eat cake.' "

John was in New York during her absence, recording a new album, *Walls and Bridges*. One of the songs, "Whatever Gets You Through the Night," had gone Top 40 in England and to No. 1 in the U.S. It was his first No. 1 single in the U.S. as a solo artist, and when he recorded the song, Elton John was there. John and Elton made a pact: If the song was a hit, John would appear with Elton on stage the next time he appeared in New York.

About two-thirds of the way through Elton John's concert at Madison Square Garden on November 28, 1974, John walked onstage to join his friend in three songs—"Lucy in the Sky with Diamonds," "Whatever Gets You Through the Night," and "I Saw You Standing There."

Yoko was back in New York and had sent Elton and John a single flower apiece before the show, which they wore onstage, but John had no idea she was in the audience. (She had been taken to her seat by Beatle friend Tony King and seated in the dark.) When John came onstage, Yoko cried.

Later, she recalled, "Everybody was applauding like crazy—the house *shook* when he came on—and he was there bowing, but that's not what I saw. Somehow he looked very lonely to me and I began crying.

"Somebody next to me asked, 'Why are you crying?'

" 'I'm not crying,' I remember saying. But somehow it hit me that he was a very lonely person up on stage there. And he needed me. It was like my soul suddenly saw his soul. So I went backstage. I said hello and he said hello."

May Pang sat in the corner of the dressing room and watched her world slip away.

"Will you have me?" John asked.

Yoko smiled.

"Call me in the morning," she said.

20

Taking Over

YOKO was in complete control from the moment John moved back into the Dakota that first week of January 1975. Later, John would admit freely, and frequently, that he had asked many times to be allowed to return before she finally said yes. And to friends and interviewers alike, he seemed genuinely grateful that she took him back at all.

For *Playboy* magazine later, Yoko remembered that once she had come back from a show to find John in the living room. "We said hello and all that," Yoko recalled, "and then we sort of cried on each others' shoulders and while we were doing that, going on inside me was, 'Okay, crying's fine, but this means the whole pandemonium again. So, okay, well, goodbye.' But we were *crying* about it. It was very difficult."

The reunion was difficult, too, if May Pang's version is to be believed. She said that Yoko called John all through the 1974 holiday season and into the first week of January 1975, teasing him about a smoking cure she had discovered. At the time, John was smoking two packs of the pungent Gauloises a day and, like Yoko, for many years he had threatened to quit.

May said that Yoko wouldn't tell John about the cure, but scheduled meetings to discuss it, canceling and rescheduling the meeting several times because "the stars weren't right." May told John that Yoko was playing with him, as a cat toys with a wounded mouse, but John didn't believe her.

Finally the stars were right and Yoko told John he could move out of the Pierre hotel and back into her bedroom, providing he agreed to several conditions.

The first was that John would have to cleanse his body. There would be no more alcohol, she said. John agreed. And no more meat; instead a macrobiotic diet of fish, vegetables, rice, and fruit. John agreed. Plus, they both would see an acupuncturist (who would help them stop smoking, as well as unblock John's energy flow) and go on a forty-day liquid fast. John agreed. He said he would agree to anything.

The second condition of his return was that he would have to repair the holes in his aura. Whatever you want, John said.

The third "string" attached to his reunion with his wife was that he give Yoko day-to-day control of his business. To this John happily agreed. He hated business, always had, and that Yoko wanted to go to all those bleeding meetings was more than okay with him. She could even have that 200-page contract that Lee Eastman had been hassling him to sign, so the Beatles could legally slip into the past.

□

Almost within days of John's return, Yoko got pregnant, and when a doctor confirmed it, she was upset. At her age—forty-two—and with her history of previous miscarriages, the pregnancy was risky, both to her and the child; statistics were clear that women over forty had more problems carrying a child and a significantly larger percentage of the children were born with mental and physical defects.

Friends say that Yoko was even more concerned about the inconvenience of a pregnancy. When she was carrying Kyoko, she hated being pregnant, and she readily admitted it. The three pregnancies with John that resulted in miscarriage hadn't been any fun either.

Nor did raising a child offer Yoko any promise of enjoyment. John may have thought of Yoko as a Mother Earth type—and, in fact, he was calling her mother by now—but it wasn't the truth. Yoko was not the mothering type, and she was the first to say so.

As these arguments raced through her mind, Yoko decided that she did not want the baby. She told John she was going to have an abortion.

John pleaded. He said he thought the child was a gift, a symbol of their reunion, the answer to long-ago prayers, a sign of the good to come to them.

Although he never suggested that the child could replace Kyoko, Yoko had just marked the third anniversary of her daughter's disappearance. Consequently, the void seemed fresh, and she knew that another child might offer some relief.

(Unknown to the Lennons and their expensive private detectives,

Tony and Melinda Cox had sought refuge, with Kyoko, now eleven, in Los Angeles with the Church of the Living Word, a cult whose leader believed he was the reincarnation of Jesus Christ.)

A child by John could also provide a solution to some of the resentment she felt about Julian and Cynthia. "In other words," says one friend, "a child would give her more control. She knew that if she had John's child, she'd have John in a box forever, and could throw away the key. And the truth is, she *did* love John. So the *idea* of having a child with him was compelling."

Yoko said she would check the numbers and maybe have the tarot cards read. When those signs were favorable, or at least vague enough to seem so, Yoko changed her mind. She said she'd have the child, but only if John agreed to take over as soon as Yoko was out of the hospital. She didn't want to *raise* the child, she said. That would have to be John's contribution. John went leaping about the apartment. He said he would do anything she asked.

John called his friend Elliot Mintz in Los Angeles. "It's true," he said, "the marriage lives."

It was a time of great peacemaking. The same week that Yoko invited John to come home, and then got pregnant, John signed the agreement officially dissolving the Beatles. Within a month, all the lawsuits between the four Beatles were ended. Now the money from all the individual efforts, which had been flowing into one Apple account, were channeled into four separate accounts. No longer did John, who was selling more solo records than George, have to share his earnings with George; no longer did Paul, who was selling more solo records than John, have to share his earnings with John. They continued to share the Beatles' royalties equally, though, and for years, Yoko would fight the others over who would operate the Apple office, which continued to process the Beatles' earnings. But for the most part, the conflict was past. And everyone felt great relief.

In March, when John and Yoko made their first public appearance together at the Grammy awards ceremony, they certainly looked an odd couple. Obligingly, they allowed themselves to be photographed with a balding Paul Simon and Art Garfunkel and a skeletal David Bowie. They were dressed in typical garage sale chic: John in a beret and rumpled tuxedo, a knotted white silk scarf and medallions hung round his neck, and on his lapel an Elvis pin; Yoko was all in white and carried a feather boa. They both wore their hair long and straight, and their smiles were no less than serene.

Paul Simon was writing about himself when he wrote the title song

for the album of the year, "Still Crazy After All These Years." But he could have been writing about the Lennons, because it was, for them, a very crazy time.

Yoko was deeply committed to the occult. Already she'd sent John to see May, bearing a gift of a bottle of scented oil. "I'm supposed to put some on you," John said, not knowing that the foul-smelling liquid was supposed to bring bad luck.

Yoko was also, by spring, calling for guidance from a heavyset man named John Green, a professional tarot card reader, who came to the Dakota regularly. He was one of several readers, psychics, and numerologists she called, and according to his version of what happened in May, he was the one who devised the plan for breaking the contract with Allen Klein.

The break with Klein had been coming for more than a year. Klein had a history of moving through groups—picking them up, making fabulous deals, and usually getting dropped by them when they tired of his brashness or finally believed all the chatter in the music business that said he was not to be trusted.

So, too, the three ex-Beatles saw disenchantment replace the hope they'd felt when in Klein's presence. They acknowledged his deal-making prowess, and saw an increase in income because of his efforts, but they also noticed that he had cut himself into almost every deal and consequently he was making millions, usually for doing little more than serving as a "consultant" to this or that. There was nothing illegal about Klein's maneuvering, but to Harrison, Starr, and the Lennons, it didn't seem fair.

They'd also expected miracles greater than those he performed. Loss of the music publishing was a real blow. And however faultless Klein may have been in those negotiations, he was never quite forgiven for failing.

During one of Green's readings in what was known as the White Room of the Lennons' Dakota apartment—so-called because everything from walls to carpet to furniture was white—he suggested that they visit Klein's office and announce they had a great plan for making lots of money. They were to say they could not explain what the plan was, but were to be mysterious, saying they needed to examine the files. They were to take the files and leave, then sue Klein, leaving him with no paperwork with which to defend himself.

It was, Green later wrote in a slender book, the "first business maneuver the Lennons ever executed solely under the direction of tarot cards."

Green's description is hyperbole. While it was true that Yoko remained fascinated by her stable of unusual counselors, she never turned over control to them.

"The truth was," says a friend, "she used these people and what they said to control John and the others she had to deal with. People at Apple could never fathom her constant references to astrology and numerology and the tarot. It actually befuddled them. Or made them mad. And it gave her an advantage. People didn't know how to react to her demands, went absolutely bonkers when she said her 'reader' told her this or that. As they subsequently lost control, she gained it. It was a very clever technique."

There were others who said Yoko actually *did* listen to and follow the occult advice, saying that she did so because she really didn't know much about business and used the occult as a crutch. Anthropologists and psychologists have long argued that magical rites and superstitious behavior serve very important functions; they make the world seem more controllable and create confidence in an individual's ability to cope and take action—at least when the omens are favorable. And when things didn't go the way the individual hoped, the spirits, the cards, the "vibrations" could be blamed.

☐

All through the steamy summer months, Yoko got bigger. She didn't dislike this pregnancy as much as when she was carrying Kyoko, but she was uncomfortable nonetheless. The "deal" she struck with John took shape. When the child was born she said she would return to running the business and John would handle the parenting. At the time, "house-husbandry" was uncommon, and that aspect of it alone made it attractive to John; after so many years as a sexist rock and roller, in his approaching middle age, he wished to demonstrate liberal, or progressive, attitudes and behaviors, finally putting his sexist behavior in the past.

In the meantime, Yoko went to bed. Her doctor was cautious when he told her she was pregnant, and in light of her previous miscarriages, he strongly suggested that she do nothing to exert herself.

According to Peter Brown, John returned from the studio one night—where he was recording a new album—and told Yoko he had a surprise for her.

"What is it, Daddy?" Yoko said. They had begun calling each other Mummy and Daddy.

"I'm going to cancel the new album and stay home with you while you're pregnant."

"Oh, gooooood, Daddy!"

In the months that followed, John assumed control of the apartment—more or less putting the business on "hold" until Yoko could return to it after the baby was born in November—and at the same time became Yoko's personal servant. He carried her meals to her bed, insisting that she stay there throughout the pregnancy. When she wanted to move around the apartment, John pushed her in a wheelchair.

Yoko watched television with John. And she read her books and called in her psychics and seekers after truth. The months passed.

☐

Meanwhile, the battle over deportation continued. By now, Nixon had resigned the presidency in disgrace, and in June, the Lennons' lawyers had sued the two former U.S. attorneys general, John Mitchell and Richard Kleindienst, claiming that the deportation actions they took against his clients were improper.

Yoko and John were angry. In the past few months John had paid more than half a million dollars in taxes to the U.S. government and some of that money probably went to kick him out of the country. So it was with considerable joy that the Lennons greeted the news that came to them on October 7. It was on that date that the U.S. Court of Appeals overturned John's deportation order and noted in a thirty-page ruling that "Lennon's four-year battle to remain in our country is testimony to his faith in his American dream."

The ruling was made on the narrowest of legal points when the judge accepted the argument that John's 1968 conviction in London should be ignored because the law in Britain at that time did not require that John *know* that the cannabis was illegal.

Most important, the judge ordered the Immigration and Naturalization Service to reconsider John's application for permanent residence.

Two days later there was cause for greater celebration when, on October 9, John's thirty-fifth birthday, Yoko was rushed to the hospital, where by Caesarean section she gave birth to a boy, whom they named Sean Ono Lennon.

Later, John told Elliot Mintz that he and Yoko had taken classes in the Leboyer and Lamaze techniques of "natural" childbirth, but at

the last minute, Yoko was anesthetized and she was asleep when John first saw the 8-pound, 10-ounce child.

"I was jumping around and swearing at the top of my voice and kicking the wall with joy, shouting, 'Fucking great!' " John said. "Then I was just all eyes for the baby. I just sat all night looking at it, saying, 'Wow! It's incredible!' She'd been knocked out after the Caesarean and when she woke up, I told her he was fine, and we cried."

John greeted the press. "Yoko's fine," he said, "and the father is pretty good, too."

After Sean's birth very little was heard, or reported, by the press for nearly a year. The Lennons were in seclusion.

With the agreement to dissolve the Beatles behind them, they had no money worries, and Yoko, typically, began to spend. By the summer of 1976, when Sean was nearing nine months, the Lennons had added a third apartment in the Dakota to their holdings, and then they bought an estate on the north shore of Long Island, along with a 90-acre parcel in upstate New York.

John was not recording. And Yoko later recalled that some of the "business people"—their own as well as those at EMI—said, "Okay, John, you're not so hot any more, if you're not going to record alone, we are not going to take you."

So John said the hell with it, refusing to re-sign with EMI or Capitol when his contract ran out. He was, he said, in retirement. He was now a house husband who was not interested in music in the same way he once had been. Capitol was not pleased, and while Sean was still an infant, the American record company released an anthology of early material.

There were eleven tunes on the album, which they called *Shaved Fish*, all of them previously released in America as singles. The songs included several of John's hits—among them "Power to the People," "Instant Karma," "Cold Turkey," "Whatever Gets You Through the Night," and "Imagine"—as well as "Give Peace a Chance" (McCartney still got co-writer's credit) and two songs for which John shared writing credit with Yoko, "Happy Xmas (War Is Over)" and "Woman Is the Nigger of the World."

The album jacket and record sleeve said more than the songs. Both featured the full red circle of the Japanese flag, and the jacket included a drawing of a package of "shaved fish," a Japanese delicacy (fish that has been dried and chipped, to be eaten as a snack or included in soups and salads and with noodles). The drawings illustrating each of the songs also connected East and West. "Happy Xmas (War Is Over)"

was illustrated with an American bomber from World War II dropping a Christmas tree ornament. "Power to the People" was written out in the script usually identified with the U.S. Declaration of Independence, and the message below began, "We the People of the United States, in order to further advance the causes of international artistry and human relations, do ordain one John Lennon with a most prized and coveted 'Green Card.' . . ." (In anticipation of official permission to remain in the U.S., so long as he was gainfully "employed.") Yoko's "Woman Is the Nigger of the World" was presented with a drawing of a naked woman on her hands and knees, long, fat bullets plunging sexually from the sky toward her open rear.

In America, the album entered the *Billboard* charts in November 1976, peaking at No. 12 a month later. In England, the record went to No. 8. Nonetheless, in all, there were fewer than half a million sold, and after that, there was a recording silence that lasted for nearly two years.

□

During the next years, Yoko and her husband emerged rarely from their cloistered life-style. One event that brought them out came on July 27, 1976, when the Lennons and their attorneys appeared in a small hearing room on the fourteenth floor of the Immigration and Naturalization Service building in New York.

The lawyers were taking no chances. A green card was assured, but they still marched out a parade of sympathetic witnesses, including writer Norman Mailer, ABC commentator Geraldo Rivera, Japanese sculptor Isamu Noguchi, and actress Gloria Swanson.

John was asked to stand.

"Other than your original conviction," he was asked, "have you ever been convicted of any other crime?"

"No."

"Were you ever a member of the Communist Party or any other organization that attempted to overthrow the United States government?"

"No."

"Do you intend to make the United States your home?"

"I do."

"What are your plans?"

"I hope to continue living here with my family and make music."

It seemed a reasonable wish, and moments later, Yoko (wearing a black suit, white shirt, and black tie) was huddled with her mane of

black hair shoved into her husband's chest as he held his newly issued green card aloft for the television cameras.

□

In the summer of 1977, Yoko was feeling very good about herself. Early that year she had negotiated a separation from Allen Klein in a fashion that still makes him shudder. Later he would say that the settlement never would have been reached without Yoko's "tireless efforts and Kissinger-like negotiating brilliance." The truth was, she both angered him and baffled him. Mostly she angered him. In the end, he was given nearly £3 million (about $6 million), but it was less than fifteen percent of what the feisty New York manager had asked. His friends knew that he had sued for $35 million, and when Yoko began telling the press how much he got, he felt it made him look as if he had lost, as if Yoko had out-negotiated him.

Something else happened that bolstered Yoko's self-confidence. She had been included in a prestigious *Who's Who* sort of book called *Contemporary Artists, 1977*. Yoko had completed the biographical questionnaire herself, listing all of her schools and early shows (from the Village Gate in 1961 to the Everson ten years later), her albums and films, and a listing of her best newspaper and magazine reviews. (In a listing of her husbands, she left out Tony Cox, and when asked her nationality, she responded "American.") The publisher printed her every word. With the publication of the book, she finally achieved credibility as an artist. And for many months the book occupied a prominent place in the Ono/Lennon living room, as well as in the offices.

In July, Yoko and John went to Japan. According to John Green, Yoko's tarot card reader, John questioned Yoko's motives for the visit. He wondered if Yoko really wanted to see her family, or if she just wanted to show Mama-*san* that the black sheep in the family had done well.

Whatever John's doubts may have been as to Yoko's reasons, he prepared this time by studying Japanese and told Yoko he would make her proud of him. On the previous visit, he had met the Onos unshaven and in jeans. This time, he promised to wear a suit.

The trip started unfortunately. Yoko had consulted her Korean numerologist and determined that John and Sean had to leave five days ahead of her and had to travel eastward over Europe rather than westward over the U.S. and the Pacific. They were scheduled to arrive in Tokyo ahead of Yoko. On the way they made an unscheduled over-

night stop, and when they finally arrived in Japan, the hotel had given their rooms away.

That problem was no sooner resolved than Yoko arrived. She had arranged for a "spontaneous" press conference in Tokyo, at which she intended to announce that she and John would be writing a musical for Broadway, but John failed to show up. The numbers were "all wrong," according to Green, and Yoko was determined to set things straight by remaining in Japan for three months. John was appalled.

Yoko's version of what happened next—as communicated in daily phone calls to Green, who remained in New York—was nothing short of weird. Yoko refused to call her parents to let them know she was in Japan, figuring they'd call her after seeing all her publicity. Finally, at John's insistence, Yoko called, but her parents said their social calendar was too full to work them in before August.

Green's tales of the weeks that followed were no less bizarre.

When John got reclusive and refused to leave the hotel, Yoko bought bicycles, at Green's suggestion, and soon John and Yoko were rolling through Tokyo with some of Yoko's nieces in tow, followed by Japanese taking pictures and asking for autographs.

John quickly tired of Japan. They were spending too much money, first on the "Japan-nieces" and then on the rental of the Ono's ancestral home. Yoko was refusing to let John smoke cigarettes, while continuing herself to smoke "like a chimney." When John said he wanted to go back to New York, Yoko said the numbers were wrong. At first, John began standing in a corner of the room, moaning. Finally, he went mute, telling Green—on the phone—that he had died.

At last came August and the date for the meeting with Yoko's parents. According to Green, Yoko was terrified that John would upset her mother, which would result in Sean's being cut off from the Ono fortune. Yoko put in an emergency call to Elliot Mintz, telling him to come to Tokyo immediately. Mintz said he couldn't leave; his home was performing as homes often do in Los Angeles: It was sliding down a hill. Yoko told Mintz she would give him $30,000 to take care of the house; Mintz caught the next plane.

When the Lennons and Onos met, John couldn't be shut up. Suddenly he was Mr. Charm, showering Yoko's mother with attention and gifts, speaking to her only in Japanese. Yoko called Green and said her mother was testing them to see if they were as rich as people said Beatles were. She said John's lavish attention reinforced her mother's grand opinion of herself, while it diminished her opinion of Yoko. At

the same time, Yoko said, her mother called her "silly" and said she was not surprised that Yoko had married so often, so badly.

Yoko could take no more and in October, after selecting a "safe" traveling day, Yoko left Japan five days ahead of John, while John stayed on with Mama-*san*.

21
Starting Over

S EAN was two years and a few months old when his father went to
bed for fifteen months.

The pressures had been building for John as Yoko took up the
reins of running his business, leaving him with a child too young to do
anything much with, which, coupled with no career nor any desire to
re-create one, left him sullen and depressed.

Japan had left them cash-poor, yet Yoko saw clearly that their
income for the year had been huge, and if they didn't take steps
immediately, the tax bill would be unaffordable. With Green's tarot
cards, she discovered a "solution." The Lennons would buy farms and
cows.

In the end, Yoko bought nearly a thousand head of prize holstein-
friesian bulls and cows and four farms in Delaware County, in the
green rolling farmland in upstate New York not far from the Catskill
Mountains.

Yoko told John that her plan couldn't fail. The four farms together
offered more than 2,000 acres, which could be turned into the largest
organic farm in the U.S. So close to Manhattan, it could become the
major source of food for the burgeoning "health food" restaurant
craze.

One of the farms was a dairy farm and the milk produced could be
sent to the same stores as "raw" milk, while the bulls could be gelded
and raised as organic beef. Even the fresh spring water could be bot-
tled and sold.

Yoko's mind whirled as she explored her options. She could put in
chickens, who would lay organic eggs and, later, provide organic
chicken legs and breasts. She could plow the entire acreage and call it

a worm farm, taking the "farm development" tax deduction. On top of which she could pile other tax advantages offered by the government for using hydroelectric, geothermal, and solar energy sources.

Finally, she argued with the conservative accountants who were by now driving her crazy, if all else failed, the proximity to major highways and the popular Catskill resorts could only increase the value of the land for use in future development.

It was during that winter that the Lennons received the first serious threat on their lives.

Since obtaining John's green card, they had wandered the streets and highways freely, just as they always had, feeling no fears. When they drove north to visit their new farms, they traveled in a brace of long, black limousines. (Sean and his nanny were in the second car so his crying wouldn't annoy John.) And they openly signed all documents for purchase of the property, rather than have a lawyer sign. The word spread. A Beatle was in Delaware County.

It probably wasn't related, but one day a few weeks later, Yoko picked up the telephone at the Dakota and someone said, "We want $200,000 or we will do something terrible to your family."

In reaction, Yoko and John and Sean went south to spend the Christmas holidays in Palm Beach, where Julian Lennon was to meet them. Julian was thirteen years old, and John said, later, that he wasn't able to handle him. He said he decided that for once they wouldn't exchange gifts, but only give of themselves. Julian asked his father if this new behavior was an "act."

"An act?" John later cried to Green. "I'm trying to be genuinely myself for the first time since I was a kid and nobody wants me! I can't fuckin' believe it! I feel pleased, honored, fulfilled, and privileged because I am finally being myself for a change, and nobody wants me.

"Well, I gave them what they wanted. I gave 'em a mega–material gift gala and I hope it brings them great pleasure. Julian, Yoko, both seemed much relieved that I went back to being my other, older, lesser self. And if that's what they want, they can have it till the money runs out or I do with a Merry Christmas and a Happy Fuckin' New Year on top."

That's when Green says John went to bed.

It was an ordinary bed in an ordinary room in the Dakota flat that was home. There was a television set that was nearly always turned on, with the sound turned off or down. John's guitar was hung symbolically on the wall and near it hung a scimitar, representing the notion for both Lennons that they had each cut all ties with the past.

Except for the staff, very few people visited the apartment and offices. Elliot Mintz came by freely, as did the actor Peter Boyle and his wife, writer Loraine Alterman. And there were isolated evenings with Paul and Linda McCartney, who were somewhat reconciled by now.

At the same time, neither John nor Yoko ever called Mick Jagger, who lived only a block north on Central Park West. John had only a dozen or so names in his address book and never called any of them. He lay in his great white bed and watched the flickering TV.

This left Yoko completely in control, free to indulge in her wildest whim. Once, in the midst of negotiating with the Apple lawyers in the endless struggle to dissolve the company and resolve the money differences, she dragged John off to Egypt to spend a night in the Great Pyramid, collecting needed, and deserved, energy for the fight to come.

Yoko returned with trunks loaded with thousands of dollars' worth of ancient Egyptian artifacts, more thousands of dollars in Egyptian clothing, and a taste for Egyptology (which fitted her love of the occult). For some time afterward, she often appeared at meetings wearing ancient Egyptian robes and headdresses, upsetting the lawyers from Apple.

Many details remained to be resolved in the ongoing conflicts between Lennon and his fellow Beatles. The disagreements about Apple had not all been resolved. Nonetheless, much money had been released. And in the second half of the 1970s, from 1976 to 1979, when John and Yoko were silent, the Beatles were suddenly big hits again, and the royalties came roaring in.

By the mid-seventies, "bootleg" tapes of previously unreleased songs and in-concert performances had gained a significant foothold in the album market, cutting into conventional album sales. Record companies reacted by issuing many "historical" albums of their own. Some of the most successful released were by the Beatles.

In England, where punk rock was rearing its first electric head, Polydor and Parlophone, two of the early Beatles labels, reissued long unavailable albums and previously unreleased tapes and saw some of them become great hits. For example, in 1977, a collection of love songs went to No. 7 and a largely unintelligible recording of the Beatles performance at the Hollywood Bowl in 1964 went to No. 1.

In America, where record success was more modest, there was, in 1977, a successful musical revue on Broadway called *Beatlemania*, a show that ran for more than a thousand performances.

John didn't pay attention to any of it. He watched the world parade on TV, flat on his back in bed.

In 1978, John watched *Saturday Night Fever* become one of the biggest-grossing films of all time, catapulting John Travolta from one of an ensemble of actors on a television show into what seemed to be larger-than-Beatle eminence. He watched the U.S. government examine the assassinations of Martin Luther King, Jr., and Robert Kennedy, concluding conspiracies likely in both cases, but failing to recommend further prosecution. He watched the punks in England and the new wave in America, and reggae happening everywhere. He watched *The Deer Hunter* win a best picture Oscar and Jon Voight and Jane Fonda win best actor and actress for another Vietnam film, *Coming Home*. On the surface, it seemed his kind of news.

He ignored it all, and Yoko continued to run the show. John Green told a story about Yoko's negotiations for the purchase of a Middle Eastern mummy case. She had been told that the sarcophagus contained the corpse of a woman from "the East," and she took that to mean the ancient coffin contained the evidence of one of her previous incarnations, and she wanted the power that her early life form would bring.

When the wooden box decorated with jewels and gold leaf arrived—after Yoko finally agreed to pay half a million dollars for it—she was dismayed to find the face on the outside didn't look Japanese. She had to be reminded that Persia was also considered Eastern.

Green also reminded her that no matter what the coffin contained, or looked like, it was worth more than she paid for it, because New York's Citibank had just announced that it was investing in Egyptian and other Middle Eastern art and artifacts, which drove worldwide prices up. Yoko said she knew that was going to happen, that's why she bought Egyptian artifacts in the first place.

As John sank further into depression, however, Yoko began to lose control. She told friends that he never moved from the bed, sleeping as much as twenty hours a day, chain-smoking marijuana cigarettes whenever he was awake. In her meetings with Apple attorneys and others regarding her husband's business, she suddenly lost her energy. No longer did she have a desire to outmaneuver or wear down the opposition. Now she agreed to everything (which, in fact, put everyone off-balance, giving her an advantage she never recognized).

By 1979, Sean was in a preschool. It was better, John said later, than being told by his nanny not to bother John and being told by Yoko that she was too busy to play with him.

Yoko admitted it. At the end of the day, when she came back to the apartment from her offices on the first floor, she blew her son a kiss and that was about it. "How was your day?" she'd ask.

They were buying more apartments in the Dakota. The suite of rooms on the first floor had been converted to offices and called Studio One. Rooms were filled from floor to ceiling with file cabinets that held millions of pieces of paper—every contract and photograph and exhibit program and letter Yoko and John had ever written or received.

In one room, Yoko had her desk and telephones. As always, Yoko loved the telephone and spent hours every day talking with a collection of attorneys, accountants, landlords, shopkeepers, old friends, psychics, and numerologists—exchanging gossip, making demands and buying things, ordering friends to and fro.

"To watch Yoko in the office was to watch one of those peculiar perpetual motion machines," says someone who was there at the time. "You know the kind of machine that's got a thousand interlocking gears, with ball bearings rolling down little metal troughs, only to be carried to the top again by some of the gears. To watch her was to be mesmerized. You were certain that there was a system, and meaning, there, but you weren't really sure because it seemed so random, so peculiar."

The beginning of 1979 John began to recover from his long lethargy. He slept less and started spending more time with Sean. He even started using Sean's small indoor trampoline. He began to show real interest in what Sean experienced at school, and insisted that the boy not be given any sugar or allowed to watch too much TV.

It was around this time that John baked his first loaf of bread, and he took a picture of it to send to friends.

Yoko was delighted to have him back from what John Green called "the Land of the Dead."

In the *New York Times* on Sunday, May 27, 1979, there appeared a full-page advertisement headlined "A Love Letter from John and Yoko to People Who Ask Us What, When, and Why." Everything was perfect, they said in a message written largely by Yoko. They found themselves wishing and praying for things together now, because it made them happen faster. Magic was simple, real, and logical, they said, so when they met someone who was angry with them, they mentally drew a halo around his or her head. At the same time they were creating "quiet spaces" in their heads to make their wishes come true.

Yoko wrote all of the final paragraph, saying that their long public silence was one of love, not indifference. "Remember we are writing in the sky instead of on paper—that's our song," she said, recalling the whimsical prose style of *Grapefruit*. "Lift your eyes and look up in the sky. There's our message."

"Remember," they closed, "we love you. P.S. We noticed that three angels were looking over our shoulders when we wrote this!"

The next day, newspapers around the world published bits and pieces of the letter, making them look perfect fools.

"John, Yoko and the Three Angels," headlined the *London Observer*, one of that city's more sympathetic dailies.

Nearly everyone noted how much the advertisement cost: $18,240.

Said England's *Daily Mail*, "Ex-Beatle John Lennon and his wife Yoko Ono have paid £10,000 for a remarkable advertisement to tell the world how much they are in love."

John and Yoko said they didn't think that was a waste of money. They felt if everyone spent a small part of their income proclaiming love, the world would be a better place.

By now, Yoko was showing her strength in peculiar ways. One of the strangest was in sending John on "direction trips." Elliot Mintz explained that if Yoko said it was important for John to travel in a northwesterly direction for 18,000 miles the following day, John wouldn't question it, he'd call the travel agent and in the morning he'd be gone.

Mintz says that he also took such trips. Yoko always said, "If you do this, it's going to dramatically alter the next six months of your life in a favorable way." Mintz swears that there were direction moves that she gave him that did "significantly alter the structure of my life."

There are, of course, others who view such opinion somewhat skeptically. Some think the whole concept of "directional travel" to be nonsense of the highest order. They also notice that for those who have been sucked in, and made the ordered moves, it was natural to justify the action by later saying that it really worked.

"It was," said one cynic, "very good for Yoko and very good for the travel agent."

One day in late autumn, the telephone rang; Yoko, who was with John in bed, answered. At first, John failed to look up from the sketch pad in his lap.

Yoko gasped.

Now John looked at her. "Who is it?" he asked.

Yoko was visibly stunned. She glanced at John and said, "It's

Kyoko!" In the same breath she asked her daughter where she was. Kyoko refused to say, but asked if Yoko still lived in the Dakota.

"Yes," Yoko said, "it's the Dakota apartments at Seventy-second and Central Park West."

Kyoko spoke for a moment more, and then, abruptly, hung up.

Yoko turned to John excitedly. "She's coming here," she said, not really believing it. "Kyoko's coming for Christmas!"

Yoko was shaking. "Oh, John. She's alive."

The weeks crawled until Christmas Eve, when Yoko had a special meal prepared. Candles were lighted for her daughter's arrival. Outside, there was snow. The evening passed slowly, with much conversation about how Kyoko must have been held up by the weather.

But Kyoko never came.

Despite the great disappointment, John planned a romantic New Year's Eve.

For John's thirty-ninth birthday, on October 9, 1979, Yoko had bought an old bubble-top Wurlitzer jukebox, which John installed in a vacant room in the main apartment. Infatuated by the idea of having his own club—much as John Belushi and Dan Aykroyd had their private Blues Bar in downtown Manhattan—John decided to create the "Club Dakota."

He filled the jukebox with records by Bing Crosby and Frankie Laine and other American singers of the 1940s and 1950s. When Elliot Mintz next came to town, John said he wanted to surprise "Mother" with the club, so for several days they secretly shopped, furnishing the room with art deco antiques. Finally, on New Year's Eve, John hand-delivered an invitation on a silver tray.

John wore tails, a white T-shirt, his old Liverpool school tie, and white gloves. Yoko wore a black gown. At midnight, they danced to Guy Lombardo's "Auld Lang Syne," toasted Mintz (who also wore tails and white gloves), and watched the fireworks over Central Park.

Then, for the next few months, they were apart again, as John stayed in their home in Palm Beach (visited by Julian) and Yoko remained in New York, working.

In March 1980, John returned to the Dakota for their eleventh wedding anniversary—he gave her heart-shaped diamonds and 500 gardenias; she gave him a vintage Rolls-Royce—and then he went to live for a while in the big house on Long Island.

He was there when Paul McCartney was arrested for possession of marijuana upon entering Japan for a tour. Yoko worried that John

might be depressed, thinking of his own troubles with drugs and the law, but John was merely angry, and he told Yoko that he thought Paul was framed.

Yoko told John Green that she thought it all happened because Paul was going in the "wrong direction."

"I've been studying his numbers," Yoko said, "and I can see where he made his mistake."

In July, John left New York again, this time with Sean, on a 43-foot yacht that Yoko had bought, the *Isis*, named for the Egyptian goddess. Yoko said that Bermuda was a good direction, and she sent with him Fred Seaman, nephew of Norman Seaman, who had produced her early shows in the Carnegie Recital Hall. Seaman and his mother, Norman's wife, Shirley, had joined the Lennon staff.

Some time before, the young Seaman had given John cassette tapes of the Pretenders, Madness, the B-52s, and Lene Lovich. He started listening to them in Bermuda, discovering that much of their music—especially that of the B-52s—sounded like what Yoko had been doing ten years before.

The off-key wailing, the all-out vocal assault, what *New York Times* critic Robert Palmer called "vocal brinksmanship," rang clear and true for John. Suddenly he was proud of Yoko in a way he hadn't been before. He called her in New York.

"Have you heard this New Wave stuff?" he said.

"Which one?"

"Any of it. There's nothing new about it. You've been doing it for years. . . ."

They talked for nearly an hour, and although Yoko had much to report regarding the sale of one of their prize cows, which brought an astonishing $265,000 at the State Fair in Syracuse, it was John's news that dominated. He was, he said, writing songs again, and he wanted Yoko to start doing the same.

"We're gonna make an album, love."

John Green was with Yoko when John called. He said that Yoko was unimpressed by the news.

"It isn't important, is it?" she asked.

"One of the world's foremost songwriters hasn't written in six years and all of a sudden he's unblocked and writing again? I would say that's important!"

Yoko told Green that John had sung one of his songs to her on the phone, and she said it wasn't much. Green said that may have been true, but please don't discourage John, because writing weak songs

was better than writing none at all. With time, perhaps John's songs would improve.

Before the afternoon was out, John called Yoko again to say that he'd written two more songs.

Yoko told Green that she was afraid John would be disappointed. There were other times, she said, when he thought he had broken his long, dry spell, only to sink back into silence again.

Her fears were unfounded. When John returned with Sean, he was dancing. He had, he said, fourteen new songs and expected to write several more, which would give them more than enough for an album, because he wanted her to write an equal number, and the idea was they'd alternate songs; he'd sing one of his, and she'd sing one of hers, he'd sing another of his, and so on.

Yoko was dazzled and charmed. She especially liked the idea that their songs would appear on alternate tracks. In past album collaborations, and on singles as well, John had sung on one side, Yoko on the other, and it was well known that only one side of those records got any significant play, either on the radio or in record buyers' homes, while all her own solo efforts had died horrible deaths. Now she, and her songs and voice, would be unavoidable.

Yoko told John that to arrange the songs in such an order would be to create a sort of radio drama, a dialogue between the two.

"Both John and I thought that this is a time that dialogue is necessary between men and women again," Yoko later told an interviewer. "Of course, in the sixties there was a sexual revolution and everybody was all excited about it. But then it turned out to be a sexual revolution for men and not for women. And so women started to feel very resentful and felt like you were used, you know, for their revolution or whatever.

"I think it's time that we could come back together again. At the same time, it has to be that men would extend their hands to us, you know, cause in a way it's their turn, you know, to understand the situation and say, 'Let's start over again.' "

When word got out that John Lennon was ready to go into the studio after a six-year absence, hundreds of calls came in to the Lennon and Apple offices and to anyone who had even the flimsiest connection to the couple. Musicians everywhere wanted to participate. Together, they decided they didn't want to use anyone from their past, including old friends like Klaus Voorman.

At Yoko's suggestion, however, they did ask Jack Douglas to be their producer. He had been chief engineer on some of their earlier

New York albums, including Yoko's *Feeling the Space* and *Approximately Infinite Universe*.

In just ten days, John and Yoko recorded twenty-two songs. In a time when rock bands were spending six months to two years to produce a dozen songs for an album, this was quite unusual.

The songs were simple and direct, the messages what Yoko called "sort of old-fashioned: family, relationships, children. But it's not just showing what happened, but what we gained from the experiences. It reflects the kinds of things we learned from life, you see."

John said the songs were "completely autobiographical." When he wrote and sang "Starting Over," it was about and to Yoko, a romantic promise to re-create the love they had when they first loved in 1968. "Cleanup Time" was about Yoko's years running the business and his as a house husband. "Losing You" was a lament for the mistakes he felt he'd made, and "Woman" was an apology, as well as surrender and thanks.

However different Yoko's songs, they were compatible. When John recorded a song called "Beautiful Boy," a clean, clear love poem to his son Sean, Yoko countered with "Beautiful Boys," in which she addressed both Sean and John, then aged four and thirty-nine, but very much alike.

As they began mixing the songs, "Starting Over" was picked as the first single to be released, with Yoko's "Kiss, Kiss, Kiss" to be on the other side. This was one of the most controversial songs of the entire album. Not because of its pained and somewhat desperate lyric, but because of Yoko's blatantly sexual groans and cries, ending in what sounded like orgasmic ecstasy.

"I started to do it," Yoko said later, remembering how she recorded the song, "and then I suddenly looked and all these engineers were all looking, and I thought, I can't do that, you know. So I said, 'Well, turn off all the lights and put the screen around me,' and I did it that way."

Her other songs were closely linked. Some, like "Give Me Something" and "I'm Moving On," recalled the hard times, when the relationship was on rocky ground, and Yoko still sounded angry. In others, notably "I'm Your Angel" and "Every Man Has a Woman Who Loves Him," Yoko clearly and warmly pledged her love.

In the month of remixing that followed the splendid burst of recording activity, it was decided to end the album with Yoko's "Hard Times Are Over."

The title said it all.

22

Double Fantasy, Multiple Nightmare

THE ALBUM was entitled *Double Fantasy*, the name of an orchid John had seen while in Bermuda, and after several record companies were rejected because they wanted to hear the music before making an offer, the record went to David Geffen, an aggressive young talent manager and record company owner in Los Angeles who had made his name recording Joni Mitchell, Jackson Browne, Tom Waits, Linda Ronstadt, and the Eagles. He was also known, in the popular press at least, as the man who succeeded Sonny Bono in Cher's life.

When the *Double Fantasy* project came his way, Geffen had sold Asylum Records to the Warner Bros. group, and before signing the Lennons his biggest coup was capturing Bob Dylan from Columbia for two albums in the 1970s. Yoko and John said later that the main reason they went with Geffen was he trusted them enough to say yes before listening to the music. They also didn't want to commit themselves to the "gray suit" mentality of the big companies.

As Geffen was leaving the studio after first hearing the songs, John pulled him aside. "You know," John said, "we have to take care of Yoko. You and I have what we set out to have, but Yoko never got what she deserves. And that has to be our goal with this record."

Geffen said that until then, he thought of Yoko as "this ambitious woman who was pushing out her music through John's success. What I came to learn was quite different. She kept saying, 'Oh, John, you

don't want me on this record. People really want to hear you.' And he would say that he wouldn't *make* records without her, and he was going to see that she got the recognition she deserved. This was a constant theme in my conversations with John."

Because so much material had been recorded, at first there was talk about releasing a double album. But finally the number of tracks was pared to fourteen—still a "bargain" for the record buyer in a time when ten or eleven songs were standard—and Geffen began talking about releasing a separate single or LP of Yoko's songs.

The music industry was buzzing. Everyone wanted interviews and photo sessions, and for the first time in many years, the Lennons said yes to practically everyone.

This didn't mean that Yoko made it easy. For some she did not. David Sheff was an interviewer for *Playboy* who had talked with Jimmy Carter, Martin Luther King, Jr., Bob Dylan, Albert Schweitzer, and others. Nonetheless, when he called, one of Yoko's assistants asked for the time and place of his birth.

"The interview apparently depended on Yoko's interpretation of my horoscope, just as many of the Lennons' business decisions are reportedly guided by the stars," Sheff later said. "I could imagine explaining to my *Playboy* editor, Barry Golson, 'Sorry, but my moon is in Scorpio—the interview's off.' "

Sheff passed the first test and was asked to come to the Dakota offices. Upon arriving there he was told to remove his shoes and, when finally meeting Yoko, was informed that she had read his numbers as well as his stars.

"This is a very important time for you," she said. "This interview will mean more than you can comprehend now."

Yoko and John then gave Sheff the longest and one of the most revealing interviews of their lives. However, it was not so different from the dozens that followed. In all of them, in the weeks before and after the release of "Starting Over" on October 21 and the album one month later, the Lennons welcomed dozens of people, candidly and effusively answering anything they were asked.

They welcomed old friend Bob Gruen, who had taken so many early photographs (including album covers for some of Yoko's solo LPs), and whose wife, Nadya, had worked for Yoko as a personal assistant for a while. He took pictures of the couple in the recording studio, some showing Yoko napping on a couch that had been placed next to the recording console.

To another photographer, Allan Tannenbaum, they revealed them-

217 | *Double Fantasy, Multiple Nightmare*

selves most completely. Tannenbaum met John and Yoko while shoot-
ing pictures to go with an interview that was to appear in the *SoHo
News*, a New York weekly that focused on the arts and politics. He
was later asked to be present at the filming of a video in a SoHo gallery
in which a white bedroom had been built. The nude lovemaking
scenes that followed would later be considered too erotic for broadcast,
but popular at selected discotheques throughout much of the Western
world.

The Lennons posed in the studio, on the street, in their apart-
ments—in kimonos, in jeans and berets and turtleneck sweaters, in
cowboy shirts and shorts. Nothing they wore looked like it cost very
much. And in perhaps half of the sessions, whether indoors or out,
they wore their trademark sunglasses.

When the photographers and interviewers came to the Lennons'
offices, they saw floor to ceiling filing cabinets with headings ranging
from "Holsteins" to "Beatles" to "Palm Beach." Generally, the visitors
were served hot tea.

When invited into Yoko's private office, shoes were removed be-
fore crossing the white shag carpeting (much like that in their Ascot
home long ago). On the walls were glass cases containing Yoko's collec-
tion of Egyptian artifacts. Over a white piano was a large oil portrait of
John and Sean, painted by someone John met in Bermuda. While
talking with the press, Yoko sat on a big white couch and flicked her
cigarette ashes into a jade ashtray on a glass coffee table. John usually
sat at her side, sharing the ashtray and the microphone. As always, no
matter what the interviewer wanted, John was determined to give
Yoko equal interview time.

Patiently, for everyone they met, they retold the story of their
meeting and early romance, and of their subsequent separation and
reunion. They talked openly about the women's liberation movement
and role reversal, and of the pain they both felt when so many rejected
Yoko so cruelly. Yoko admitted she had been an "offbeat mother" to
Kyoko, said it probably was wise when that court in Majorca made its
custody decision based on Kyoko's desire to remain with her father.

"I'm very clear about my emotions in this area," Yoko told *Play-
boy*. "I don't feel guilty. I am doing it my own way. It may not be the
same as other mothers, but I'm doing it the way I can do it."

Yes, they had money, Yoko said, but, "I don't have a penny. It's all
John's." She laughed, then said they were giving ten percent to the
needy.

"To make money, you have to spend money," Yoko said. "But if

you are going to make money, you have to make it with love. I love Egyptian art. I make sure I get all the Egyptian things, not for their value but for their magic power. Each piece has a certain magic power. Also with houses. I just buy ones we love, not the ones that people say are good investments."

But how much did they have? the interviewers continued to ask. Was it true what the *Daily News* said? $150 million?

Yoko stared blankly and John said he really didn't know.

On September 29, *Newsweek* magazine carried a two-page interview with the Lennons. *Newsweek* said it was John's first major interview in five years. *Playboy* was furious at losing its exclusive and requested more interview time. The Lennons agreed.

Between interviews and sessions in the studio remixing *Double Fantasy*, John and Yoko often strolled from the Dakota to La Fortuna, a neighborhood coffee shop where they liked to drink cappuccino and read the *New York Times*. There, over cigarettes and pastry, they read that John Bonham, the drummer of Led Zeppelin, choked to death on his own vomit after downing forty drinks of vodka on the eve of the band's U.S. tour. Two weeks later, Bob Marley collapsed onstage during a Wailers concert in Pittsburgh—his last public performance before dying seven months later of a brain tumor. Queen's No. 1 hit that week was called "Another One Bites the Dust."

Yet all the news was not grim. The same week the Lennon interview appeared in *Newsweek*, John's friend David Bowie opened to rave reviews in a Broadway play called *The Elephant Man*. Paul McCartney was recognized by the *Guinness Book of World Records* as history's all-time best-selling songwriter and recording artist. And on October 9, Yoko rented the Tavern on the Green in Central Park to celebrate John's fortieth birthday and Sean's fifth. She hired a magician-mime to entertain, a skywriter to etch a "Happy Birthday" message across New York's skyline, and had Bob Gruen record the event with a video camera.

"Starting Over" entered the *Billboard* chart one month later, on November 9. Yoko smiled when told the news. She reminded John that they had met on November 9, 1966, at the Indica Gallery. And as John well knew by now, the number nine dominated much of his life.

Yoko kept track of such things. Didn't they live on 72nd Street (and 7 plus 2 equals 9)? Hadn't he written songs called "Revolution No. 9" and "No. 9 Dream"? And didn't one of the most important songs of his career have nine key words: "All we are saying, is give peace a chance"?

Yoko had pages of such material in the Lennon files. She told John that the November 9 *Billboard* date was a good omen. She then called John Green and asked him to read the tarot cards for each of her songs.

The way Green later told the story, Yoko sang each song—with "teeth-grinding determination"—and asked him to predict which ones would be hits. When he said they couldn't all be No. 1, she responded that they could all be in the Top 10. This would still leave room near the top for John's songs.

It was important, Yoko said, that people heard her music, because she was an important influence on the New Wave groups.

Green told Yoko he thought she was starting to believe her own press releases. He told her that in her future interviews she should talk about how much she had been hated in the past.

"Hating you used to be fashionable, but that time is past," Green said. "It makes interesting copy. 'Why did people hate this excellent person?' That's how you have to play it. Otherwise, if you try to ignore the past, someone else will dig it up for you. It's better if you hit the issue head on. It makes you look stronger."

Not long after that, Yoko had John call Green and fire him. Yoko was getting stronger psychic messages, John said, so she wouldn't be needing so many spiritual guides any more.

Yoko never talked to Green in friendship again.

☐

The first week of December 1980, the Lennons revealed more and more of themselves, as they agreed to several major interviews and blocked out sections of two days for a photo session with *Rolling Stone* photographer Annie Liebovitz.

Liebovitz was one of the pop world's most acclaimed photographers that year. Fourteen years before, her first professional assignment had been to photograph John for *Rolling Stone*. She was a tall, self-assured professional now, and the Lennons took her direction comfortably.

On December 3 and 8, before the two days of shooting were over, John took off his clothes and straddled his fully clothed wife, wrapping his legs around her in a fetal position.

"I know you wanted to photograph me in an apron," Yoko told the photographer at one point, "but like any rich housewife, I can afford a cook."

The Lennons scheduled one major interview a day and went into

the studio at night to continue work on some of Yoko's songs.

On December 5, they sat down with Jonathan Cott for *Rolling Stone*, talking about the songs on the album, then took him along to the Hit Factory, where John talked until 2:30 in the morning and Yoko napped on the studio couch.

On December 6, they met with Andy Peebles of the BBC. It was in the final moments of this interview that John was asked how he felt walking around the streets of New York. Wasn't he worried about some crazy coming up and doing who knows what?

Yoko sat there and watched John say, "She told me that, 'Yes, you can walk on the street.' You know. She says, 'You will be able to walk here. . . .' "

On December 7, the *Playboy* interview was on the streets, and Yoko called David Sheff to say that John was pleased.

On December 8, between 2:00 and 5:00 P.M., the Lennons were interviewed by Dave Sholin, a San Francisco disc jockey, for RKO Radio, an American network.

As they had for everyone, Yoko and John again patiently rolled out their memories and delivered a sermon on love.

"We are fully aware of our power, whatever that is," Yoko said, "and we nurture it and we try to be very careful about our own life because of that and also to try to communicate as much as we can with our power."

John's words conveyed the same thoughts. He said he and Yoko always were on the cutting edge. "Being artists, when we get into something, we get into it! We wanted to be right there, right on the front lines, that's what we always said to everybody, and even now, we're still right down there, we want to go all the way with it.

"There's only two artists I've ever worked with for more than a one-night stand: Paul McCartney and Yoko Ono. I think that's a pretty damn good choice."

Later it would sound prophetic; at the time it sounded romantic: "I hope I die before Yoko, because if Yoko died, I wouldn't know how to survive. I couldn't carry on."

☐

Even in the first weeks, the single and then the album seemed clear hits. But not all the early interviewers were pleased. Several, in fact, were distinctly annoyed by Yoko's tracks, especially with their placement on the album. It thus became quite popular, among critics and John's fans alike, to buy the album (or borrow a friend's) and make a

cassette tape of the Lennon tracks so that Yoko's material could be discarded.

Nonetheless, both records went right onto the charts in both Britain and the U.S. Yoko also noticed that some of the critics even seemed to prefer her material.

Charles Shaar Murray was one of them. In *Melody Maker*, Murray called the album an "event," if for no other reason than it broke a long silence from John Lennon. However, he said, all the most interesting material was Yoko's, and her verse in "Beautiful Boys" clearly demonstrated that "her love and admiration for her husband are considerably more clear-eyed than his for her; he writes about her as an omnipotent, benevolent, life-giving Natural Force; she writes about him as a gifted human who is still a child. . . ."

Yoko's songs easily were the album's "best moments," Murray said, and he was looking forward to Yoko's solo album then being discussed in the press.

At the time, Yoko and John were remixing, with David Geffen, what was to be Yoko's first truly successful pop song—the one that Charles Shaar Murray was waiting for—"Walking on Thin Ice."

After the December 8 session, someone suggested going out for something to eat. John and Yoko decided they'd go home instead and ordered their driver to take them to the Dakota.

John had no way of knowing it, but he had been stalked for several days and was, in fact, approached by his killer for an autograph outside the Dakota earlier that day. It was rare when fans didn't do that, so when he and Yoko emerged from the limousine, neither of them paid much attention to the small group of people standing near the entrance.

"Mr. Lennon."

The call came from the darkness. John looked toward the voice as Yoko preceded him toward the guard gate and the courtyard entrance to the apartment building. Yoko was near Jay Hastings, the burly young doorman who was such a fan himself. It was shortly before 11:00 P.M.

There were shots. Yoko spun around and saw John coming toward her. Together, they stumbled into Hastings's small office.

Yoko was screaming now. "John's been shot! John's been shot!"

John walked a few steps into the office and then fell, scattering the cassette tapes of that night's session, which he'd been holding in his hands. His glasses fell away, splattered with blood. More blood gushed from his mouth and began to stain the front of his shirt.

Yoko screamed for help. Hastings dialed 911 and reported the shooting, then returned to John's side and said, "It's okay, John, you'll be all right."

Hastings then rushed outside to find the young killer, Mark David Chapman, calmly reading *The Catcher in the Rye*, the pistol on the sidewalk nearby.

Two police cars arrived. Four cops jumped out, their guns drawn, and slammed Chapman against the wall.

Two of the officers went to John, who lay motionless on the office floor in a spreading puddle of blood. Against Yoko's wishes the policemen turned him over to examine him.

Knowing they couldn't wait for an ambulance, they carefully carried him into one of the squad cars. Hastings said later that he heard bones snap when the body was lifted. Yoko followed in a second squad car.

John was dead by the time they arrived at the emergency entrance of Roosevelt Hospital, about ten minutes away. The doctors tried anyway, opening his chest and massaging his heart.

By now, Geffen had arrived and he retreated with Yoko to a small office adjacent to the room where emergency personnel finally gave up. Time of death was officially recorded as 11:15 P.M. When the body was wrapped and taken away in the morgue wagon, Yoko remained behind, returning to the Dakota with Geffen.

By now, the fans were coming by the thousands, standing silently at first, and then singing. At two in the morning, police called for reinforcements and ordered the erection of barricades.

Many of the fans brought portable radios and soon the area outside the Dakota rumbled with the sound of the network news and a marathon of Lennon songs.

At 4:30, the mourners were asked to turn down their radios because Yoko was having trouble sleeping.

The next day, Yoko issued an eighty-seven-word statement to the tens of thousands who were, by now, camping at the Dakota gate and in Central Park across the street, and to the millions worldwide in grief.

There is no funeral for John.

Later in the week we will set the time for silent vigil, to pray for his soul.

We invite you to participate from wherever you are at the time. We thank you for many flowers sent to John.

But in the future, instead of the flowers, please consider sending

donations to Spirit Foundation, Inc., which is John's personal charitable foundation.

He would have appreciated it very much.

John loved and prayed for the human race.

Please pray the same for him.

The message was signed, "Love, Yoko & Sean." The Spirit Foundation's address was below the names.

Later, Yoko called Paul McCartney at his farm in Scotland and John's Aunt Mimi in England.

She still hadn't told Sean.

That came the next day, when Julian arrived. Julian had heard the news in Wales, flew to London (on a plane where everyone was reading the story of his father's murder), then caught the Concorde to New York.

Julian says today that Yoko was "over the top"—composed one minute, hysterical the next. He told her she had to get control and tell Sean.

"How am I going to tell him?" she cried.

"You just have to tell the kid straight."

They rehearsed what Yoko would say. It wasn't easy. Yoko kept getting hysterical.

Finally, Sean was brought in and Yoko told him. She showed him a newspaper and took him to the spot where his father had been killed. The blood had been washed away, but was still discernible.

Sean asked why, if the killer had liked his daddy, he had killed him.

Yoko said she thought he must have been confused.

Outside the Dakota, the crowd grew and the outpouring of public grief that was emerging in the media was astonishing. No one could have guessed that John's "assassination"—and that's the word most used by now—could have drawn so much sympathetic attention.

Newspapers everywhere on the planet devoted pages and pages to John's death and Mark David Chapman's life every day for weeks. As each new fact was uncovered, no matter how miniscule, it was greeted with headlines and long dissertations on the six o'clock news.

Ringo Starr, who had been with the Lennons on Thanksgiving, cut short a vacation in the Bahamas and flew to New York with his fiancée, Barbara Bach.

For a week, Yoko remained in seclusion, greeting only close family and staff. Most of the week, she stayed in her bedroom. Occasionally, she talked quietly on the phone.

Yoko asked Julian to stay in New York, to live with her and Sean, but he returned home to Wales after a few days.

The telegrams came pouring in by the hundreds from rock stars, movie stars, politicians, several heads of state, as well as thousands of fans.

Sales of John's recordings, old and new, increased dramatically, breaking the sales records set by Elvis Presley fans after he died in 1977. In West Germany, orders for *Double Fantasy* reportedly rose from 10,000 a week to 50,000 a day. In Britain and the U.S., stores could not keep the record stocked, and in *Billboard* magazine it went instantly to No. 1.

John's killer was locked away in a cell in Bellevue Hospital, where the city's insane were kept until they could be moved to a more appropriate place. In a signed confession, Chapman said the Devil made him do it.

For Yoko, the week was bizarre. It was as if the gods were on a capricious rampage, creating incredible "what-ifs" more fantastic than any Yoko herself had devised in *Grapefruit*.

On Wednesday, December 10, Yoko greeted a few members of the press and recalled the shock she felt. She asked fans of her husband to join in a ten-minute prayer vigil on Sunday, and said she disagreed that his death signaled the end of an era.

"The future is still ours to make," she said. "The eighties will blossom if only people will accept peace and love in their hearts. It would just add to the tragedy if people turned away from the message in John's music."

While Yoko talked to Bob Hilburn of the *Los Angeles Times* and a few others, Geffen and Elliot Mintz hovered nearby, watchful and solicitous. Yoko lay in bed in a semi-darkened room, smoking a cigarette. When someone mentioned the violence inherent in big cities, she said it wasn't New York's fault; John loved New York.

"We had planned on so much together," she said. "We had talked about living until we were eighty. We even drew up lists of all the things we could do together. Then it was over. But that doesn't mean the message should be over. The music will live on."

A second written statement was distributed, telling Sean's reaction to his father's death—Sean reportedly said that John was "a part of everything now"—and Yoko set the Sunday vigil for 2:00 P.M.

The media was in full feeding frenzy. Every interview and photograph taken recently was sold and resold then sold again as newspapers and magazines turned over thousands of pages to public tribute

and grief. *Rolling Stone* churned out an entire issue devoted to John's life, putting a nude Lennon back on its cover, the one of him in a fetal position holding a fully clothed Yoko. *Time, Newsweek,* the *Sunday Times* magazine in London, and dozens more also put John on the cover. Instant specials were produced for network TV. Publishers in the U.S. and England began commissioning books.

Mailbags carrying more than 4,500 telegrams of sympathy had been hauled into the Dakota by week's end, when millions worldwide paused in silent tribute. More than 100,000 gathered in New York's Central Park, where they sang, cried, and prayed and for ten remarkable minutes the only sounds were of the wind, the helicopters overhead, and weeping.

Yoko sent Sean to the house in Palm Beach with members of her household staff, and on Sunday instructed those remaining in the apartment that she didn't wish to be disturbed from eleven in the morning until five that afternoon.

Elliot Mintz visited with Yoko that night and said that she was feeling much better. "She told me for the first time that she understood why it happened. She had worked it through in her mind." Mintz then collected some of the notes that had been left by fans outside the Dakota, delivering them to Yoko. He left her sitting on her bed, reading the messages.

What she had "worked through in her mind" she revealed simply a few days later in still another message, released in Los Angeles by Geffen, who had become Yoko's official pipeline to the press.

"Bless you for your tears and prayers," she said. "I saw John smiling in the sky. I saw sorrow changing into clarity. I saw all of us becoming one mind. Thank You. Love, Yoko."

After that, Yoko went into seclusion.

23
Vultures
on
the
Line

YOKO walked through the vast, seven-room apartment that first
week seeking comfort in its familiarity.

She stood at the door to Sean's room taking in the big tram-
poline and the set of monkey bars with a diving board over an enor-
mous stuffed pillow. The jukebox that had once been in the Dakota
bar was in here now; Sean's favorite record on it was Elvis Presley's
"Hound Dog." The room seemed especially empty with Sean away.

The living room was empty, too. This was one of Yoko's all-white
rooms, with a white rug and piano and stark white walls. This was
where many of the Egyptian artifacts were on display, including the
jeweled sarcophagus.

Down the hall was the kitchen, where Yoko began each morning
with one of the hundred teas she kept in stock. This was where John
had started his days, too, usually with coffee and his awful Gauloise
cigarettes. It was in this room that John baked his first, proud loaf of
bread.

John's bedroom was the most difficult. Yoko shared the room—
and always slept on the right side—but it was really John's, not hers.

The bed was just box springs and a mattress resting on two wooden
church pews. The bed was made up in white linen and brown quilts.
The floor was carpeted in deep white pile.

Yoko stood for a long time looking into the room but not entering
it. She remembered all the hours that John spent in his bed, watching

226

television. Elliot Mintz had given John some books about Howard Hughes and they started joking about how Hughes had spent most of his final years in just such a room, watching the very same shows. Mintz had started calling John "Mr. Hughes."

Some of John's tapes were in the room, on the floor near the bed. When television bored him, he listened to tapes of the old radio mystery, "The Shadow," and old albums by Jerry Lee Lewis, Carl Perkins, Hank Williams, and, oh God, Bing Crosby; oh, how he loved Bing Crosby.

Over the bed the scimitar still hung, a gift from Yoko and, John always said, a symbol of how they had cut away their past.

Yoko smoked her cigarettes and went to the office to get her mind off the horrible subject at hand, and then she tried to sleep, remaining in her bed for days at a time in much the same way John had spent days in his bedroom. By her own admission, she later went on a chocolate binge.

"I kept remembering how much John loved chocolate," she said. "When I would go out, I'd bring him a little chocolate something home and he enjoyed it so much. Now it was all I wanted to eat. Elton [John] was so sweet—he sent me a big chocolate cake. My diet went crazy for about a month afterwards—nothing but chocolate and mushrooms."

The tears came frequently—when she tried to escape in TV and saw one of the shows John liked, and when she saw the racks of John's clothes that she couldn't yet discard, and when she saw the small painting John did when he was eleven and a student in Liverpool's Dovedale Primary School, and when she thought of Sean.

"I felt so guilty towards Sean, like, 'What did we do to him?' Well, we didn't do it, but somehow we had brought him into the world hoping that he would have a happy life. And then this terrible, cruel thing happens. How can a five-year-old face that?

"I felt—I'm sure many widows go through this—I felt I lost the purpose of living. I thought, 'He's up there, I should go to him.' The thing that kept me going was Sean. He's going to be an orphan if I go. I *have* to stay. I'm *responsible*. I have to do it for both of us, for John and me, and I think John is helping from up there, too. I keep saying to John, 'Please help!' "

By the middle of January, Yoko was more in control, a fact demonstrated in three significant incidents.

Yoko insisted upon seeing the press that followed her husband's death, and when she came upon a story published in *Billboard* in

which the writer said John had bad table manners, Yoko picked up the phone. It was the only article in a commemorative issue that was even slightly critical of Lennon, and Yoko, in her grief, called the publisher to try to get the writer fired.

The second incident also involved the media. This came on January 18, when Yoko spent close to $100,000 thanking John's fans for their "letters, telegrams and thoughts" in a newspaper advertisement placed in London's and New York's Sunday newspapers.

She thanked the fans for their feeling of anger and said she shared that anger. She was angry at herself, she said, for not being able to protect John and at everyone for their allowing society to disintegrate to the point where poets are shot. The only "revenge," Yoko said, was to turn that society around. "The only solace," she said, "is to show that it could be done, that we could create a world of peace on earth for each other and for our children."

The third incident involved the release of "Walking on Thin Ice," the disco-styled song they had been remixing the night of John's death. In an effort to publicize the record, she authorized the production of a video. Of itself, this was not unusual—by 1981, rock videos were fairly standard. What made this notable was the fact that Yoko included not only some scenes from John's fortieth birthday party and his view from the Dakota, but also some erotic lovemaking. The following week, the Lennons made love in color and stereo in most of New York's prominent discotheques.

She talked with her family in Tokyo. When John died, her brother had been interviewed on television and he said she should come home to Japan, where such things as assassination never happened.

What did that mean? she asked. John was dead. She should go home to Japan *now*? A relative said that perhaps someone else would shoot her or Sean. Yoko decided not to call home again.

Her friends were hovering in support. Elliot Mintz was in and out of New York, checking on Sean in Florida, then flying back to Yoko to attend to business matters, then off again to London or Los Angeles, wherever business required. Others on staff, in the apartment, and in the offices reported faithfully to work, tiptoeing around Yoko. When the maids cleaned, nothing was disturbed or removed. Not even John's blood-splattered glasses, which remained on Yoko's desk, where she had placed them the night of the murder.

Yoko decided to have a photograph taken of the glasses for the cover of her next album, *Season of Glass*. This was her next solo LP, which was quickly scheduled for release to radio stations the end of

May. She called David Nutter, the English photographer who had been present when she and John married and who, since, had worked frequently for Elton John.

"She invited me to the apartment at 6:00 A.M.," Nutter says. "She asked me what lens to use, which room to take the picture in. Then I never heard a word, and she took the picture herself and another photographer, Bob Gruen, was there to take a picture of her taking a picture of the glasses. I think she was into chronicling everything. Even her grief."

The riches came roaring in.

Before John died, "Starting Over" and *Double Fantasy* had stalled midway up the charts. After his death, they shot to the top, and by the first of January 1981, both the single and the album were in the top position on virtually every record sales chart in the Western world. By mid-January, sales of the album had topped 4 million. The demand for Lennon material was so great that "Imagine" and "Give Peace a Chance," both reissued by EMI in Britain, also went onto the charts.

At the same time, posters and lapel buttons and bootleg recordings and every manner of unauthorized souvenir appeared in the marketplace. It was no accident when Yoko included in her thank-you advertisement the warning: "Do not ask for my authorization of your ventures . . . since it will be unfair to give to one and not to the others. Individuals and corporations who wish to exploit John's name in a large scale: I ask your voluntary act to report to me of your intentions and plans, respecting the feelings and legal rights of his family, and make arrangements to satisfy them."

Yoko was no dummy. She was what the British tabloid press was by now calling "the world's richest widow" with good reason, and to her credit. She had run the Lennon business for years and there was no reason to quit with John's death.

She was also the most famous widow, eclipsing after seventeen years the mourning of Jacqueline Kennedy Onassis.

Already books about John were appearing on the bookstalls, as American and British publishers reprinted John's two slender works, *In His Own Write* and *A Spaniard in the Works*, as well as the *Rolling Stone* interview *Lennon Remembers*. So Yoko made a deal with Jann Wenner at *Rolling Stone* for a book that would collect many of the stories that appeared in the rock semi-weekly as well as several original articles chronicling and evaluating the Lennon work. It was agreed that some of those commissioned to write original works would be those who viewed Yoko's art favorably, and that Yoko would be given

an opportunity to review the manuscript before publication. *Rolling Stone* also agreed to make a contribution to the Spirit Foundation, the charitable trust that Yoko had started with John two years before.

So, when Yoko had a product of her own to sell, she did what she had always done so well: promote it. Although initially she refused to talk about *Season of Glass* publicly—because, she told friends, she didn't want to open herself to new charges of exploitation—she continued to issue messages, one on the album jacket itself.

When she started to sing, she noticed that her voice cracked. She said she thought that might make people ask if she wasn't recording too soon. She then thought of all the people whose voices were cracking, and so she could be singing for them. Besides, hadn't the critics always accused her of having a croak for a voice? "That gave me a laugh," she said, "and it became easier."

To some, it all sounded a bit too glib. Others, including London's *New Musical Express*, were not convinced. The lyrics were "often hard and starkly moving," said Graham Lock, but the production by Phil Spector seemed better suited for a cocktail lounge. The album was "trivial . . . banal . . ."

Still others accepted the album totally, and by June, Yoko was getting some of the best reviews of her life.

In the *Los Angeles Times*, Robert Hilburn said that Yoko "frequently achieved the sort of intimacy and vision associated with Joni Mitchell's early work." There was, he said, a "maturity and purpose," and in the end, *Season of Glass* was "a story of survival, a brave and original work that confirms in its best moment all the claims that Lennon made over the years about Ono's gifts as a sensitive, mainstream—rather than simply experimental—pop musician."

Even Robert Palmer of the *New York Times* was heaping praise. Her singing was both "eerie and confident," he said, and when John delivered a guitar solo of "pulse-quickening rock-and-roll brinksmanship . . . Miss Ono follows it with a wordless vocal solo that manages to get under the listener's skin in an almost unnerving manner. 'Walking on Thin Ice' is both danceable pop music and bracing experimentation."

Palmer didn't stop there. "Some of Mr. Lennon's fans still see Miss Ono as a kind of artsy dabbler whose most notable accomplishment was keeping her husband healthy and happy. Mr. Lennon detested that point of view, and rightly so. Miss Ono's music is adventurous, substantial and utterly distinctive. One hopes that she will continue to find the strength to keep making it."

At last, Yoko thought as she read these reviews, she was getting the attention she deserved.

Palmer interviewed Yoko and told her he thought she was "doomed to offend" if for no other reason than because she had put John's bloody spectacles on the jacket cover.

"What was I supposed to do," she asked Palmer, "avoid the subject?

"A lot of people advised me that I shouldn't put that cover on the record, but I really wanted the whole world to see those glasses with blood on them and to realize the fact that John had been *killed*. It wasn't like he died of old age or drugs or something. People told me I shouldn't put the gunshots on the record and the part where I start swearing, 'Hate me, hate us, we had everything,' which was just letting those feelings out. I know if John had been there, he would have been a lot more outspoken than I was."

Yoko was also criticized for including Sean on the album, telling a story his father had told him. Yoko defended Sean. He was with her through the album's recording, she said, and "his voice, those gunshots—those are the things I heard. Everything I've done has always been directly autobiographical, and those sounds were my reality."

Yoko had spent much of the summer of 1981 trying to create a sense of normalcy. She had been spending more time with Sean and had a man named Sam Havadtoy resume the redecorating of the apartment that had begun just before John was shot. Sam was a tall, slight Hungarian who shared many of Yoko's artistic interests. She liked being with him and noticed that he was good with Sean.

But the vultures were circling ominously. In September, it became clear that her onetime tarot card reader finally had to be cut loose. She hadn't used him as a reader for a long time, but had allowed him to stay rent-free in a loft where she and John had stored many of their files. The understanding was that he would not have visitors, and when Yoko learned that he had been inviting strangers in for a tour, she evicted him.

John Green refused to move, and when Yoko sent some of her representatives to the loft, they found a manuscript that indicated Green was writing a book about his alleged relationship with John. A glance at the pages showed that Green thought Yoko was manipulative at best, and probably evil as well. Before the episode was over, Yoko had agreed to pay Green $30,000 to vacate the premises. (His book would be published the next year.)

That same month, Yoko and Sean's primary bodyguard quit. Ever since John had been shot, Yoko employed round-the-clock security and Doug MacDougall was a favorite of Sean's. Yoko was a demanding boss and once, in Central Park, when he let Sean wander out of his view, she snapped at him for the final time. Sean was upset when his big friend left, but Yoko was more upset when, a couple of months later, the ex-bodyguard called to say he would be happy to return a number of items—including a love letter from John to Yoko in which he wrote an early version of his song "Dear Yoko"—if Yoko would agree to give him some unspecified "back pay." Once again, Yoko agreed.

In October and November, the vultures circled lower.

Elvis Presley's death in 1977 had spawned an entire industry in publishing; by 1981, there were more than forty books in print, all professing to reveal the ultimate truth. Now it seemed the same thing was happening to John Lennon.

In November, Playboy Press published the transcript of its previous year's interviews, calling it *The Playboy Interviews with John Lennon & Yoko Ono: The Final Testament*. That same month it was announced that Albert Goldman had signed a $750,000 contract to write a biography of Lennon; it was assumed that, like his earlier books about Lenny Bruce and Elvis Presley, it would be a clinically revealing book, yet most wondered exactly what Goldman would reveal that John hadn't already confessed himself.

Barbara Graustark, who had conducted the interviews for *Newsweek* magazine, was preparing a transcript paperback.

Even May Pang, with Henry Edwards of the *New York Times*, was writing her version of the perfect truth.

When Yoko was handed a letter from the man who killed her husband, Mark David Chapman, she thought she had heard the worst. Chapman said he wanted to write a book, but wouldn't if Yoko didn't approve. It was an idle "threat," and because New York law created substantial roadblocks for any criminal to profit from the commission of his crime, it wasn't viewed seriously. Nonetheless, Yoko was upset.

Still, the worst was to come.

It was bad enough that outsiders and onetime confidants were exploiting John's memory. Now Yoko was being presented with evidence that someone *inside* the Lennon organization was betraying her.

One of the first clues came in November 1981, when Yoko read in an English newspaper that Julian Lennon had begun recording some

of his father's final, unreleased songs. Yoko called the young Lennon and asked him if the report was true. He said yes, he had been given a cassette of the songs by Fred Seaman, who had visited the boy the previous spring. Yoko said John had intended to record the songs himself, and Julian apologized for the confusion.

Also in November, some of John's personal audio equipment disappeared. Yoko said something to Mintz, who had been taking an inventory of his own. He said much appeared to be missing from the apartments. Yoko's chief of security suggested she have all employees take a lie detector test, but she rejected the idea, fearing the "bad vibes" that might result.

In December, there were more clues when Seaman appeared at an employee's party wearing one of John's scarves and got into an accident using the Lennon Mercedes for personal business, causing $12,000 in damage. A few days later, Yoko found Seaman taking a bath in her private bathroom during working hours. She fired him, giving him $10,000 in severance pay.

The full extent of the Seaman thefts would not be realized for another nine months. In the meantime, Yoko tried to stay on course: dispensing money donated, since John's death, to the Spirit Foundation ($7,500 to a fund to help families of victims of violent crimes, $15,000 to families of New York policemen killed on duty).

The first anniversary of John's death approached and everyone wanted interviews. She agreed to several, and also agreed to appear at a concert in John's memory at New York's Radio City Music Hall. At the last minute, though, she canceled her own appearance and sent Sean, heavily protected by bodyguards.

Yoko did issue a statement on a home-produced video and made it available to more than 400 stations worldwide: "I hope his death serves as a springboard for finally bringing sanity and peace to the world. John died in the war between the sane and the insane. He was killed by an insane act at a time he was enjoying the sanest moment of his life."

On December 8, 1981, she then followed Japanese tradition and cut off 30 inches of her long, black hair.

"It was not an easy year for Yoko," says a friend. "No one expected it would be, but no one, least of all Yoko herself, expected that so much shit would come down, that so many people would want a piece of John's corpse. It was ghoulish. Even more ghoulish than Elvis, I think."

In interviews, Yoko herself called attention to another surprise.

She said her image had changed. In 1981, she had received more than 250,000 letters and nearly all of them had been positive. Where once she had been blamed for breaking up John's first marriage (as well as the Beatles), now *The Ballad of John and Yoko*, the book being published in another month by *Rolling Stone*, was being subtitled, "Love Story of the Century" (a phrase which she ultimately rejected).

"For 10 years I was the devil," she said. "Now I'm an angel. Did the world have to lose him to change their opinion of me?"

24
Strange Days, Indeed

B Y JANUARY 1982, Yoko decided to write her own book. There were, after all, more than a dozen "John Lennon books" in the works or in the stores—every one of them published because, the assorted authors said, the "truth" needed to be told.

"These people don't know what the truth is!" Yoko cried to friends. "They weren't even there!"

By February, Yoko had a deal with one of the most respected old-line publishers in New York, G. P. Putnam's Sons. Putnam had only recently recognized popular music as a source of book material, and had experienced some early success with a sensational book about the Rolling Stones; subsequently, the company had commissioned biographies of Elvis Presley and Jimi Hendrix.

Putnam offered Yoko $1.5 million for her story, a record amount for a book of its type, a figure so large, in fact, that when the details of the offer leaked out, most people in the industry refused to believe it.

Six months later it was said that Yoko refused the offer, saying it wasn't enough. The truth is somewhat more interesting.

The deal had been made when a publisher from London was in New York making her yearly round of industry visits. She arrived at G. P. Putnam's the day the Yoko contract was signed, and she remembers watching with surprise as Putnam's publisher ran up and down the halls shouting, "We got her! We got her!"

The next day, the English publisher was at Simon & Schuster, where she gossiped about what she'd seen the day before. Then, in all innocence, she said, "Didn't you publish Yoko's first book?"

Indeed. Simon & Schuster had published *Grapefruit*, and although it hadn't made much money for the company, Yoko's contract required her to give Simon & Schuster first refusal rights on any subsequent book. That meant the contract with Putnam was invalid and Yoko had to resubmit the book proposal to Simon & Schuster instead. It also meant that she couldn't refuse whatever reasonable offer Simon & Schuster might make.

Simon & Schuster's offer was substantial, but under a million dollars, and Yoko quickly rejected it. Even when they upped the amount to $1.5 million, she said no. She was incensed. She had forgotten about the long-ago, standard "option" clause in her *Grapefruit* contract and didn't think it proper, after so many years, for it to still be binding. After all, Simon & Schuster hadn't come to her and *asked* for another book.

Yoko decided the hell with it. She didn't really know yet how much money she had—the first audit turned up $30 million, and everyone knew it was much more than that—but she knew it was enough not to *need* a book advance. The "authorized" Yoko story could wait.

Besides, Yoko was busy with another solo album project and had plans to attend, in February, the annual awards ceremony of the National Academy of Recording Arts and Sciences, where she would eventually accept a Grammy for "Album of the Year" (1981) for *Double Fantasy*. Sales by now topped 7 million worldwide, making it one of the all-time best-sellers in recording history.

Yoko wore a white dress for the occasion—her first public appearance in anything but black. (It was also, she said, a dress that she had bought when John was alive because John liked it, but she never had had a chance to wear it.) Sean was with her when she took the microphone and said, "John is with us here tonight. John and I were always proud and happy that we were part of the human race and made good music for the earth and the universe. Thank you."

There were nearly a dozen employees in Studio One, the ground floor offices in the Dakota. They were kept busy filing and making calls and answering mail while Yoko continued to put in twelve- and fourteen-hour days.

"For hours every day Yoko would be on the phone," says a friend of that period. "When Elliot Mintz was home in L.A., she called him daily. People she *saw* almost daily she called almost every day. I don't think a day went by when Yoko didn't make at least twenty-five calls, and many lasted more than an hour."

In addition, there were meetings with the accountants and lawyers and record company executives who handled much of the Lennon business. Lawsuits were a constant in Yoko's life, attorneys a daily conversation at least. She and Paul McCartney were still determined to get back the rights to the early Beatles songs and, in April 1982, put into motion a lawsuit against Lew Grade.

Three months later, Yoko was sued by Jack Douglas, the co-producer of *Double Fantasy*. He claimed he had been cheated out of royalties and was asking for $750,000. Yoko's attorneys responded, saying the contract, signed four months before John's death, had been written in "excessive haste," while its terms were "obtained by fraud." Ultimately, the court awarded Douglas more than $2.5 million for *Double Fantasy*, plus an amount to be determined for *Milk and Honey*.

Yoko was feeling good about herself, and on June 14, marched in an antinuclear peace protest—wearing an "Imagine" sweatshirt and carrying a rose—as the crowd that surrounded her (and her bodyguards) sang "Give Peace a Chance."

Early the year before, when New York Mayor Ed Koch honored John posthumously with the Handel Medallion, the city's highest cultural salute, Yoko agreed to accept if she could, in turn, have the city rededicate a portion of Central Park opposite the Dakota as "Strawberry Fields."

The idea was to invite leaders from foreign nations to send cuttings and seeds and plants, to create an international "peace pavilion." Yoko said she would pay all costs involved, and the section of the park would be named for the Beatles song. It was an election year and Koch agreed happily.

By summer 1982, thirty-one countries had contributed trees. Yoko was flying high.

But that August, she was shot down, suddenly and brutally, when she learned that her former assistant Fred Seaman, before his dismissal a few months earlier, had systematically looted the Lennon files, taking, among other things, all of John's personal journals.

Police and court records show that for several months before he was fired, Seaman had taken hundreds of pounds of material, conspiring with a writer to create what he soon presented to publishers as an "authorized" Lennon biography. He was John's closest friend, he said, otherwise he wouldn't have the journals and tapes and boxes of personal documents. Yoko later learned that Seaman's partner in the joint venture, Bob Rosen, had been living for more than a year on money Seaman took out of the Studio One petty cash box.

In time, Seaman brought in another partner, a diamond merchant named Norman Schonfeld, who in turn urged Seaman to dump Rosen. Subsequently, Rosen was sent on a "vacation" to the Caribbean while Seaman entered his apartment and took every scrap of Lennon material.

When Rosen returned, he was stunned. Not willing to give up, he approached several publishers anyway, claiming he had a photographic memory. No one paid any attention. He then called Elliot Mintz, who turned him over to Yoko's friend Sam Havadtoy. (By now, Sam had his own room in the Lennon apartment and he was well known as Yoko's "constant companion.") After Sam heard Rosen's story, he decided Yoko should hear it, too. Rosen was confessing everything.

In a few days' time, Yoko had the New York district attorney brought in. Because he had volunteered the information about the theft—becoming, in Mintz's phrase, "the John Dean of the story"—he was not charged. And because he said he feared for his life, Yoko agreed to pay Rosen's hotel bill. She then sent Havadtoy to her oldest and dearest New York friends, Helen and Norman Seaman, to talk about their nephew.

Initially, the Seamans defended Fred, but it soon became clear that he was guilty of theft, and shortly afterward, a poorly dressed man arrived at the Dakota with a box of documents. He told Havadtoy he obtained the material from a junkie in Harlem and asked for $5,000 to obtain some more. Before examining what the man had brought in the first load, Havadtoy handed him the cash. The man disappeared and was never seen again.

In a short time it became evident that the Lennon diaries and other missing material might be in the hands of the diamond merchant, who by now had sunk $33,000 into the project. He told Havadtoy that in exchange for some unspecified "expenses," the diaries could be returned. The agreed-upon sum was $60,000.

Yoko searched the boxes of returned material, discovering that John's final 1980 diary was still missing. (To this day, it has never been found.) Yoko decided to press charges of grand larceny.

There was another incident only a month later, when the mother of one of Sean's playmates sued Yoko for more than a million dollars after her child had been injured while visiting the boy in Cold Spring Harbor. Yoko looked into it and discovered that although she had instructed Helen Seaman not to take anyone to the Long Island mansion that weekend, she had done so, using a chartered limousine. She

then had lied to Yoko about the events. Yoko subsequently fired the wife of her friend, giving her a $10,000-a-year pension.

Rumors then started circulating about Sam Havadtoy, which said Yoko and the tall Hungarian would marry. Yoko denied it, saying he was a dear friend and that was all: "I'm not interested in having a big, smashing romance of the sort of involvement I had with John, and I don't know if I ever will be. That relationship never waned. It was abruptly cut off. When John died, I felt like I had been kicked down to the bottom of a lake, and I'm still struggling to the surface to breathe. I'm eighty percent there, but it could take another year.

"No one can compete with the dead," she added. "If I'm crying about John, or Sean is, and [if] our house is filled with his pictures, I don't know how another man would deal with that, and I don't want to know right now. The past is still my life, and I have my hands full."

Nonetheless, it was Havadtoy who uncovered the next ripoff. This one involved Eddie Germano, owner of the Hit Factory, the recording studio where John and Yoko recorded *Double Fantasy*, where Yoko had made her first solo album, and where, in September 1982, she was mixing her second, *It's Alright*. Germano had always been comforting, and when Yoko began to show signs of dissatisfaction with David Geffen and his company, he offered to introduce Yoko to a friend of his at PolyGram Records.

Yoko's relationship with Geffen had deteriorated slowly but steadily in the year following John's murder. Yoko valued his help at the time of great trauma, but she also had to agree with friends who later pointed out how happy he seemed to be by the amazing sales figures that came in on *Double Fantasy* in the first days afterward. In time, Yoko came to believe that Geffen was only interested in the bottom line, and if Yoko's albums didn't sell, it wouldn't matter to him whether she was John Lennon's widow or not.

In fact, Geffen had done enormously well with the Lennon agreement. Not only had *Double Fantasy* sold more than 7 million copies worldwide, staying at No. 1 for eight weeks and in the Top 200 for more than eighteen months, all three singles from the album (each of them offering one of John's songs on the "A" side, one of Yoko's on the "B" side) went into the Top 10. Geffen also would release *The John Lennon Collection* in November. This included many songs from John's final recordings for EMI, but none of Yoko's. It, too, became a best-seller.

Nonetheless, when Yoko said she wanted out, Geffen didn't resist.

"Walking on Thin Ice" went to No. 58 on the American *Billboard* chart and *Season of Glass* followed it, going to No. 49. Geffen didn't consider this any mark of great success, and besides, he had *hated* *Season of Glass*, had, in fact, been one of those offended by it. So when Yoko said she had no interest in renewing her contract, Geffen said his farewells without argument.

Yoko signed with PolyGram Records. The terms of the contract were good, and for a year there was nothing that Yoko wanted that she didn't receive: A million dollars was deposited in her bank account. She was given complete artistic freedom to record whatever she wished and to package it in any manner she chose. Large promotional budgets were committed.

When Germano told her that he was given a $50,000 "finder's fee" for his part in the deal, Yoko was pleased.

More and more, Yoko was making public appearances—in restaurants with Sam Havadtoy, in Central Park with Sean and bodyguards, and occasionally at special events. One of those came in August 1982, when she surprised Elton John at Madison Square Garden by walking onstage with Sean after he had sung his tribute song to John, "Empty Garden."

Sean was wearing jeans rolled up, sneakers, and a white T-shirt with big block letters that said "Working Class Hero." Yoko wore black slacks, a men's white jacket, and under it a dark T-shirt that said *"Voulez-vous coucher avec moi ce soir?"* ["Will you go to bed with me tonight?"]

At the same time, she recorded *It's Alright, An Air Play By Yoko Ono*—ten original songs, words and music by Yoko Ono, music published by Ono Music, arranged and produced by Yoko Ono. She had dropped Phil Spector as producer halfway through *Season of Glass* and now was determined to do nearly everything herself.

Again the lyrics were achingly autobiographical, and again the reviews were good.

She had nightmares she could never share, she said in a song called "Never Say Goodbye"; they were the kind that kept her up all night. The titles of the songs said it all: "My Man," "Loneliness," "Let the Tears Dry," "Tomorrow May Never Come." Sometimes it was such a drag, she said in the title tune, she didn't want to get up in the morning, but then something clicked and she knew it was going to be all right.

On the front cover of the jacket, Yoko wore her ever-present sunglasses. On the back, she stood with Sean in Central Park (sunglasses

still in place), while a black-and-white, ghostlike photograph showed John standing nearby.

Again, Yoko was criticized for her choice of album art. She exploited John when she used his picture, some said, but Yoko said she selected the photograph carefully.

"He's standing beside us," she said, "but he's looking at the audience, as if saying, 'See these two orphans? They're mine.' That's the feeling I was trying to convey."

The two top newspaper critics, Robert Palmer in the *New York Times* and Bob Hilburn in the *Los Angeles Times*, leapt to her praise and defense.

According to Hilburn the record was flawed when Yoko resorted to "feathery romanticism," but it was her most accessible pop album yet. It was, he said, almost chocolatey.

Palmer was more effusive, using such phrases as "exceptional vitality and richness . . . a renewed sense of independence and purpose . . . her most sustained and captivating album . . .

"Those who have dismissed Miss Ono's forays into popular music as a conceptual artist's dabbling are going to have to think again," Palmer said.

The critical appreciation fell on rocky soil and sales were poor. Neither the album nor the singles from it entered a chart anywhere in the world.

□

The satisfaction Yoko felt at the end of 1982 over the critical reception of *It's Alright* quickly turned into despair when, in January 1983, Sam Havadtoy learned that Eddie Germano hadn't been given $50,000 as a "finder's fee" from PolyGram, but had received $600,000 as an advance against future albums; the understanding was that some of these albums would be John's and not Yoko's, or at least include John's songs and voice.

Yoko was incensed. According to friends, she sat in her all-white "Egyptian Room" drinking tea and meditating, slowly turning the tarot cards to learn, if she could, why so many confidants were turning against her.

A month later there were death threats.

February was the month that Yoko celebrated her fiftieth birthday. It was also the month that the president of the Mark Chapman Fan Club came to New York to "get" Yoko. The threatening note was accompanied by one of Yoko's albums riddled with bullet holes.

Yoko was told by her security that her safety couldn't be guaranteed so long as she remained at the Dakota, so she and Sean moved into a midtown hotel for a night.

There were other similar incidents.

"When I was 18," she said, "I had this image of a 50-year-old as very mature, someone who knows all about life. But here I am turning 50, and it's like I'm starting all over. I'm supposed to be old and wise, but I'm less sure of life than ever before. I thought I would learn by now, but things keep hurting me, knocking me down. I think to myself, 'You mean, it doesn't get easier?' "

It got harder in the spring, when the books began to appear in the stores and excerpts in popular magazines.

The first blow came in April, when Yoko learned that Simon & Schuster was planning to publish the Fred Seaman book *Living with Lennon* in January 1984.

John's 1980 journal was still missing, and for all Yoko knew, so was a lot more; even with three people working full time on the files for two years, no one really knew what was there. And now Seaman was going to publish a book? With Simon & Schuster? The company that had stopped Yoko from getting a multimillion-dollar advance from Putnam? Yoko told her people to call Simon & Schuster.

She needn't have bothered. On May 27, 1983, Seaman pleaded guilty to second-degree larceny and was sentenced to five years' probation. He also agreed to keep his mouth shut about the material in the diaries and to cooperate with authorities in investigations of others involved. That ended Seaman's hopes for a book. Simon & Schuster dropped him immediately, canceling his $90,000 advance.

Within two weeks of Seaman's guilty plea, *The Love You Make*, the book written by old Beatle friend Peter Brown, was published, going almost immediately onto the American best-seller lists. Yoko had given Brown hours of her time in an interview and then had let him and his co-writer, Steven Gaines, use the Long Island estate to complete the manuscript.

Yoko had decided by now not to read any of the exploitative books about John, assigning the task to Elliot Mintz and others on her staff. When Mintz reported that she was treated unfairly, that she was described by Brown as manipulative and cold, Yoko decided not only not to talk to Brown again, but also not to cooperate with any outside writers on any book.

It was not a good summer.

In June 1983, about the same time Seaman's book plans were

dashed by Simon & Schuster, John Green's hardcover confession appeared, with excerpts in *Penthouse* magazine. The book was small—only 50,000 words—and modestly titled—*Dakota Days*—but the story told was sensational. Yoko was artistically competitive with John, Green said, and besides that, strangely manipulative, sending John on peculiar trips for thousands and thousands of miles for no apparent reason other than to resolve mysterious "directional" difficulties. Once, Green said, Yoko dragged everyone off to South America to rendezvous with a witch. Worst of all, Green quoted John as saying he frequented prostitutes.

That hurt, and Yoko decided to respond. Sex with John was "very ordinary," she told John Fielden for London's *Sunday Mirror*. "He was from England, I am from Japan, and we used to say to each other—and laugh about it—that we were both rather shy and rather ordinary in that way.

"I could not imagine John even knowing where a brothel *was* in New York. Apart from anything else, he was honest to a fault—he would have told everyone if he had been to somewhere like that, and he didn't. Apart from that, he was very scared, in his position, of being blackmailed or being caught. . . ."

The *Mirror* ran the story under the headline, "Those Filthy Lies About Our Sex Life by Yoko Ono."

Mintz also talked with the press about Green's book. He said that John hardly ever saw Green and wondered how he was able to quote the dead so voluminously when Green himself admitted he never took any notes. Green said he had a good memory. The book sold poorly, and in the subsequent press, Green appeared an unlikely source, but the impression was made—and many wondered that even if a tenth of what he said was true, wasn't it still clear that Yoko was somewhat bizarre?

In July came May Pang's book, *Loving John*, with excerpts in *US* magazine. Once again, Yoko was made to look cold and manipulative, as May told the story of her arranged affair and John's ten-month-long "lost weekend" in California. Mintz rushed to Yoko's defense as usual, saying he had talked with John "every day when he was in Los Angeles [and] almost everything she describes did not happen that way."

However true or untrue the stories, every day through the summer and early autumn of 1983, Yoko was smeared in the daily press. Sometimes the newspapers used May Pang quotes to attract readers, as when one London tabloid said, "Yoko Forced Me to Be Lennon's Lover," and another headlined, "John Kicked the Baby and Beat Up

His Wife." Others were content to report the "news," such as when photographs of John and Yoko making love—taken for the *Double Fantasy* album but never used—appeared in one of the more graphic men's magazines and Yoko sued to halt distribution; she lost that battle when a New York court said the Lennons were public figures and thus had given up much of their right to privacy.

Yoko was incensed. "The most difficult thing has been getting over the public attacks," she told London's *Sunday Times Magazine*. "I've had them for more than a decade, and I should be used to them by now, but I'm not."

By September, Yoko had taken several large steps to right her "wronged" public image. For PolyGram, she and Sam Havadtoy had no less than three albums in development.

The first of these was *Milk and Honey*, subtitled "A Heart Play." This was the most overt declaration of Yoko's romantic notion of her marriage yet. Yoko, and PolyGram, regarded this as a companion album to *Double Fantasy* because in it were the unreleased Lennon songs from the *Double Fantasy* sessions. In the liner notes, Yoko told a story about how she came to write a song called "Let Me Count the Ways." It was inspired by the famous poem by Elizabeth Barrett Browning, the one that began, "How do I love thee? Let me count the ways . . ." Yoko went on to explain that she and John had considered themselves the reincarnation of "Liz and Robert Browning," who together represented the romantic Victorian era even more than Queen Victoria, for whom the period was named, and her consort Prince Albert. In response to Yoko's song, John had taken the first two lines of a Robert Browning poem and written a song of his own, suggesting that she grow old with him, because the best was yet to come.

Again, Yoko and John alternated songs on an album, and again, the Lennons were shown nuzzling in Central Park. (This time in color; the *Double Fantasy* cover had been in black and white.) And in an attempt to diffuse the impact of the photographs that had appeared in that men's magazine, Yoko included a postcoital picture inside the album sleeve; both she and John were nude, and he clearly was on top of her, and they were smiling.

If there was any question what Yoko was saying in the album, she answered it in the final paragraph of her liner notes. For three years, she said, it was as if she and Sean had been surrounded by human wolves who claimed to be John's friends.

Yoko wrote that she saw "beautiful rainbows behind the black

forest and people calling us with love from the distance." Finally, Yoko said, she and Sean decided to call the rainbow to them by sharing the songs on the album.

The second album project was somewhat subtler and was comprised of excerpts from the taped interviews she and John had conducted with *Playboy* magazine shortly before John's death. At the time, they were to be used as part of an authorized documentary. This album took as its title the same words used for the subtitle of *Milk and Honey*—*Heart Play*—and was, in turn, subtitled "Unfinished Dialogue."

The conversation, as programmed, was disjointed and, in the end, rather uneasy to hear. Listening, one got a sense of who John and Yoko were and certainly John was clear about his feelings for Yoko when he proclaimed, "She's my teacher, she's taught me everything I fucking know!" (A segment of the interview that Yoko insisted upon including in the album.) However, there was a chilling bit of prophesy that made the overall impact very difficult to take. That came when John said, "Gandhi and Martin Luther King are great examples of fantastic non-violents who died violently. What does it mean, that you're such a pacificist that you get shot—I can't understand that."

Both albums were released in October to coincide with John and Sean's birthdays. The third project begun that summer took longer to organize. Yoko said this also was one of John's ideas—to have a number of singers record several of Yoko's songs. John had frequently said that he could have recorded one of her songs, but people would have shrugged it off, figuring he only did it because they were married. However, if someone else were to do it . . .

At Yoko's urging, Sam Havadtoy began calling and writing friends, including Roberta Flack, who lived next door to one of the Lennon apartments in the Dakota, to ask them to record one of Yoko's songs.

At the same time, Yoko finalized plans to publish a book of photographs taken during John's last summer, and met secretly with Jacqueline Kennedy Onassis to discuss a multimillion-dollar offer from Doubleday, for whom Onassis worked as an editor, to write her autobiography. Nothing came of the meeting. The photography book was published later in the year.

In addition to albums and books of her own, Yoko made plans to step up her contributions to various charities. She was, after all, according to *Forbes* magazine, one of the richest individuals in the world, having inherited at least $150 million. In October, only weeks after

Forbes published its annual "400 richest people" list, one of Yoko's spokespersons announced that she was giving more than $3 million in property and cash to a variety of worthy causes. The donations included: a 22.5-acre waterfront property in Virginia, the proceeds of its sale to go to a Virginia foster homes organization; another, 128-acre Virginia estate, this money to be given to the Strawberry Fields Orphanage in Liverpool; and 19 acres of land on the Isle of Dornish (where, so many years ago, Yoko had spent a crazed night with John and friends), earnings from this sale to aid Irish orphans.

Loving albums, photographs, and books, and hefty donations to orphans notwithstanding, Yoko was still at the brink of collapse, according to her closest friends. So upset was she, in fact, that she decided to leave New York. In September, she and Sam were in San Francisco, where it was rumored she was house-hunting.

Yoko and Sam had planned, tentatively, to travel on to Japan, but instead stayed in the Bay Area to explore the wine country and visit old friends in Marin County. Sean was enrolled, temporarily, in a day school as Yoko and Sam met quietly with a realtor. The local paper headlined the development, "Yoko Moving West!"

The fantasy ended abruptly when San Francisco police called Yoko in her hotel room to warn her that they had arrested someone who had a number of guns, a collection of Lennon books, and who, after firing a number of shots out his window, told police he was "after" Yoko Ono.

A day later, Yoko learned from friends that one of the editors of *People* magazine had been interviewing Mark David Chapman in jail so that he could write a Chapman book. According to the same friends, Yoko burst into tears, and with security doubled, she and Sam and Sean returned to New York to plan their next move.

25

The
Presence
of
Love

T HERE IS a wise saying that peace doesn't come with the absence of conflict, but with presence of love.

From 1984 through 1986, this is the mood and philosophy that Yoko tried to experience and project. At no other time in her life was conflict more present, and difficult. Yet Yoko insisted upon carrying on—writing and recording new love songs, issuing statements of forgiveness to the public at large, making million-dollar contributions to charity, dedicating a section of Central Park to the memory of her husband, proclaiming her desire for world peace.

In an effort to preserve John's memory, Yoko took Sean for his first visit to England the last week of November 1983. The primary reason for the trip was for Yoko to meet with the three surviving Beatles to discuss Apple business.

They met at the Dorchester hotel, where Yoko stayed in a $600-a-day suite overlooking Hyde Park. They had been through much together, and apart, these four. On this day they seemed only to have royalty statements in common.

Paul McCartney, the richest of the ex-Beatles—estimated to be worth at least $400 million—now lived frugally with his wife, Linda, on a farm in Scotland, where the children attended public schools and the McCartneys were left alone. Linda came to the meeting with Paul.

George Harrison was driven to the meeting alone from his thirty-eight-room Gothic estate in Henley-on-Thames, where he spent much

of his time gardening. He was the most reclusive of the three, having withdrawn completely from public view after John's murder.

Ringo Starr was the sole jet-setter left in the group, and he came to the summit with his wife, Barbara Bach.

Very little was accomplished at the meeting, which, according to witnesses, ranged from the awkward and civil to the totally rude and ridiculous.

"The tension was still there," a friend says. "Yoko was not forgiven. Oh, Ringo was nice. He always was nice. And Paul was charming in the way that he could always be when he chose to. He knew how to turn it on and off, and Yoko saw right through it. George still didn't care. He didn't like Yoko when John first met her and he didn't like her in London three years after John was dead. So nothing was accomplished at the meeting. What they had gotten together to talk about went right back on the shelf."

The next day, Yoko took Sean to see the changing of the guard at Buckingham Palace. Flanked by leather-jacketed, mustachioed bodyguards, Yoko wore her ever-present sunglasses and Sean took pictures avidly.

Plans were made to return to England in January, when Yoko would visit Liverpool.

Yoko and Sean were back in New York for Christmas, and by the end of January 1984, things were looking good—better than they'd seemed in years.

One of the most positive developments came with the reaction to *Milk and Honey*. Yoko was candid in her interviews, admitting openly that she didn't know what to do with the unfinished Lennon tapes, so she had let them sit for two years before going back into a studio to finish them.

The reviews were excellent. Robert Palmer, by now almost a fan of hers, said in the *New York Times* that Yoko "wisely avoided the temptation" to polish the material. At the same time, he said, her songs "are some of her best. They are imaginative, compressed little sound-poems, full of odd, shimmering guitar effects and buoyant quasi-reggae rhythms.

"As on *Double Fantasy*, her songs often question or amplify Mr. Lennon's and his songs comment on hers. Comparing the two albums may not be entirely fair to either of them, but to these ears, the harder edge and more diverse textures of *Milk and Honey* make it the finer record."

Other critics agreed, including Bob Hilburn of the *Los Angeles*

Times, who said, "Ono's input seems tame next to the emotional out-pouring of her last two severely underrated solo albums, but her songs and vocals here do seem more assured than on *Fantasy*."

The record sold well, going to the No. 1 position in both the U.S. and England, as well as in several European countries and Australia. One of John's singles from the album also went Top 10.

At the end of January, Yoko and Sean and their bodyguards were back in England, in Liverpool this time, where they visited the Salvation Army Children's Home, called Strawberry Fields, and the Cavern, the nightclub where the Beatles got their start. They visited the art college where John had been told to give up his guitar for a paintbrush, and then they called on John's beloved Aunt Mimi.

Back in London, before returning to the U.S., Yoko gave an interview to the *London Times*, making another public reference to her ongoing relationship with suicide, and her willingness to talk openly about it.

"Last year, I broke it to Sean that maybe I am not going to survive and that he should remember that his Mummy and Daddy loved him very much. And he said he didn't want to live alone, so let's die together.

"So now we are both glad to be alive. But it means that we can't go around the corner to a shop like everyone else. That's how it is."

When asked about the recent, exploitative books about John, Yoko was forgiving. She said she still hadn't read the books and despite what she'd heard from friends, she preferred to think of the writers as she had known them years before.

However calm this may have made her seem, she was quick to admit that even though more than three years had passed since John's murder, she hadn't yet relaxed. She was grateful she had been so busy. "Working and doing my own thing is the only way I will keep my mental health," she said.

She also said that she really didn't want to put her life back in order. "John used to smoke Gauloises, you know? And just before . . . well, there's a closet full of Gauloises that we'd just bought. I can't bring myself to throw them away."

If the business kept her sane, it also interfered with her relationships, especially that with her son. Yoko admitted she still worked twelve- to eighteen-hour days in the Dakota offices, which left for Sean only minutes a day, sometimes none at all for several days in a row.

When Julian visited, he said he enjoyed playing with Sean, but

found Yoko difficult to be with. She fidgeted and insisted upon talking business, or interfered with his. When he was recording his first album—*Valotte*—she tried to halt the New York sessions because she didn't like the man who ran the studio.

"She always talks about business," Julian said. "It always rolls round to business. She's into making money. So I just stay away from all that. It annoys me that she drags Sean into it."

At the same time, she continued to languish in her memories of life with John. Meeting with Andrew Solt, a Los Angeles–based film documentarian, she recalled that when John started to write again and they started to record *Double Fantasy*, it was "like we were on acid again. And we weren't. We were up there and it was like we'd just fallen in love."

Through the spring of 1984, Yoko met frequently with Solt to talk about a definitive Lennon documentary. Already she had commissioned and completed a documentary about herself, working with Barbara Graustark, the writer who had conducted a 1980 interview for *Newsweek*. The fifty-minute film included interviews with her childhood piano teacher and with Paul McCartney, both of whom had nice things to say. Only once did she lower the gates and reveal herself, when she said that after Kyoko's disappearance, she vowed never to create another relationship that would hurt so much when it ended. She did not mention Sean by name, but there were critics who, when they heard this, whispered knowingly.

Some were still calling her "the widow of the year," recalling the rude Beatle remark "flavour of the month" of so many years before. (In the Graustark documentary, Yoko described herself as "the keeper of the wishing well.") Others delighted in sharing personal stories.

One of her lawyers talked about when he visited Yoko at the Dakota, the servants entered and exited the rooms on their knees while serving tea—perhaps a tradition in Japan when Yoko was a child, but hardly suitable in New York in the 1980s, or in the home of an avowed feminist.

Betty Rollin, who had gone to Sarah Lawrence with Yoko and who had interviewed Yoko and John for *Look* magazine many years later, was approached by Sam Havadtoy to do an interview for French television for Yoko's fiftieth birthday. She agreed, and Havadtoy came to her apartment with the French film crew. The first question from Sam clearly had been dictated by Yoko: "Why [Yoko asked after eighteen years] did you write that awful story about Yoko in *Look* magazine?"

In October, as Julian Lennon's album and a single, "Too Late for Goodbyes," were becoming worldwide hits, Julian lashed out at his father's widow, saying she was exploiting John. "Me, I would have just liked to have had a guitar of his or some clothes or, y'know, things that mean more to me than money," Julian said. "I think I got a jumper out of it. I had a guitar of my dad's but she wanted it back. So she got a guy to come over and take it back."

"She's so disliked!" said Howard Smith, a former columnist for the *Village Voice* who had known Yoko for more than twenty years. "She was always saying things like, 'I'm doing another happening—most important in history of world.' She screamed that Marcel Duchamp stole her art. I remember, later, she held a press conference about women's feminism. She was wearing a cartridge belt. Then, when the press left, she turned on some female employee and screamed at her, 'Why didn't you get my shirt pressed right?' "

"There are sides of Yoko Ono," says Norman Seaman, her longtime friend. "Some will say she's violently self-centered, and evil in many ways. Others will say she is a generous, concerned human being, interested in women's rights and loyal to her friends. Her friend Charlotte Moorman was in and out of Sloan-Kettering for years, the bills were horrendous, and Yoko paid them all. Some will say she is an artist, is talented. Others will say she is a phony with absolutely no talent at all. You know what? It's all true, every single contradictory bit of it."

And Yoko carried on. She dedicated Strawberry Fields in Central Park (with both Sean and Julian on hand), a tribute to her dead husband that newspapers claimed cost Yoko $1 million (for landscaping and future maintenance). She also conducted an elaborate auction of Lennon-Ono goods. Among the items sold were John's 1965 Rolls-Royce (which brought nearly $250,000, more than five times its market value), a piano, the 1947 jukebox that John and Elliot Mintz had included in the Club Dakota, some gold records, and tickets to a 1966 Beatles concert. In all, Yoko raised nearly half a million dollars for charity.

She made deals, finally agreeing to cooperate in the making of a television movie about her life with John. Oddly, she granted these rights to a company owned by the late-night TV host, Johnny Carson, Carson Productions, Inc. It was announced that the script would be written by Edward Hume, who wrote the antinuclear TV film *The Day After*, and that two unknowns would play the Lennons. Yoko was given $4.5 million, plus casting and script approval.

Through PolyGram, she finally released *Every Man Has a Woman Who Loves Him*, the collection of songs written by Yoko and sung by other artists. Sam had been working on this compilation for nearly two years, and had supervised the recording of a dozen songs. Artists included John himself (singing the title song), Harry Nilsson, Eddie Money, Rosanne Cash, Elvis Costello, Roberta Flack, and Sean (who reprised Yoko's title song from her album *It's Alright*).

For the liner notes, Yoko wrote a short story about a small boy who had to carry a bomb to the top of a mountain. His mother followed him as he made his way, and once there, they discovered that it wasn't a bomb, but a crystal ball. Yoko ended the notes with a popular cheer from the sixties:

> SO---
> GIVE ME AN L
> GIVE ME AN O
> GIVE ME A V
> GIVE ME AN E
>
> WHAT DO WE GET?
> PEACE!
>
> y.o. '83

The album was released in September 1984, just before John's birthday (he would have been forty-four). Yoko said in promotional interviews that the important thing to remember was that "all kinds of people and styles of music were coming together and sharing their love. The spirit is the real message of the album."

The spirit sold poorly. Some radio stations played the album out of curiosity and loyalty to Lennon. (The album was widely hailed, after all, as one of John's ideas.) And there were respectable critics who liked the record. But the radio loyalty and critical praise mattered not a bit. The album sank like a rock.

□

There were by now more than twenty books about John on the market; most of them mentioned Yoko, but only a few regarded her in a positive light. Among the writers of Lennon books, Yoko was generally portrayed again and again as manipulative and cold.

Some said she was John's "mother figure," filling a need created when his own mother died. They said that he truly needed someone to tell him what to do, even if it was to travel in a northwesterly direction for 5,000 miles. He also, clearly, wanted someone to take care of his

business. Yoko was always ready for that, even if she did take her tarot cards into the boardroom with her. (John liked that.)

Others said Yoko was a royal bitch, that she controlled John by telephone (when he was in L.A. on his "lost weekend") and magic (with the use of numerology).

The level of insult probably peaked when Yoko became a popular target in comedy. By 1985, Joan Rivers was using her as an inspiration for material as regularly as she was using Elizabeth Taylor. "You know how Yoko Ono got her name?" Rivers asked. "John Lennon saw her naked and said, 'Oh, no!' She points her finger and they think it's E.T. They combed her hair and they found the Lindbergh baby. . . ."

Other comics were even harsher. In the late winter and early spring of 1985, as Ethiopia was devastated by the worst famine since biblical times, one of the most popular jokes being told in New York asked, "What does Yoko have in common with the Ethiopians?" The answer: "They both live off dead beetles (Beatles)."

Later in the year, Yoko was asked about such jokes. "Well," she told Rona Elliot of NBC, "you never get over that. You know, in a way you always get hurt . . . when you see it in the morning papers. There were times when I just didn't feel like reading the papers."

She forgave her critics, she said. "We're all human. And they weren't getting the right message, so of course they're going to misunderstand me. So it wasn't their fault, in a way."

In February and March, Yoko had begun work on still another album. Originally, this was conceived as a project with her son, called *Mother and Child*. Sean had been at dinner with Yoko and some of Yoko's friends one night when the conversation lingered on the conflicts and grief in her life.

Sean interrupted, "Mommy, life is horrible, isn't it? I mean, it's terrible."

Yoko was startled. "No, no," she said, "it's going to be very good, you'll see. You know, life can be very beautiful, Sean. . . ."

Yoko stopped, realizing—she said later—that life *was* terrible for them, and she wasn't doing anything about it.

She wrote songs about this and the first that came to her projected a message long associated with Yoko and John. She didn't want to turn into Miss Havisham, the character in Charles Dickens's *Great Expectations* who stopped her clock and buried herself in the past after being stood up at the altar. At the same time, she decided to pick up John's fallen torch.

The album contained a song called "Remember Raven," a biting

retort to critics who tried to dig up dirt. The rest of the songs cele-brated peace and love. And the album itself, in a not-so-subtle nod to President Reagan's Star Wars program, was called *Starpeace*.

In the fall, the events were purposefully planned. On what would have been John's forty-fifth birthday—and was Sean's tenth—October 9 was the date set for the long-delayed opening of Strawberry Fields. This was followed by the release of the album, and, on December 2, the television broadcast of the three-hour movie, *John and Yoko: A Love Story*.

The movie, produced by Carson Productions, had attracted much media attention when the unknown actor originally cast as John Len-non turned out to have been born with the same name as Lennon's killer, Mark Chapman.

"The name problem didn't really occur to us at first," said John McMahon, the film's executive producer. "When it became apparent to us, it just seemed inappropriate to have an actor named Mark Chapman playing John Lennon, especially since we are focusing on the love story between John and Yoko. It would be like having an actor named Lee Harvey Oswald play John F. Kennedy. We thought it was in the best interest of the production to recast."

Another unknown, Mike McGann, was hired. Kim Miyori, a young Japanese-American actress who worked on the "St. Elsewhere" series, was retained in the Yoko role.

The film was not very good, largely because it was so squeaky clean and predictable. Produced with Yoko's advice and consent, it was most interesting not for what was included, but for what was left out. As might be expected, there was no mention of Yoko's plan to meet and marry Lennon; instead, the hoary old myth about her not even knowing who he was when they met was marched out once more. And while John was portrayed rather honestly—booze, women, drugs, and all—Yoko was painted as a guru of goodness, ever-understanding, and rarely understood.

Because it was a film produced for television (NBC), it received only a few advance reviews. (*People* magazine gave it a B−, praising the music and McGann, faulting the script, and calling Miyori's por-trayal of Yoko limp; others fell in line.) The audience, however, was huge, wiping out all competition for the evening.

Reviews of *Starpeace* were more numerous and more flattering. The producer, Bill Laswell, used a chorus of backup singers on key lines and assembled a solid, rocking band that included a Jamaican rhythm section, a South Indian violinist, percussionists from Cuba

and West Africa, and the brilliant jazz drummer Tony Williams. This was, Yoko said, an open attempt to make her message more available.

Newsweek called it her "most successful album yet," and the *Los Angeles Times* said it was her "most enjoyable." *Rolling Stone* said the album "seamlessly fuses artistic daring with accessibility" and closed its rave review with the statement that "there can be no denying that this 52-year-old pop star now fully deserves to be reckoned with on her own demanding terms." Bob Palmer wrote in the *New York Times* that this was her "most balanced album" yet, "state-of-the-art pop music for 1985, and a vision of the international, trans-idiomatic popular music to come."

Yoko did all she could to promote the album. She gave dozens of major interviews, and as a result, appeared on the cover of several magazines, including the big-circulation tabloids—*Parade* and *USA Weekend*. She made a lighthearted video for her single, "Hell in Paradise," dancing in the center of a line of dark-suited men who ranged from a giant to a midget.

Nothing worked. The album sold poorly.

Christmas at the Dakota was quiet as Yoko prepared for a world tour whose start date kept changing according to the latest numerology readings, or ticket sales, depending on who you believed.

By now, the seventh-floor apartment had settled into a semblance of a routine. On a typical day, Sean prepared his own breakfast cereal and then was taken by a bodyguard to his nearby private school. Yoko started the day about the same time with a pot of sweet English tea and spent her day in the first-floor office, talking on the phone and answering mail from an overstuffed chair.

In the evenings, Sean did his homework on his McIntosh computer, or talked with his mother in the kitchen, where many of John's pictures were displayed.

Sam was still a fixture, what Yoko called "a close companion and a close friend." Was marriage a possibility? It wasn't in the cards.

Then, in January 1986, the domestic tranquility was suddenly broken with numbing impact when Tony Cox came in from the cold. In an interview with *People* magazine, he said he and Kyoko had left the Church of the Living World in Los Angeles in 1977. Cox's second wife had remained behind.

Cox wouldn't say where he and Kyoko had lived since then, and when asked if Kyoko would be reunited with her mother, he said that it was up to the child; she was now 23 and able to make up her own mind. "She's a completely independent individual," Cox said. "After

seeing what some of the aspects of public life are about, she realized that was one thing she did not want."

Yoko was stunned when news of the interview reached her, and when *People* asked for her reaction, she asked for twenty-four hours. The next day she gave the magazine an open letter to her daughter:

Dear Kyoko,

All these years there has not been one day I have not missed you. You are always in my heart. However, I will not make any attempt to find you now as I wish to respect your privacy. I wish you all the best in the world. If you ever wish to get in touch with me, know that I love you deeply and would be very happy to hear from you. But you should not feel guilty if you choose not to reach me. You have my respect, love and support forever.

Love, Mommy

Yoko decided to start her world tour in Europe, and as she began to rehearse with a band, she again granted major interviews. As usual in such situations, her past came up. Once more, Yoko was left to review her life.

And what a life it had been so far.

She had lived for more than half a century, a witness to two great cultures at war, becoming, in time, a link between those cultures— someone who was the best-known Japanese woman in the West, and simultaneously so much an alien at home that Tokyo magazines used *katakana* when they printed her name.

In the art world, her early efforts were, if not elaborately praised, at least recognized as seminal. By 1986, there were composers and artists actually making a living in minimalism and earning rave reviews in national magazines besides. It was with great pride that Yoko found herself included in the sixteenth edition (1984) of *Who's Who in American Art*.

The ups and downs had been sudden and frequent. Born into a home with more than two dozen servants, she experienced near starvation during World War II, then the new wealth of postwar recovery. This was followed by years of hungry bohemianism on the streets of New York and London and this, in turn, was succeeded by so much of John Lennon's money that, when he died, she found herself included on *Forbes* magazine's list of the 400 wealthiest humans and *Playgirl*'s list of the fifty richest American women. And now she, too, had more than two dozen employees and servants.

She had been married three times, divorced twice, widowed once, and there were two children, one of whom she hadn't seen for fifteen of her twenty-three years. Her relationships with her own family in

Japan suffered, too. The Onos spoke kindly, or circumspectly, but rarely. While Yoko spoke hardly at all.

How many times had she experienced cruel rejection? Hadn't her parents disowned her when she married that penniless pianist? In an art world dominated by men, hadn't she been ignored in New York, or at best regarded as a peculiar oddity? Hadn't Paul, George, and Ringo and Beatle fans everywhere turned their backs, and worse? Hadn't John Lennon's friends laughed at her? Hadn't her recording efforts been denied by critics most of the time and the public always? Hadn't her only daughter refused to acknowledge her? Such rejection must have had tremendous impact.

Yoko merely smiled and said, "I think that things happen in a mysterious way. And it seems like whatever happens seems to have a benefit for all of us, you know. So, I'm just doing my best and see what happens. In other words, I feel that I'm probably used for some high purpose that I don't know."

Yoko had forged several indelible images by 1986.

To some, she was a somewhat Americanized copy of her mother, a Park Avenue matron who dressed in silk suits, smoked cigarettes, drank tea, went to the opera, served on committees (in Yoko's case, with Burt Reynolds, Richard Pryor, and Brooke Shields in an AIDS benefit), went everywhere accompanied by bodyguards, and hid behind dark aviator glasses.

To others, she was an eccentric millionairess who once had dabbled in art, then, after capturing a Beatle, collected cows and Egyptian artifacts, ran a $150-million empire on tarot card readings and brown rice, and once a year tried to be a rock star. In other words, a flake.

To still another group, Yoko was one of the vultures who fed on Lennon's corpse. Hadn't she signed agreements to authorize the marketing of more than a dozen "tasteful" products bearing the name or based on the work of her late husband? Hadn't she also gone along and permitted the use of the Beatles song "Help!" (which featured John's vocal) to sell Mercury automobiles? And wasn't her upcoming concert tour just one more example of her eagerness to capitalize on the Lennon legacy?

To most, she was still, and probably would always be, the keeper of the wishing well, the individual who had inspired the song that had become an anthem, "Imagine." This is the title that Yoko wore comfortably.

"I mean, even when John and I did the bed-in, and people would say, 'Well, what is your actual plan to bring peace?' Or they would say,

'Well, what do you want us to do?' And we kept saying, 'No, this is just to remind you of peace, and you have to do it in your own way.'

"It's very dangerous to try to control people or try to make them do what you think is the best, because we're not gods, you know. And all we can do is to just give some encouragement and energy. And they have to use that energy to do their own thing."

Whatever she was, to whatever group, there was one thing she was to all: a presence in the life of one of the pivotal and catalytic figures in the second half of the twentieth century. A presence and an *influence*. Surely she knew this. How often had John said that she was his teacher as well as his lover? He meant it. And the evidence was there. When Ray Coleman, an English journalist, wrote a biography of Lennon, he had it published in two volumes: before and after Yoko. It was not an inappropriate way to review John's life; that was, after all, how he regarded it.

Initially Yoko's tour planned to visit thirty-two cities in eleven countries, including nations on both sides of the Iron Curtain in Europe, Japan, the U.S., and Canada.

In Vienna, only 700 of 1,800 concert tickets were sold, so 300 were given away to make the crowd appear less embarrassing. In Berlin, the club was a third empty, in Hamburg, a third full.

The brightest shows came in Budapest, Hungary, where she performed to 15,000, her largest audience. She was an unfamiliar figure in this Communist country because her albums were generally unavailable. Nonetheless, the young crowd listened attentively, many of them clutching John Lennon books and posters in their laps as they watched.

The enthusiasm of those in attendance was rewarding. Yoko was given respectful attention as she moved through her personal musical history, performing material that went back to 1971: "Midsummer New York" from the *Fly* album and soundtrack, as well as the orgasmic "Kiss, Kiss, Kiss" from *Double Fantasy*. Each set closed with an emotional rendition of "Imagine," usually with many in the audience holding lighted matches and flashing the international symbol of peace, first and second fingers held aloft in a V.

London was another mini-triumph. The night before the scheduled show, she greeted the press (many of whom had been with the tour since it started, including the *Los Angeles Times* and *Rolling Stone*). "Look," she said, "I know if I just shut up and stay home at the Dakota and accept flowers every December 8, people will say, 'Okay, we'll leave her alone.'

"I also knew that some people would say, 'Oh, no . . . not another peace campaign. You did that years ago with the bed-in and stuff.'

"But I'm not living for those people . . . in that sense. It's my life and I have to do what I think is right. I had begun to look in the mirror and I didn't like my face. I didn't want to be one of those people who just give up."

In the U.S., tickets were moving very slowly. At one of the most important venues, the 6,000-seat Universal Amphitheatre in Los Angeles, only 1,500 tickets had been sold. In the Midwest, it was much worse.

Yoko conferred with her business advisers. They told her that if she continued with the tour, the way things were going, she'd lose between $1 and $2 million.

Yoko called her numerologist.

When they returned to the U.S., the first week of April 1986, it was announced that the American dates had been canceled due to poor ticket sales.

Yoko got back on the phone.

INDEX